Childe Hassam

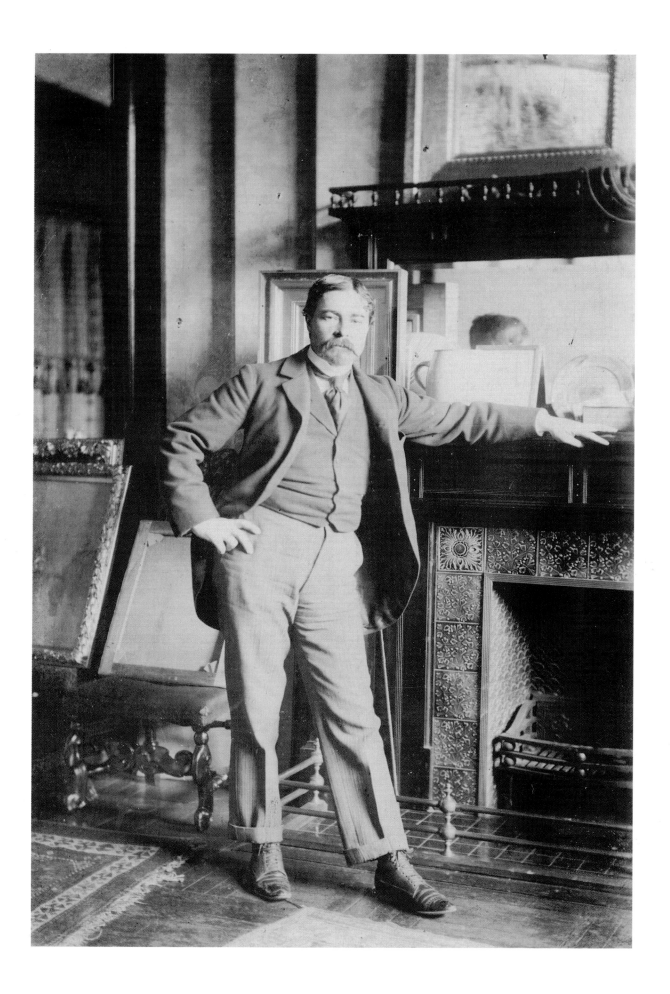

Ulrich W. Hiesinger

Childe Hassam

American Impressionist

Prestel · Munich and New York

This book was published in conjunction with the exhibition of the same name held at the Jordan-Volpe Gallery, 958 Madison Avenue, New York, from May 20 to July 1, 1994.

Cover: *Geraniums*, 1888 (detail; fig. 48)
Frontispiece: Hassam in his studio, c. 1896

Prestel-Verlag
16 West 22nd Street, New York, NY 10010
Tel. (212) 627 8199; Fax (212) 627 9866
Mandlstrasse 26, D-80802 Munich, Germany
Tel. (89) 381 7090; Fax (89) 381 7 0935

Distributed in Continental Europe by Prestel-Verlag
Verlegerdienst München GmbH & Co. KG
Gutenbergstrasse 1, D-82205 Gilching, Germany
Tel. (8105) 38 81 17, Fax (8105) 38 81 00

Distributed in the USA and Canada on behalf of Prestel by te Neues
Publishing Company, 16 West 22nd Street, New York, NY 10010, USA
Tel. (212) 627 9000; Fax (212) 627 9511

Distributed in Japan on behalf of Prestel by YOHAN Western Publications Distribution Agency, 14-9 Okubo 3-chomo, Shinjuku-ku, J-Tokyo 169
Tel. (3) 3208 0181; Fax (3) 3209 0288

Distributed in the United Kingdom, Ireland and all remaining countries on behalf of Prestel by Thames & Hudson Ltd, 30-34 Bloomsbury Street, London, WC1B 3QP, England
Tel. (71) 636 5488; Fax (71) 636 1059

Typeset by OK Satz GmbH, Unterschleissheim, Germany
Offset lithography by Fotolito Longo, Frangart, Italy
Printed and bound by Passavia Druckerei GmbH, Passau, Germany

Printed in Germany

ISBN 3-7913-1364-9

Contents

Acknowledgments

This volume was made possible through the cooperation of many individuals and institutions. No contribution has been more important than that made by the many interested collectors who made their paintings available for study and who graciously agreed to have them reproduced. Their trust and generosity are deeply appreciated.

Among others who provided information and help in securing photographs we are indebted to: Kelley Anderson; Joan Barnes; Joni Bomstead; Lillian Brenwasser; Melanie Brownrout; Larry Casper; Ralph Connor; David Doepel, CVA Media; Michele M. Ridge, Erie County Library System; Vicki Gilmer; M. Rémy Guadagnin, President, J. P. G. F. de Villiers-le-Bel; Tod Ruhstaller, The Haggin Museum; Charles E. Hilburn; Fred Hill; Thomas Butler and Dan Siloski, Huntington Museum of Art; John Hutchinson; Laurene Latine; Kelly Longbottom; Pamela McKay; Robert Moeller; Heather Hornblower, McNay Art Museum; Heather Cleary, Museum of Fine Arts, Boston; Marc Wilson, Nelson-Atkins Museum of Art; Karen Montalbano and Margaret Di Salvi, The Newark Museum; Vera Novak; Martha Parrish; Ursula Pfeffer; Cheryl Robledo; Edward Roddy; Christina Ryan; Patterson Sims, Seattle Art Museum; Edward L. Shein; Abbott W. Vose; and Robert Vose III.

For facilitating research in many useful ways sincerest thanks are owed to: Gina Erdreich and Lilah Mittelstaedt, Philadelphia Museum of Art, Library; Janice Lurie, Albright-Knox Art Gallery; Nancy Johnson, Larry Landon, and Kathryn Talally, American Academy of Arts and Letters; Jennifer Cook, Appledore Marine Laboratory; Judy Throm, Archives of American Art; Sally Pierce, Boston Athenaeum; Karen Shafts, Boston Public Library, Print Room; Dennis Rowley, Brigham Young University Library; Kelly Lewis, The Art Institute of Chicago; Lawrence Campbell, Art Students League; Terry Carbone, The Brooklyn Museum; Louise Lippincott, The Carnegie Museum of Art; Martha Thomas, Cleveland Museum of Art; Marisa Keller, The Corcoran Gallery of Art; Michael Komanecky and Darlene La Croix, The Currier Gallery of Art; Nancy Rivard Shaw, The Detroit Institute of Arts; Adam Van Doren; Caroline Durand-Ruel Godfroy, Durand-Ruel & Cie., Paris; Dr. Stuart Embury; Jeffrey W. Andersen and Debra A. Fillos, Florence Griswold Museum; Lita Garcia and Sue Hodson, The Huntington Library; Stephen E. Ostrow, Prints and Photographic Division, Library of Congress; Sue Reed, Museum of Fine Arts, Boston; Ann Lewis, Inventory of American Painting, National Museum of American Art; Christian Prevost-Marcilhacy, Inspecteur Général des Monuments Historiques; Messrs. Edouard and Laurent Prevost-Marcilhacy; Lynn Putney, National Museum of American Art; Caleb Mason; Nancy Noble, Portsmouth Library; Lorna Condon, Society for the Preservation of New England Antiquities; Christen Start, Star Island Corporation; Charles Sweetman, Jr.; Amy Day, Texas A&M University; Barbara Lovejoy, University of Kentucky, Lexington; and Ron Bergeron, University of New Hampshire.

Special thanks are owed to David Dufour, B. J. Topol, and Josh Muntner for their generous help and encouragement.

To Margaret Amalia and William Matthias also go thanks for their usual careful attention and appreciation.

Finally, grateful acknowledgment is made once more to the editor and staff at Prestel, whose intelligence, patience, and superb professionalism helped make work on this book a pleasure.

FOREWORD

Several years ago, the Jordan-Volpe Gallery sponsored research that resulted in *Impressionism in America: The Ten American Painters,* a book by Ulrich W. Hiesinger that dealt with the career of Childe Hassam in the context of that group of artists. In a volume devoted to several painters, space limitations made it impossible to include all the unpublished paintings and documents discovered in the course of work on that project, many of them relating to Hassam. The importance of this material, together with the fragmentary state of Hassam studies, underscored the need for a study devoted exclusively to Hassam.

Childe Hassam has long been considered America's preeminent Impressionist painter, yet this is the first monograph to examine his oeuvre in a comprehensive manner, encompassing all the wide range of styles and subjects developed during a career that exceeded half a century. This is not to imply that the present volume is intended as the final word on the subject. Rather, it attempts to provide a substantial framework within which to assess a painter who has always found great favor with both collectors and the general public, but whose considerable appeal and accessibility have helped divert attention from the need for a soundly researched overview. *Childe Hassam: American Impressionist* fills this long-standing void and, it is to be hoped, will encourage the discovery of further material that would enlarge our understanding of this most important American artist.

Vance Jordan

January 1994

INTRODUCTION A PROFILE OF THE ARTIST

Childe Hassam is acknowledged today as the leading exponent of Impressionism in America. As the painter who most persistently and effectively applied the principles of French Impressionism to the American setting, he was considered even by his contemporaries to be America's most important representative of that style. Both his voice and range of subjects were uniquely his own, and Hassam took greatest pride in having preserved experiences that he felt were distinctly American. By contrast, most of the commentary about him during his lifetime stressed the foreignness of his style. Yet although Hassam was linked to French Impressionism in general, and to Claude Monet in particular, with numbing regularity, even to the point of being named Monet's direct pupil, in time Americans learned what French critics had known all along. Thus, on the occasion of Hassam's first major retrospective exhibition in 1910, Anna Seaton-Schmidt wrote: "Although Mr. Hassam is the American representative of French Impressionism, his works reflect the strong personality of their creator. It is true that he studied his technique in France, where his personal vision was much enlarged, but he remains himself always and his poet's soul receives its inspiration solely from nature."[1]

As is often the case with those who rise to fame, a disproportionate amount of material survives from Hassam's later years, while the earlier and most vital phases of his career are poorly documented. At the height of his success, around the time of World War I, Hassam assumed a near mythical stature. The painter Jerome Myers, who knew him then, recalled: "In the army of artists, Childe Hassam was like a major general, covered with medals and honors, with stripes of long service. He commanded the art dealers, issuing his orders of the day, supervising the galleries, a general whose word was law to 57th Street."[2] Behind this splendid metaphor of a peacetime general lay the indelible experiences of a younger, battle-worn recruit, who for decades had fought thanklessly in the service of an unpopular cause. Hassam grew more conservative as the world became more receptive to his art, yet for all his success — which was actually less exalted than Myers's eulogy implies — Hassam never was reconciled to what he continued to regard as "the ever stupid public."[3] His commercial success in

later years was based increasingly on his early reputation. Thus, while Myers looked on awestruck from the sidelines, Hassam privately expressed his own reaction to success, grumbling in the midst of telling how the dealers were hounding him for pictures: "They might have done all this when I was younger."[4]

Hassam learned to paint in his native Boston. During three years spent in Paris he greatly expanded his vision and technical skills, but it was only after he moved to New York in 1889 that his mature artistic style became fully developed. His subsequent career unfolded not as a linear progression, but as a series of overlapping episodes, each distinguished only by the relative dominance of certain stylistic elements. Hassam never forgot anything and, while constantly probing in new directions, kept all his previous work as a reserve on which he drew freely.

The foundation of Hassam's art was his skill in manipulating color and light, in accordance with his belief that the primary appeal of painting was emotional rather than intellectual.[5] Like other American Impressionist painters, he initially employed techniques of rendering light as a form of realism, but eventually pursued their expressive potential in the direction of abstraction. Bold sunlight was only one of the things that fascinated him. He dealt with atmosphere and light in all its manifestations, in rain, snow, mist, moonlight — indeed, in any phenomenon of nature that could lend drama and energy to a scene, and that helped finally to transform it beyond its ordinary physical condition. He saw nature as still life and, even in his early works, often stressed the abstract beauty of surfaces, whether revealed in rain-slicked pavements, the rocks of a craggy shore, or an ice-covered river. From his initial attempts at realistic portrayal, he moved steadily toward a greater analysis of his subject's formal, decorative qualities, so that at times the merging of textures and colors in his canvases comes close to pure abstraction.

Like other Impressionists, Hassam was convinced that the painter's first priority was to paint his own time, which he himself found most authentically manifested in the spectacle of America's great cities. This now obvious idea was considered revolutionary by the majority of his contemporaries, who be-

lieved that modern subjects and settings were ill-suited to serious painting. As one Boston critic said of Hassam's urban views: "very pleasant, but not art."[6] Hassam did not originate the idea of painting city streets, but he awakened to its promise sooner, and applied it with more consistency and originality, than any other American painter.

Although the investigation of natural phenomena interested Hassam intensely, he never viewed his quest in scientific terms, nor was he much concerned with general theoretical issues. His method, instead, remained purely instinctive, intuitive, and pragmatic. "I am often asked," he once said, "what determines my selection of subjects, what makes me lean toward impressionism. I do not know. I can only paint as I do and be myself, and I would rather be myself and work out my ideas, my vagaries, if you please, in color, than turn out Christmas cards and have to hire a clerk to attend to orders. I am often asked why I paint with a low-toned, delicate palette. Again I cannot tell. Subjects suggest to me a color scheme and I just paint."[7] Hassam referred again to these personal "vagaries" when he told a friend many years later that he considered the essence of painting to be "something baffling and elusive, that sets it apart from the easy, obvious expression — something that one labors over lovingly, glowingly."[8]

Having begun to earn a living as a draftsman even while still quite naive artistically, Hassam's early education was a patchwork of supportive friendships with older artists and intermittent spells of formal instruction. In the end, he was more self-taught than not, always retaining something of the self-reliance and curiosity of the Yankee tinker. Early experience as a commercial draftsman and the absence of any truly decisive artistic mentor produced in him a strange dichotomy of seemingly contradictory qualities: on the one hand, an instinct toward the creation of saleable pictures and, on the other, a sense of absolute independence and confidence in his own artistic judgment. Throughout his artistic career, Hassam never encountered an impasse, never hesitated, and never doubted.

Hassam shrewdly managed his professional life through tireless attention to the sale and exhibition of his pictures, but, at the same time, seemed incapable of dealing with daily practical matters. In keeping track of expenditures, as he once explained, he employed a simple system: start with a known sum and, when the time comes, count up what is left over. "Nobody has ever accused me of having much common sense about spending money," he said.[9] Ironically, his first job had been in the accounting department of a Boston publishing firm, and it was his inability to deal with numbers that led him directly into the profession of art. His wife, Maude, seems to have taken charge of the practical aspects of life, running their household, handling travel arrangements, and so forth. Beyond a few shadowy outlines, her role in more than fifty years of married life with Hassam is unknown. She seems to have kept her own group of friends, and was evidently a woman of personal reserve, firmness, competence, and loyalty. Particularly during the early years, she regularly appeared as a subject in Hassam's paintings, yet the generality with which he portrayed his figures leaves her identity in doubt more often than not.

One of Hassam's most striking characteristics as an artist was his productivity: his oeuvre consists of literally thousands of works in virtually every medium, from oil painting and watercolor to pastel and printmaking. His friend J. Alden Weir once characterized Hassam as an artist who "can paint on the wing," comparing his own modest capacity for six or seven canvases a season to Hassam's ability to create thirty or forty in the same time.[10] The range of Hassam's subjects was equally impressive, extending from the city streets and squares of Boston, New York, Chicago, Paris, London, and even Havana to the myriad seaports and small villages of New England, the alkali deserts of Oregon, and figural house and studio interiors.

Wherever Hassam went he painted, and his whereabouts usually reflected a purpose with regard to his work. His versatility, too, was the result of conscious choice, of the conviction, newly gained in his generation, that the artist practiced not merely as craftsman but as observer of, and commentator on, the world around him. "A good painter," said Hassam, "should be able to paint the object before him. A good painter should be able to paint anything that he sees."[11] Hassam's surroundings were indeed the raw material for his art, and he was at every moment the professional painter. In his outlook he might be compared to another Bostonian, the writer Henry James, who based his work on the subtle impressions and relationships of passing life.

Hassam approached his subjects with an air of aesthetic detachment derived from the teachings of James McNeill Whistler. Whether in city views or landscapes, visual beauty was his primary concern. The more brutal or squalid aspects of city life held no interest for him, and even his concern for working-class subjects was tinged with romantic idealism. However, the idealism and seeming detachment of his paintings often obscure the fact that his work stems from the most direct personal experiences — whether they were of neighborhoods he walked in, sights discovered in some foreign town, or views obtained from his studio window.

Hassam was a powerfully built, athletic man, with enormous physical energy and an endless appetite for work. His personality was a composite of dual forces in which New England propriety mixed with a good deal of irreverence. He was argumentative, opinionated, yet genuinely kindhearted and capable of self-mockery. According to friends, he left his large ego out of private art conversations. While outgoing and unassuming in congenial company, he cherished a good fight with those who did not meet his particular standards. Then he could reveal a sharp wit and a gift for pungent aphorisms, pleased to classify some rival artists as members of the "baked apple school" or to refer with broad disdain to his "contemptuaries."

Though without the sartorial dedication of an artist such as William Merritt Chase, Hassam, too, was fond of stylish, if not

always elegant, clothing, which he alternated with normal business suits. He preferred English costumes, and once jokingly referred to himself in tweeds and puttees as looking like an English jockey. For a brief time in the 1910s he even affected a monocle, to the mild astonishment of his friend Weir, who thought that he was "truly more foreign than he ought to be."[12]

Behind the gregarious public figure was a man who closely guarded his personal and domestic life. A critic for the *New York Herald* once characterized Hassam as someone who would express his artistic ideas half in seriousness and half in jest.[13] This evasiveness in the face of potentially serious matters reveals itself also in his letters, even those to close friends, where his bluff, bantering style seems to give warning against getting too near to what he considers private. So persistent was this trait that one finally suspects Hassam of screening himself from any unpleasant personal realities.

Like that of all great artists, Hassam's work has the capacity to enliven our perceptions of the world and to change our view of familiar things. This it does by capturing in paint the delicate, transitory sensations of the artist's environment. As his friend Ernest Haskell said in introducing the first book on him over a half century ago: "The real Hassam will never be found in written eulogy—but in his pictures...observe them carefully and then you will find what cannot be described, that intangible something, the charm of the true artist."[14]

NOTES

1 Anna Seaton-Schmidt, in *L'Art et les Artistes* 6, no. 67 (Oct. 1910), p. 45.

2 Jerome Myers, *Artist in Manhattan*, New York, 1940, p. 101.

3 Hassam to C. E. S. Wood, Feb. 7, 1929; Wood Papers.

4 Hassam to Royal Cortissoz, Dec. 18 (?), 1926; Cortissoz Papers.

5 See, for instance, his remarks to S. J. Woolf ("Hassam Speaks Out for American Art," *New York Times Magazine*, Oct. 14, 1934, p. 7), in which, criticizing the direction of modern art and its study, he said: "Art, instead of remaining emotional, has become intellectual....A picture that does not carry its own message of loveliness, but which requires the services of an artistic guide, is not, to my mind, a work of art."

6 Hassam Papers, clipping identified as from *Boston Transcript*, (March) 1887.

7 Quoted in Frederick W. Morton, "Childe Hassam, Impressionist," *Brush and Pencil* 8 (June 1901), p. 143ff.

8 Quoted in Carl Zigrosser, *A World of Art and Museums*, Philadelphia and London, 1975, p. 20.

9 Hassam to John W. Beatty, Nov. 23, 1904; Carnegie Papers, File 15.

10 J. Alden Weir to C. E. S. Wood, May 4, 1915, and Nov. 13, 1910; quoted in Dorothy Weir Young, *The Life and Letters of J. Alden Weir*, New Haven, 1960, pp. 250 and 227.

11 Lockman Interview, Feb. 3, 1927, p. 19.

12 J. Alden Weir to C. E. S. Wood, Oct. (probably) 1914; quoted in Young, *op. cit.*, p. 246: "I had to go to N.Y. for a day and I met Muley with a one eye glass and a rough English tweed, truly more foreign than he ought to be. He shot out the glass with a haw haw, when he caught my eye. He is now beginning his decoration for the San Francisco Ex." Hassam's friends called him "Muley," a nickname that, while many thought it reflected his stubbornness, was in fact a play upon his oriental-sounding name: it was reportedly given him by Frederick Remington after the character Muley Abul Hasan in Washington Irving's *The Alhambra*. For Hassam's remark about looking like an English jockey, see Lockman Interview, Jan. 31, 1927, p. 28.

13 Hassam Papers, undated clipping from *New York Herald* (1935).

14 Ernest Haskell, in Nathaniel Pousette-Dart, *Childe Hassam*, New York, 1922, p. x.

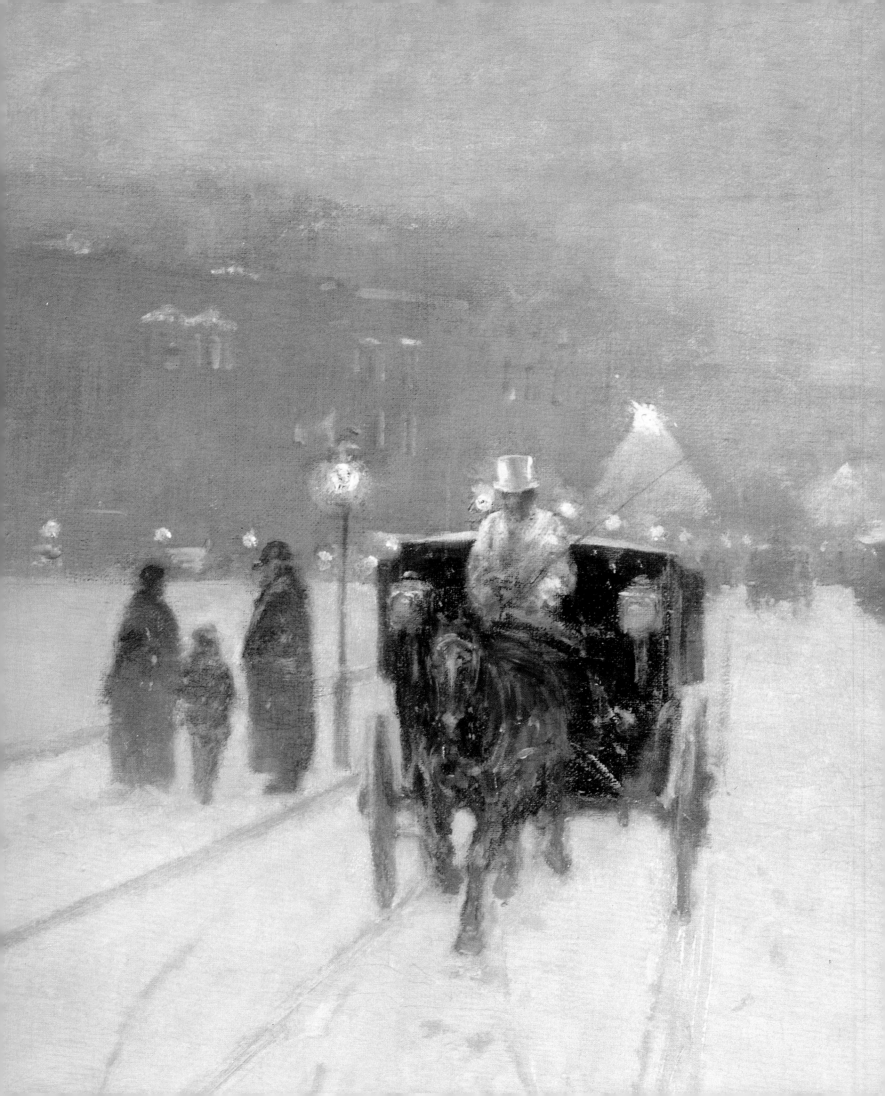

I EARLY YEARS IN BOSTON 1859-1886

The first phase of Hassam's artistic career began with his employment at about age eighteen as a wood-engraver's apprentice, and ended some nine years later when he left for France to further his studies. By that time, according to one critic, at least three stages were recognizable in his development, the first a "poetic" style, which included flowering landscapes as well as moody twilight pieces; a subsequent (short-lived) realistic style, noted for its "breadth and solidity"; and, finally, his most recent scenes of urban Boston.[1] Although our understanding of Hassam's work is still far from complete, the essential accuracy of this account is confirmed by the surviving pictures and by contemporary literature.

The artist, christened Frederick Childe Hassam, was born in 1859 at his family home on Olney Street, Dorchester, Massachusetts. Though an outlying suburb of Boston (incorporated into the city proper in 1870), Dorchester still retained the character of a small New England country town, with green open spaces and old frame houses set on the low hills overlooking Dorchester Bay. It was here that Hassam recalled spending an idyllic youth, filled with the boyish camaraderie of baseball and rugby games, of clandestine boxing matches, and the pleasures of summer swimming, which became a lifelong passion.

Frederick Fitch Hassam, the artist's father, earned his living in Boston as a cutlery merchant, and claimed descent from a long line of New Englanders, as did his wife, Rosa Hawthorne, a native of rural Maine. Childe maintained that the family name was a corruption of the old English surname Horsham, though by an alternative account it was originally Hassan.[2]

Hassam's father was a collector of American antiques, and filled the family barn and carriage house with a large miscellany of early furniture, firearms, Indian weapons, Eskimo artifacts, and old sporting prints. Although the artist never claimed that these objects had any special relevance to his later career, one of his earliest memories, as a boy of five or six, was retreating to his father's barn to play with watercolors while ensconced in an ancient coach that had once belonged to the Massachusetts governor William Eustis and had served Lafayette on his triumphal tour of America in 1824. "It had steps that let down," said Hassam of the coach, "and a large flap pocket in the door.

I would open the door, let down the steps and put my water colors in the flap with my pad of Whatman paper— climb into the well cushioned seat and stay there as long as a boy stays put anywhere."[3] Hassam recalled: "I had artists' material given me as early as I can remember. I cannot remember when I did not have artists' materials. Water colors, colored crayons, etc."[4] His education at the Mather public school included his first formal instruction in freehand drawing and watercolor. This childhood interest prompted at least one family member, an aunt named Delia, to encourage Hassam's involvement in art by arranging visits to several obscure local painters— among them, Robert Hinckley in Milton, Massachusetts, and Frank Myrick— in the apparent hope of some guidance or advice. Little came of the effort, however, as Hassam's parents appear to have remained aloof to his artistic inclinations.

Hassam related that, when he was thirteen, his father's business was destroyed in the famous fire that wiped out much of Boston's downtown commercial district in November 1872, though there are, in fact, indications that the firm had been in financial difficulties before that.[5] At any rate, the effect on the family was severe. Hassam's father had to sell off his collection of antiques, and Hassam himself was ultimately forced to leave high school before graduating, in order to find work. The likely date for this is 1877. A first job was arranged for him in the accounting department of the Boston publishing firm of Little Brown & Co., but this lasted just three weeks: the kindly supervisor was forced to dismiss him as he had not the slightest aptitude for figures, but counseled that, since he spent all his time drawing, he might as well consider an artistic career.

Heeding this advice, his parents set him to work in the shop of the wood engraver George E. Johnson.[6] After first being assigned to mechanical tasks, such as cutting lines and routing out the backgrounds of wooden engraving blocks, Hassam was soon elevated to the position of draftsman, producing designs for commercial engravings. Among his early projects were a view of a shoe factory for a letterhead, an image of the Farragut Hotel in Rye Beach, and a panorama of the town of Marblehead that had been commissioned for the masthead of a local newspaper.[7]

Fig. 1 *Grews Woods, Hyde Park, Massachusetts*, c. 1882.
14 x 10 in. (35.6 x 25.4 cm). The Charles F. Sweetman, Jr. Family

Fig. 2 The artist in c. 1883/84. Photograph inscribed
"Childe Hassam, to my sisters"

From 1879 to 1881 Hassam is listed in the Boston city directory as "draughtsman" at 9 Milk Street, one of Johnson's business locations. After that, he established his own studio to work as a free-lance illustrator and to further his education as a painter. By July 1882 we find him at a new studio address, 28 School Street, and registered for the first time as "artist."[8] Until then, Hassam had commuted to work in the city while boarding in Hyde Park, a suburb not far from Dorchester to which his family had moved in 1879 or 1880. One of his earliest landscapes in oil shows a scene in the woods near this home (fig. 1).

During the next few years Hassam supported himself as an illustrator specializing in children's stories. He produced an extensive body of illustrations both for specialty publications, such as *Babyland* and *Wide Awake*, and more widely read magazines, including *Saint Nicholas*, *Harper's*, *Scribner's*, and *The Century*, as well as for numerous books. Some of his earliest efforts in this field are markedly juvenile but, like his more independent work over the years, they show a steady gain in competence.[9]

Hassam's commissioned work was paralleled and increasingly overtaken by work done privately in the open air, a practice then still considered peculiar by many.[10] Much of this activity seems to have been concentrated in summers, when most of Boston's artists headed off to various resort locations. In 1880 or 1881 Hassam paid his first visit to Gloucester, Massachusetts, traveling with his friend Ross Sterling Turner and meeting there a company of painters that included Kenyon Cox, Will Hicok Low, Louis Ritter, and John Leslie Breck.[11]

While Hassam seems to have begun experimenting with oil paints as early as 1878,[12] his preferred medium at the beginning was watercolor. His very first solo exhibition, held at the Williams & Everett Gallery, Boston, in the autumn of 1882, comprised about fifty watercolors.[13] Many of these were scenes derived from a stay on Nantucket the previous summer, advertised as "quaint studies at Nantucket — bits of beach, with boats and figures; old cottages, with glimpses of sea and sky."[14] Hassam's early watercolors survive in surprising numbers, their subjects centering on rural scenery — woodlands, streams, and old farmhouses (see fig. 3) — with an occasional anecdotal scene like that of 1882 depicting children with fishing rods digging for bait.[15] While, for the most part, these works are conventional in theme and technique, occasionally a sign appears, as in *Blossoming Trees* (fig. 4), of that gift for deft summary, of that vitality and lively color that later became his strengths.

Fig. 3 *Wayside Inn, Sudbury, Mass.*, 1882.
Watercolor on paper, 9½ x 14 in. (24.1 x 35.6 cm).
Private collection. Photo courtesy Vose Galleries of Boston, Inc.

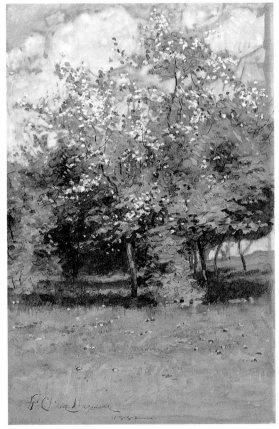

Fig. 4 *Blossoming Trees*, 1882.
Watercolor on paper, 10½ x 9 in. (26.7 x 22.9 cm).
Museum of Fine Arts, Boston; Bequest of Kathleen Rothe

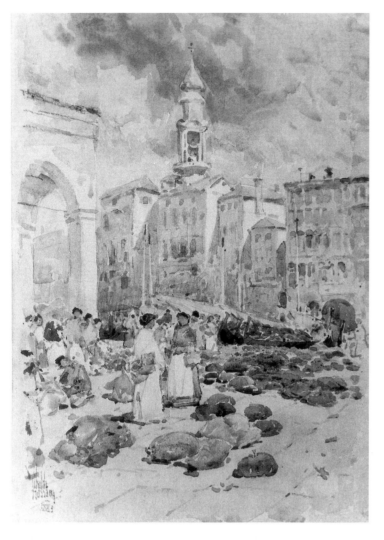

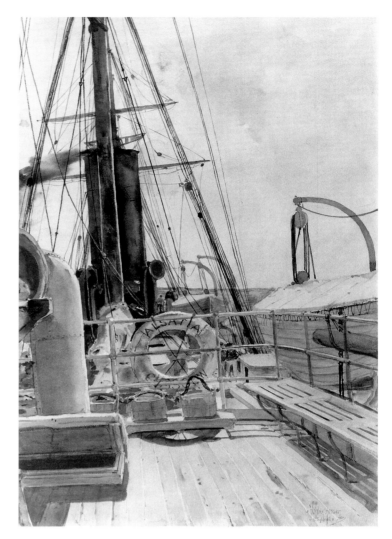

Fig. 5 *Rialto Market, Venice*, 1883.
Watercolor on paper, 14 x 9½ in. (35.5 x 24.1 cm).
Mead Art Museum, Amherst College; Museum Purchase

Fig. 6 *On the Deck (S.S. Alsatia)*, 1883.
Watercolor on paper, 18¾ x 12¼ in. (47.6 x 31.1 cm).
Private collection

It was said of Hassam at the time of this first solo exhibition that, "for a number of years [he] has been quietly at work, a student in arts preparing himself by diligent study and earnest work for a professional career." The same writer also observed that Hassam had already exhibited and sold works through local art stores, and had attracted some attention at recent exhibitions of the Boston Art Club.[16]

The details of Hassam's early studies are obscure, but we do know that he attended evening lectures and drawing classes at the Lowell Institute and, from 1883, also the life painting classes initiated that year by the Boston Art Club. One of his instructors was Tommaso Juglaris, a competent Italian painter who had come to Boston after studying in Paris under Jean-Léon Gérôme and Alexandre Cabanel.[17] Hassam applied himself in these life classes to highly realistic studies of the models,[18] an effort that brought a noticeable improvement to the extreme awkwardness of his earliest figure style. Hassam apparently mentioned studying for a time with the German painter Ignaz Gaugengigl.[19] He was also acquainted with the

anatomist William Rimmer, and learned anatomy and dissection in a private evening class run by one of Rimmer's pupils.

Hassam made his first trip to Europe in the summer of 1883, accompanied by a fellow illustrator and friend from his wood-engraving days, Edmund Henry Garrett.[20] They began their tour in Scotland, stopping at Glasgow and Edinburgh, and then went to London, where Hassam toured the galleries, sketched, and made watercolors in the city and nearby countryside. Hassam later remembered being especially impressed during his stay by the watercolors and drawings of J. M. W. Turner and by English watercolorists in general. Traveling on to the Netherlands and France, with a brief stop in Paris,[21] the two artists then made their way through Switzerland to Venice and Naples. On the return home, they also visited several cities in Spain while their ship stopped to take on cargo. Hassam painted watercolors at every stage of this trip, including some made on shipboard (see figs. 5, 6). Sixty-seven of these watercolors formed the basis of his second solo exhibition, which was held at the Williams & Everett Gallery in 1884.[22]

The year 1883 seems to have been an especially eventful one for Hassam, encompassing at once his move to a large studio building on Tremont Street, the beginning of life drawing classes at the Boston Art Club, his first exhibition at the National Academy of Design in New York, and the development of some enduring artistic friendships. At some time in the early 1880s — when he was not much past twenty, he recalled — Hassam also made the acquaintance of the poetess Celia Thaxter,[23] who was to become an important inspiration to him throughout the next decade. For a time, Hassam instructed her in watercolor painting, along with William Morris Hunt's sister, Jane, who was also an amateur artist.[24] By the time they met, Thaxter was already in her late forties, and had won a considerable reputation for her flowery and sentimental poetry. She spent winters in Boston, but, during the summer, she held court to a famous coterie of artists, writers, and musicians at her summer home on the Isles of Shoals off the New Hampshire coast. Many painters, including Hunt, and such younger artists as J. Appleton Brown, Ross Turner, and Ellen Robbins enjoyed going there. Hassam's first recorded visit to the Isles of Shoals occurred in August 1886, and whether or not he had been there earlier remains a minor consideration in the absence of any

significant influence on his work.[25] According to Hassam, it was Thaxter who persuaded him to drop his Christian name Frederick, by pointing out that a man in search of fame should capitalize on the memorable quality of a name like Childe. This conversation probably took place in mid-1883, for it was around the time of his first European tour that the artist stopped signing his work "F. Childe Hassam" and began presenting himself simply as "Childe Hassam."[26]

At this time, Hassam also started adding a crescent in front of his signature, the precise meaning of which is not known. It may have alluded to the oriental flavor of his name, but we also know that the crescent sun was a poetic image used by Thaxter to symbolize Hassam's emerging fame, and so it may have begun as a playful reference to this idea. Carefully drawn at first, the crescent became increasingly perfunctory over the years until it was finally reduced to a mere slash. In this unrecognizable state, the mark nonetheless remained an inseparable part of Hassam's signature, and was, no doubt, what he once referred to as the missing "secret part" of a signature he found on a forged painting.

On returning from Europe, Hassam resumed his dual career as student and free-lance illustrator. A photograph taken

Fig. 7 The artist in his Boston studio, c. 1885/86

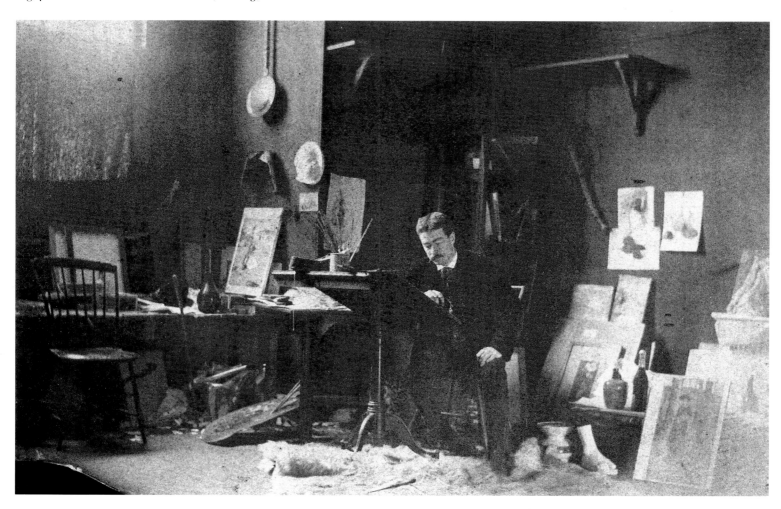

in his Boston studio shows the artist at his drafting table surrounded by the paraphernalia of his profession (fig. 7). Visible are some of his painted illustrations, presumably recent work, among which, on the table to the left, is a scene recognizable as *On the Beach* of 1884.[27] Other matted pictures and canvases are stacked against the wall, while on the floor can be made out the cast of a foot and what look like casts of Antique bas-reliefs. The various bottles and vases were presumably the subjects of still life studies, examples of which, similar to the few that have survived from this period, hang upon the wall. In addition to magazine and book illustration, Hassam carried out an occasional odd job, in one case sharing with his friend the painter Emil Carlsen a project for making "very careful architectural designs" for a steel engraver named John A. Lowell.

In addition to studio work, Hassam also spent a good deal of time painting outdoors. The list of sites, deduced either from surviving pictures or from the titles of those included in exhibitions, is impressively large, encompassing Boston itself and the surrounding areas of Nonquitt, Beverly, Milton, Dedham, Nahant, Swampscott, and Nantucket.

Hassam's need to support himself, together with his early viability as a commercial artist, were undoubtedly the reasons why he never attended the Boston Museum School, as most Boston artists of his age did, including his later colleagues Frank Benson, Robert Reid, and Edmund Tarbell. Aside from his intermittent classes, Hassam seems to have profited most from his professional relationships, especially those made through membership of the Paint and Clay Club, an organization for practicing artists founded in 1880 that also included many of the city's most important critics. Headquartered in a rent-free commercial garret on Washington Street, the club was described as having the liveliest exhibitions and receptions in Boston, its membership containing "the readiest and smartest of our younger generation of artists, illustrators, sculptors and decorators — the nearest thing to Bohemia that Boston can boast."[28]

Hassam said apropos his early friendships: "I was very fortunate, I think, in being brought up in Boston, which was the centre of culture, for I had the advice of my fellow painters in my youth. There was Fuller, Johns[t]on, Cole and Robinson."[29] George Fuller was one of the occupants of the studio building at 149A Tremont Street, into which Hassam had moved by January 1883.[30] He apparently gave Hassam some early encouragement, even insisting at one point that he be included in a show of Boston painters that was sent to New York — much to the consternation of such older painters as J. Foxcroft Cole and John J. Enneking, who thought Hassam too much a novice.[31] Although Fuller died when Hassam was still relatively unproven, his possible influence on the young artist should not be discounted, for Fuller was keenly interested in problems of color, light, and atmosphere, and laid great stress on the underlying emotional character of painting, values which Hassam adhered to from the start.

Hassam also mentioned learning from the landscape and cattle painter Thomas Robinson and from the animal painter John B. Johnston. A further mentor was Marcus Waterman, whom Hassam held in particular regard, and who imparted some technical advice that seems to have served him throughout his career. It was Waterman, said Hassam, who "instructed me about the use of colors and the permanence of colors...he was somewhat of a chemist."[32] Among the valuable lessons in oil painting that he learned from Waterman were the advantages of working with unadulterated colors, the sparing use of medium or varnish, and the avoidance of mixing additional oil with pigments, which would cause them to darken over time. Hassam later described how this advice was important in making the transition from watercolor to oil paint: "I made my sketches from nature in watercolor and I used no white. It was this method that led me into the paths of pure color. When I turned to oils I endeavored to keep my color in that medium as vibrant as it was in watercolor."[33]

However important his artist friends were to Hassam personally, the most important influence on his early development were the teachings of Boston's foremost painter, William Morris Hunt. Hassam was distantly related to Hunt through his father's family, but never actually met him. Hunt died when Hassam was still a beginner in Johnson's wood-engraving shop, yet even posthumously, the effect of his teachings remained strong in Boston. In fact, virtually all the painters mentioned by Hassam as having influenced him in his early days were members of Hunt's circle; indeed, several of them, including Johnston and Robinson, had been his intimate working companions. While a student in France, Hunt had become both a disciple and a patron of Jean-François Millet, and was famous in America from the 1860s as an ardent champion of the painterly methods practiced by Millet, Jean-Baptiste Camille Corot, Théodore Rousseau, Charles François Daubigny, and others of the Barbizon school. Later, he also came to admire the still more modern landscapes of the Dutch painter Johan Barthold Jongkind. Hunt preached the necessity of working outdoors, directly from nature, and, recognizing that the act of seeing was not a systematic inventorying of detail, but a selective and synthesizing process, he argued that painting ought to imitate the true nature of optical perceptions. "Atmosphere and light are the great things to work for in landscape painting," said Hunt,[34] and, in acting on this principle, realized his own landscapes by means of broad, summary masses unified by an overall tonality. Add to this Hunt's emphasis on the personal, spiritual element in painting, and we have a synopsis of the ideas propagated by his followers and absorbed by Hassam.

Referring to these Boston years, Hassam traced the route of his early influences when he cited his friend Robinson as quoting Hunt to the effect that Jongkind was the model to follow, the "modern man, who paints out-of-doors scenes right, as I think it ought to be done."[35] In considering his own later turn to Impressionism, Hassam always discounted — albeit too com-

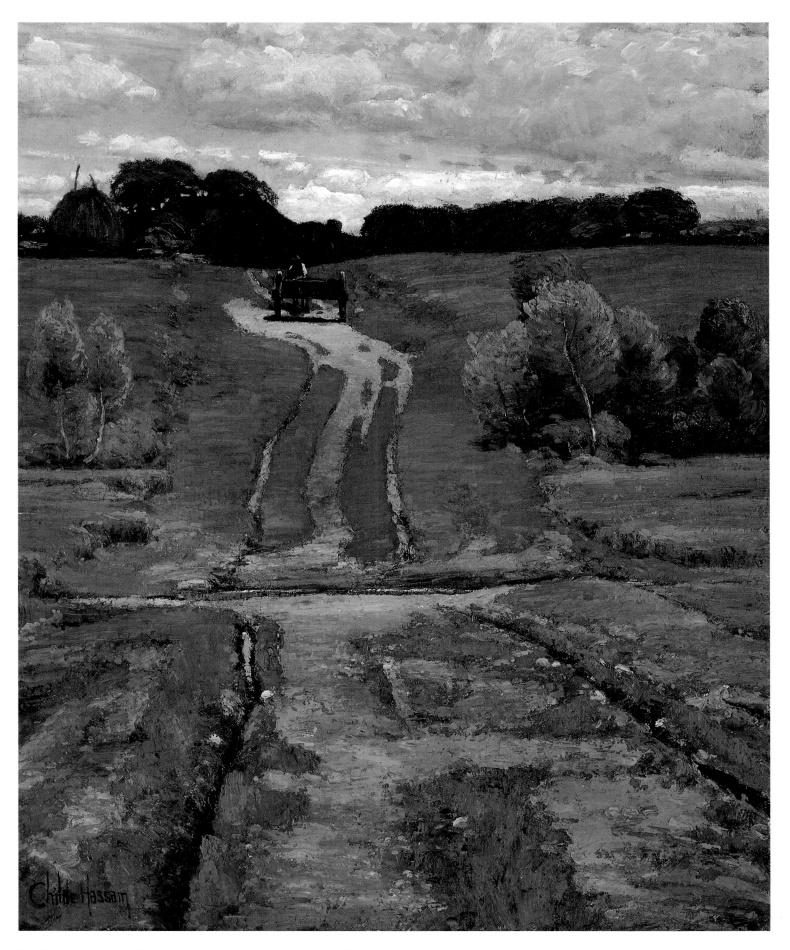

Fig. 8 *A Back Road*, 1884. 31¼ x 25 in. (79.4 x 63.5 cm). The Brooklyn Museum; Polhemus Fund, 47.122

pletely—any direct influence from Claude Monet and other French Impressionists, arguing instead that it was the Barbizon painters and Jongkind who had inspired him, providing as they did the common point of departure for himself and for the French Impressionist group. In holding to this account right to the end of his life, Hassam was obviously overlooking the many significant things he learned after he left Boston, but he was honestly echoing a view that was prevalent among Boston artists in the mid-1880s, even before the French Impressionists became well known.

One Boston critic, writing in March 1885 under the pseudonym "Greta," summed up the artistic situation in Boston. Painting, said Greta, had been relatively fallow of late, except for that school of landscapists working in the Barbizon tradition (whose older representatives included virtually every painter with whom Hassam associated). More recent painters, such as William Lamb Picknell, a Bostonian who had just gained success abroad, and still younger artists, such as Hassam, were bringing forth an advanced and updated version of this style:

The English critics recognize in [Picknell] more of the fruits of that great school of landscape that has arisen in France, strangely enough, on the teaching and example of Constable.... Strangely enough, too, this borrowed landscape school, as improved upon by French taste and technique, has become the best and most enduring of contemporary French art. After all its academic compositions, its Salon sensations, its Meissoniers and Bonnats have passed into the limbo of rococo and bric-a-brac, this landscape of Corot and Daubigny, of Troyon and Courbet, and their fellows, will hold out true, fresh and cheering to the heart. What wonder that the Boston taste for landscape painting, founded on this sound French school, is the one vital, positive, productive and distinctive tendency among our artists today.... Being the newest comer, he [Picknell] has the benefit of the latest development of the school, the ultra style of it, so to speak, which embodies the realism and naturalism...of everything in French art nowadays. The two most notable landscapes at the current Art Club exhibition are evidently inspired by this cult, the "Upland Ranche" of Stites, and the sunny rough country-road of Childe Hassam.... Both are boldly, strongly, realistically true, frank and unconventional in their delineation of the facts of nature. The truth is poetry enough for these radicals of the new school. It is a healthy, manly, muscular kind of art, having the courage of its convictions, and must continue to flourish and exert a vitalizing influence.[36]

Fig. 9 *The Barnyard*, 1885. 30 x 41½ in. (76.2 x 105.4 cm). Private collection. Photo courtesy Coe-Kerr Gallery, New York

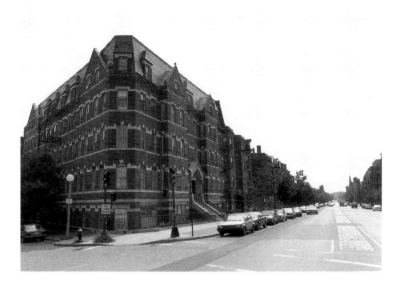

Fig. 10
The artist's apartment building at 282 Columbus Avenue, Boston

The landscape singled out by Greta was Hassam's *A Back Road* (fig. 8), a canvas praised as a "brilliant piece...a solid, vigorous painting, full of bright air and light," by a second critic who felt that its realism served as an antidote to the "false sentimentalism" of so much current work.[37] Another of Hassam's Barbizon-inspired canvases, on the theme of rural labor, is *The Barnyard* (fig. 9) of 1885, whose color scheme of stark whites and silver grays and greens explores those problems of depicting light — here, notably, the effort to maintain luminosity in shadows — which Hassam was to pursue throughout his career. When *The Barnyard* was sold in 1887, a critic admired not only its effects of light, but also its sense of breadth and solidity, characterizing it as "an effect of resonant color, vigorous, massive and masterly." Hassam, he stated, was "one of the men destined to hold high place in the landscape art of the century."[38]

Although he received only modest prices, Hassam was apparently successful at selling his pictures (mainly watercolors). The combined income from all his activities enabled him to marry his sweetheart of long standing, Kathleen Maude Doan, on February 1, 1884. At this point he moved into the city proper, where he occupied an apartment at 282 Columbus Avenue (fig. 10), one of the main thoroughfares that radiated from the old city center into Boston's Back Bay. This fashionable west end district, created from marshland along the Charles River, was Boston's newest pride, a planned development of broad avenues lined with brownstone houses, interspersed with squares, churches, museums, libraries, and parks on the example of Baron Haussmann's plans for Paris. These new surroundings inspired a momentous change of direction in Hassam's painting as, for the first time, he began to explore the subject of modern city life. "I lived in Columbus Avenue in Boston," he said later. "The street was all paved in asphalt, and

I used to think it very pretty when it was wet and shining, and caught the reflections of passing people and vehicles. I was always interested in the movements of humanity in the street, and I painted my first picture from my window."[39] This statement discloses one of the most fundamental aspects of Hassam's artistic nature and working method, namely, that the true stimulus for his paintings always lay immediately in front of him. It is a fact of startling simplicity that, unlike many of his peers, he painted what he saw.

Hassam's early involvement with the Boston cityscape lasted two years or so, and, though only a handful of paintings from this period survive, they reveal very clearly his continuing growth and ambition. Although he reportedly began painting urban views as early as 1884, no examples from that year have yet come to light, nor are they suggested by the titles of works he exhibited during it. In 1885, however, the titles of several (now lost) watercolors bespoke his new interest, including two — *Springtime in the City* and *Rainy Day, Columbus Avenue* — that were shown at the Boston Watercolor Society exhibition and another, *In the Public Garden*, that was exhibited that spring at the Boston Art Club. That year's earliest known works show him already in firm command of his new subject (see figs. 11-13). As he later confirmed, Hassam was particularly fond of scenes of rainy days and nights, when the streets were shrouded in mist, and lights and shadows were reflected everywhere in the gleaming surfaces. *Columbus Avenue, Rainy Day* (fig. 12), a view looking along Columbus Avenue toward Boston Common, is set within a few blocks of his home and establishes the basic ingredients of these early city compositions. The familiar buildings provided setting and perspective for the

Fig. 11 *Rainy Day, Boston*, 1886. Pen and ink, black crayon or chalk, and Chinese white on paper. 10³/₁₆ x 12½ in. (25.9 x 31.8 cm). In the Collection of the Corcoran Gallery of Art; Bequest of Bessie Potter Vonnoh Keys

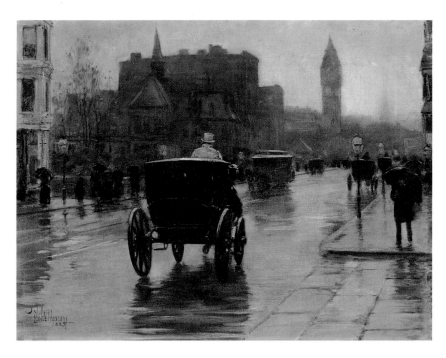

Fig. 12 *Columbus Avenue, Rainy Day*, 1885. 17⅛ x 21⅛ in. (43.5 x 53.7 cm).
Worcester Art Museum, Worcester, Massachusetts

Fig. 13 *Rainy Day, Boston*, 1885. 26⅛ x 48 in. (66.3 x 122 cm).
The Toledo Museum of Art, Toledo, Ohio;
Purchased with funds from the Florence Scott Libbey Bequest
in Memory of her Father, Maurice A. Scott

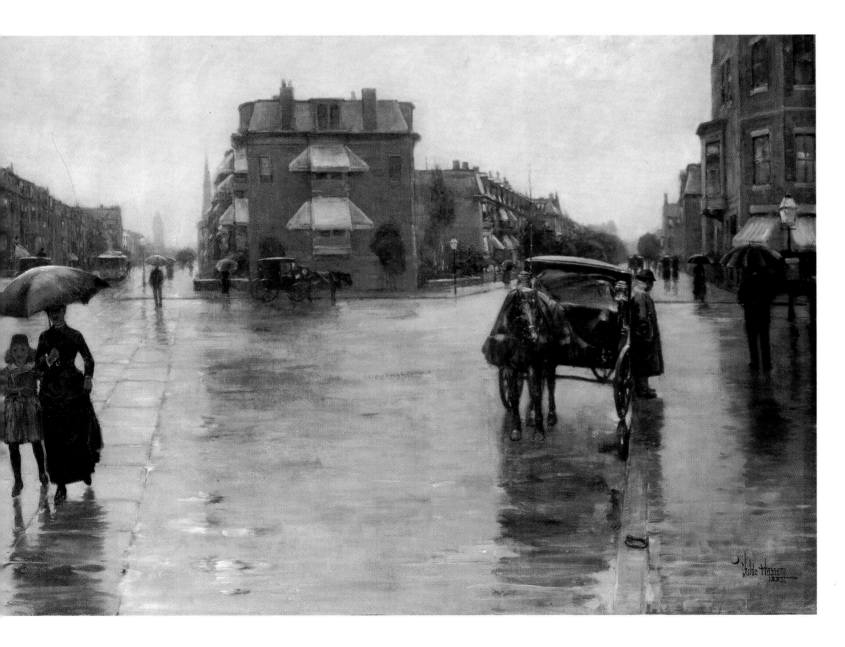

rain-washed forms of horsedrawn cabs and trolley cars, and for a few isolated pedestrians striding purposefully under their umbrellas.

Compared to the relatively modest scope of such pictures, the composition of *Rainy Day, Boston* (fig. 13), also painted in 1885, is both physically and thematically far more ambitious. The scene is set several blocks west of Hassam's apartment, at the junction of Columbus Avenue, which recedes leftward toward the Common, and Appleton Street, a site that offers a broad sweep of space while introducing the complexity of a dual perspective. In attempting to record the sense of formal spaciousness inherent in the whole Back Bay area, Hassam had to deal simultaneously with a number of different issues — the plunging perspective, the interplay of architectural and figural elements, and the variety of different surfaces — and, in doing so, clearly overreached himself. Each of these elements competes somewhat uncomfortably with the other, disturbing the sense of unity, just as the incomplete resolution of the two vistas suggests the slight disjunction in a stereoscopic photograph. Hassam's composite approach is underscored by the fact that

Fig. 15 Horticultural and studio buildings, Tremont Street, Boston. Photograph by John P. Soule, 1870s

Fig. 14 *Boston Common at Twilight*, 1885/86. 42 x 60 in. (106.7 x 152.4 cm). Museum of Fine Arts, Boston; Gift of Miss M. E. Appleton

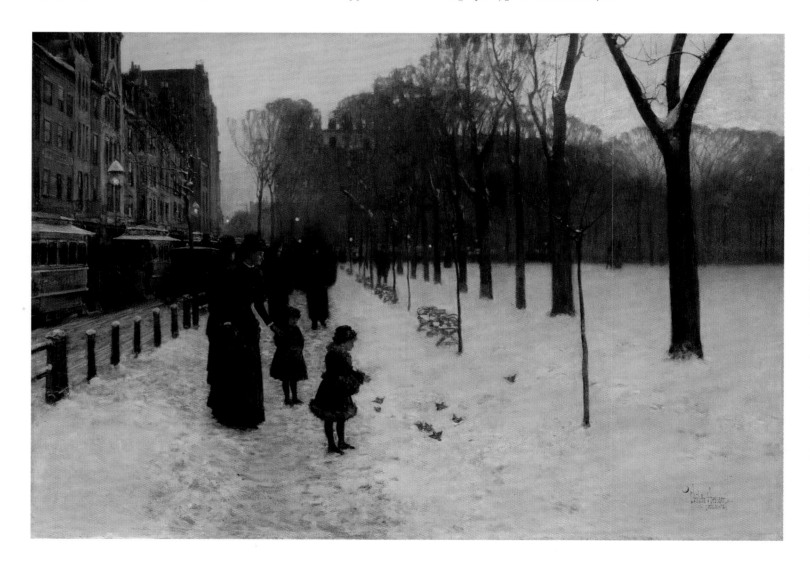

he later extracted the foreground motif of the lady sharing her umbrella with her child and made of it an independent composition titled *A Wet Day in the City*.[40] Its shortcomings the result of pressing ambition, *Rainy Day, Boston* was one of Hassam's principal early canvases. In the spring of 1886 it was chosen by the artist for exhibition at the Society of American Artists in New York, which was generally regarded as the country's most prestigious showcase for advanced art.

Prior to this, Hassam had also been at work on its successor, the monumental *Boston Common at Twilight* (fig. 14), which, according to the inscribed date, was painted during the winter of 1885/86.[41] In this instance, Hassam found his subject not in the neighborhood where he lived, but in the public park that lay directly opposite his studio building on Tremont Street (see fig. 15). The scene centers on a mother watching over two small girls who are scattering food to pigeons in the snow, with a streetscape behind charged with the bustle of passing vehicles and pedestrians. Like *Rainy Day, Boston* this large painting seemed to require some controlling structure (which his smaller canvases did not), and so here again he established a strong linear perspective through the converging lines of buildings, curb posts, and trees. At this stage, Hassam was an observer of detail, rendering with considerable precision the vehicles, buildings, and sharply contoured trees. There is a similar specificity in the description of the appearances of season, time of day, and place. The air is heavy with moisture and the sky is suffused with the reddish glow of the setting winter sun in the late afternoon, evoking the powerful mood of a stark environment warmed by the collective human element.

In taking up the subject of contemporary city life, Hassam entered a field which few American artists had explored. Nothing in Hassam's Barbizon-oriented background could account for his interest in the urban scene, although that back-

Fig. 17 *Woman Reading* (*Portrait of Nellie Dubois Boyle*), 1885. Watercolor and gouache on paper, 17 x 21¾ in. (43.1 x 55.2 cm). The Water House Collection

ground did influence heavily the way in which he treated the theme. While there can be little doubt that the ultimate inspiration for such scenes can be traced to Europe, there are no easily identifiable sources either among the work of French Impressionists—Camille Pissarro had not yet begun his city series, while the often suggested link with Gustave Caillebotte is unconvincing—or among such well-known urban genre painters as Giuseppe De Nittis and Jean Béraud or the less familiar urban scenes of Telemaco Signorini or Giovanni Boldini. By the time Hassam took up his urban themes he had undoubtedly had the opportunity to see a good deal of contemporary painting both in Boston collections and exhibitions and in New York, which he visited from time to time and where, on at least one occasion in the early 1880s, he actually worked.[42] Hassam had certainly viewed contemporary work on his 1883 summer tour through Europe, and he may have recalled what he had seen when he took up urban subjects the following year.

To Hassam, the cityscape represented a challenge to academic tradition: a modern theme, relevant to contemporary life, for which there was no historical precedent. One might say that the concept of modernity and of progress itself, with which America was increasingly being identified, had become the general issue. In an article of 1885, the critic "Greta" urged painters to devote themselves to subjects of their own day in order to realize the "true ambition of American art." In illustrating this point, Greta quoted from a private letter written a short time previously to an artist friend in Boston by a young French painter—a member of "the realistic school of France today." After years of training in the atelier of the academic master Jean-Léon Gérôme, the Frenchman had recently undergone a conversion after experiencing the bustling street and waterfront life in London. Now he appealed to his Amer-

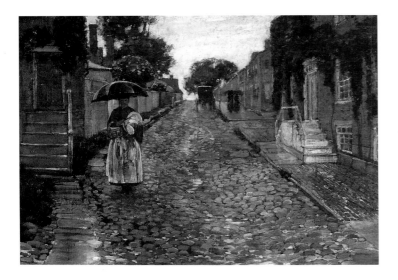

Fig. 16 *A Showery Day in Nantucket*, 1886. 14 x 20 in. (35.6 x 50.8 cm). Private collection, by courtesy of Martha Parrish

ican friend, as "a child of [a] people which has cast aside the traditions of the past!", to stop worrying about drapery folds, the Greeks and Romans, the Dantes and Beatrices and Holy Families, and other academic concerns and to devote himself to recording modern life. "Look around you and paint what you see. Forget the Beaux-Arts and the models and render the intense life which surrounds you," he wrote, "and be assured that the Brooklyn Bridge is worth the Colosseum of Rome, and that modern America is as fine as the bric-a-brac of antiquity." This sentiment was fervently seconded by Greta, who added: "There is the spirit, that will produce a modern art worthy of the rest of modern progress!" The advice to American artists, Hassam included, was simply "to paint America — the real America of today."[43]

Hassam was neither the only nor the first American painter to pursue this ideal. In 1881, for example, Fernand Lungren had exhibited a canvas titled *Impression of a Rainy Night, N. Y.* at the Society of American Artists that prompted a memorable reaction from the critic Edward Strahan. Calling it the keynote of the Society's exhibition, Strahan described it as "a vital and rude impression straight from nature. In this vigorous bit of an 'impression' we have the real confusion and blotted splendor of lamplight on wet streets, a mad ballet of umbrellas and cancan-ing cabs hurled together in bursts of illumination, the yellow dots of street-lamps looking bleared under the broad desert-like glare of the electric globes.... Vollon, with his still-

life or his port views; De Nittis, with his city fogs; Degas, with his ballet girls in lime-light are all suggested by this most difficult, most sincere, most able picture.... Such a picture forms a criterion, and in some sense a date. It would not have been comprehended ten years ago."[44] While it is unnecessary to suppose that Hassam knew either Lungren's paintings specifically, or even the city scenes of a more prosaic artist such as Harry Chase, these examples serve as a reminder that Hassam's views and practices were shared by some other American painters.

A City Fairyland (fig. 19) was Hassam's last major cityscape from his early, Boston period, and the fact that it is a winter scene means that he must have worked on it soon after, or perhaps while he was still engaged on, *Boston Common at Twilight*.[45] The scene takes place, probably in Copley Square, on a late winter afternoon, when the city lights emerge even as the sky is gently illuminated by the setting sun. A few flakes visible against the side of a cab and the overcoats of passersby give evidence that snow is falling, but the principal effect of time of day and weather is conveyed by the dense atmosphere, which solidifies a beam of light here and there and mutes the surfaces. The whole scene is suffused with a blond tonality, detail is reduced, and edges are softened. Hassam succeeds here in subordinating all else to the light-filled atmosphere: the buildings provide a loosely defined, generalized background for the activity on the streets, and the perspective is noticeably less assertive than in *Boston Common*.

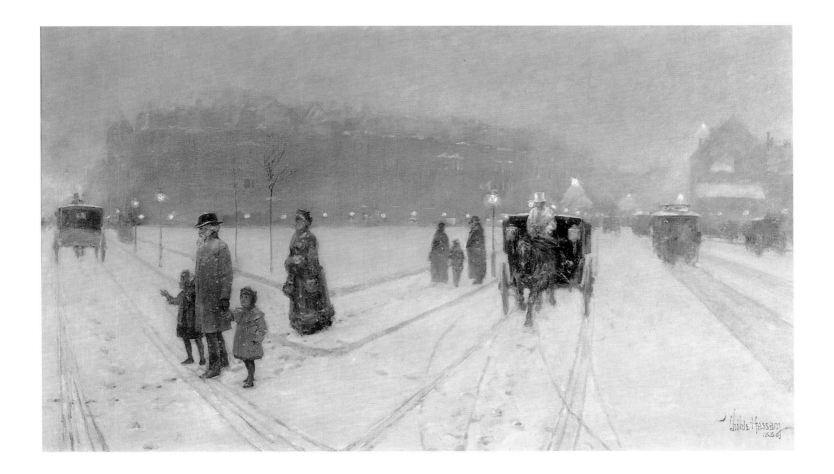

While working on this picture Hassam faced the inevitable decision as to whether to continue with commissioned illustration work, which evidently kept him very busy, or to devote his full time to painting. For all his accomplishments, of which *A City Fairyland* serves as a summary, he still felt the need to complete his education as a painter on a more formal basis. In 1886 Hassam resolved to go to Paris, which, as the natural goal for young American artists seeking a finishing experience, had been sought out by nearly all the painters Hassam knew. Before leaving for Europe, the young artist left behind a large number of pictures to be sold at auction, a collection that, according to contemporary accounts, illustrated his steady evolution as an artist:

A large collection of oil paintings and water colors by F. Childe Hassam, who is now in France, has been placed on exhibition in the galleries of Noyes, Cobb & Co., 127 Tremont Street, and will be sold at auction on the afternoon of Wednesday and Thursday of next week. Mr. Hassam is a Boston artist in a peculiar sense, for he has not only lived here but he has taken many of his most important subjects from the streets and parks of this city. In this collection of 120 works several of the largest urban views are hung.... These pictures are not literal,

nor commonplace in quality. They are impressions in the best sense; and give a good notion of local color, life, movement, and atmosphere. They usually represent the effect of rainy weather, and in the description of wet pavements, mist and mud, the confused gleam of lights in long vistas as evening draws on and the many reflections and furtive flashes of brilliancy that night discloses in the streets of a busy town, they manifest not only an extraordinarily clever perception, and an original way of seeing, but also an artistic grasp of fleeting effects which is little short of mastery. Mr. Hassam's work in general is strong and sound in color; one sees that at the first glance. He takes his inspirations direct from nature, and renders his report with a fine youthful freshness and vigor that is very pleasant to behold. That a man who already paints so well and so honestly as this should now be in Paris for the purpose of perfecting his knowledge of drawing, instead of resting content on his laurels, is a circumstance that proves his deep seriousness and ambition to excel, and redounds to his credit.[46]

Years later, Hassam recalled the moment of decision that led him to France: "I had made money by selling water colors. Then I made illustrations that were very well paid for, as you know. Harpers Magazine etc . . . I was well paid. I said to myself if you're going to paint let's stop. So I stopped."[47]

NOTES

All uncredited quotations are from documents published on pp. 177-82 of the present volume.

1 Hassam Papers, "Childe Hassam's Work at Noyes & Cobb's," clipping from *Boston Transcript*, 1887.

2 First-person information on Hassam's early life is derived mainly from autobiographical material in the Hassam Papers and from the Lockman Interviews.

Although Hassam took great pride in his New England ancestry, a curious footnote to the issue of his Near Eastern sounding name was contained in a letter written to the *New York Times* by the painter Albert Rosenthal shortly after Hassam died. Rosenthal recalled visiting Boston in 1888, while Hassam was in Paris, and spending an evening with Frederick Hassam at his home in Hyde Park. Rosenthal described the painter's father as a "short, swarthy gentleman," who greeted him saying: "You are an oriental like myself. I am Frederick Hassam. Our name is really Hassan but two cousins having the same names, my ancestor changed his to Hassam. After 150 years of intermarriage with New England people, look at me, I am still the Arab" (*New York Times*, Sept. 2, 1935, p. 16). Adeline Adams, *Childe Hassam*, New York, 1938, p. 4, declared this account to be "mistaken."

3 Hassam Papers, autobiography, p. 22.

4 *Ibid.*, p. 22, and Lockman Interview, Jan. 25, 1927, pp. 6-7.

5 This is suggested by the disappearance of the father's business listing in the later 1860s and by the number of household moves made by the family between 1870 and 1875. Federick Fitch Hassam's business address is listed in the Boston city directory until 1865 under "Hassam Brothers, cutlers, 146 Washington Street" with a home address at Dorchester. Between 1866 and 1869, however, no listing appears for either Frederick Fitch Hassam or Hassam Brothers. From 1870 to 1875 Frederick is listed at a home address on Green Street, Dorchester, while no business address is given. In 1876 and 1877 his home address has changed to "Columbia cor. Wales," in 1878 and 1879 to Michigan Avenue, Dorchester. Thereafter, he disappears from the Boston directory, presumably having moved to the suburb of Hyde Park, where Childe Hassam was boarding.

6 Lockman Interview, Jan. 25, 1927, p. 9ff.; also Hassam Papers, autobiography, p. 30.

7 The masthead for the *Marblehead Messenger*, which was still being used in the 1930s, showed a view of the town from across the bay.

8 Addresses listed in the Boston city directory could be valid for up to a year prior to its publication on July 1. Hassam's addresses are listed as follows: 1879—9 Milk, boards Michigan Ave, Dorchester; 1880 and 1881—9 Milk, boards at Hyde Park; 1882—28 School, rm. 56, boards at Hyde Park; 1883 and 1884—149A Tremont, boards at Hyde Park; 1885—12 West, rm. 29, home 282 Columbus Ave.; 1886—home 282 Columbus Ave.

9 Among the books he contributed illustrations to in the 1880s were Jean Ingelow, *The High Tide on the Coast of Lincolnshire, 1571*, Boston, 1883; *The belle of Australia or Who am I?* by William H. Thomes (originally serialized in Ballou's monthly magazine), Boston: De Wolfe, Fiske & company, 1883; *On Land and sea, or, California in the years 1843, '44 and '45* by William H. Thomes (from Ballou's monthly magazine), Boston: De Wolfe, Fiske & company, 1884; E. S. Brooks, *In No-Man's Land: A Wonder Story*, 1885; M. E. Blake, *Youth in Twelve Centuries*, 1886; Margaret Sidney (pseudonym of Mrs. Harriet Mulford Stone Lothrop), *A New Departure for Girls*, 1886; Susan Coolidge (pseudonym of Sarah Chauncey Woolsey) et. al., *Ballads of Romance and History*, Boston, 1887; "*Bye-O-Baby Ballads,*" Boston: D. Lothrop & Co.

10 See, for instance, Greta, "Boston Correspondence," *Art Amateur* 3 (Sept. 1880), p. 73.

11 Lockman Interview, Feb. 3, 1927, p. 10.

12 See Christie's, New York, auction catalogue, Mar. 12, 1992, no. 93. Hassam first exhibited oil paintings at Boston Art Club in 1882.

13 *Water Colors by Fred C. Hassam*, Williams & Everett Gallery, Boston, 1882.

14 Hassam Papers, unidentified clipping under "Boston Journals." Two of the Nantucket scenes, *Old Doorway, Nantucket* and *Woman with a Parasol*, are illustrated in Robert A. di Curcio, *Art on Nantucket*, Nantucket, 1982, figs. 173 and 175.

15 See Parke-Bernet Gallery, New York, auction catalogue, Mar. 14, 1956, no. 22.

16 Hassam Papers, unidentified clipping under "Boston Journals."

17 Juglaris was active as a muralist in Boston and later became professor of drawing at Providence, Rhode Island, before eventually returning to Italy. Hassam remembered the flower painter Abbott Fuller Graves (1859-1936) as being among his classmates at the Boston Art Club.

18 See Hassam Papers, autobiography, p. 6; Lockman Interview, Jan. 25, 1927, p. 11; and Adams, *op. cit.*, p. 19.

19 Adams, *op. cit.*, p. 19, is the only source for this information; she may

have confused Gaugengigl's name with that of Juglaris.

20 For Garrett, see Frank T. Robinson, *Living New England Artists*, Boston, 1888, pp. 67-73.

21 Most writers have accepted the statement by Hassam's biographer Adeline Adams (*op. cit.*, p. 22) that he did not visit Paris, yet Adams's account of the 1883 trip is demonstrably inaccurate (she says it took a whole year and omits France entirely from the itinerary) and Hassam himself acknowledged that he had been to Paris in 1883, declaring that he and Garret "did not do much work in Paris at that time" (Lockman Interview, Jan. 25, 1927, p. 10). While Hassam did sometimes confuse dates and circumstances, the wording in this instance would seem to leave no room for doubt. A further account by the artist (Lockman Interview, Jan. 25, 1927, p. 3) may actually have mingled memories of the 1883 trip with his 1886-89 stay, since he claimed to have spent *most* of his time in London and Paris, and none in the Netherlands, where he is certainly documented in 1883: "I went [abroad] in 1882 [sic] with Edmond H. Garrick [sic]. I was then twenty three years of age. That was just a trip. I did not go into the schools. I went around and saw things. I just looked at the galleries. I spent most of my time in London and Paris.... went to London and Paris and I managed to get to Spain. That was quite a start for any boy's European education. I would not advise any boy to do anything different today. Except to put in Holland. I did not go to Holland." Later in the interview (p. 7) Hassam said: "[From London] We went to Paris...we did not stop long. We went down to Venice."

Jennifer A. Martin Bienenstock, "Childe Hassam's Early Boston Cityscapes," *Arts Magazine* 55 (Nov. 1980), p. 169, correctly acknowledged this early visit to Paris, citing as evidence a watercolor in the Milch Galleries files dated "Paris 1883."

22 *Water Colors by Hassam*, Williams & Everett Gallery, Boston, 1884. Many watercolors from the trip were included in the auction of Hassam's work at Noyes Cobb & Co. in March 1887.

23 See Hassam Papers, autobiography, p. 5. Surviving family members claim he had visited the Thaxter family farm in Kittery, Maine, before October 1881. See Rosamond Thaxter, *Sandpiper: The Life and Letters of Celia Thaxter*, Francestown, N. H., 1963, p. 156.

24 Jane Hunt was a frequent companion of her brother in his later life. One of her watercolors, showing Hunt's studio at Magnolia, Massachusetts, is part of the "Magnolia Sketch Book" owned by the Cape Ann Historical

Association, Gloucester. See Frederic A. Scharf and John H. Wright, *William Morris Hunt and the Summer Art Colony at Magnolia, Massachusetts 1876-1879*, exhibition catalogue, Essex Institute, Salem, Mass., 1982, p. 16, fig. 3, and p. 25, no. 14. William M. Hunt had been close friends with Celia Thaxter's husband, Levi.

25 That visit took place shortly before Hassam set out for Europe. His main body of work at that time appears to have been a series of watercolors of the White Island lighthouse. See David Park Curry, in *Childe Hassam: An Island Garden Revisited*, exhibition catalogue, Denver Art Museum, 1990, p. 117ff. and pl. 55, and William E. Steadman, in *Childe Hassam, 1859-1935*, University of Arizona Museum of Art, Tucson, 1972, p. 63, no. 24. According to a letter written that summer, Hassam also painted a "Moonrise" on the Isles of Shoals that was bought by the Boston painter Rose Lamb for $25 (Hassam to Miss Rose Lamb, Aug. 28, 1886; Portsmouth Library, Lyman V. Rutledge, Isles of Shoals Collection). In a subsequent letter to Lamb, Hassam referred to the picture as a "Shoals Moonlight" (Appendix A, 5). A watercolor titled *A "Shoals" Day* (unlocated) was also exhibited by Hassam not long after.

26 Hassam Papers, letter to Miss Farmer, Feb. 22, 1933, in autobiography. Since watercolors from the 1883 European tour show both versions of his signature, Hassam seems to have made the change during the trip or immediately thereafter. It is possible that those marked "Childe Hassam" were signed after his return, in preparation for his 1884 exhibition at the Williams & Everett Gallery, Boston.

27 This was used as an illustration in Celia Thaxter's *Idyls and Pastorals: A Home Gallery of Poetry and Art*, Boston, 1886. See Curry, *op. cit.*, p. 32, fig. 1.13. Curry (*ibid.*, p. 38) believed the photograph to show Hassam around 1890 in a studio on the Isles of Shoals. However, Hassam appears considerably younger than in his 1889 Paris photograph (fig. 20) and has not yet grown a Van Dyke beard. Neither is there any evidence that Hassam ever had a studio of such magnitude on the Isles of Shoals. Moreover, the paintings visible in the photograph all reflect the kind of work he was doing in the early and mid-1880s, but not later. It is unlikely that, given all that he had accomplished by 1890, Hassam would still be prominently displaying illustration work done five or six years earlier. (For a still life of 1886 similar to those in the photograph, see Susan E. Strickler, ed., *American Traditions in Watercolor*, Worcester, Mass., 1987, p. 205.)

On the basis of the dated Paris photograph, I would be inclined to date the group of early photographs of Hassam on the Isles of Shoals (see fig. 90 and Curry, frontispiece and figs. 1.14, 1.15, 3.17, 3.38) to 1890, rather than 1886, as Curry does.

28 Greta, "Boston Correspondence," *Art Amateur* 12 (Mar. 1885), p. 82.

29 Lockman Interview, Feb. 3, 1927, p. 15.

30 Hassam gave this as his address on the occasion of the Boston Art Club exhibition held from January 19 to February 16, 1883.

31 Lockmann Interview, Jan. 25, 1927, p. 11. The transcription reads "Elling," which is presumably an error for Enneking. The exhibition was possibly that held at the American Art Galleries, Madison Square, and reviewed in *Art Amateur* 8 (Feb. 1883), p. 56.

32 Lockman Interview, Jan. 31, 1927, p. 37; see also *ibid.*, Feb. 3, 1927, p. 7.

33 Quoted in "Death Stills Brush of Childe Hassam," *Boston Evening Transcript*, Aug. 27, 1935, p. 4.

34 Quoted in Henry Angell, *Records of William Morris Hunt*, Boston, 1881, p. 45.

35 Lockman Interview, Feb. 3, 1927, p. 15; for remarks on Jongkind by Hassam himself, see *ibid.*, Jan. 25, 1927, p. 12.

36 Greta, "Boston Correspondence," *Art Amateur* 12 (Mar. 1885), p. 82.

37 "The Landscapes at the Art Club," *Boston Evening Transcript*, Jan. 22, 1885, p. 6. The painting was exhibited as no. 63 at the Boston Art Club from January 17 to February 14, 1885.

38 Hassam Papers, clipping "Childe Hassam's Work at Noyes & Cobb's," *Boston Transcript*, 1887. Another critic did not hesitate to compare Hassam's work to the Barbizon group, referring to his painting *Sundown, French Village* (no. 87) as "an example of warm coloring worthy of Troyon." Hassam Papers, clipping "Mr. Hassam's Exhibition," *Boston Advertiser*, 1887. *The Barnyard* was probably the work exhibited under the title *The Haystack* (no. 130) at the Pennsylvania Academy of the Fine Arts annual from October 29 to December 10, 1885.

39 Quoted in A. E. Ives, "Talks with Artists: Mr. Childe Hassam on Painting Street Scenes," *Art Amateur* 27 (Oct. 1892), p. 117. Robinson (*op. cit.*, p. 103) stated that Hassam painted Boston views in 1884, the first year at his new location. See also the artist's remarks in Lockman Interview, Jan. 31, 1927, p. 16.

40 *Catalogue of the Thirty-third Exhibition of the Boston Art Club*, Jan. 15-Feb. 13, 1886, no. 45 (ill.).

41 This is probably the canvas exhibited with the title *At Dusk* (no. 21) at the Boston Art Club exhibition in January 1887 and at the Noyes & Cobb sale that March.

42 "I came to New York occasionally from Boston and finally from Paris—so I did not know it well until later" (Hassam to Homer Saint-Gaudens, Dec. 10, 1934; Carnegie Papers, File 673). Hassam mentioned meeting Robert Louis Stevenson in Augustus Saint-Gaudens's New York studio while the latter was working on his portrait relief of the writer. Although this must have occurred after Hassam returned from Paris in 1889, the artist, misled by Homer Saint-Gaudens's statement "The relief was completed in 1887," thought it was before he left in 1886 (Hassam to Homer Saint-Gaudens, Dec. 5, 1934, and Homer Saint-Gaudens's reply, Dec. 7, 1934). For the history and dating of the Stevenson relief, see Homer Saint-Gaudens, ed., *The Reminiscences of Augustus Saint-Gaudens*, New York, 1913, vol. I, p. 373ff., and *Augustus Saint-Gaudens: The Portrait Reliefs*, exhibition catalogue, The National Portrait Gallery, Washington, D. C., 1969, no. 39.

Two works document Hassam's presence in New York at this time: a watercolor, dated 1883 and inscribed "Artistic/Maiden Reading G. R. Halm's bon-mots in the N.Y. DAILY NEWS" (see *American Drawings and Watercolors*, exhibition catalogue, Hirschl & Adler Galleries, New York, Oct. 6-29, 1979, no. 44), and an unlocated oil painting titled *Union Square, New York* that was offered for sale as no. 76 in the artist's 1887 Noyes & Cobb exhibition.

43 Greta, "Art In Boston," *Art Amateur* 14 (Jan. 1886), p. 30.

44 Edward Strahan, "Exhibition of the Society of American Artists," *Art Amateur* 4 (May 1881), p. 117. The painting was listed in the catalogue as no. 67, *Impression of a Rainy Night, N. Y.*, by J. H. (sic) Lungren. A few of Lungren's city views have appeared on the art market in recent years and they confirm Strahan's appraisal of him as a vivid chronicler of modern city life.

45 A related watercolor, *Copley Square, Rainy Morning After a Snow Fall*, was exhibited at the Boston Art Club spring exhibition from April 9 to May 10, 1886. See "Boston Art Notes," *Art Interchange* 16, no. 9 (Apr. 24, 1886), p. 131.

46 Hassam Papers, "Mr. Hassam's Exhibition," clipping identified as from *Boston Advertiser*, 1887.

47 Lockman Interview, Jan. 25, 1927, p. 12.

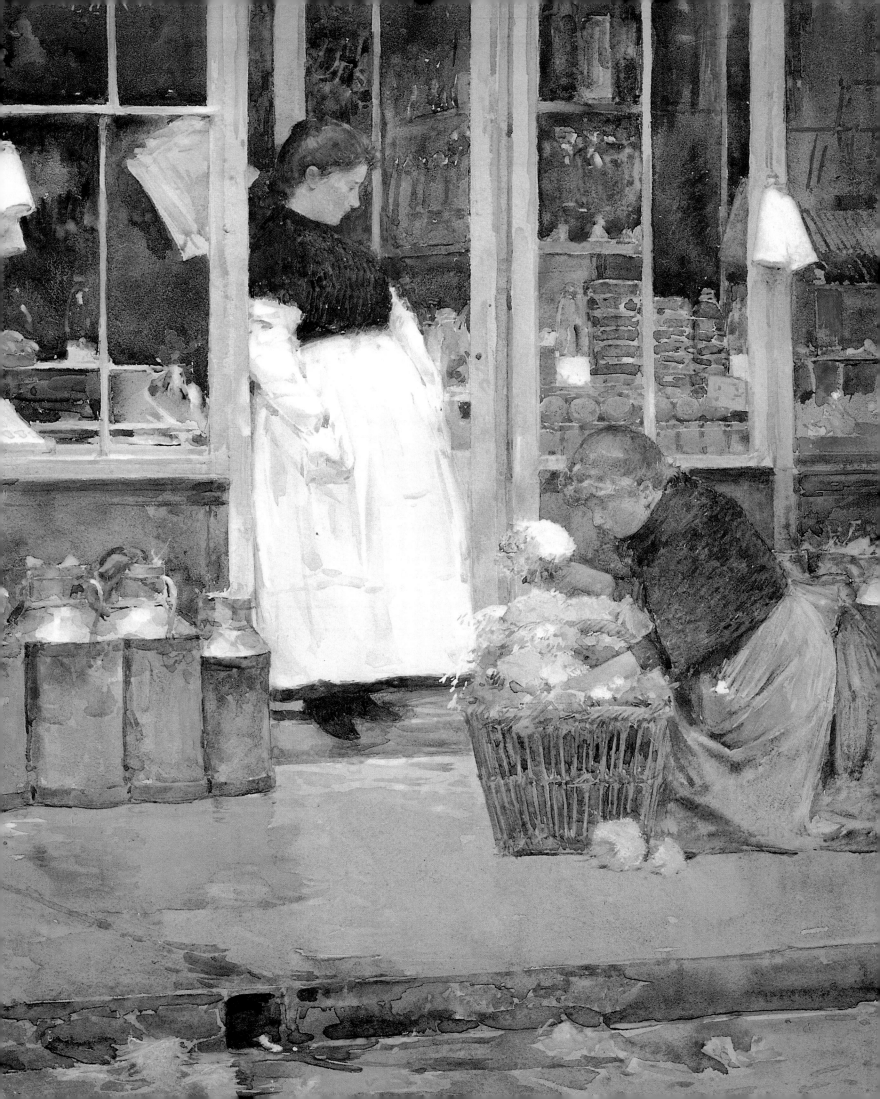

II PARIS 1886-1889

Hassam sailed for Europe with his wife, Maude, in the autumn of 1886, an event marked by a short notice in the November issue of *Art Amateur* stating that "Childe Hassam, the audacious and brilliant watercolorist and landscapist, is off for three years study in Paris."[1]

In one of his first letters home, written on November 20 to a friend in Boston, Hassam related his satisfaction at having found an apartment with a fine view and an excellent studio attached, and reported that he had even begun his first painting a few days earlier:

We have arrived safely and have at last found a nice little apartment—with a tremendously fine large studio connected. It is fifty feet square, and as high, I should think. I wish you could see it. I am sure you would like it very much. Mrs. Maude likes Paris only pretty well as yet. She will be sure to like it better. We are slowly furnishing our apartment with artistic bits of furniture that we pick up here and there.... We are on high ground and look down on Paris,—i.e. the Grand opera and finest Boulevards are at the foot of the hill (Montmartre). We shall be first rate and snug when we are fixed up a little more. I started my first picture 3 days ago (a small one).

In choosing his apartment at 11 Boulevard de Clichy, Hassam placed himself in the heart of the Parisian art world, where almost all the apartment buildings contained ateliers, and where but a step beyond his door lay Place Pigalle, the marketplace for artists' models. There, artists of every status and persuasion lived and worked, from the reigning academic masters to the Impressionists and their followers. In Hassam's own building were also the studios of no less figures than Puvis de Chavannes, Giovanni Boldini, and the salon favorite, Henri Pille.

Hassam recalled with a certain pride the luxury of having his own spacious apartment and studio in Paris, where he lived not as the proverbial struggling artist, but, in his own words, just like any painter who had already "arrived." Said Hassam: "We had a French maid and lived there like a very proper worth-while family."[2]

In their effort to live as natives, the Hassams avoided the company of most other Americans and of the several artists' societies that drew together many members of the large colony of American painters. "We lived among French people, spoke French," Hassam recalled. "It was a French house and we wanted to speak French." Hassam did name Gari Melchers and Frank Myers Boggs as being among the American painters he knew in Paris.[3] Boggs had a studio in the same building, and was remembered by Hassam for having pursued a vein of urban painting similar to his own; but in general Hassam gave no indication that he had formed any meaningful artistic friendships in Paris.

Maude Hassam's initial reserve toward the city seems to have gradually vanished, her change in outlook probably coinciding with the acquisition of her own set of friends. Her foremost companion seems to have been the daughter of the late famed French painter Thomas Couture, who had married a German businessman named Blumenthal, and who apparently spent a good deal of time showing Maude the sights of the French capital.

Hassam had come to Paris to learn, specifically, to acquire experience in the kind of rigorous figure drawing taught under the French academic system. Like most Americans in his circumstances, Hassam preferred to attend the Académie Julian, a private school operated from several studios under the entrepreneurship of Rodolphe Julian, one of the city's famous characters. The Académie Julian owed its success to the absence of the strict entrance requirements and red tape that were involved in gaining admission to the state-run Ecole des Beaux-Arts and, at the same time, to the presence of prestigious professors and the promise of access to the annual salons that such connections implied. Hired by Julian from the ranks of the official academy, the eminent teachers were supposed to hold classes twice a week in which they appraised student work. In practice, however, as Hassam himself attested, this occurred far less frequently. Indeed, for all its reputation, the academy offered very little of what today might be considered formal instruction. With little supervision, the studios were run almost like a student union, and became notorious for their unruliness and for their overpowering odors and noise. Attendance was strictly voluntary and, if the diligent student received the personal attention of the master for a few moments, this was considered a special benefit rather than routine.

Fig. 20 The artist in Paris, March 1889. Photograph by Eugène Pirou

Fig. 21 Studio building at 11 Boulevard de Clichy, Paris

With an introduction from a friend, Hassam duly enrolled in what was known as the "petit atelier," the most popular of Julian's studios, located in the Rue du Faubourg St Denis and placed under the direction of the academic painters Jules-Joseph Lefebvre and Gustave Boulanger. Work there consisted largely of standard life classes — for Hassam, a continuation of the exercises he had practiced sporadically in Boston. For his first trial piece he produced what he described as a "very careful academic drawing" that seemed to satisfy his instructors. "After that," he said, "I could do as I wanted to." Although he did some painting at Julian's, most of his work seems to have been in drawing.[4] After a few months, Hassam reported that he was working hard at the academy, although he found the method of teaching there not entirely to his liking. "I am drawing like a slave at Julian's," he wrote in January 1887, "and shall until Spring. I don't believe all that there is in the academy is good. It teaches whoever comes within to draw mechanically exact — That's about all but it is of importance of course as far as it goes." Further experience of the French system only deepened his misgivings, for later he called the pictures of his teacher Boulanger "stiff, academique and paradoxical to the last degree" and those of Lefebvre "stupid." By the time Hassam was ready to leave Paris, his aversion to the French academic

system was complete. "The Julian academy is the personification of routine," he stated, and, as for French academic training in general: "It is nonsense. It crushes all originality out of the growing men. It tends to put them in a rut and it keeps them in it." In the long run, Hassam's experience at Julian's seems to have affected him very little, and with time the habit of anatomical drawing wore off. In later years Hassam was careful to disclaim either Boulanger or Lefebvre as his master — and with total justification, for, as he had done in Boston, he gathered the most important lessons in Paris on his own, learning by example and practice. Acknowledging this, he later said "[my] Boston art education was preliminary and [my] Paris instruction was superfluous."[5]

From the outset, Hassam also worked independently of Julian's, following, as he put it, "my own method in the same degree."[6] His first major painting completed in Paris was *Cab Station, Rue Bonaparte* (fig. 24), a view of the Rue Bonaparte looking from the Place St Sulpice toward the Luxembourg Garden. It is possible that a smaller, abbreviated version of the picture is the one mentioned by Hassam as being his first Paris painting, begun in November 1886.[7] In response to a journalist's inquiry, Hassam wrote a description of the finished picture, which is the longest account he gave of any of his paintings:

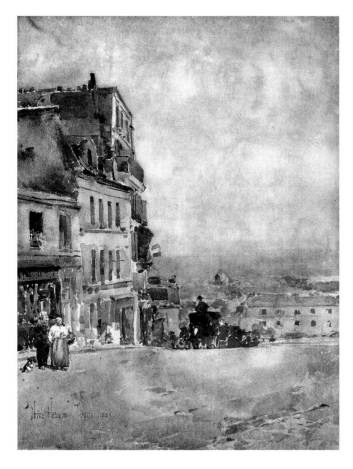

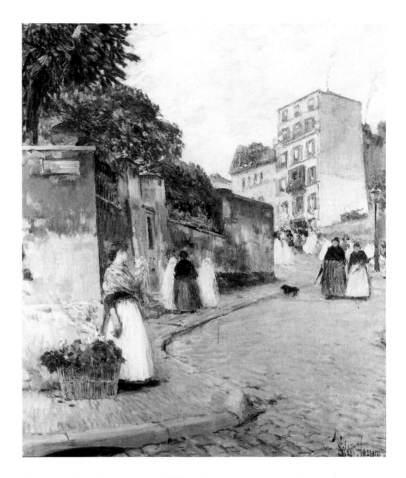

Fig. 22 *View in Montmartre, Paris*, 1889.
Watercolor over pencil on paper,
13⅞ x 9¹⁵⁄₁₆ in. (35.3 x 25.2 cm).
The Art Museum, Princeton University;
Gift of Stuart Riddle Stevenson

Fig. 23 *Rue Montmartre*, 1888. 18 x 15 in. (45.7 x 38.1 cm).
Private collection. Photo courtesy Laurence Casper, Casper Fine Arts

Fig. 24 *Cab Station, Rue Bonaparte*, 1887. 40¼ x 77¼ in.
(102.2 x 196.2 cm). The Manney Collection

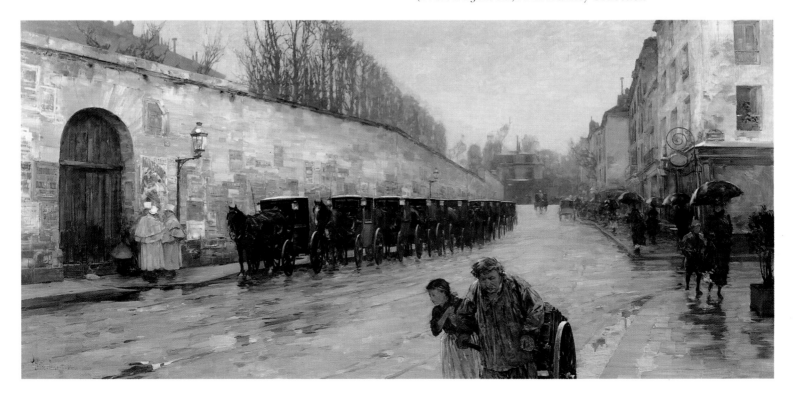

It is a *light* Paris rainy day. The long dark line of "fiacres" with their tops shining with the wet are contrasted to the length of a flat wall covered with the warm tones of numberless bill-posters. Behind the wall lifts up a line of hedge which greys into the distance with the wall and fiacres. Near the first fiacre, and near a large oaken door in the wall three "cochers" are chatting. In the foreground is a labourour [sic] pulling along his hand cart aided by his little girl. They are both bare-headed according to their custom — rain or shine. Along the sidewalk to the right come the better dressed and more fortunate wayfarers with umbrellas; and the buildings characteristic of the "Latin Quarter" fade down in to the distance. This is the Rue Bonaparte looking from the Place St. Sulpice toward the gardens of the Luxembourg. Size 6 ft. 8 in. by 3 ft. 4 in.

Susan Hale, who visited Hassam in Paris while he was working on the painting, correctly viewed it as a continuation of the kind of rainy day images he had done in Boston, comparing it to a view of Columbus Avenue that he had shown the previous year at the Boston Art Club. "No doubt you will hear more of this picture later," she wrote, "so do not forget I have told you about it.... Mr. Hassam has given great care and attention to its details and composition."[8]

Hassam's own description suggests his intention to illustrate something of a cross section of Parisian street life, including the pointed social contrast between the toiling farmhand and his daughter in the foreground and the "better dressed and more fortunate wayfarers" to the right. Beyond that, Hassam was obviously exerting himself in technical matters in order to recreate the silvery lights and mirrored reflections of the wet streets, the variegated tones and textures of the bill-laden wall of the garden, and the subtle effects of objects receding in the gray mist. His underscoring of the fact that it was a *light* rainy day suggests his ambition to capture specific effects of atmosphere. It was his success in this respect that led the critic Theodore Child to single out Hassam, during the next salon, as one who possessed "delicate faculties of vision, and a sensitiveness to the values of objects in ambient atmosphere," qualities Child associated with the Parisian and London views of the late Giuseppe De Nittis.[9]

Work on *Cab Station, Rue Bonaparte*, together with his classes at the Académie Julian, must have occupied most of Hassam's time during his first winter in Paris. Yet he also seems to have found the opportunity to begin some smaller works, referring in a letter of January 1887 to "some little Paris thing of the streets" that he had painted and, at the same time, announcing: "I have unquestionably arrived at my selection of subjects." One of these street scenes is the brilliant little Whistlerian study *Along the Seine, Winter* (fig. 25), a painting which probably originally bore the title *A l'Heure*. As a rule, Hassam's work in Paris falls into the categories of large exhibition pieces or, as here, small-scale, intimate studies. *Along the Seine, Winter*, nearly a grisaille in its severely restricted color range of gentle browns and grays, manages to evoke with special delicacy and velvety finesse the kind of transcendental wintry mood that he strove for, but found difficult to sustain, in his larger canvases.

During that first winter in Paris, Hassam was also preoccupied with the outcome of the auction sale of roughly 120 of his works that had been arranged prior to his departure for Europe and that was scheduled to take place over two days in March at the Noyes & Cobb Gallery in Boston. It was to be one of those auctions peculiar to the times, in which needy artists were forced to sell their paintings — often the work of several years — under fire sale conditions. Although reviews of the exhibition preceding the auction were favorable — thanks, in part, to the artist's solicitation of friendly critics — Hassam remained nervous about the financial results of the auction itself. In January, feeling poor after the expense of setting up his apartment in Paris, Hassam wrote to William Howe Downes with a plea for some advance publicity, promising the Boston critic a small sample of his recent work in return: "I wouldn't bother you if it was an exhibition simply," he wrote, "but you know an auction in Boston is a beastly venture i.e. a matter of life and death. Weeks [the critic] got a little oil of mine just before I left so he will I am sure feel kindly disposed to drive his quill a few blocks for Hassam.... I depend a good deal on the success of that sale. I am settled well here but it has taken about all of my spare cash. I have a very large studio and a nice little apartment attached...but it has taken some time and money to fit it up I can assure you."

Separately, to an artist friend, Hassam expressed his pessimism about the possibility of sales owing to the fickleness of the buying public. "My exhibition had a lot of bad stuff in it, I am sure, and they were principally old water colors that I should have burnt up. It also had the best water color I ever did, and some of the oils I was really sorry to part with. For they will go for nothing and will not be appreciated. I don't know as they will be able to give them away. Although at this date the sale is 10 days old I have heard nothing about it. Expect to get a letter saying, Could not give your work away!!! Boston did not want it!! But a lot of Modern French School, tinpan painting, will sell in Boston every winter."

As it turned out, the sale realized Hassam about $4,000 before commissions, an amount that must have relieved any immediate financial pressure. Yet, as was true throughout his life, Hassam remained dogged in his efforts to exhibit and sell his works even if it meant, as now, sending them across the ocean. In January he discussed his plans to exhibit in London and, in March, he sent three recent works — *Snow Storm on the Boulevard*, *Winter Morning in Paris*, and *Through the Rain* — to the National Academy of Design's spring exhibition in New York. He continued during that first year abroad to send pictures to the Boston Art Club, The Paint and Clay Club, and the Boston Water Color Society and, after showing *Cab Station, Rue Bonaparte* at the 1887 Paris Salon, he sent it off to major exhibitions in Philadelphia and Chicago. Hassam was to persist in such efforts in each of the years he spent in Paris.

The large scale of *Cab Station, Rue Bonaparte* leaves no doubt that it had always been intended for the Salon. By having it ac-

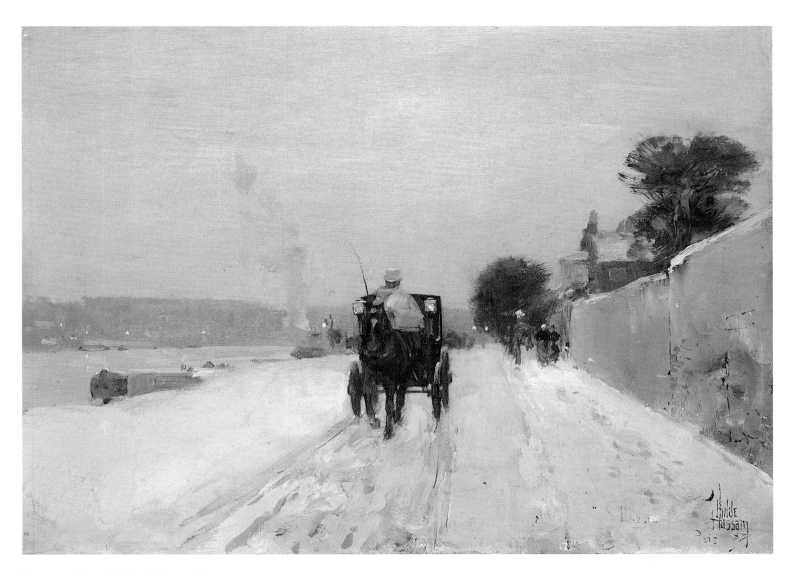

Fig. 25 *Along the Seine, Winter,* 1887.
Oil on cardboard, 8 x 11 in. (20.3 x 27.9 cm).
Dallas Museum of Art; Bequest of Joel T. Howard, 1951.40

cepted in his first year, Hassam scored a triumph that any American painter in Paris might envy. Now he joined the company of America's celebrated Salon members, and was cited in the reviews alongside such established painters as Daniel Ridgeway Knight, Julius L. Stewart, Charles Sprague Pearce, Frederick Bridgeman, Henry Mosler, and others. In addition to favorable mention in the American press, including an illustration of his picture in *Art Amateur,*[10] at least four French journals also praised the work. To cap his success, *Cab Station, Rue Bonaparte* was exhibited at Goupil's gallery for a week after the Salon closed, leading Hassam to declare: "This is my luckiest stroke since I have been here."

If the official success of *Cab Station, Rue Bonaparte* was considerable, artistically it revealed some refinements but no real change in the style that Hassam had developed in Boston. During his first year in Paris, in fact, he seems to have been more intent on reaffirming truths he already knew than on exploring new ground. His letters from Paris confirm this, his comments

on the paintings he encountered in galleries revealing the persistence of his earlier attitudes and opinions. He was predisposed to dislike much current academic work and, true to his Boston training, he was most interested in seeing work of the famous Barbizon painters, including Jean-François Millet, and that of Gustave Courbet and the Old Masters. In the few exhibitions he visited in the winter of 1886/87 he found little to admire, with the notable exception of a twilight painting by Jean Charles Cazin called *Close of Day,* which he considered "Stunning!!" Hassam was mostly disappointed in what he saw at the first Salon he attended, but did praise works by Aimé Morot, Luis Jiménez, and especially a "gray day" scene of horses plowing by Otto de Thoren; this he thought a "chef d'oeuvre" that recalled the work of Corot. Another of his favorites was a scene of Breton peasants at worship by P. A. J. Dagnan-Bouveret, an artist of whom he said in deep respect: "He is one of the last men." Hassam would not easily surrender his predilection for the Barbizon painters and, in an interview con-

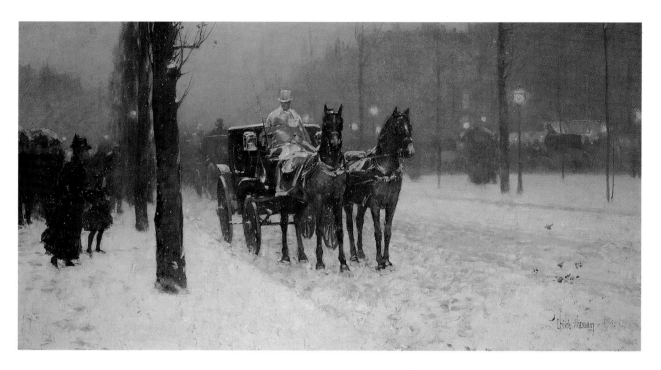

Fig. 26 *Street Scene with Hansom Cab*, 1887. 17 x 31 in. (43.2 x 78.7 cm). Private collection

Fig. 27 *Paris Street Scene*, 1887. 21½ x 26 in. (54.6 x 66 cm).
Private collection. Photo courtesy Laurence Casper, Casper Fine Arts

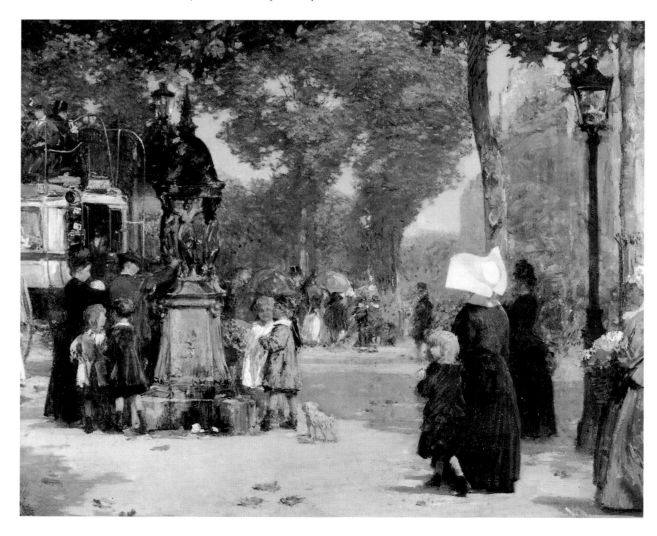

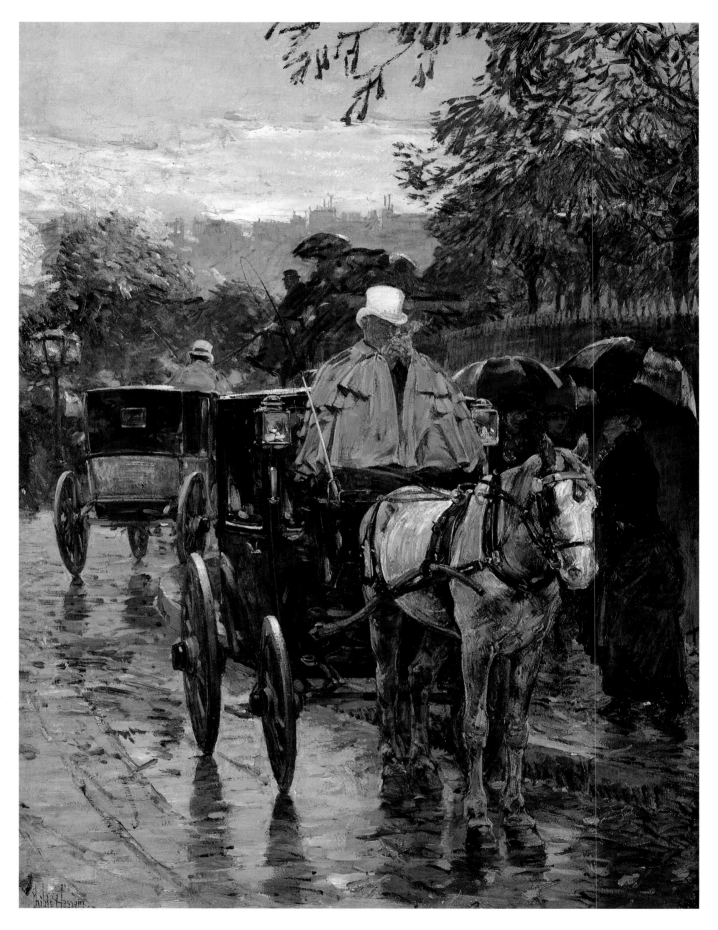

Fig. 28 *Fiacre, Rue Bonaparte*, 1888.
41 x 30½ in. (104.1 x 77.4 cm). Private collection

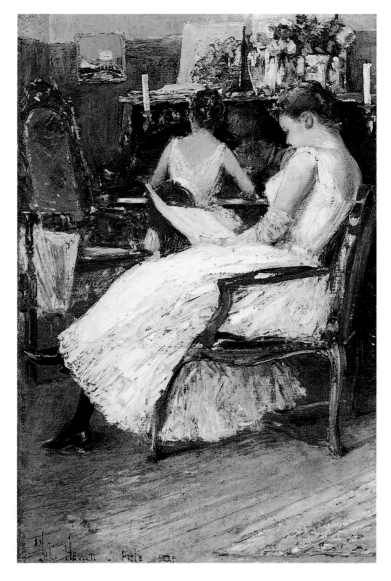

Fig. 29 *Mrs. Hassam and Her Sister*, 1889. 9¹³⁄₁₆ x 6⅛ in. (24.9 x 15.6 cm). Terra Foundation for the Arts, Daniel J. Terra Collection, 1992.40; courtesy of Terra Museum of American Art, Chicago

ducted during the Salon of 1888, he characterized that year's battle as having taken place between the Academics and what he termed the "Poetic School." Although he tactfully refrained from taking sides before the reporter, it is clear from other remarks he made that Hassam's sympathies lay with the poets and their "fine feeling."[11]

In the summer of 1887 Hassam announced plans to go to Normandy, "to [visit] a little village where artists never go." Nothing is known of his precise destination, or of the work he did there, yet the mention remains intriguing, for it was at this very time that a group of Boston artists, including John Leslie Breck, Willard Metcalf, Louis Ritter, and Theodore Wendel (along with the New Yorker Theodore Robinson), made their first visit to Giverny, where Monet lived and worked, and thus opened an important new chapter in American involvement with Impressionism.

In the fall of 1887 the Hassams moved to a new apartment at 35 Boulevard Rochechouart which, as Hassam reported to his friend Miss Lamb on November 29, offered better living conditions. This must be the apartment recorded by Hassam both in the charming domestic scene painted during the latter part his stay in Paris when Mrs. Hassam's sister, Mrs. George Cotton, came to visit (fig. 29) and in the painting *Twilight* (fig. 31), where the glass wall of the studio is visible at the right of the terrace. Hassam said of his new quarters: "The studio is good in this way, that one side is all glass nearly to the floor, so that I can paint a figure here the same as on the street. That is to say grey day effect." It is an important reminder that the majority of Hassam's larger exhibition pieces—which tended to be "grey day effects"—were likely to have been painted in the studio, while those requiring sunlight were the result of work done outdoors.

That autumn, in fact, Hassam was at work on an outdoor piece that has come to be regarded as a landmark in his artistic development. It represents the first major canvas in which he committed himself to a bright new palette that captured the effect of full sunlight. With this painting Hassam discovered color, which not only provides pure, bright accents, but informs the entire image, even the shadows. The work in question is *Grand Prix Day* (*Le Jour du Grand Prix*), which exists in two almost identical versions in the Boston Museum of Fine Arts

Fig. 30 Studio building at 35 Boulevard Rochechouart, Paris

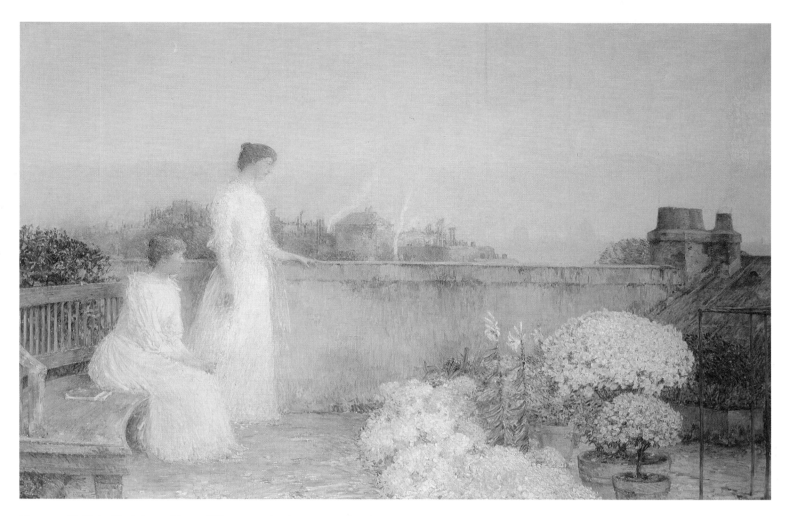

Fig. 31 *Twilight (Le Crépuscule)*, c. 1888. 50 x 77 in. (127 x 195.6 cm). Private collection. Photo courtesy Laurence Casper, Casper Fine Arts

and the New Britain Museum of American Art, respectively (figs. 32, 33). The theme of the pictures is the fashionable parades in Paris that inaugurated each horse racing season. Both canvases are carefully signed and dated, yet, because of its smaller size and differences in handling, the Boston version has sometimes been thought to be a preliminary study for the larger, New Britain painting.[12] Smaller versions of *Cab Station, Rue Bonaparte* and of a later painting called *Autumn* suggest that Hassam bowed to local studio custom and, after a loose fashion, worked toward his finished compositions through several preparatory stages. Boston's *Grand Prix Day*, however, shows every sign of being an independent, fully realized picture. New documentation enables us, for the first time, to verify this supposition through Hassam's own testimony. In his letter of November 29 to Miss Lamb he wrote:

Just now, by the way, I am painting sunlight (a picture 4½ ft. by 3 ft.) — a "four in hand" and the crowds of fiacres filled with the well dressed women who go to the "Grand Prix." The effect is on the "Avenue de la Grand Armée," quite near the "arc" with the long line of horse chestnut trees [on] one side of the street, the top of a palace and part of the arc. I sold the smaller picture that I painted of the same subject to Mr. Williams when he was here, so I will not describe the motif as I

hope you will see it there [in the Williams & Everett Gallery]. Some of my friends, after I had the first picture under way told me I must paint it larger, it was such an interesting motif. I hope I shall do it as well as the smaller one which I thought was successful in some ways. I do hope you will get a chance to see it.

It is probable that Hassam used the term "Grand Prix" in its generic sense, referring to the Paris racing meets in general. The actual high-stakes race that bore this name took place each year in early June, but there were also separate racing seasons in April and September that were accompanied by fashionable parades like that which Hassam painted. The April meet seems to have been the most prominent, inaugurating a season of new fashions and gala events in the capital, but the dark-colored foliage of the chestnut trees in the picture suggests that, if Hassam made studies of the Grand Prix spectacle in the spring, he did not get down to painting it until autumn, after he had returned from a summer in the open.[13]

Hassam may have been inspired by the racing scenes of Edouard Manet, Edgar Degas, and Giuseppe De Nittis, or, in his central motif, by the memory of Thomas Eakins's *The Fairman Rogers Four-in-Hand*, which he must have seen when it was shown at the Boston Art Club in 1881. Yet the simplest ex-

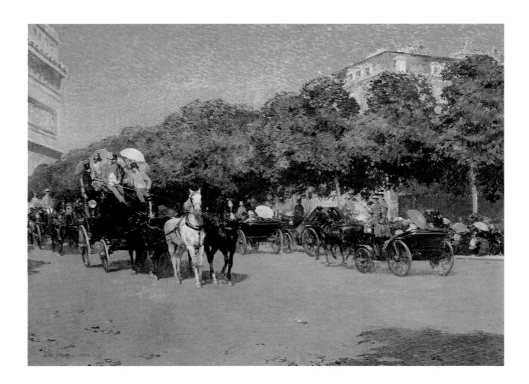

Fig. 32 *Grand Prix Day* (*Le Jour de Grand Prix*),
1887/88. 36 x 48 in. (91.4 x 121.9 cm).
New Britain Museum of American Art,
Connecticut; Grace Judd Landers Fund

Fig. 33 *Grand Prix Day*, 1887.
24 x 34 in. (61 x 78.7 cm).
Museum of Fine Arts, Boston;
Ernest Wadsworth Longfellow Fund

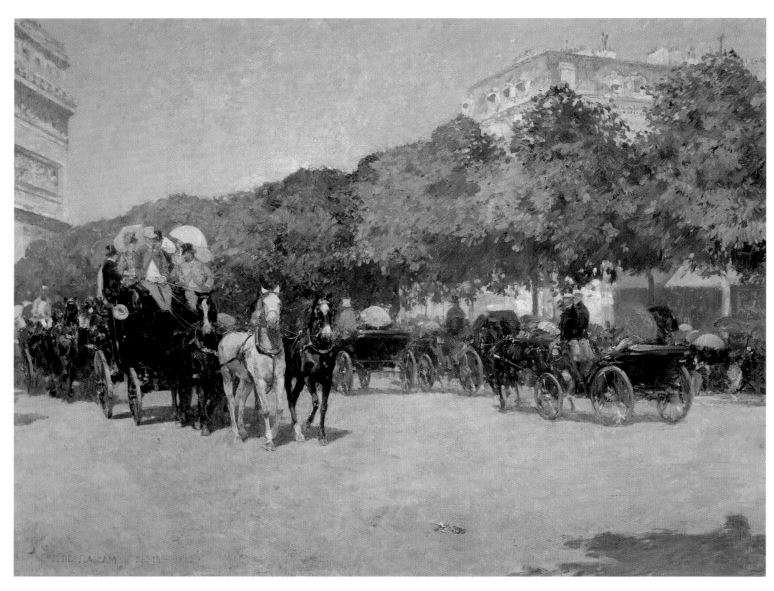

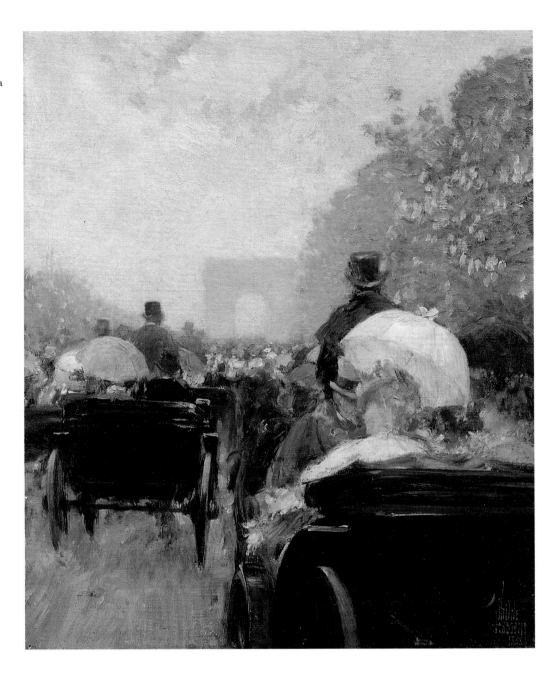

Fig. 34 *Carriage Parade*, 1888.
16¼ x 12⅞ in. (41.5 x 33 cm).
From the Haggin Collection,
The Haggin Museum, Stockton, California

planation, consistent with his general method, is that he happened to view the parade spectacles and decided to paint them. As for his light-filled treatment of the subject, Hassam certainly had practiced *plein air* painting in Boston, although his interest in it may have been revived by his summer in Normandy or even by the experiences of his Boston colleagues who had spent that same season painting at Giverny.[14]

It would be gratifying to be able to say that Hassam moved forward from this point and never looked back, but the reality is more complicated. He did indeed build on this new experience of light and color, but used it selectively, while continuing to rely on his earlier tonalist manner for his large exhibition pieces.

Grand Prix Day, presumably the New Britain version, was accepted for inclusion in the 1888 Paris Salon, where Hassam said it was "very well hung." It was exhibited again in Chicago in 1888 and well received, being described as superior to *Cab Station, Rue Bonaparte* and "a very brilliant picture, full of life and light and movement, and instinct with the gayety of the bright French capital."[15]

In the following years Hassam continued to treat racing day themes, sometimes as a forum for experiment, and to practice his new technique of light and color, although never again on the same scale as in these two paintings. In *Carriage Parade* of 1888 (fig. 34) he once more portrayed the colorful, festive procession, but made a startling shift of perspective from the sidelines into the midst of the action, a first person view from behind one of the moving carriages. This is the first example of Hassam's use of a deliberately fragmentary composition, a device, suggesting a random, accidental encounter, that he came increasingly to employ. Here, the cutoff view charges the picture with energy and drama, and brings the viewer directly

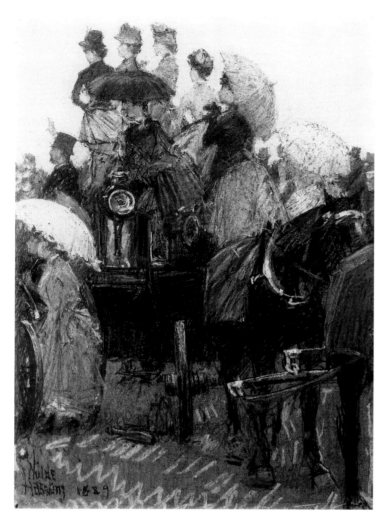

Fig. 35 *At the Grand Prix*, 1889. Pastel on paper.
Whereabouts unknown

into the scene from a vantage point that Hassam may have experienced himself on his way to the races. A related pastel showing the same carriage in wooded surroundings suggests that he first conceived the composition while further toward the Bois de Boulogne and, to enhance its interest, relocated it to one of the boulevards with the Arc de Triomphe in the distance.[16]

A number of watercolors and pastels bring us with the same sense of immediacy and involvement to the racetrack itself, where a crowd of spectators, many standing in their elegant carriages, are shown watching the race (see fig. 35).[17] In what was to become characteristic fashion, Hassam does not show the race itself, but rather the supplementary spectacle of viewers cheering what is presumably an exciting finish.

In a rare foray into portraiture that suggests the artist's role not only as spectator but as participant, *At the Grand Prix in Paris* (fig. 36) shows three ladies and a gentleman conversing on the turf at Longchamp. In this close-up view executed in pastel, the figures are rendered with a high degree of specificity in both their facial features and their costumes—white dresses, bon-

nets, parasols, tail coat, and top hat. Contrary to Hassam's later use of pastel as a medium of the utmost delicacy, here he wields it as a dense, painterly medium, while still exploiting its capacity for fine detail. The distinguished gentleman at right might be identified as M. Blumenthal, the wealthy businessman of mature years whose wife had befriended Maude Hassam and the only person capable of introducing the Hassams to the milieu of wealth and fashion that is otherwise so conspicuously absent from their experience abroad. Mme. Blumenthal, perhaps the lady in gray, Maude Hassam, the lady beside her, and the other woman, possibly Maude's sister, who came to visit in 1889, complete the group. Identifying the figure as Maude's sister requires a re-reading of the date the pastel bears. Traditionally understood as 1887, the last digit may be a "9," its loop abridged or compressed as was occasionally Hassam's wont.[18]

With their sunlit palette, the first Grand Prix paintings marked a breakthrough for Hassam on several fronts, not the least of which was the end to his almost exclusive preoccupation with rainy day effects. Critics had begun to complain about this. "Childe Hassam ought to 'come in out of the rain,'" one of them wrote after seeing *Cab Station, Rue Bonaparte*. "[It] is a very clever piece of work, but unless the subject is changed soon, one will have to take a dose of quinine as an antidote against the dampness that pervades Mr. Hassam's artistic environment."[19] Henceforth, Hassam began to show far greater freedom, both in technical means and in his range of subjects. Despite his long involvement with the racing theme, he remained generally impervious to the host of other lively public spectacles—for example, the theaters, cabarets, and *café concerts* that had provided the French Impressionists with such fertile material. By his own account, Hassam was temperamentally unsuited to such things and once, when recalling a well-known dance hall in his neighborhood, the Bal de l'Elysée-Montmartre at 80 Boulevard Rochechouart, said only: "It did not interest me much."[20]

Hassam's greatest amusement was to wander about the streets of Paris in search of motifs for his paintings. This he did with increasing frequency for, by the spring of 1888, he had stopped going to the Académie Julian and was working entirely on his own. Thereafter, his output of paintings increased dramatically.[21] One of the first canvases produced under these new independent circumstances was *Le Val de Grace, Spring Morning* of 1888 (fig. 37), a view that centered on a horsedrawn carriage making its way toward the foreground of a steeply receding avenue. The theme had become standard for Hassam, yet here he introduces some bold color notes and uses the brush in a much looser, freer manner. This is particularly noticeable in the broad expanses of street, sky, and distant trees, where the brushstrokes are not only tremendously varied, but also deliberately vague, and even decorative in intent, rather than descriptive. A comparison with the seamless blending of pigment in *Along the Seine, Winter* (fig. 25), painted a year earlier, gives some measure of this change.

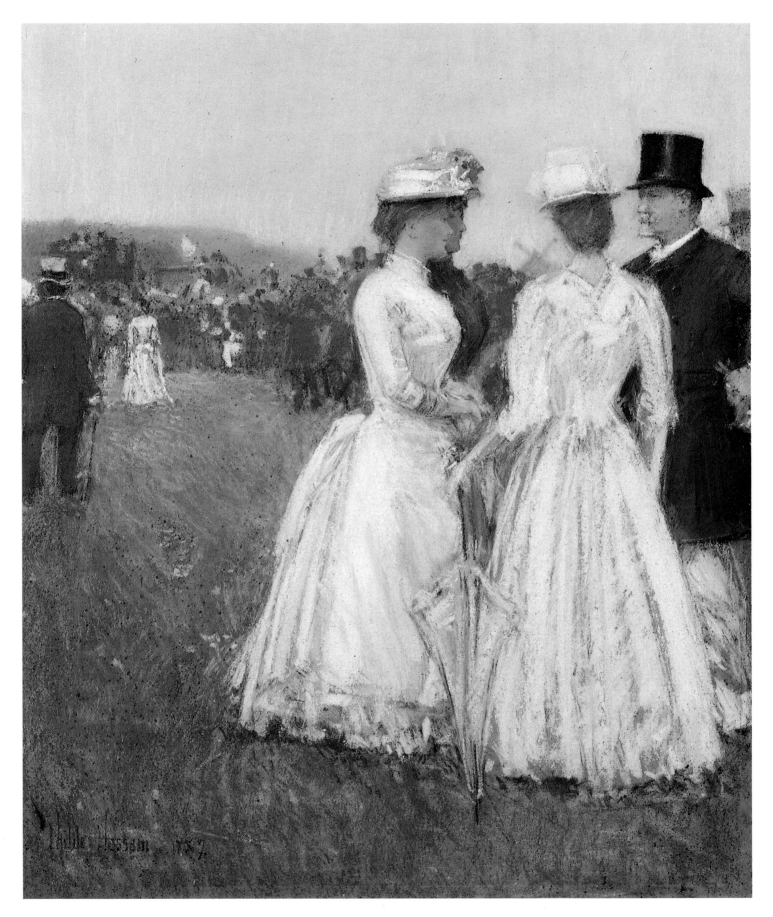

Fig. 36 *At the Grand Prix in Paris (Au Grand Prix de Paris)*, 1887.
Pastel and pencil on tan board, 18 x 12 in. (45.7 x 30.5 cm).
In the Collection of the Corcoran Gallery of Art; Bequest of James Parmelee, 1940

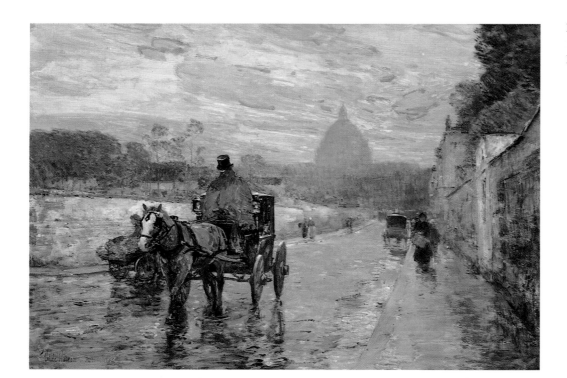

Fig. 37 *Le Val de Grace, Spring Morning,* 1888. 16¾ x 24 in. (42.6 x 61 cm). Private collection

Hassam continued to be fascinated by the picturesque figures of cab drivers and their equipage, but now also opened himself to the broader spectacle of the city's bustling public life. The subjects he chose ranged widely, from the leisurely strolls of the affluent in bright sunlight in the city's public parks (see fig. 38) to the nocturnal stirring of crowds shrouded in the evocative mystery of street lights (see fig. 39). At times, Hassam included the famous landmarks of Paris, as he had done in *Grand Prix Day.* In *Notre Dame Cathedral, Paris, 1888* (fig. 40) the cathedral provides a background for the painting's real subject, the heavy clouds of steam rising from the Seine barges to merge with the clouds of an immense, steely bright sky. Often his attention was caught by the everyday scenes that unfolded around him at each street corner or at the newspaper kiosks and bookstalls on the quais (see fig. 41). One of his favorite haunts was just a step beyond his door in the winding, steep streets of Montmartre, a quarter peopled with shopkeepers and artisans. There, in an atmosphere more reminiscent of a French rural village than a great metropolis, Hassam roamed purposefully, recording the shop fronts with their colorful displays and the earthy characters who tended their businesses and watched from doorways (see figs. 42, 43). James McNeill Whistler's views of shops in London's Chelsea district may have pointed him in this direction, but such subjects also echo the working-class themes he had absorbed from Barbizon tradition. While in no sense a social activist, Hassam remained sensitive to the class distinctions that city life seemed to magnify and, through his interest and attention, invested these subjects with their own simple charm and dignity.

La Bouquetière et la Laitière (fig. 43), an unusually large and carefully finished watercolor, focuses with meticulous attention on the keeper of a dairy store and a neighboring flower girl. The care given to every surface and detail points to an interest in still life that is an overlooked aspect of Hassam's early years, one inaugurated by studio exercises in Boston (see fig. 7). Hassam must have felt particularly pleased with his performance here, which he acknowledged with a whimsical graffito on the storefront to the left—an animated stick figure who exclaims "EPATANT" (amazing).

Hassam developed in these Paris scenes a working catalogue of themes that was to serve him through the following years. More than professional duty, we sense in this process of

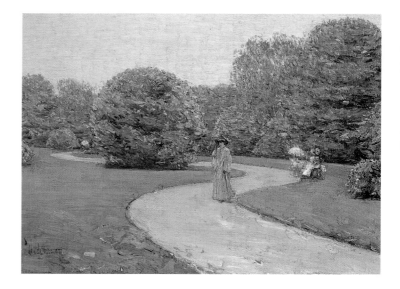

Fig. 38 *Parc Monceaux, Paris,* c. 1888/89 15 x 21 in. (38.1 x 53.3 cm). Private collection

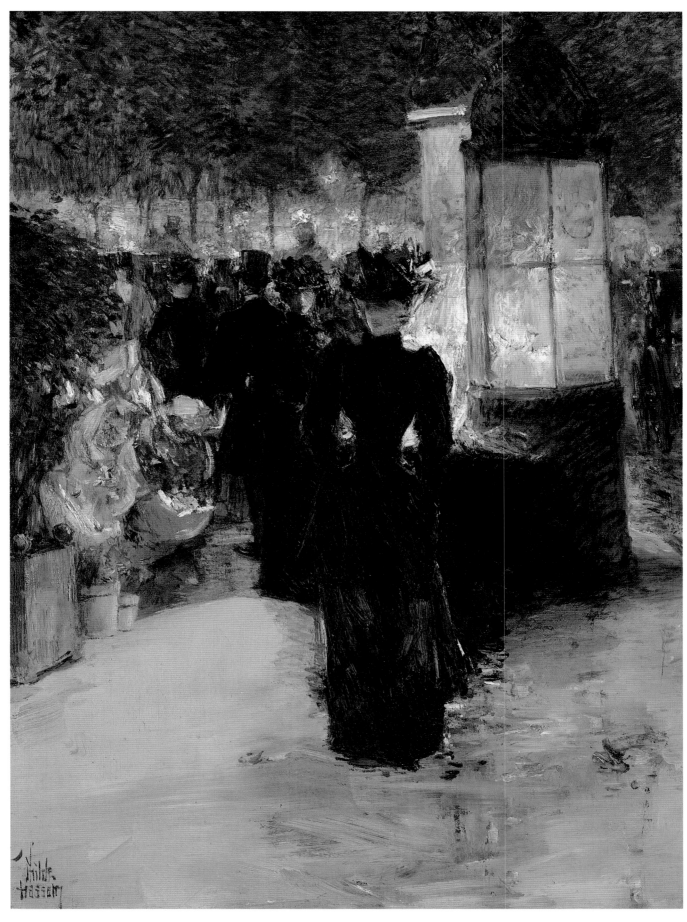

Fig. 39 *Paris Nocturne*, c. 1889.
27¼ x 20¼ in. (69.2 x 51.4 cm). Manoogian Collection

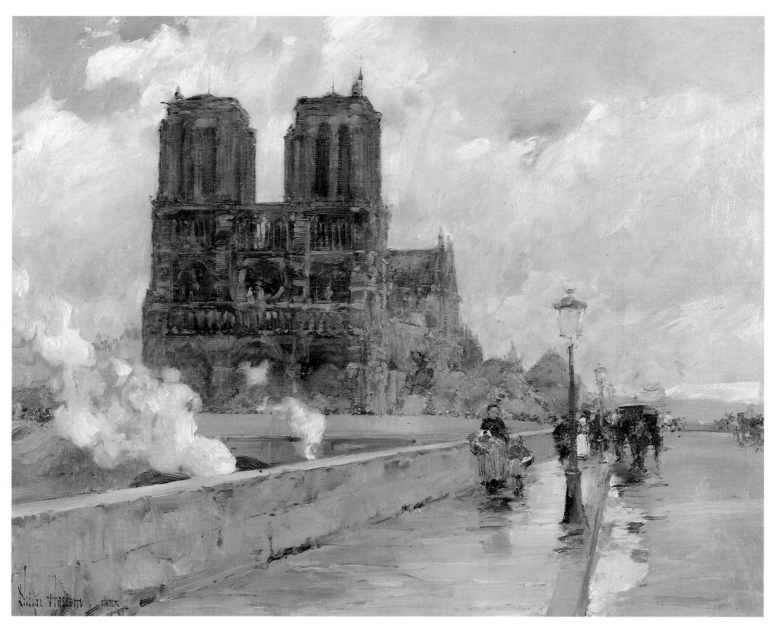

Fig. 40 *Notre Dame Cathedral, Paris, 1888*, 1888. 17¼ x 21⅝ in. (44 x 55 cm).
© The Detroit Institute of Arts; Founders Society Purchase, Robert H. Tannahill Foundation Fund

Fig. 41 *The Quai St. Michel,* c. 1888.
21¾ x 28 in. (55.3 x 71.1 cm). Private collection

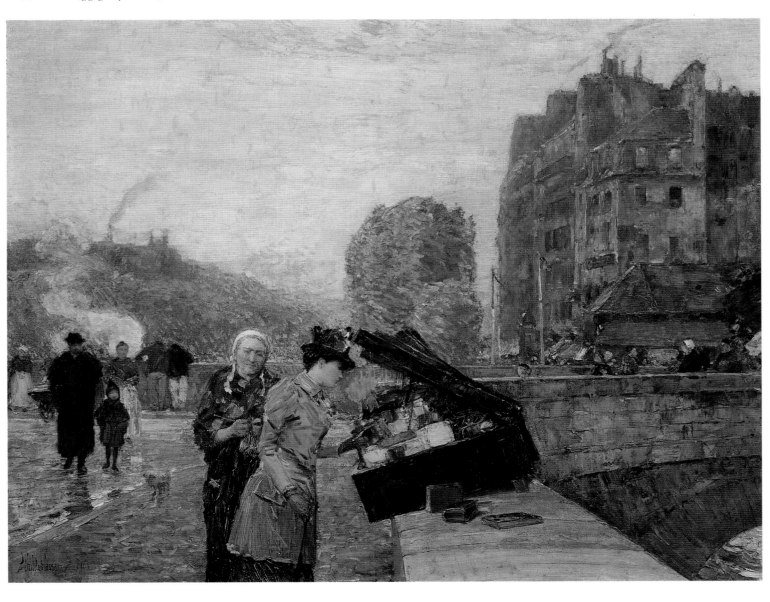

Fig. 42 *La Fruitière*, c. 1888/89. Oil on composition board, 14 x 10 in. (35.6 x 25.4 cm). The Regis Collection, Minneapolis, Minnesota

Fig. 43 *La Bouquetière et la Laitière*, c. 1888. Watercolor on paper, 17 x 26 in. (43.2 x 66 cm). Private collection. Photo courtesy Jordan-Volpe Gallery, New York

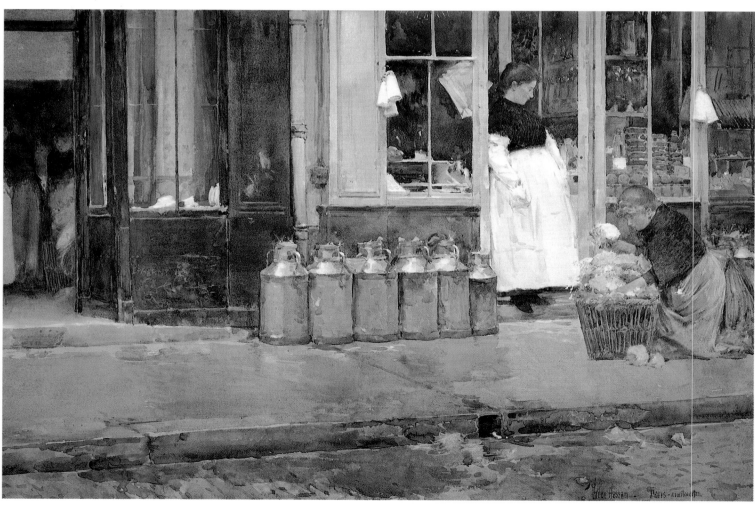

Fig. 44 *Paris Street Scene*, 1889.
Oil on board, 9¼ x 6¾ in. (23.5 x 17.2 cm).
Inscribed "a mon vieux E. H. Garrett/souvenir du quartier."
Collection of Mrs. Candy Spelling

Fig. 45 *April Showers, Champs Elysées Paris*, 1888.
12½ x 16¾ in. (31.8 x 42.5 cm).
Joslyn Art Museum, Omaha, Nebraska

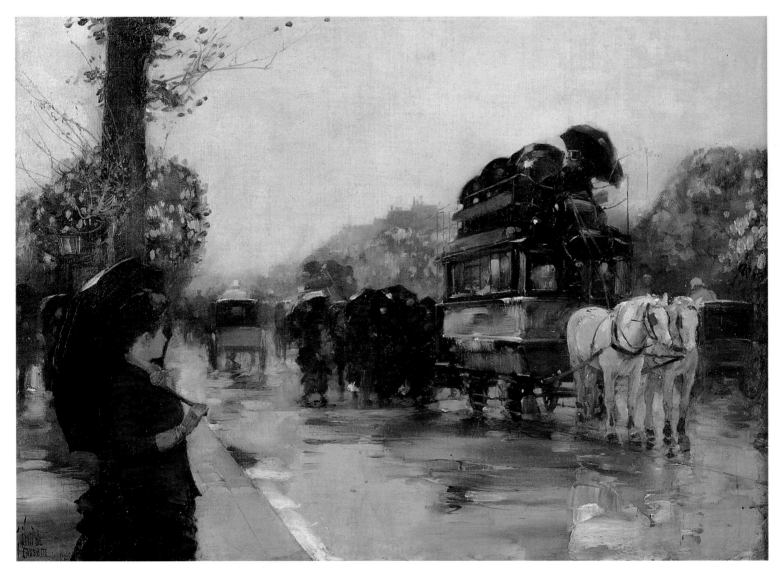

Fig. 46 Thomas Couture's house at Villiers-le-Bel, 1876

accumulation the drive of personal curiosity, a faith in the artistic process as a genuine search for truth, and a belief that his role as artist-observer was to discover and communicate the often unrecognized aspects of life. The strength of his street pictures lies in their energy and spontaneity, precisely the qualities that he had difficulty in translating to his larger, more labored exhibition pieces.

Except for a trip to England in the summer of 1889, the Hassams spent all of their time abroad either in Paris or in the nearby countryside. Given Hassam's later penchant for travel, this is rather unusual, but the Hassams' standard of living in Paris evidently left them little money for travel. In January 1887 Hassam announced his intention of going to paint in London soon, but there is no evidence that this trip ever materialized. He was in Normandy the following summer and, in 1888, he visited Le Havre and Auvers sur l'Oise. He also spent part of a summer at Ecouen, north of Paris, where he recalled finding a number of French painters at work and, among them, the Italian expatriate animal and landscape painter Luigi Chialiva.[22]

At Villiers-le-Bel, the Blumenthals provided Hassam with the opportunity of creating a now celebrated series of garden pictures with women (see figs. 47-50). Hassam first mentions this in a letter to a friend vacationing on the Isles of Shoals in June 1888. "I wish we were at the Shoals for this summer," Hassam wrote, "but we will really go to Villiers-le-Bel and I shall paint in a charming old French garden." Set in the Oise Valley, Villiers-le-Bel is a small rural town about ten miles northeast of Paris. The Blumenthal property had once belonged to the painter Thomas Couture, master of Manet and of several American painters, including John La Farge and William Morris Hunt. Hassam was certainly aware of the latter connection and surmised that Hunt must have been there as well.[23]

During several long stays at Villiers-le-Bel, which seem to have occurred in each of his three summers abroad, Hassam occasionally ventured into the surrounding countryside to paint pure landscape.[24] However, he did his most important work in the large formal garden attached to the Blumenthals' villa, a walled enclosure that included formal terraces, flower beds, winding paths, earthen walkways, and benches set beneath shade trees. Hassam always remembered the immaculate care with which the Blumenthal gardener tended the property, and was especially fascinated by the French technique of raising flowers into tailored bushes.

Among the most beautiful of the pictures Hassam painted at Villiers-le-Bel during the summer of 1888 is *Geraniums* (fig. 48). Depicting a young lady seated on a flowered terrace, it is almost certainly the picture Hassam exhibited at the 1889 Salon under the title *Soleil et fleurs* and later at the National Academy of Design in New York as *A Corner from a French Garden*. While Hassam is known often to have used his wife, Maude, as a model, this is the only instance in which we are assured of the fact by his own testimony. "Villiers-le-Bel...is where I painted many of my garden things," he said. "One is of Mrs. Hassam seated under a glass awning. Of course, the awning does not show. The geraniums are banked on a series of two or three steps."[25]

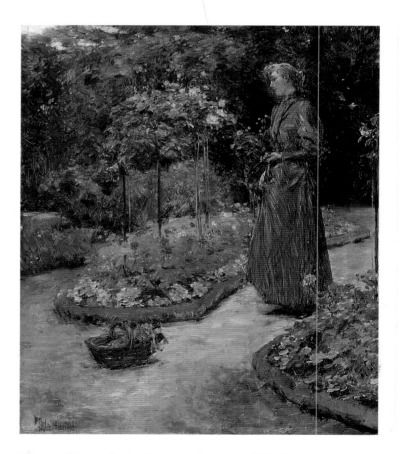

Fig. 47 *Woman Cutting Roses in a Garden*, c. 1888/89.
Oil on wooden panel, 18⅛ x 14⅜ in. (46 x 36.5 cm). Collection of The Newark Museum; Bequest of Diana Bonnor Lewis, 1988

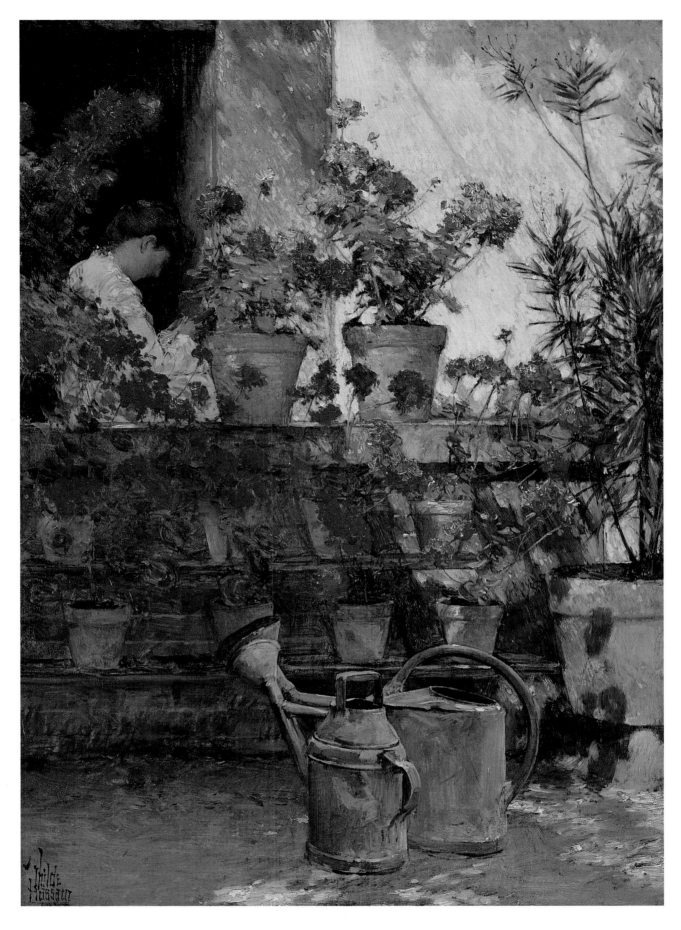

Fig. 48 *Geraniums*, 1888. 18¼ x 12⅞ in. (46 x 30.5 cm).
The Hyde Collection, Glens Falls, N.Y., 1971.22

The picture is exceptional for the delicate care used in rendering the female profile. Yet the figure is a secondary, though brilliant, element in a floral still life of blossoms ranged on several steps with large watering cans in the foreground. Hassam displays a wonderful range of light effects, alternating from full sun to shadow, reflecting differently on the various surfaces of wall, dress, metal watering cans, ground, earthenware flower pots, and, not least, with shocking radiance on the red blossoms, which seem to burst like scarlet fireworks across the surface of the painting.

In the Garden at Villiers-le-Bel (fig. 49), painted in the same luminous technique the following year, is a somewhat freer composition with a more even tonality. The door at left indicates an interior, perhaps a conservatory, in which the figure, half hidden by a thicket of leaves, suggests the possibility of an unforeseen encounter.

Hassam's interest in the gardens at Villiers-le-Bel carried over into his work in the Paris streets, where he found the flower vendors with their gorgeous baskets of merchandise a compelling opportunity to explore color. Hassam not only included figures of flower vendors in his more general street scenes, but developed the subject into a distinct category of its own. *Flower Girl*, reputed to be "one of his favorite flower girls,"[26] and *Woman Selling Flowers* (figs. 51, 52) are similar variants of this theme, showing a flower girl proffering her wares at curbside beside a basket loaded with bouquets. The viewpoints, with passersby cut off by the frame, suggest a random encounter, yet, despite the accidental quality, the restraint and deliberation of the compositions imposes its own sense of abiding significance.

In *The Rose Girl* (fig. 53) the flower vendor theme comes to an elaborate and striking conclusion. Once again, Hassam frames the composition almost as if by chance, but, instead of keeping a comfortable distance, propells the viewer directly into the scene, as a companion to the person evidently being offered a bouquet. The flower vendor herself is a keen character study, at once alert and obliging, yet with an air of inward detachment that is the merchant's traditional defense. Nearly closing off the space from behind is a carefully detailed carriage, where, in the flicker of lights in the rear window, it is left unclear whether a glimpse of the interior is intended or a reflection of the viewer's own space. As in Manet's *The Bar at the Folies-Bergère* of 1881, the beholder is thrust into the psychological action of the picture, yet Hassam here deliberately reinforces the artifice of his medium by decorating the side panels with floral sprays against a gold-leaf ground. In finishing the painting as a triptych, Hassam questions whether it is primarily an objective perception of the real world or an autonomous painted surface, an issue that other painters and critical theorists were then addressing in France. *The Rose Girl* was a singular endeavor and, though Hassam executed a few other triptychs during his career, he never again attempted so overt a fusion of representation and decoration. The impulse behind it, nonetheless, remained an important factor in his development.

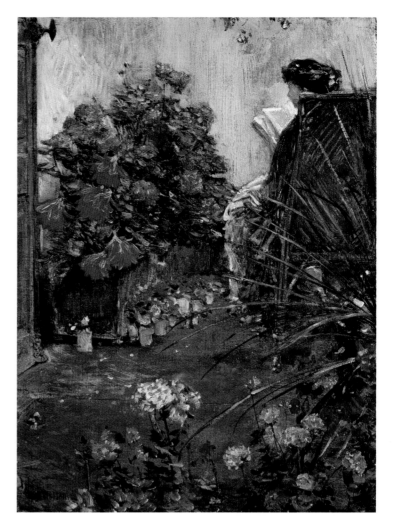

Fig. 49 *In the Garden at Villiers-le-Bel*, 1889.
18¼ x 12⅞ in. (46.4 x 32.7 cm).
Private collection, courtesy R. M. Thune

When the picture was exhibited along with three others at the Society of American Artists in New York in 1890, the *Times* reviewer commented on Hassam's "surprising versatility" and compared his manner to that of James Tissot.[27]

One of Hassam's last major compositions in Paris was *At the Florist* (*Chez la Fleuriste*) (fig. 54), a large painting that he left behind in Paris to be shown at the 1890 Salon. In it he adopted a curiously shallow, stagelike space in which the figures, pushed against the forward plane, are firmly modeled with hard, detailed strokes. The precision of the modeling and the bright tonal clarity produce a near illusionistic quality in the manner of Jules Bastien-Lepage and his friend Dagnan-Bouveret, whose *The Pardon in Brittany* Hassam had so admired at the 1887 Salon. There is every indication that *At the Florist* represents the outcome of Hassam's investigation into that popular *plein air* style. In it he attempted to elevate a scene of casual encounter into a large Salon format, with the predictable result of preserving a brilliant technical performance within a dubious conceptual framework. Its airless precision, when compared to

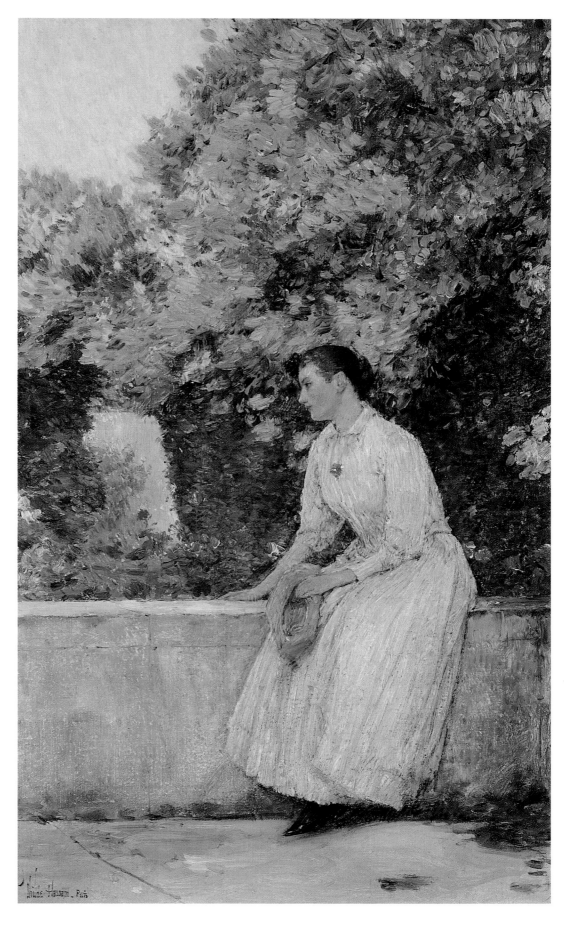

Fig. 50 *In The Garden*, c. 1888/89.
18 x 10¾ in. (45.7 x 27.3 cm). Private collection

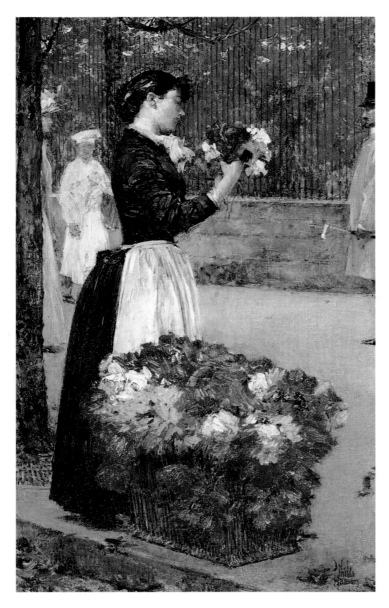

Fig. 51 *Flower Girl*, c. 1888. 14¼ x 8⅝ in. (36.2 x 21.9 cm).
Senator and Mrs. John D. Rockefeller IV

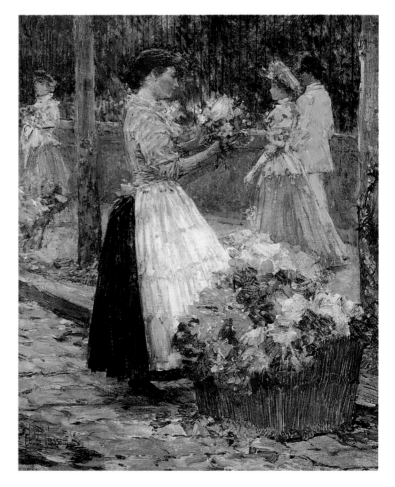

Fig. 52 *Woman Selling Flowers*, c. 1888/89.
13¾ x 10½ in. (34.9 x 26.7 cm).
Private collection, courtesy Barridoff Galleries, Portland, Maine

Fig. 53 *The Rose Girl*, c. 1888.
Center panel: oil on canvas with gold leaf, 21¾ x 30⅛ in. (55.2 x 76.5 cm);
side panels: oil on wood with gold leaf, 15¼ x 6¼ in. (38.7 x 15.9 cm).
Senator and Mrs. John D. Rockefeller IV

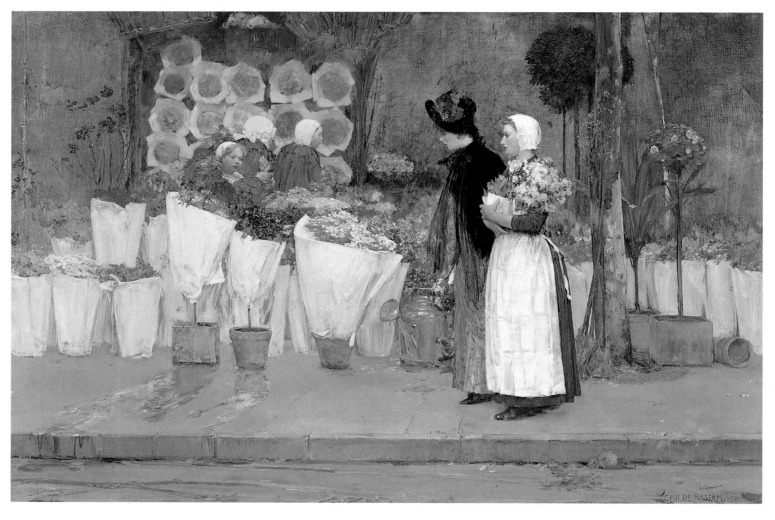

Fig. 54 *At the Florist* (*Chez la Fleuriste*), 1889. 36¾ x 54¼ in.
(93.4 x 137.8 cm). The Chrysler Museum, Norfolk, Virginia;
Gift of Walter P. Chrysler, Jr., 71.500

the rosy atmospheric qualities of a picture such as *Twilight* (*Le Crépuscule*) (fig. 31), demonstrates the extremes of which Hassam was capable in the process of finding himself artistically. These two polarities—on the one hand, moody, atmospheric, and even sentimental propensities, on the other, an optically precise, almost crystalline appreciation of the properties of matter—manifest themselves in varying proportions throughout his career.

Hassam's Paris pictures were beginning to attract attention in America. In March 1889 Hassam held an exhibition and sale of thirty-five paintings at Noyes, Cobb & Co. in Boston. This seems to have been both a financial and a critical success, as reviewers acknowledged Hassam's enormous accomplishments and growth during his years in Paris. The reviewer for the *Transcript* wrote that Hassam's paintings were

full of gayety and brightness [with a] truly Parisian savor. Mr. Hassam has been in Paris two or three years, and his pictures are largely of the streets, gardens and environs of that capital. Since he left Boston, he has made a very noticeable gain, especially in color, and he has never painted so well as now. Those who "know their Paris" will be pleased

to recognize the truth of observation illustrated in such works as "Twilight" (29), "Vespers at the Madeleine" (31), "A l'Heure" (11) and "A Little Old Shop on Montmartre" (22)—small and dainty pictures, which are thoroughly enjoyable and artistic.... It is refreshing to note that Mr. Hassam, in the midst of so many good, bad, and indifferent art currents, seems to be paddling his own canoe with a good deal of independence and method. When his Boston pictures of three years ago—such as the "Public Garden" (30)—are compared with the more recent works mentioned above, it may be seen how he has progressed.... We should fail to do justice to the artist if we did not call attention at the same time to the delightful effects of sunlight which he so skillfully manages in several garden scenes, where the soft breath of summer can almost be felt.[28]

Another reviewer remarked that Hassam still had difficulty with figures: "his treatment of the figure is not yet correct or skillful, but it is effective as an adjunct to his nicely composed landscapes and architectural backgrounds."[29]

Along with *Geraniums*, Hassam exhibited at the 1889 Paris Salon a huge canvas—described by him as eleven feet long—called *Autumn* (*L'Automne*) (fig. 55), which depicted an old man with a harp making his way at dusk along a leaf-strewn

boulevard. *Autumn* must have been started in the fall of 1888 not long after Hassam's summer work at Villiers-le-Bel and is curiously retrospective, its emphasis on steep perspective and moody, atmospheric effects recalling his earlier Boston pictures. Here, street genre is transformed into an obvious metaphor of life. Its scale and sentimental subject were patently and self-consciously directed toward the expectations of official audiences, who might not so easily have appreciated the virtues of his more current work. The critic for the *New York Herald*, in fact, praised it as "full of poetic feeling, unmarred by the realism of a Paris street scene,"[30] and no other work of Hassam's either before or for a long time afterward attracted as much press attention in America. In addition to the reviews, *Autumn*, together with *Twilight*, was illustrated, from plates made by Goupil, in George William Sheldon's book *Recent Ideals of American Art*, affording the artist a certain amount of favorable exposure alongside many solid Salon favorites. Hassam was described in the book as the only American at the time who specialized in depicting life in the cities, in paintings which "tell interesting stories" and which were notable for their delicate atmospheric effects.[31]

Hassam remained in Paris for the great Exposition Universelle of 1889 and exhibited four paintings in the American section, of which only *Twilight* has been located. Hassam won a bronze medal for his efforts, his first French award.[32] It was at the Exposition that Hassam remembered meeting Edward Simmons for the first time, a painter whom he would know later as friend and colleague in New York.

The American exhibition at the Exposition Universelle, which included 188 of his countrymen, convinced Hassam that an American school of painting did truly exist, although he saw it as threatened by the affection of weaker American artists for all things French and for academic training in particular: "The American Section in the Universal has convinced me for ever of the capability of Americans to claim a school. Inness, Whistler, Sargent and plenty of men just as well able to cope in their own chosen line with anything done over here. But as long as a crowd of apostates from America who have more money than brains continue to go to France to study for such a long time, sometimes so long that they finish by staying there altogether, there will be little growth of an American school."

By this time Hassam had formed some very decided opinions about the nature of painting and about those artists, French and American, whom he considered successful. In the same remarkable letter to his Boston friend, the critic William Howe Downes, he wrote:

An artist should paint his own time and treat nature as he feels it, not repeat the same stupidities of his predecessors, for mechanical exactitude becomes stupid in art and tiresome, like all things photographic to the real artist. The men who have made success today are the men who have got out of the rut. Henner, Dagnan-Bouveret and Cazin (and Cazin paints the figure too although some fools say he can't draw. These same people and some of them unfortunately write on art mat-

Fig. 55 *Autumn*, c. 1888/89. Whereabouts unknown

ters would find a thing charming that had been photographed onto a canvas and fairly well painted over it for the drawing). Even Claude Monet, Sisley, Pissaro [sic] and the school of extreme impressionists do some things that are charming and that will live, and even the major part of their work, although they are not always serious and some time they try too much to "étonner le bourgois" [sic] are less tiresome than those, the "type" who goes out with a camera and a paint box and who has no more idea of what a "value" is or what air is than the "bourgois" himself. John Sargent whose best things can vie with anything that has been done or is being done in art, did not learn what he knows in the academy. George Inness, who is admitted by men over here to be the greatest landscape painter living never studied here, and if he had would no doubt have had as original a style as he has all the same.... I don't mean men of real talent, of course; it don't make any difference where they live or where they paint as long as they see nature with their own eyes and do something a little different from other painters. All this tends to show you Downs [sic] that I believe too much of this foreign study for Americans is going to do what the Prix de Rome system has done and is doing for France."

It is particularly instructive to read Hassam's private comments on the Impressionists. Although he admired and accepted them, there is no trace of hero worship, and he even expresses reservations, apparently believing some of their methods to be too extreme. Equally significant is his unequivocal admiration of John Singer Sargent and George Inness.

In the summer of 1889 Hassam created a number of small scenes recording the Bastille Day celebrations on July 14 (see fig. 56).[33] Then, perhaps spurred by the presence of Mrs. Hassam's sister, who had come to visit that summer, as well as by the prospect of finally returning home, the Hassams traveled to the region west of Paris, where the artist painted watercolor scenes at Bougival,[34] to nearby St Cloud (see fig. 58), and then to England, where they spent about half the summer. The Hassams vacationed part of the time at the seaside resort of Broadstairs and then visited London and several other places, including Chiswick and Canterbury (see figs. 57, 59).

On returning to Paris at the end of the summer, the Hassams began to make preparations to leave the city where they

Fig. 56 *14th July, Paris, Old Quarter*, 1889. Watercolor and pastel on paper, 5⅞ x 8½ in. (14.9 x 21.6 cm). The Carnegie Museum of Art, Pittsburgh; Andrew Carnegie Fund, 1907

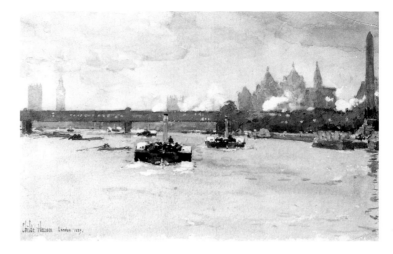

Fig. 57 *View of London*, 1889. Watercolor on paper, 7½ x 11 in. (19 x 27.9 cm). Private collection. Photo courtesy Coe-Kerr Gallery, New York

had lived for nearly three years. Hassam explained that, in anticipation of their return home and wishing to sell their furniture, they gave up their large apartment and moved to a smaller studio apartment, which they rented by the month. What has hitherto gone unnoticed is that Hassam's new studio at 35 Boulevard Rochechouart had been previously occupied by the painter Auguste Renoir, who, discouraged by the progress of his work, had left Paris the previous winter.[35] It was only much later, said Hassam, that he appreciated the celebrity of his predecessor. "A crazy painter" (une peintre fou) is how the concierge described Renoir to Hassam, yet Hassam's own reaction to the paintings left behind by Renoir in his studio was quite different:

In this place were all sorts of little experiments. I did not know anything about Renoir or care anything about Renoir. I looked at these experiments in pure color and saw it was what I was trying to do myself. He was a very able painter and his finished things are academically complete. They are as complete as any Academician. I did not know anything about where he was or care anything about it. But I looked these little things over and afterward began to realize that I had lived for a few months in the studio of this very modern painter—seeing his good things and his good things were very fine. They are as suave and smooth and as lightly finished as any one could imagine.... I was a young man under thirty and I had never heard of Renoir. I had never heard of Renoir and I cared less. But I knew that he was trying for the same thing that I was trying for."[36]

There is little evidence that this direct and intimate, if unsought, contact with Renoir's work influenced Hassam in his development beyond confirming the direction that his painting had taken. In fact, Hassam used the Renoir studio for only a "few months," and that at the very end of his stay in Paris.

On leaving Paris, Hassam had every reason to feel satisfied with his accomplishments. He could claim to have undergone the rigors of French academic training, had succeeded in exhibiting at the Salon in each of the three years of his stay—no ordinary feat for a young painter—and capped this by receiving a medal at the Exposition Universelle. Hassam was under no illusions about Parisian art politics. The Salon he called a "farce" and wrote to Downes: "If you could live over here a couple of years to see how things are run here in art matters it would make you sick. Americans ought to know this. It ought to be shown up. The 'French disinterestedness' does not exist for any *stranger*." On the other hand, Hassam had seen his name and reputation steadily increase at home. He received admiring attention in art journals and press reviews. He had even managed to keep selling his work all the while. If he was still not well known, let alone famous, he had certainly moved far beyond the small world of Boston to join the international ranks of professionals worthy of serious attention.

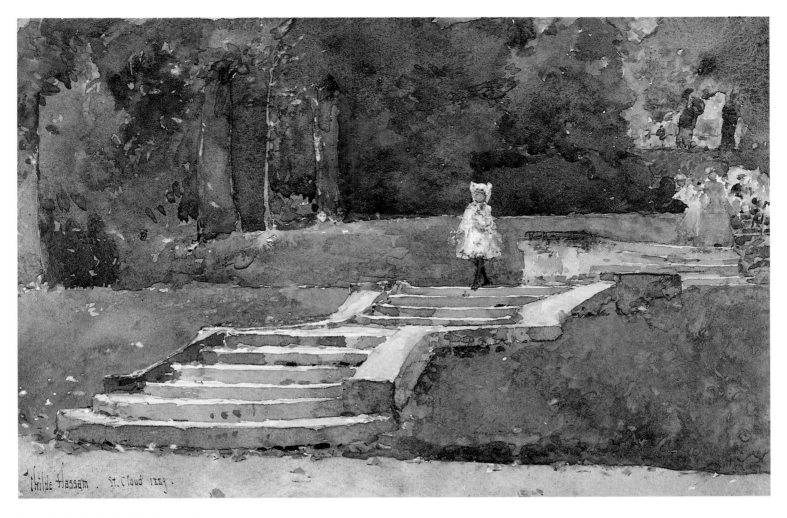

Fig. 58 *In the Park at St. Cloud*, 1889.
Watercolor on paper, 7½ x 11⅛ in. (19 x 28.3 cm).
The Art Institute of Chicago; Bequest of Marion E. Merrill, 1978.481

All uncredited quotations are from documents published on pp. 177-82 of the present volume.

1 *Art Amateur* 15 (Nov. 1886), p. 113. Although he had thus announced his intention to be away for a full three years, remarks made later by Hassam in his correspondence reflect some uncertainty about these original plans.

2 Lockman Interview, Jan. 31, 1927, p. 17; see also *ibid.*, Jan. 25, 1927, p. 14.

3 Included in the odd assortment of Americans whom Hassam remembered meeting in Paris were Ogden Wood (1851-1912), an old painter named Moses White who had settled there permanently, Arthur Mathews (1860-1945), and, at the very end of his stay, Edward Simmons. He also kept up some contact with Edmund H. Garrett, his friend from Boston, who was studying at the Académie Julian at the same time (see fig. 44). See Lockman Interview, Jan. 31, 1927, p. 16ff.

4 Lockman Interview, Jan. 31, 1927, p. 13ff. Hassam said that it was Albert H. Munsell (1858-1918), painter and celebrated color theorist, who had introduced him to Julian's.

5 Quoted in Frederick W. Morton, "Childe Hassam, Impressionist," *Brush and Pencil* 8 (June 1901), p. 146.

6 Quoted in John Kimberly Mumford, "Who's Who in New York—No. 75," *New York Herald Tribune*, Aug. 30, 1925, p. 11.

7 For this version, see Parke-Bernet Gallery, New York, auction catalogue, Feb. 17, 1944, no. 35: *Paris Street Scene at Twilight*. The large version was also variously titled *Une Averse, Rue Bonaparte* and *Rainy Day, Rue Bonaparte*.

8 Hassam Papers, undated clipping from *Boston Transcript*, 1887. For later reviews of the picture, see the clippings in the same location from *Chicago Times*, 1887, and *New York Sun*, 1887.

9 Theodore Child, "The Paris Salon of 1887," *Art Amateur* 16 (May 1887), p. 126.

10 *Art Amateur* 16 (May 1887), p. 126.

11 Hassam Papers, clipping identified as from *New York Herald*, Paris, 1888. The painting by Dagnan-Bouveret that Hassam admired at the 1887 Salon was undoubtedly *The Pardon in Brittany*, now in the Metropolitan Museum of Art, New York.

12 See Donelson F. Hoopes, *Childe Hassam*, New York, 1979, p. 28, pl. 4. Hoopes observed the relative lack of

spontaneity in the New Britain version, but believed it to be the result of the deliberate method employed by the artist. New information does not support Hoopes's opinion of the Grand Prix pictures that "[as] Hassam's first essay into Impressionism...[they were] not the product of the free and spontaneous *plein air* methods normally associated with the style" or that "Hassam wished to achieve the assured performance possible only through rigorous preparation." One should also correct Hoopes's mistaken notion that *Grand Prix Day* won any honors, let alone a gold medal, at the 1888 Salon.

As Hoopes rightly observed, Hassam made a number of changes in the New Britain version, treating many details with greater care and adopting a looser style of brushwork in the sky, foliage, and foreground. These differences, however, may have been the result of a later reworking, perhaps at the time Hassam erased his original block-letter signature—the style found on the Boston version—and replaced it with one in a smaller, lower case script. This, and other possible alterations, could have been effected within a year or two of the initial work on the painting, while Hassam was still in Paris.

13 For the racing events at Longchamp, see Robert L. Herbert, *Impressionism, Art, Leisure, and Parisian Society*, New Haven and London, 1988, p. 176ff. Two related watercolors or pastels, titled simply *Going to the Race, Paris* and *At the Race, Paris*, were shown as nos. 447 and 448 at the Pennsylvania Academy of the Fine Arts annual exhibition from February 16 to March 29, 1888, while Hassam made no mention of the Grand Prix painting when he wrote to Miss Lamb in July 1887.

14 This group included Breck, Metcalf, Ritter, and Wendel (along with New Yorker Robinson). We possess almost no information about Hassam's relationships with these men, but the smallness of Boston's art world would have encouraged at least some acquaintance with them. Hassam did know Breck and Ritter in Boston in the early 1880s, and probably also Metcalf. Breck was studying at the Académie Julian in 1886 and 1887 (as was Wendel in at least 1886), thus overlapping with Hassam. We are fairly certain that Hassam never went to Giverny, but it is possible that, through word of mouth and through examples brought back by these men to Paris, he may have been exposed to the work they had done there. Hassam al-

ways denied that Monet influenced him during this period, attributing his own interest in light and clear colors to his experience as a *plein air* watercolorist following the style of English masters.

15 Hassam Papers, clipping identified as from *Chicago News*, 1888.

16 Peter A. Juley and Son Collection, National Museum of American Art, Smithsonian Institution, neg. J0027157.

17 See also the 1888 watercolor *At Grand Prix*, in *Retrospective of a Gallery: Twenty Years*, exhibition catalogue, Hirschl & Adler Galleries, New York, 1973, no. 51.

18 See, for example, the unlocated Grand Prix pastel recorded in the American Academy of Arts and Letters files, in which similar digits read unmistakably as 1889. One might note that a bearded male figure like the one in *At the Grand Prix in Paris* identified here as M. Blumenthal recurs in several other Grand Prix compositions. Identification of the female figures is less easy. Mme. Blumenthal might also be the second figure, usually identified as Mrs. Hassam's sister, in *Twilight* (fig. 31).

19 Hassam Papers, undated clipping from *Boston Transcript*, 1887.

20 Lockman Interview, Jan. 31, 1927, p. 17.

21 Hassam (*ibid.*, p. 14) said that he worked at Julian's for a year and a half, which would encompass two winter seasons, ending in the spring of 1888.

22 In Lockman Interview, Jan. 31, 1927, p. 16, his name and that of Ecouen, which he visited frequently, were bowdlerized to "Chalivier" and "Nilire Le Ecorum."

23 Hassam to Rose Lamb, June 27, 1888 (Appendix A, 7). For Hassam's description of the Blumenthals, see Lockman Interview, Jan. 31, 1927, pp. 15-16.

24 Works identified as deriving from these excursions include the large canvas of 1889 depicting fields with haystacks sold as no. 126 at Sotheby's, New York, on October 27, 1978, and the undated *Blossoms: Villiers Le Bel* (Parke-Bernet Gallery, New York, Oct. 17, 1962, no. 50).

25 Lockman Interview, Jan. 31, 1927, p. 15.

26 Hassam Papers, unidentified clipping "Life in the Studios," c. 1890-92.

27 Quoted in John I. H. Baur, *Leaders of American Impressionism*, exhibition catalogue, The Brooklyn Museum, 1937, pp. 11-12.

28 Hassam Papers, "Fine Arts, Exhibition of Mr. Hassam's Paintings at

Noyes, Cobb & Co.'s Gallery," undated clipping from *Boston Transcript*. The Hassam Papers also contain reviews from the Boston *Sunday Herald* and *Saturday Evening Gazette*.

29 Hassam Papers, undated clipping from *Sunday Herald*, Boston.

30 Hassam Papers, clipping identified as from *New York Herald*, Paris, 1888. See also a further clipping from *Journal des Artistes*, Paris, 1889, and references in *Harper's Weekly* 33 (Apr. 27, 1889), pp. 334 and 323 (ill.); *Art Amateur* 21 (July 1889), p. 27; and *ibid.* (Oct. 1889), p. 91.

If the published date of 1887 is reliable, the basic idea for *Autumn*, had been worked out by Hassam several years earlier in a smaller canvas that shows a woman rather than an old harpist as the principal figure. See *Selections from the Collection of Hirschl & Adler Galleries: American Paintings 1876-1963*, New York, 1963, p. 15. A picture of the harpist alone, probably a preliminary study, is illustrated in Nathaniel Pousette-Dart, *Childe Hassam*, New York, 1922.

31 George William Sheldon, *Recent Ideals of American Art*, New York and London, n. d. (c. 1890), p. 146.

32 For the Exposition Universelle, see *Paris 1889: American Artists at the Universal Exposition*, exhibition catalogue, Pennsylvania Academy of the Fine Arts, 1989, with essays by Annette Blaugrund and others. Hassam's entries were *Twilight, Rue Lafayette, After Breakfast*, and *Letter from America* (nos. 149-52). In his letter of April 8, 1889 (Appendix A, 8), Hassam said that five of his paintings had been accepted. One of these must have been eliminated due to the jury's need to reduce the overall number of pictures shown. Modern writers have sometimes credited Hassam with a medal at one or another Salon, yet he never received any Salon honors.

33 See p. 156. To the paintings mentioned there should be added the unlocated *Decorations of a Little Paris Shop on the Fourteenth of July*, exhibited by Hassam at Noyes, Cobb & Co., Boston, in the early 1890s.

34 See the 1889 watercolor inscribed "Chateau near Bougival," Museum of Fine Arts, Boston (58.598).

35 Renoir had occupied the studio since October 15, 1886. See Barbara Ehrlich White, *Renoir: His Life, Art, and Letters*, New York, 1984, p. 185ff.

36 Lockman Interview, Jan. 31, 1927, pp. 19-20.

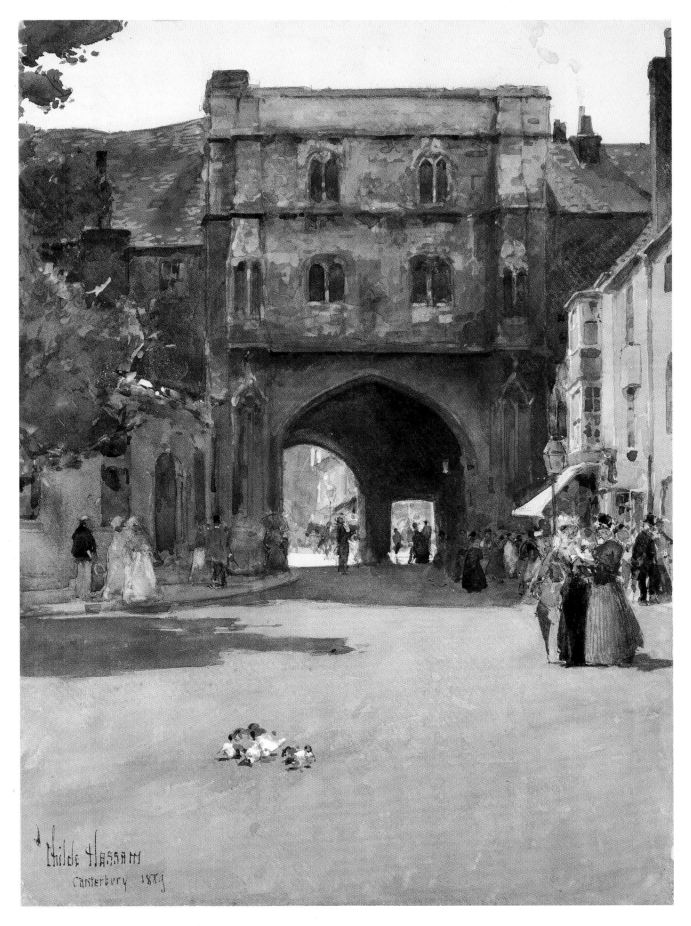

Fig. 59 *Gateway at Canterbury*, 1889. Watercolor on paper,
13½ x 9½ in. (34.3 x 24.2 cm). Museum of Fine Arts, Boston; Gift of the heirs of Elizabeth A. Cotton

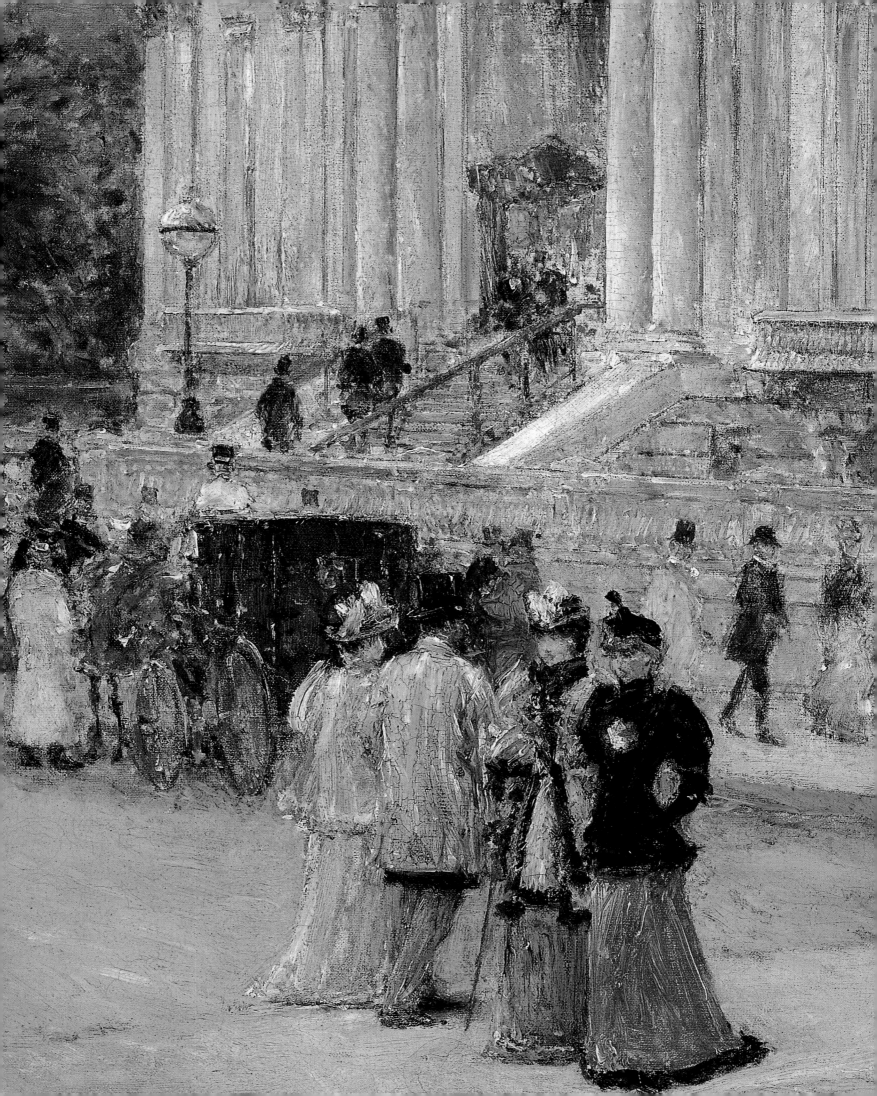

III EXPLORING AMERICA 1889-1896

The Hassams sailed for home in October 1889 and were still at sea on the 17th of the month, when the painter celebrated his thirtieth birthday. Returning with them on the steamer were Mrs. Hassam's sister and brother-in-law. Although we can be fairly certain that Hassam had already decided to settle in New York, after landing there he immediately went to Boston for a month, occupied no doubt with family visits and preparations for moving.

New York, as the acknowledged art center of the country, was the logical destination for any young artist with high ambition. Boston, although recently stirred by interest in Impressionism among a small group of collectors and artists, still remained a place of limited opportunities where, as a critic once said, an exhibition or two would exhaust the possibilities for the season.[1] Edmund Tarbell and Frank Benson, two painters with whom Hassam would associate intimately, had been able that very year to secure steady teaching jobs at the Museum School, but in the commercial arena the outlook was not good. Several times in letters home Hassam had remarked disparagingly of the opportunities to sell pictures in Boston, once declaring it "such a doubtful market" that he could not hope to sell any large paintings there. Hassam's old studio neighbor, the landscapist John Enneking, stated at about this time: "Art has always had a hard time in America. 'No one buys an American picture,' the dealers say, and they're about right. We all have to teach or paint potboilers to make a living."[2]

On arriving in New York some time in November, Hassam moved into a studio apartment at 95 Fifth Avenue on the corner of Seventeenth Street which, according to him, was one of the first homes in the area to be divided into rental units.

Hassam knew virtually no one at that time in New York and the evidence of his earliest activity there is meager. He apparently obtained some paying work as an illustrator, for among his earliest New York subjects is a pen and ink drawing, dated December 1889, of the park in front of City Hall that seems made for commercial use (fig. 60). His circumstances were probably reflected in the account he gave of the origins of the New York Water Color Club, an organization that he helped found the following year, whose purpose was, in part, to pro-vide an immediate sales outlet for young artists returning from Europe with limited, if any, means.[3]

By the start of the next year Hassam was beginning to gain a foothold in his new surroundings. He sold his first watercolor in New York—to the painter Samuel Colman—on opening night of the American Water Color Society exhibition on January 31, 1890. Also that evening he made the acquaintance of J. Alden Weir and John Twachtman, two painters who were to count among his closest artistic allies. Hassam remembered the meeting well: "They [the members of the Water Color Society] gave an artists' night.... It was for the buyers and everyone. It was the social art event of the year.... They had beer and sandwiches in quantities. No end to them. They sold most of the pictures the first night. It was the only time that American art was popular. In the sense of the people. People came and bought. After that meeting I came to know Twachtman and Weir very well."[4] Somewhat older than Hassam, Weir and Twachtman were close friends and firmly allied with the progressive elements that had shaken the conservative New York art world during the preceding decade. Twachtman was a dedicated, brilliant, and impractical visionary. Weir, a scion of one of America's most distinguished painting families, was friendly, outgoing, and had just begun his conversion to Impressionism. The sympathy between Weir and Hassam seems to have been immediate, and Hassam recalled that the first dinner he went to in an artist's home in New York was at Weir's.[5]

By the following spring Hassam had become fully immersed in New York's organized art world, having been welcomed into The Players, a social club whose membership encompassed most of the progressive painters in the city. He was also made a member of both the Society of American Artists and the American Watercolor Society[6] and served as the first president of the New York Water Color Club, remaining in office until 1896.

Over the winter he had begun to exhibit the large body of material that he had brought home from Paris. He remembered selling to John Caldwell, later a friend, his first oil painting in New York, a "French street scene with snow and figures" that he had hung in the window of Reichard's art store on Fifth

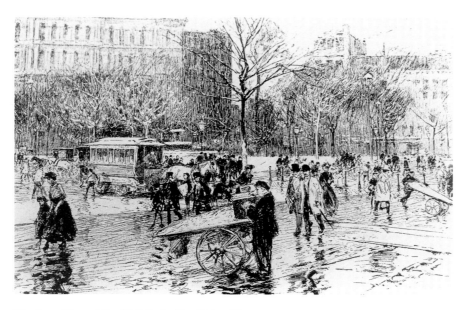

Fig. 60 *View of City Hall Park, New York,* 1889; detail. Pen and ink. Whereabouts unknown

Fig. 62 *Fifth Avenue in Winter,* c. 1890. 21⅝ x 28 in. (54.9 x 71.1 cm). The Carnegie Museum of Art, Pittsburgh; Purchase, 00.2

Fig. 61 Fifth Avenue, New York, looking north from Seventeenth Street, 1890s

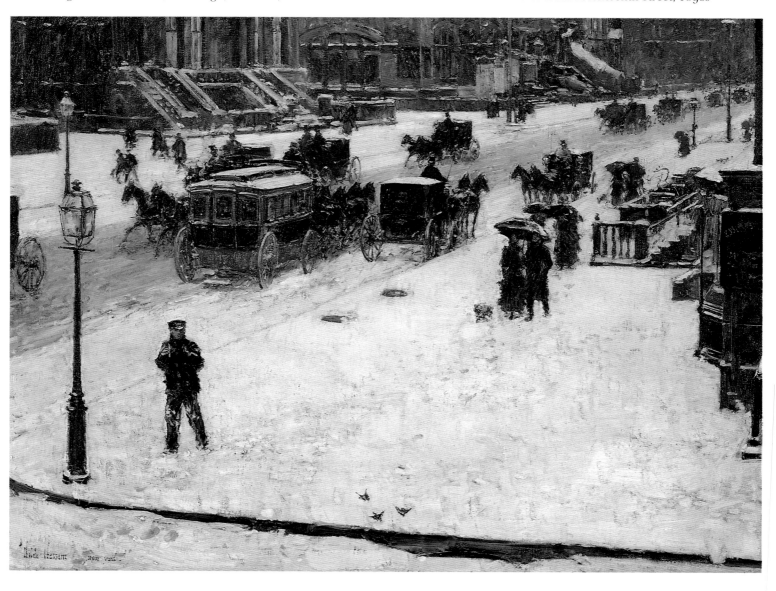

Avenue.[7] In January he had shown about a dozen watercolors at the Doll & Richards Gallery in Boston, and subsequently sent six works to the Pennsylvania Academy of the Fine Arts annual in Philadelphia, seven pastels to the fourth and last exhibition of the Society of American Painters in Pastel in New York, and four paintings each to the spring exhibitions in New York of the Society of American Artists and the National Academy of Design. Other works were shown that spring at the Art Institute of Chicago, as well as in Boston and Denver, Colorado.

As had occurred in Paris, new surroundings inspired Hassam to a burst of activity, with the result that many of his most important New York compositions were created in his very first years in the city. Most likely dating from that first winter, *Fifth Avenue in Winter* (fig. 62) is a snow scene looking up Fifth Avenue when the street is crowded with morning traffic.[8] The picture, which was painted from a window of Hassam's apartment (fig. 61) is full of observed detail and movement, from the care-fully sketched pedestrian groups to the lumbering omnibus with its glass windows, waiting cabs, and stream of fast-moving carriages. A messenger boy outlined against the snow epitomizes Hassam's method of using a solitary "leading" figure to mark the visual entry point of his compositions. In its evocation of the physical sensations and the psychological mood of the moment, the painting exemplifies what Hassam meant when he likened the portrait of a city to that of a person, with the artist striving to capture "not only the superficial resemblance, but the inner self. The spirit... the soul of a city." Perhaps for that reason *Fifth Avenue in Winter* remained among his personal favorites, chosen by him for exhibition on numerous occasions. When it was sent to represent him at a showing of American paintings at the Durand-Ruel gallery, Paris, in early summer 1891, the critic for *Le Figaro* singled it out not only as one of the few pictures there having a truly "American character," but also as one of the most appreciated in the entire exhibition.[9]

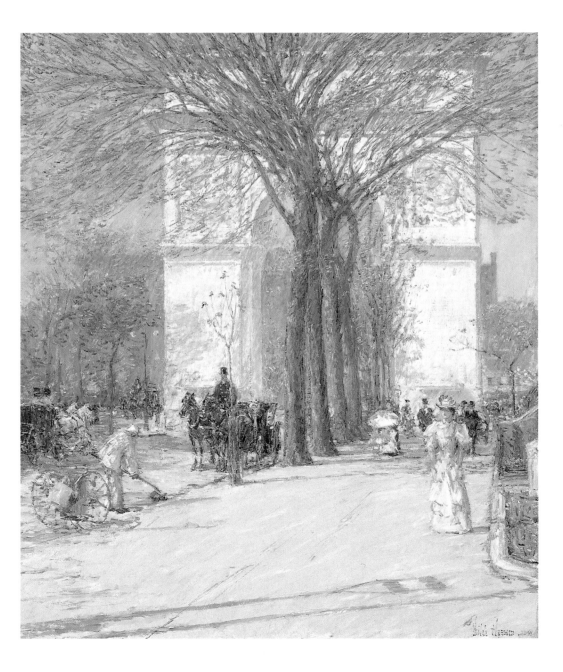

Fig. 63 *Washington Arch in Spring*, 1890.
26 x 21½ in. (66 x 54.6 cm).
The Phillips Collection, Washington, D.C.

When spring arrived and brought better opportunity for working outdoors, Hassam began to explore his new environment and, in a short time, produced several of his best known New York scenes (see figs. 63, 65). The section of New York traversed by Hassam in these early years was all within a short distance of his home, on a route extending roughly from Washington Square along Fifth Avenue to Twenty-sixth Street, and from Fourteenth Street along Broadway, encompassing Union Square and Madison Square. Though small, the area was then a major focal point of city life.

Traveling from his apartment a few blocks south on Fifth Avenue, Hassam chose the elegant Washington Memorial Arch, recently erected to designs by architect Stanford White, as the backdrop for *Washington Arch in Spring* (fig. 63), a scene of leisured, affluent life in one of New York's oldest neighborhoods. Another painting (fig. 74) featured a further famous landmark, the Civil War mansion of the late merchant prince Alexander Turney Stewart at the busy intersection of Thirty-fourth Street and Fifth Avenue, which had recently become the home of the Manhattan Club. Fond of using such architectural accents, the artist made the gilded tower of O'Neill's department store the center of *A Spring Morning* (fig. 73), although the true subject of this and other like pictures is the social spectacle Hassam observes, contrasting wealth and fashion, fine ladies and gentlemen, with cabbies, cops, and newsboys.

His scenes of Fifth Avenue evoke the era when promenading along that thoroughfare was the height of fashionable custom. Mariana Van Rensselaer, a member of one of New York's oldest families and Hassam's friend, said of the Avenue: "The pride the city then felt in this street was something quite provincial and superb. I was often told in my small years that it was the finest street in the world."[10] Hassam was obviously aware of lower Fifth Avenue's fabled past, yet must have known

that the social center of the city was then moving northward. He himself lived in what had been the center of the Avenue's principal "promenade," an area since abandoned by the truly wealthy for homes in the quieter stretches of Fifth Avenue near Central Park, from about Fiftieth to Eightieth streets. In Hassam's neighborhood, Fourteenth and Twenty-third Streets had become thriving commercial centers, their growth spurred by the elevated railroads, which brought crowds of shoppers from the suburbs. By contrast, Mrs. Van Rensselaer could remember herds of cattle being driven through the streets and the outcry that was raised when the first store opened on Fifth Avenue — coincidentally, at the intersection of Seventeenth Street, where Hassam now lived. The artist stayed at his Fifth Avenue address only two years. A photograph taken of the intersection around that time (fig. 61) bears witness to the rapid changes then taking place throughout the city; Hassam's work thus records a transitory moment in both neighborhood and way of life.

Another painting of 1890, *Spring Morning in the Heart of the City* (fig. 65), also treats one of New York's busiest intersections, where Broadway cuts across Fifth Avenue at Madison Square and Twenty-third Street. The venerable Fifth Avenue Hotel — in Hassam's picture only discretely suggested by its columned porch — was the fulcrum of all activity at this intersection: the most famous of the area's many hotels, it had long been a gathering place for the rich and famous, and the scene of special ceremonies. Delmonico's restaurant lay a few blocks north, while eastward the tower of the newly built Madison Square Garden (which Hassam omitted from his painting) rose above a glittering, block-long complex of theaters, concert halls, arenas, restaurants, and cafés. Mrs. Van Rensselaer said of Madison Square that it was "socially the most interesting spot on the avenue . . . the true center of idle New York, as Wall Street is the center of busy New York."[11]

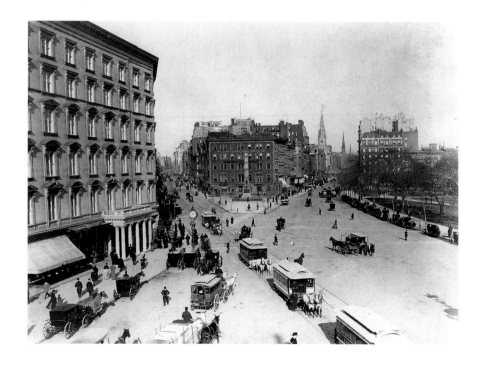

Fig. 64 Madison Square, New York, c. 1889

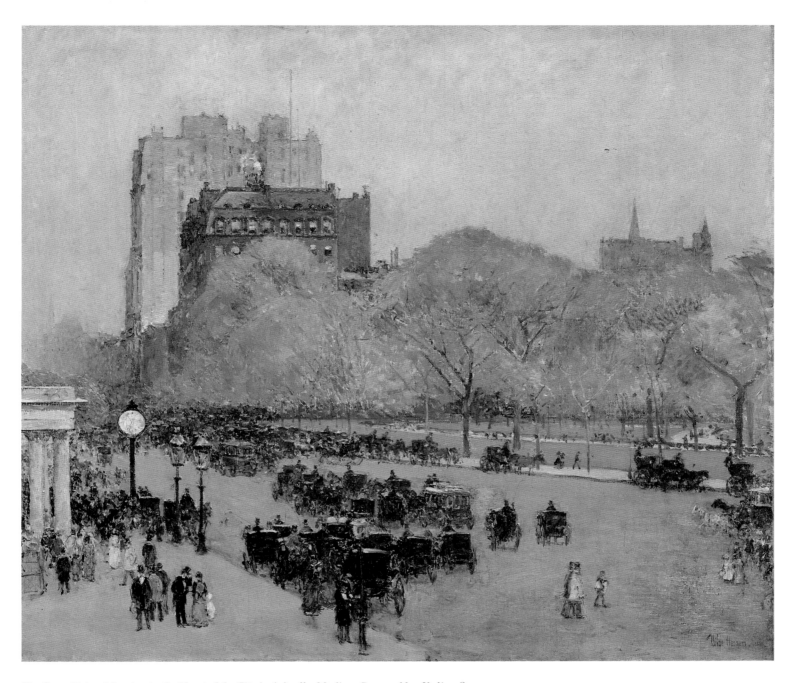

Fig. 65 *Spring Morning in the Heart of the City* (originally *Madison Square, New York*), 1890.
18⅛ x 20¾ in. (46 x 52.7 cm). The Metropolitan Museum of Art, New York;
Gift of Miss Ethelyn McKinney, in memory of her brother, Glenn Ford McKinney, 1943 (43.116.1)

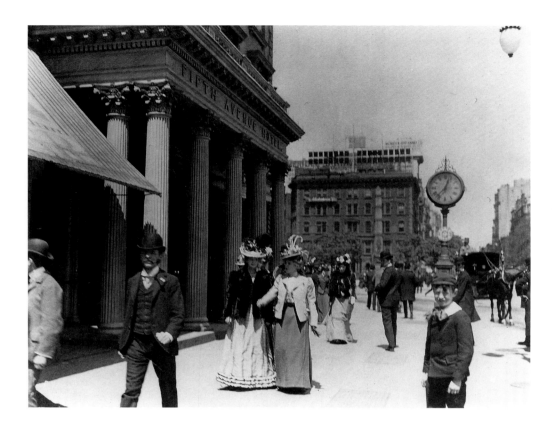

Hassam said he painted the canvas from a second-story window in "Dunlaps,"[12] which was undoubtedly the hat store R. Dunlap & Co at 178 Fifth Avenue, near the south corner of Twenty-third Street. The diagonal setback of the Fifth Avenue Hotel gave Hassam a wide field of vision, and his move above street level offered him a high vantage point with an unobstructed view. None of Hassam's previous work compares with the sense of breadth and openness that he instilled in this composition, with its open sky and tall buildings rising above the treetops in the park. Again, contemporary photographs of the square (see fig. 64) confirm the sense of its animation and bustle conveyed by the painting, as well as many details—the lines of cabs on the park side and waiting at the hotel entrance, the large circular clock, the twin gas lamps, and the tall buildings north of the square, the Hotel Brunswick and the Knickerbocker apartment building beyond.

Hassam chose to simplify his view, concentrating on the activity immediately in front of the hotel, while ignoring the tangled intersection where Broadway cuts across Fifth Avenue. His contemporary Theodore Robinson, on commission from *Scribner's Magazine*, painted the same view from the other side of the street, within a hundred feet or so of where Hassam had worked (fig. 67), yet Robinson was so discouraged by the results that he vowed to give up such paid assignments.[13]

Hassam was inspired not only by his new surroundings, but also by his friendship with Twachtman and Weir, who were also painting in New York at the time and whom Hassam frequently visited in their Connecticut homes. One critic remarked that Twachtman's home in Greenwich "seems to be a regular ren-

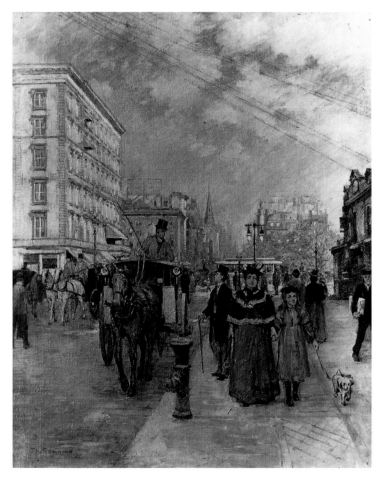

Fig. 67 Theodore Robinson, *Fifth Avenue at Madison Square*, 1894/95. 24⅛ x 19¼ in. (61.3 x 48.9 cm). Columbus Museum of Art, Ohio; Gift of Ferdinand Howald, 31.260

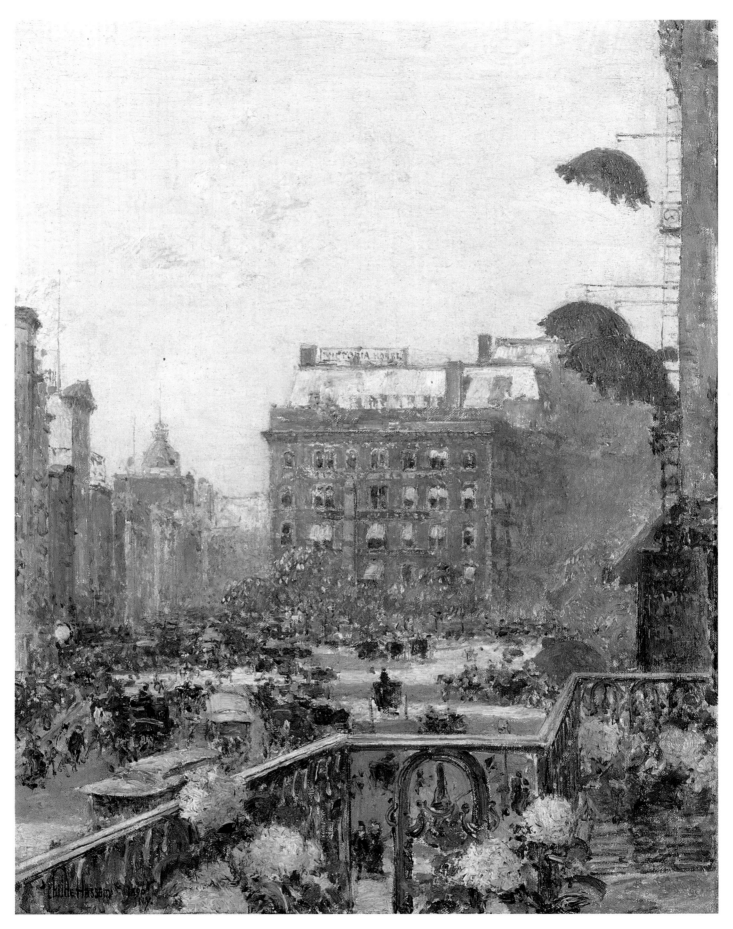

Fig. 68 *View of Broadway and Fifth Avenue,* 1890.
14 x 10¾ in. (35.6 x 27.3 cm). Private collection. Photo courtesy Sotheby's, Inc.

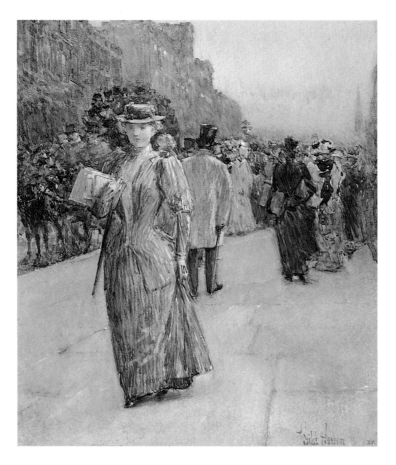

Fig. 69 *New York Street Scene*, c. 1890. Watercolor on paper, 15 x 11 in. (38.1 x 27.9 cm). Norfolk Southern Corporation

dezvous for Impressionists."[14] The square canvas used by Hassam for *Spring Morning in the Heart of the City* and for many subsequent paintings was also adopted at about this time by Twachtman, although it is uncertain which of the artists had the idea first. Hassam's increased sense of space is probably owed to Twachtman's influence, and is especially evident in *Winter in Union Square* (fig. 75) which, with its high aerial perspective, sketchy rendering, and surface texture unifying atmosphere and objects, represents an advance on anything Hassam had produced before.

From about the time they met Hassam, Twachtman and Weir became deeply interested in the cause of Impressionism, and in the work of Claude Monet in particular. This was due in part to their friendship with Theodore Robinson who, between 1888 and 1892 (when he returned home for good), was working alternately in New York and at Giverny in close touch with Monet. These were crucial years for the American Impressionist movement and Hassam, along with Robinson, Twachtman, and Weir, was among its principal activists. Only a few tantalizing hints of their activities are recorded, mostly by Robinson. These included visits to private collectors and galleries to investigate works by Monet, Edgar Degas, and Auguste Renoir, studying "*japonaiseries*" at Weir's,[15] and singular events, such as Weir's reading to his class at the Art Students League a letter by Robinson on Monet's cathedral paintings.[16]

In an interview dating from this period Hassam defined his artistic values in a way that reads as a kind of Impressionist credo:

I believe the man who will go down to posterity is the man who paints his own time and the scenes of every-day life around him. Hitherto historical painting has been considered the highest branch of the art; but, after all, see what a misnomer it was. The painter was always depicting the manners, customs, dress and life of an epoch of which he knew nothing. A true historical painter, it seems to me, is one who paints the life he sees about him, and so makes a record of his own epoch. But that is not why I paint these scenes of the street. I sketch these things because I believe them to be aesthetic and fitting subjects for pictures. There is nothing so interesting to me as people. I am never tired of observing them in every-day life, as they hurry through the streets on business or saunter down the promenade on pleasure. Humanity in motion is a continual study to me.[17]

Hassam's identification of art with modern, urbanized society and real experience, and his focus on dynamism and change, were shared by Impressionist painters in France and America.

His seeking out of subjects in the streets of New York probably differed little from his practice in Paris. At times, he hired a horsedrawn cab as a makeshift studio, using the small seat in front of him as an easel; at others, he moved about on foot making sketches. None of Hassam's early sketchbooks has survived, but, judging from his descriptions, he considered every detail,

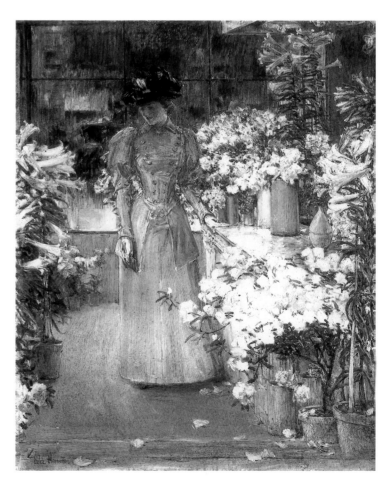

Fig. 70 *The Little Flower Shop*, c. 1892. Whereabouts unknown

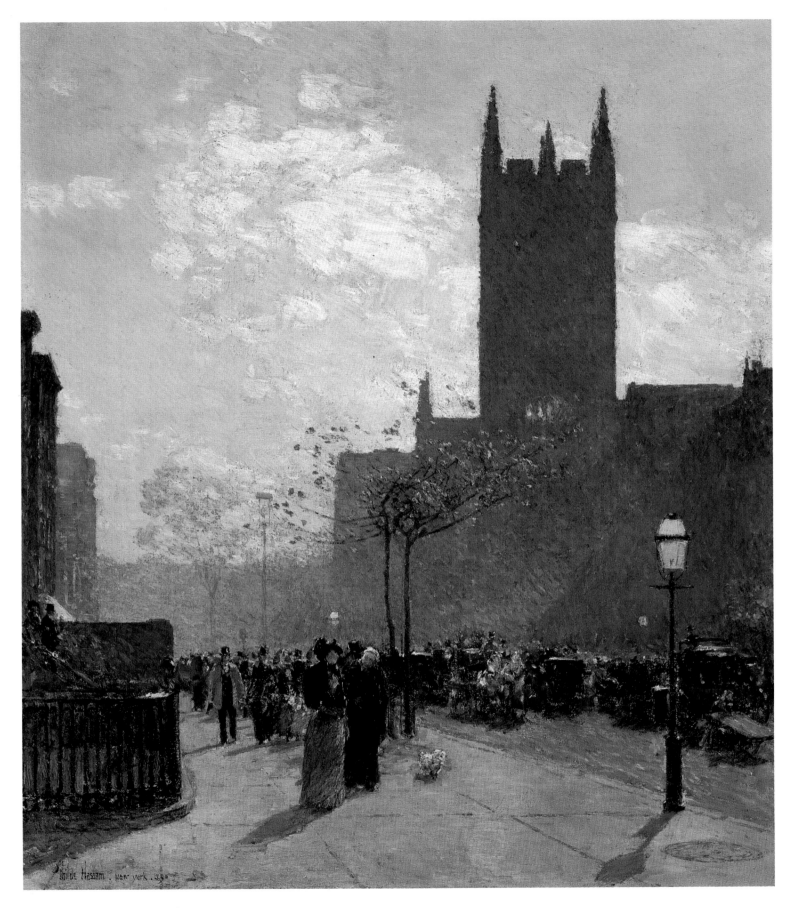

Fig. 71 *Lower Fifth Avenue*, 1890.
27 x 21½ in. (68.6 x 54.6 cm). Private collection

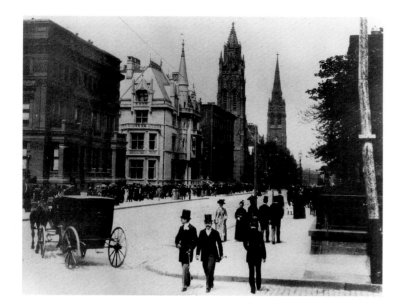

Fig. 72 Fifth Avenue, New York,
looking north from Fifty-first Street.
Photograph by Adolph Wittemann, 1890s

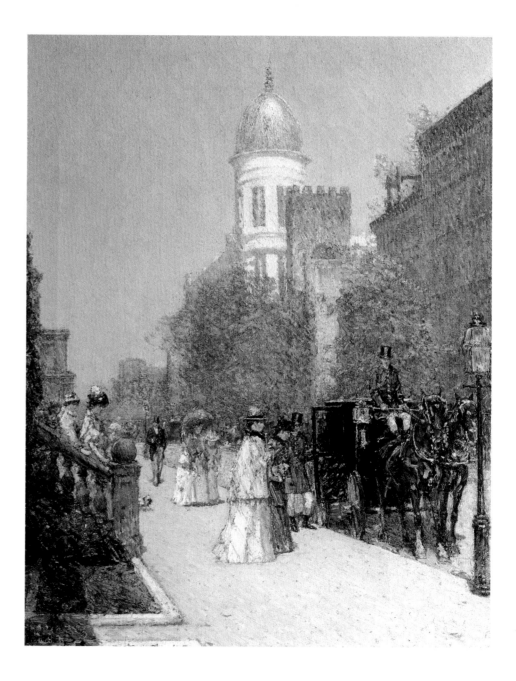

Fig. 73 *A Spring Morning*, c. 1890/91.
27½ x 20 in. (70 x 50.8 cm).
Berry-Hill Galleries, New York

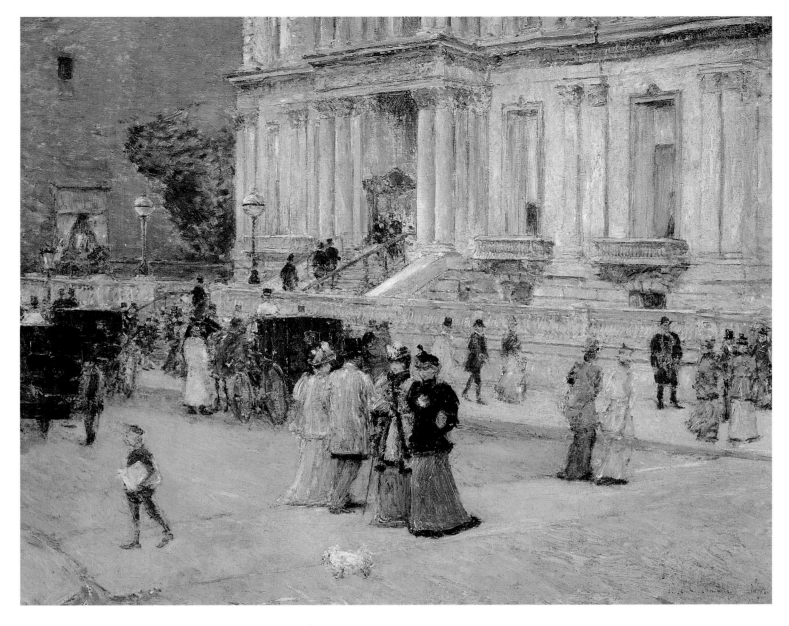

Fig. 74 *The Manhattan Club* (*The Stewart Mansion*), c. 1891.
18¼ x 22⅛ in. (46.4 x 56.2 cm).
Santa Barbara Museum of Art; Gift of Mrs. Sterling Morton for the Preston Morton Collection

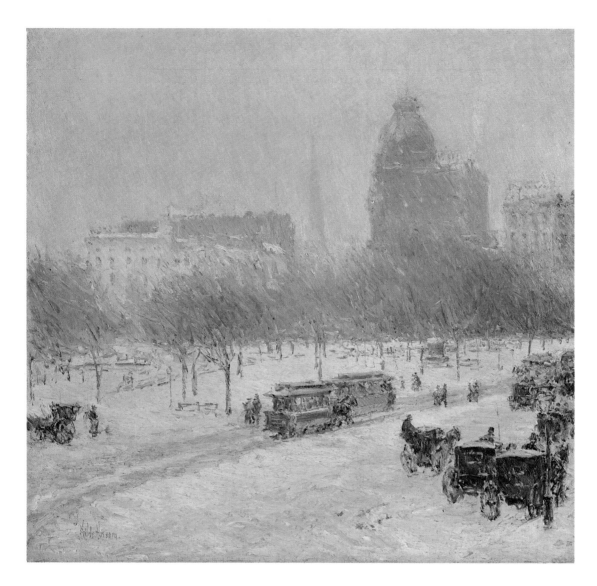

Fig. 75 *Winter in Union Square*, c. 1892. 18¼ x 18 in. (46.4 x 45.7 cm). The Metropolitan Museum of Art, New York; Gift of Miss Ethelyn McKinney, in memory of her brother, Glenn Ford McKinney, 1943 (43.116.2)

from characteristic figure types to the different effects of color and light in all weather conditions. In describing the genesis of one painting, most probably *Cab Stand at Night, Madison Square, New York* (fig. 76), Hassam said: "I use an ordinary sketch book and pencil a great deal for making notes of characteristic attitudes and movements seen in the streets. If I want to observe night effects carefully, I stand out in the street...draw figures and shadows, and note down in colored crayons the tones seen in the sky, in the snow, in the reflections or in a gas lamp shining through the haze. I worked in that way for this bit of a street scene in winter under electric light."

Such direct observation suggests a commitment to nature in his work. Yet fidelity to detail was far from being Hassam's principal concern. More important to him in these years was the ability to recreate the way people actually looked at and experienced the visual world. "I cannot imagine," he said, "how a man who sees fifty feet into a picture can paint the eyes and noses of figures at that distance. I should call such a painting a good piece of work — yes, good scientific work; but I should not call it good art. Good art is, first of all, true. If you looked down

a street and saw at one glance a moving throng of people, say fifty or one hundred feet away, it would not be true that you would see the details of their features or dress. Any one who paints a scene of that sort, and gives you such details, is not painting from the impression he gets on the spot, but from preconceived ideas he has formed from sketching studio models and figures near at hand. Such a man is an analyst, not an artist."

Hassam's understanding of "impressionism" thus opposed the traditions of academic convention to the ideal of the artist's spontaneous and original response to nature based on observation and instinct. "The true artist," he continued, "should see things frankly, and suffer no trickery or artifice to anywhere distort his vision." Such distortion was nowhere more apparent to Hassam than in the conventional treatment of atmosphere, in which the uniformly golden tones inherited from the Old Masters were perpetuated in defiance of vibrant combinations of natural color and light. To eyes trained on these rich, dark, deep tones, the work of Impressionist painters seemed unnaturally bright and blue. To this the artist responded:

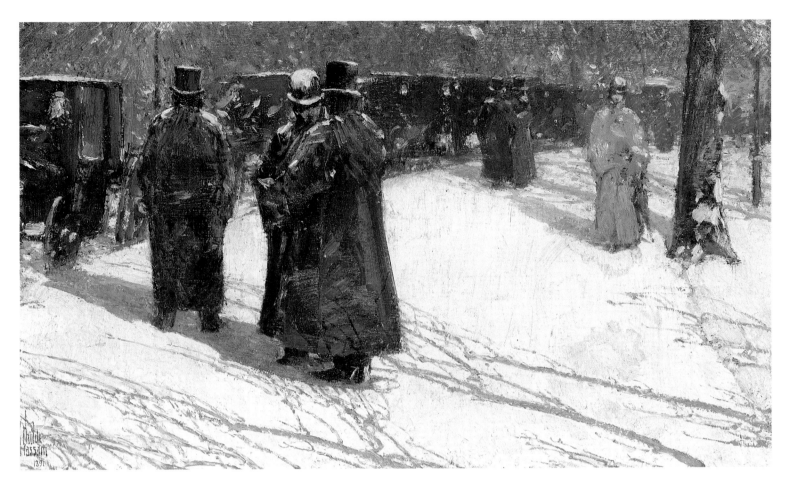

Fig. 76 *Cab Stand at Night, Madison Square, New York*, 1891.
Oil on paper, 8¼ x 13¾ in. (21 x 34.9 cm).
Smith College Museum of Art, Northampton, Massachusetts;
Bequest of Annie Swan Coburn (Mrs. Lewis Larned Coburn), 1934

They have become so used to the molasses and bitumen school, that they think anything else is wrong. The fact is, the sort of atmosphere they like to see in a picture they couldn't breathe for two minutes. I like air that is breathable. They are fond of that rich brown tone in a painting. Well, I am not, because it is not true. To me, there is nothing so beautiful as truth. This blue that I see in the atmosphere is beautiful, because it is one of the conditions of this wonderful nature all about us. If you are looking toward any distant object, there will be between you and that object air, and the deeper or denser the volume of air, the bluer it will be. People would see and know this if the quality of observation was not dead in them. This is not confined to those outside of art; there are a good many painters afflicted with the same malady.

The criticism most commonly directed at American Impressionism—one no doubt spurred by reports of pointillist methods—was, beyond its perceived slapdash quality, that it represented a sort of bizarre scientific formula, a precise set of rigorously applied rules for using color. Yet what is striking about Hassam's form of Impressionism is its commitment to the authenticity of the artist's individual, instantaneous response:

Art, to me, is the interpretation of the impression which nature makes upon the eye and brain. The word "impression" as applied to art has been abused, and in the general acceptance of the term has become perverted. It really means the only truth because it means going straight to nature for inspiration, and not allowing tradition to dictate to your brush, or to put brown, green or some other colored spectacles between you and nature as it really exists. The true impressionism is realism. So many people do not observe. They take the ready-made axioms laid down by others, and walk blindly in a rut without trying to see for themselves.

Hassam's commitment to nature and real experience required some compromise in the context of urban subjects. For the Impressionist landscapist trying to reproduce some transient effect of nature, there was always the opportunity to work repeatedly on the same canvas over short periods, since the same conditions of light and atmosphere might recur each day. For the urban painter this was, of course, impossible, for dynamic activity occurred too rapidly to be fixed on canvas immediately and was certain never to reappear in exactly the same form. Of necessity, therefore, Hassam's work as an urban painter always involved a process of creative reconstruction.

Such a complex composition as *Spring Morning in the Heart of the City* thus entailed a continuous and partly unpredictable process of collecting and adjusting its various elements. The

Fig. 77 The artist in his studio, c. 1896.
Photograph by Edwin S. Bennett

painting was also reworked by the artist sometime between 1895 and 1899, when he removed a group of pedestrians from the lower right corner. Hassam described how the flow of activity he observed both influenced and was altered to suit his purposes, and how he sometimes began a canvas without having finalized its composition:

I do not mean to convey the idea that you may at any minute find a subject ready at hand to paint. The artist must know how to compose a picture, and how to use the power of selection. I do not always find the streets interesting, so I wait until I see picturesque groups, and those that compose well in relation to the whole. I always see my picture as a whole. No matter how attractive a group might be, if it was going to drag my composition out of balance, either in line or color, I should resist the temptation of sketching it. I should wait, if it were a street scene, till the vehicles or people disposed themselves in a manner more conducive to a good effect for the whole.... Of course all those people and horses and vehicles didn't arrange themselves and stand still in those groupings for my especial benefit. I had to catch them, bit by bit, as they flitted past.

Where the architecture provided a permanent element, Hassam might work on the background and then seize the opportunity to paint moving figures as they appeared:

Sometimes I stop painting a tree or building to sketch a figure or group that interests me, and which must be caught on the instant or it is gone. Suppose that I am painting the top of the bank building here, and a vehicle drives down to the left-hand corner, just where it seems to me a good place to have something of this sort; perhaps the driver gets down and throws himself into some characteristic attitude; I immediately leave the roof of the building, and catch that group or single object as quickly as I can. You see, in pictures of this sort, where you are painting life in motion, you cannot lay down any rule as to where to begin or where to end.

Hassam, moreover, adapted the forms, colors, lights and darks of his compositions to the expressive character he wished to achieve. His view of New York in the 1890s was largely and selectively positive. He expressed guarded fascination for modern technology, the railroad and electric light, and even for the new skyscrapers of New York, which, if transformed by mist, fog, or light, could be "thrillingly beautiful." Some of the titles Hassam gave his city pictures— *A City Fairyland, The Mysterious City, Rain, Mist, and Electric Light*— indicate his tndency to romanticize the urban experience. He disregarded the disorder, violence, and poverty regularly reported in the newspapers of the day and, while the patrician ambience he painted in Washington Square was as much a reality as the east side tenement district, his treatment of it hardly constituted the "urban pastoral" as which some have described it.[18] Alongside polite society, Hassam occasionally painted the city's growing working-class population, but filtered out whatever he considered vulgar or cruel.

Hassam also found urban subjects outside New York. He continued to maintain strong ties to Boston, exhibiting there on a regular basis and painting in the city and outlying towns. One of the first images of Boston he completed after returning from France was a dynamically charged view of Columbus Avenue, *Clearing Sunset (Corner of Berkeley Street and Columbus Avenue)* (fig. 78), which, though dated 1890, was based upon a composition developed before he had left for Paris (see fig. 11). Such creative reworking of his own previous designs can be observed in other cases, too.

Contemporaries remarked on Hassam's uncanny sensitivity to the nuances of place, which allowed him to capture the distinct flavor of any locale, whether in a small town or some obscure city neighborhood. "He is as susceptible to his surroundings as a chameleon," declared one critic, noting the differences between his views of New York, Paris, and Boston, while another, in referring to the exactness of Hassam's characterizations, said of *Country Fair, New England* (fig. 83): "It is New England to the core, and the pale yet keen light is that of the season and the latitude."[19] Generally speaking, his views of Boston replace the sense of energy emanating from many of his New York scenes with a feeling of engaging tranquillity (see

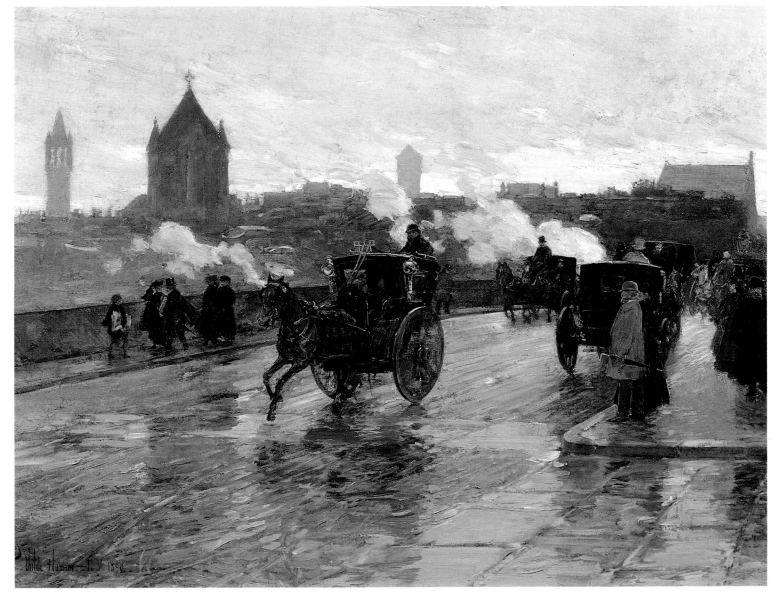

Fig. 78 *Clearing Sunset (Corner of Berkeley Street and Columbus Avenue)*, 1890. 25 x 30½ in. (63.5 x 77.5 cm). Mr. and Mrs. Hugh Halff, Jr.

figs. 80-82). *Charles River and Beacon Hill* shows a waterfront street along the Charles River in Boston's Back Bay area—a site Hassam must have enjoyed for the mild irony of its village-like ambience existing only a few minutes walk from the Back Bay thoroughfares—with the center of the city marked in the distance by the gilded dome of the Massachusetts Statehouse. Henry James regarded this area as perfectly "Venetian" in character, while for Hassam it may have recalled Montmartre.[20]

Rather than with the quiet mood of this Boston neighborhood, Hassam seemed to identify most strongly with the dynamism, speed, and simultaneity of modern city life, particularly as found in New York:

The very thing that makes New York irregular and topsy turvy makes it capable of the most astounding effects. From the tops of the enormous buildings one can get magnificent sweeps along the rivers and over the tops of the buildings. . . . Even the elevated railroad is at some times of day, in some lights, extremely effective. To see the thing shoot by, send off great spiral masses of smoke against the sky is inspiring in the extreme. Light! Atmosphere! . . . Many of our squares here are distinguished and fine—Madison and Union Squares, for instance . . . to me, the old part, the Bowery, etc., is not so interesting as the new. The old part is picturesque, but it is not picturesque in an original way. The new part is unlike any other place. It is distinguished, vital and picturesque in its own way. It has character and force, and that is why I like it.

This perception was shared by many who viewed his paintings, including the critic who described *Spring Morning in the Heart of the City* thus: "The wide streets and sidewalks are fairly swarming with cabs, omnibuses, drags, cars and foot passengers, like the great human hive that New York is, and there arises from this vivid instantaneous glimpse of seething streets, to the ear of fancy, that muffled roar of traffic which is the incessant voice of

Fig. 79 Along the Charles River, Beacon Street, Boston.
Photograph by James A. Wells, 1880s

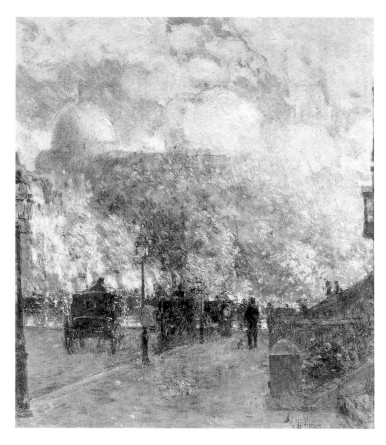

Fig. 80 *Beacon Street, Boston — October Morning,* c. 1895.
12 x 10 in. (30.5 x 25.4 cm). Private collection

the metropolis. Nothing could be gayer or more characteristic of that part of the city which visitors are likely to know, and nothing could be more appropriate to the theme, than Mr. Hassam's sprightly and sparkling style." Believing that Hassam had even equaled Edouard Manet in his suggestion of the moving crowd, the same critic added that it "is not only his best urban picture, but it is probably the best delineation of a subject of the sort that anybody has made."[21]

That which sets Hassam's involvement with the city into clearest relief is the opposite world he discovered in summers on the New England shore. His favorite summer retreat was Appledore Island, with which he had become acquainted in his youth and to which he returned faithfully each summer for several decades, beginning the first year after his return from Paris. Appledore is at the center of a group of tiny, rocky islands known as the Isles of Shoals, which lie in the Atlantic about ten miles outside the harbor of Portsmouth, New Hampshire. In Hassam's day it was a thriving summer resort capable of accommodating some five hundred guests. Despite its proximity to the mainland, the surrounding ocean and a view toward thousands of miles of open sea gave Appledore the illusion of complete isolation.

While visitors enjoyed sailing, tennis, and other public recreations, Hassam's activities were centered around those of

a group of writers, musicians, and artists that gathered daily at the summer home of poetess Celia Thaxter. "I spent some of my pleasantest summers at the Isles of Shoals," reminisced Hassam, "and in [Thaxter's] salon there where I met the best people in the country...there was from New York Henry M. Alden, then editor of *Harper's,* Richard Watson Gilder, editor of *The Century,* then in its prime, William Mason the musician — and many others."[22] Other frequent guests in Hassam's day were the writer William Dean Howells, the pianist William K. Paine, and fellow artists Ross Turner and J. Appleton Brown, to name only some of the most prominent. A holiday mood seems always to have pervaded this private company. One female guest, who spent part of the summer of 1893 with Hassam, characterized the group as a "jolly, refined, interesting and artistic set of people...like one large family."[23]

The company gathered in the main parlor, or salon, of the Thaxter cottage, a large, light, airy room facing the garden (fig. 95). Near the center of the room stood a piano, surrounded by a clutter of rugs, screens, chairs, and tables. Low, draped cabinets lined the walls, with framed pictures crowded above to the ceiling — a familiar Victorian miscellany of family photographs, engravings of famous modern and Old Master paintings, and numerous nature studies and landscapes painted by Thaxter's artist friends, Hassam among them. The

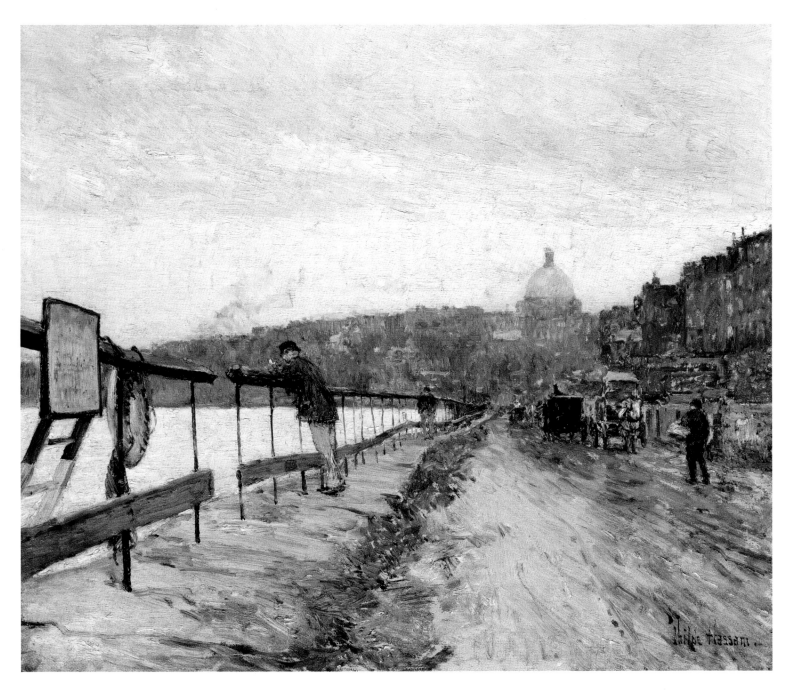

Fig. 81 *Charles River and Beacon Hill*, c. 1890/92.
18⅞ x 20⅞ in. (48 x 53 cm). Museum of Fine Arts, Boston; Tompkins Collection

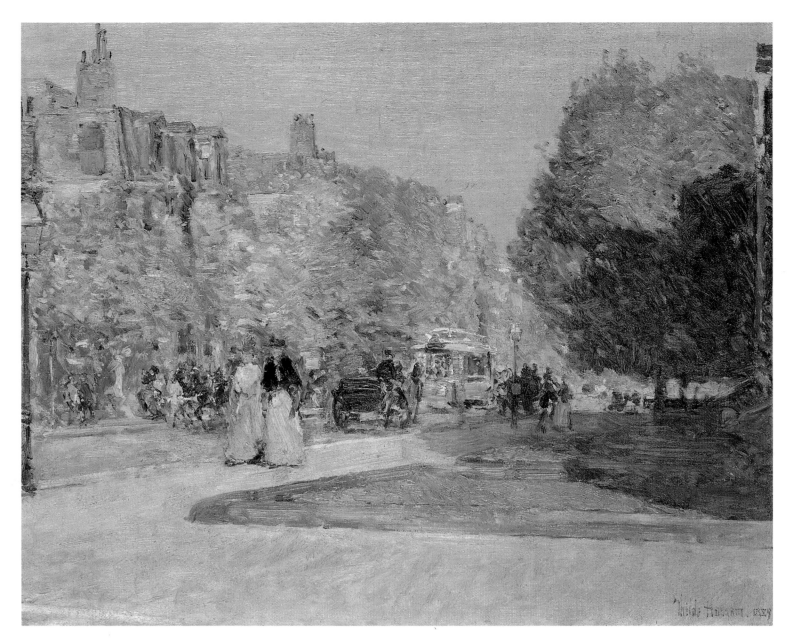

Fig. 82 *Marlborough Street, Boston,* 1889.
15 1/16 x 18 in. (38.1 x 45.8 cm).
The Nelson-Atkins Museum of Art, Kansas City, Missouri;
Bequest of Mr. and Mrs. William James Brace, 75-29

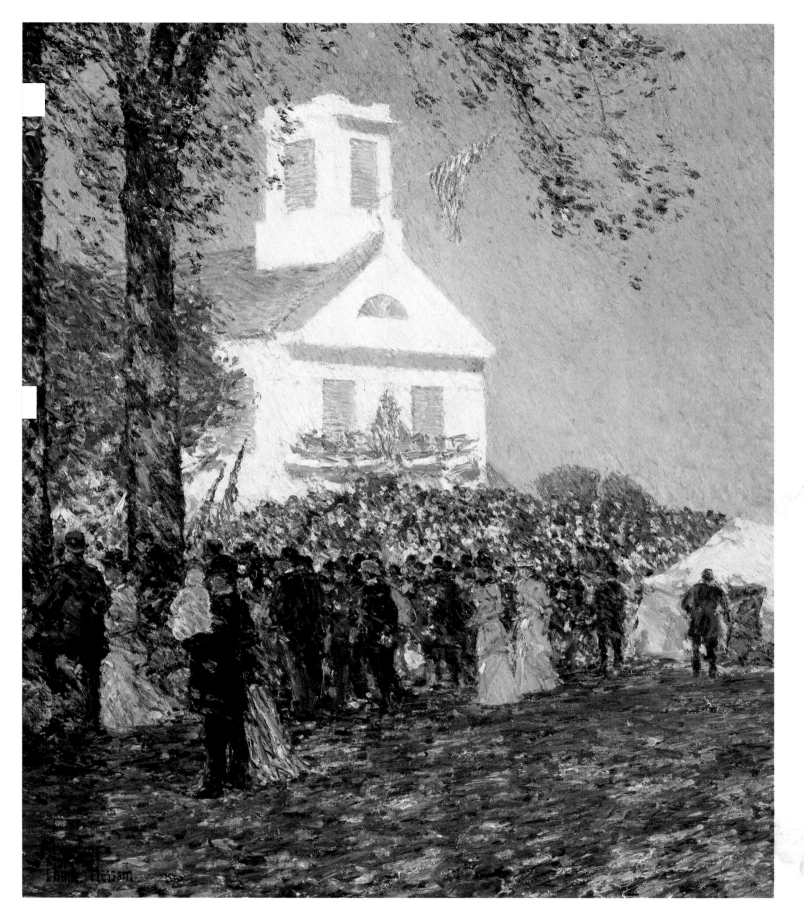

Fig. 83 *Country Fair, New England* (*Harvest Celebration in a New England Village*), 1890.
24¼ x 20⅛ in. (61.6 x 51.1 cm). Manoogian Collection

works were left not only as appreciative gifts, but were also part of an informal exhibition: Thaxter encouraged the artists to display their works in the hope of finding buyers among the curious hotel guests who were permitted to circulate through the house. One photograph of the parlor from around 1890 shows at least three, and possibly more, works by Hassam on display.[24]

Visitors to Thaxter's salon might find her and some artist friends painting with watercolors or decorating a piece of china. They would be invited to sit, browse, converse, or read a book, and perhaps consider the purchase of a watercolor, a decorated bowl, or even a corsage from the garden arranged by their host. Music would invariably be heard throughout the day, either improvised by one of the talented guests or, better yet, in the form of a recital by William Mason or John K. Paine, the two renowned musicians who played the Beethoven Sonatas and Schumann compositions that Thaxter adored. In the evenings Thaxter might read her poems by candlelight to the assembled company.

Hassam had corresponded with Thaxter throughout his stay in Paris, and their reunion during his first visit to Appledore, in the summer following his return, was particularly warm. On July 25, 1890, Thaxter composed a sonnet in Hassam's honor, rhapsodizing on his impending fame, which she likened to the rising sun. Presents were exchanged: Hassam received a signed book of Thaxter's poetry and, in turn, dedicated to her a small floral still life that later was given a place of honor on a parlor table called the "Shrine."[25]

Thaxter seems to have touched Hassam with the inspiring idealism of her personality and with her prodigious love of flowers. Behind her cottage, facing the sea, she had created a small, informal cutting garden, planted with climbing vines and many varieties of summer flowers, which blossomed in a lush, unruly fashion. A mesmerizing flourish of dazzling colors, the little garden stood out against the rocky island's sparse vegetation. During the five remaining summers of Thaxter's life, this garden became the leitmotiv of one of Hassam's most important series of outdoor paintings.

While Hassam had dealt extensively with floral subjects in Paris and at Villiers-le-Bel, the concentrated manner in which he developed this theme at Appledore from his very first summer there was wholly unexpected. With a few exceptions, including his gift to Thaxter and another present, *Roses in a Vase* (Baltimore Museum of Art), given that year to his wife, Maude, Hassam had been generally uninterested in the genre of floral still life in its own right. In Paris he had preferred to integrate floral motifs into the larger contexts of street or garden scenes. His response changed in the different surroundings of Appledore, and the outcome was an original composite of landscape and floral still life (see figs. 87-89). Hassam's favorite flowers were the red and white poppies that seemed to grow haphazardly, and his favorite view of them was taken from Thaxter's fenced garden looking northeast toward Babb's Cove, with the rounded prominence of Babb's Rock in the center. Having established this landscape/still life theme early, Hassam pro-

Fig. 84 Appledore House (right) and Cottages, Isles of Shoals, 1890s. Celia Thaxter's cottage is the second building from the left.

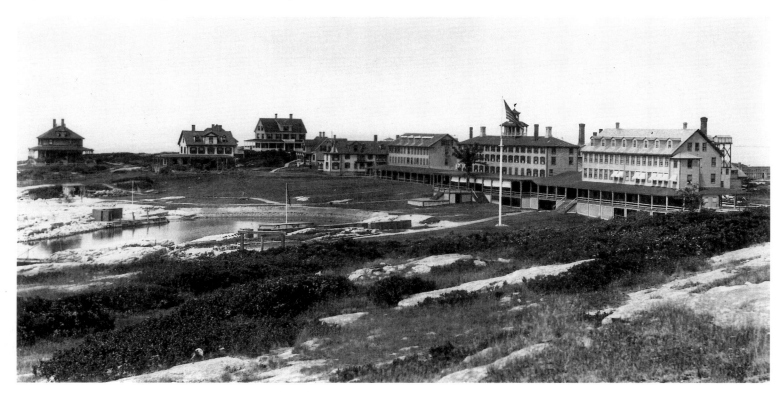

Fig. 85 The artist and friends on the porch of Celia
Thaxter's cottage, Appledore, Isles of Shoals, c. 1892.
Hassam is seated front right. In the middle row, right,
is Maude Hassam, and opposite her, with hand on chin,
J. Appleton Brown. Thaxter is standing at the rear,
alongside William Mason.

Fig. 86 Bathing pool,
Appledore Island, Isles of Shoals, 1890s

Fig. 87 *Poppies, Isles of Shoals*, c. 1890. Pastel on paper, 9¾ x 12¼ in. (24.8 x 31.1 cm). Private collection

Fig. 88 *Poppies on the Isles of Shoals*, 1890. 18⅛ x 22⅛ in. (46 x 56.2 cm). The Brooklyn Museum; Gift of Mary Pratt Barringer and Richardson Pratt, Jr., in memory of Richardson and Laura Pratt

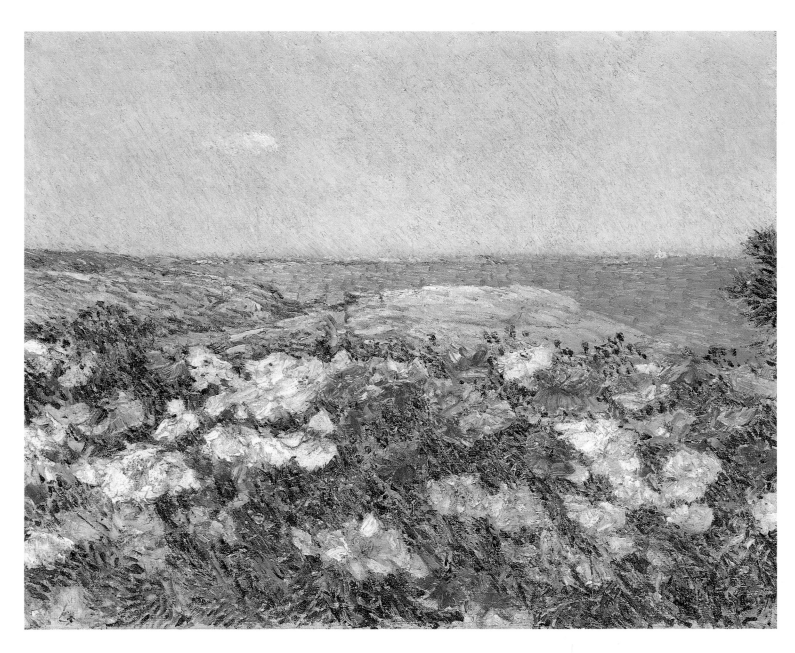

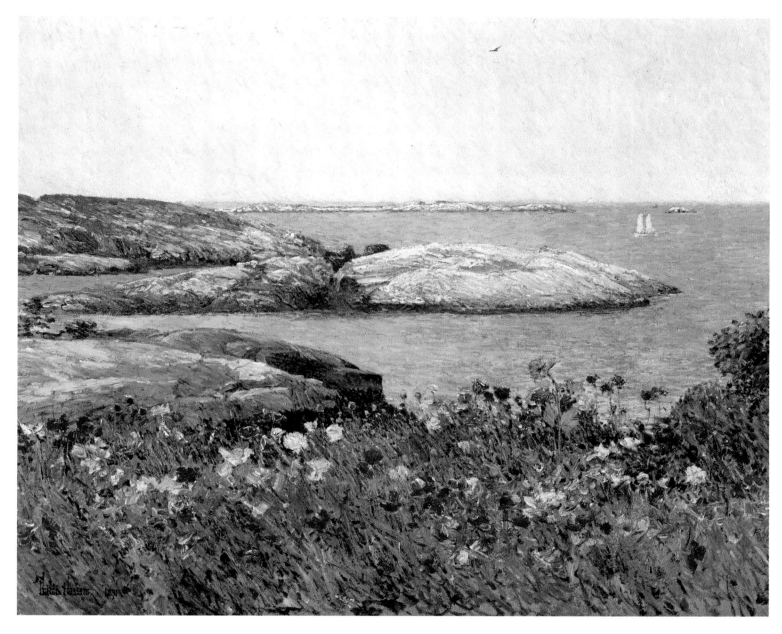

Fig. 89 *Poppies, Isles of Shoals*, 1891.
19¾ x 24 in. (50.2 x 61 cm). Private collection, courtesy Keny Galleries, Columbus, Ohio

ceeded in following years to develop it in numerous variations in oil, watercolor, and pastel. Only by comparing his views to contemporary photographs, can we appreciate how selective he was in filtering out the buildings, docks, and other signs of tourist life on the tiny island (which Thaxter herself once likened to a little city), in order to distill a pure sensation of nature. Elemental shapes of rock and sea are set in poignant contrast to a profusion of living forms. A strong compositional order throughout the series imposes the discrete simplicity, even spareness, of its discipline on the exuberant, naturalistically observed flowers. These flowering Appledore landscapes are among Hassam's finest Impressionist performances in pure color and form, every flickering brushstroke registering the effects of light on each blossom, the myriad shapes of the leaves and petals, and even the movement of the wind.

The brilliant color of these landscapes led one reviewer to declare that, for anyone used to the conservative school, an encounter with Hassam "is like taking off a pair of black spectacles that one has been compelled to wear out of doors, and letting the full glory of nature's sunlight color pour in upon the retina."[26] In fact, not only the quality of his color schemes, but also their lasting freshness was a question of deep concern to Hassam, who was always meticulous in matters of technique. The bright palette used by the Impressionists had caused the permanence of colors to become a widely discussed issue in America and France. It was debated, for instance, whether Monet's colors would not naturally mellow and soften over time. Hassam said he preferred to paint on clean, unprimed canvas and to use colors "perfectly clear out of the tube"[27] in order to preserve their purity and to insure that his paintings would not darken. His concern was related by the critic Elizabeth Luther Cary, who in 1935 described a conversation she had had with Hassam many years before in which, among other things, he argued against the use of pure white on the grounds that it not only darkened prematurely, but that it also failed to give the impression of light in the first place. Hassam boasted that a canvas then on his own easel "will not change in twenty years." According to Cary, who saw the painting again more than twenty years later, the prediction came true.[28]

Less well known than the Appledore landscapes is the equally significant series of figure paintings in which Hassam portrayed the ambience and some of the residents of the island. In these, eschewing specific narrative content, the artist offers isolated, mood-filled moments: Thaxter leading her grandson by the hand on the vine-covered porch that fronted her garden (fig. 91); a figure caught in mute reverie in a sunlit field (fig. 94); another quietly absorbed in reading by the shore (fig. 92). In some, such as *Summer Sunlight*, in which Maude probably served as her husband's model, one senses Hassam's urge to meet an especially challenging technical problem — here, the permutations of brilliant sunlight playing upon the bright, pale tones of dress, rocks, sand, and sky. In others, like the heartfelt *The Sonata* (fig. 93), there is a special note of

Fig. 90 The artist painting on the porch of Celia Thaxter's cottage, Appledore, Isles of Shoals, c. 1890

remembrance in his portrayal of one of the many musical performances in Thaxter's salon. Here, Hassam evokes the moment indirectly by representing the beautiful pianist in the brief, contemplative aftermath of her concert.

Hassam's ultimate tribute to his early years on Appledore and to the woman who had been his friend and spiritual mentor was *The Room of Flowers* (fig. 96), a view of Thaxter's salon with a female figure, painted just before her death on August 26, 1894. Hassam had come to the island as usual that year and was present when she died. Together with J. Appleton Brown, he helped prepare the funeral bier of sweet bay leaves on which Thaxter's body was displayed in the flower-filled drawing room prior to interment on the island.

Hassam must have begun the painting with some premonition of Thaxter's passing, for, although he had produced numerous watercolors of isolated parts of the salon, he had never attempted anything on the scale or complexity of this richly detailed canvas. Thaxter's house has long since been destroyed, but photographs of the parlor taken before she died (see fig. 95) prove that Hassam painted a faithful portrait of the room, reproducing not only its general ambience, but many of its furnishings as well. The view is toward the south wall, where three large windows overlooked the porch and the garden

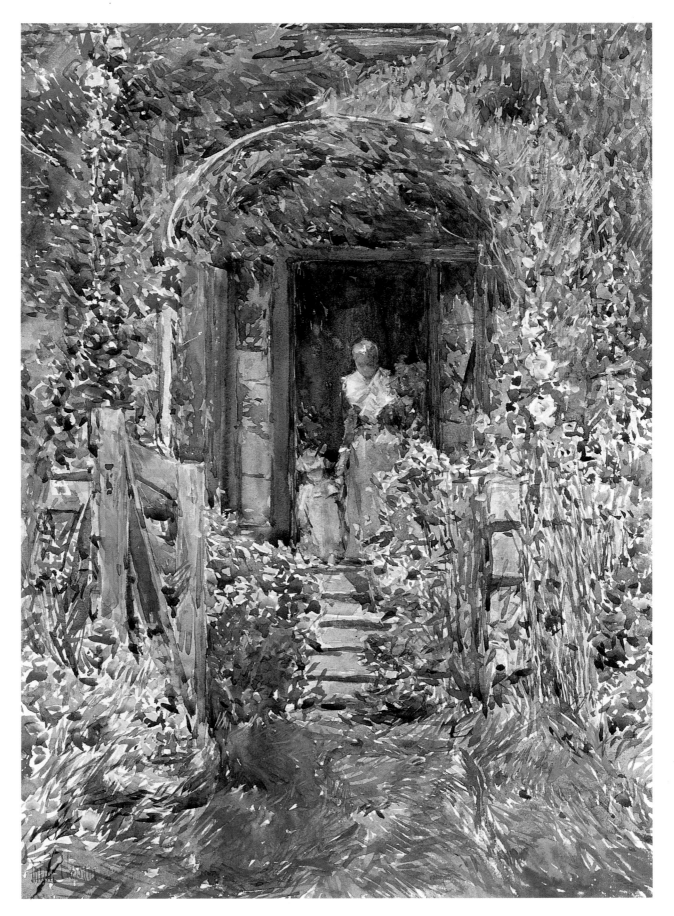

Fig. 91 *Isles of Shoals Garden*, 1892. Watercolor on paper,
19¹⁵⁄₁₆ x 13⅞ in. (50.8 x 35.2 cm).
National Museum of American Art, Smithsonian Institution, Washington, D.C.; Gift of John Gellatly

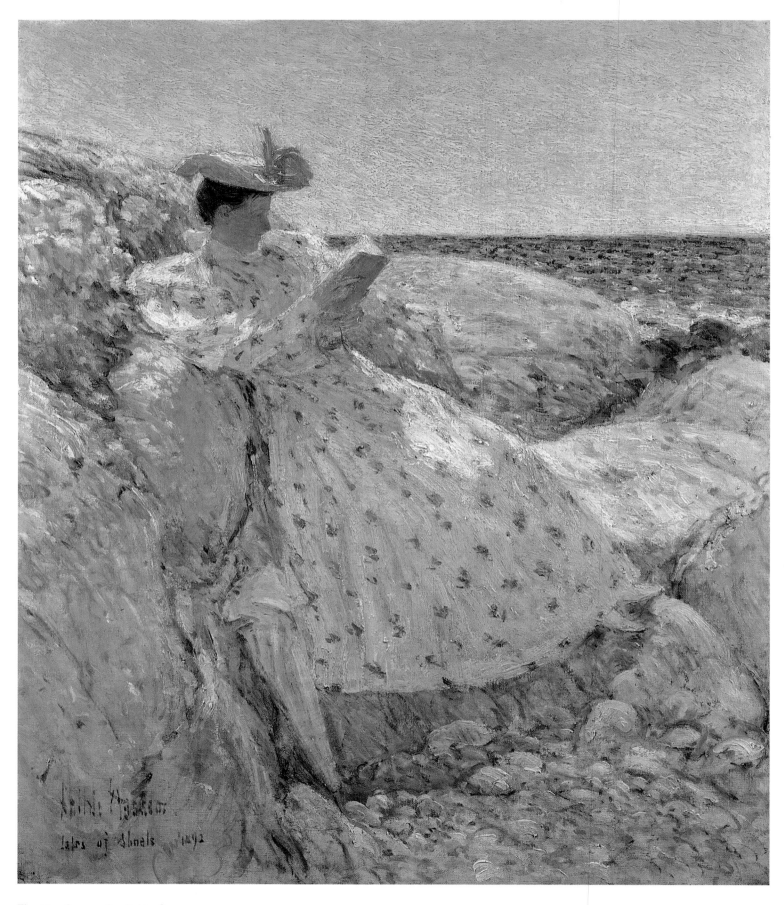

Fig. 92 *Summer Sunlight*, 1892.
22¾ x 18⅞ in. (58 x 48 cm). Israel Museum, Jerusalem

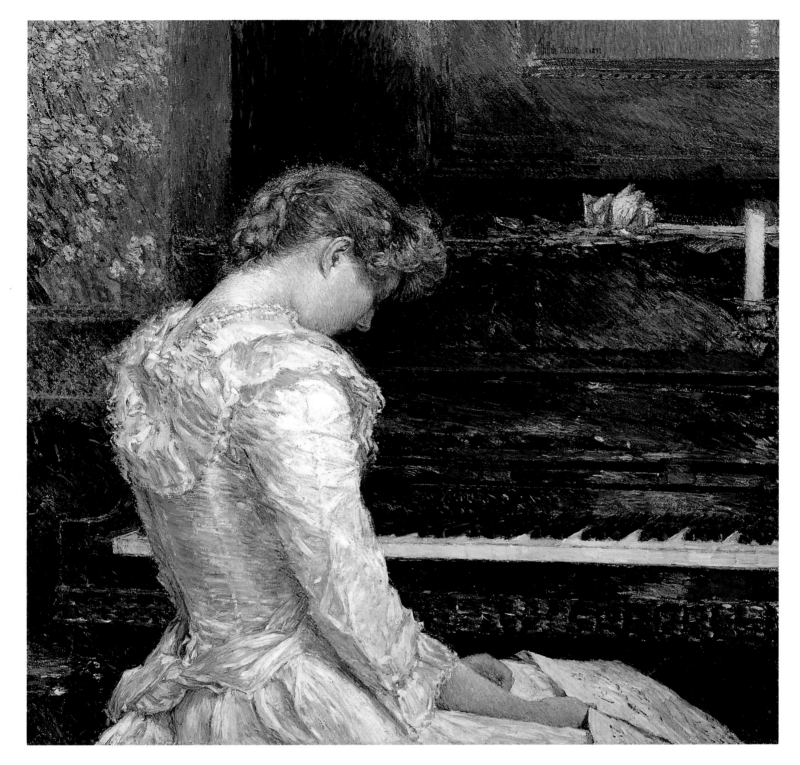

Fig. 93 *The Sonata*, 1893. 32 x 32 in. (81.3 x 81.3 cm).
The Nelson-Atkins Museum of Art, Kansas City, Missouri;
Bequest of Mr. and Mrs. Joseph S. Atha, 52-5

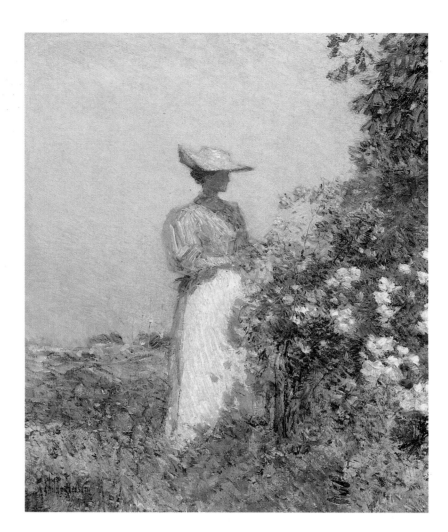

Fig. 95 The parlor of Celia
Thaxter's cottage, Appledore,
Isles of Shoals, c. 1890

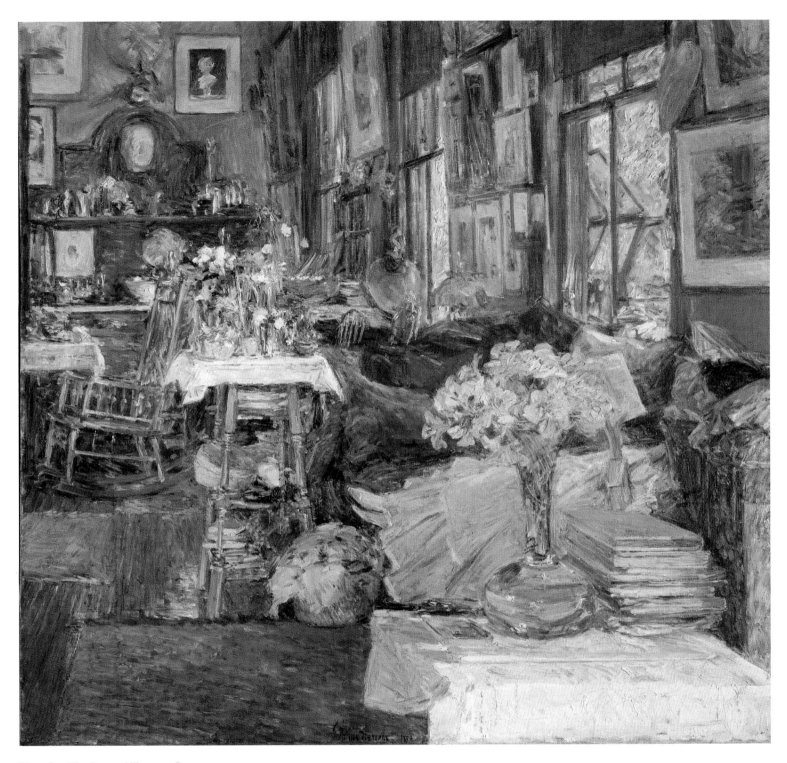

Fig. 96 *The Room of Flowers*, 1894.
34 x 34 in. (86.4 x 86.4 cm). Private collection

beyond, its vine-covered trellises suggested by the glow of pale green and yellow foliage. Among the recognizable furniture is a sideboard at the back (decorated with a death mask of Beethoven), a rocking chair, a slender table with turned legs, and Thaxter's own favorite retreat, the sofa at right on which a young lady reclines.

In a letter written from the Isles of Shoals, Hassam described *The Room of Flowers* as "a picture of Mrs. Thaxter's house here which was the most unique setting and wholly character-istic of her remarkable love for flowers. It was painted just be-fore her death and I think it [is] one of my best things."[29] The flowers Hassam referred to were the gorgeous floral arrange-ments that Thaxter lovingly prepared each day for the salon and which, for most visitors, remained the most memorable aspect of her island home. In typical vein, Thaxter herself pro-vided a rather ecstatic description of their effect:

flowers are everywhere. The shelves of the tall mantel are splendid with massed nasturtiums like a blazing torch, beginning with palest yellow, almost white, and piled through every deepening shade of gold, orange, scarlet, crimson to the blackest red; all along the tops of the low book-cases burn the fires of marigolds, coreopsis, large flowers of the velvet single dahlias in yellow flame and scarlet of many shades, masses of pure gold, summer chrysanthemums and many more—all here and there interspersed with blossoming grasses for a touch of ethereal green. On one low bookcase are Shirley poppies in a roseate cloud. All summer long within this pleasant room the flowers hold high carnival in every possible combination of beauty. All summer long it is kept fresh and radiant with their loveliness—a wonder of bloom, color and fragrance. Year after year a long procession of charming people come and go within its doors, and the flowers that glow for their delight seem to listen with them to the music that stirs each blossom on its stem.[30]

It was not in Hassam's nature to depict the company that often filled the salon. Instead, *The Room of Flowers* records a moment on a bright and solitary afternoon when the parlor, nearly empty, has regained its private aspect. For Hassam, the picture was a "Room of Memories," evoking the presence of Thaxter in a way that no actual portrait could have done.

Although Hassam continued to visit the Isles of Shoals with-out interruption after Thaxter's death, for a while he directed his artistic attention away from them toward Gloucester, which

Fig. 97 *At Gloucester*, 1890. Watercolor on board, 14⅛ x 20 in. (35.9 x 50.8 cm). Bequest of Marion Koogler McNay, McNay Art Museum, San Antonio, Texas

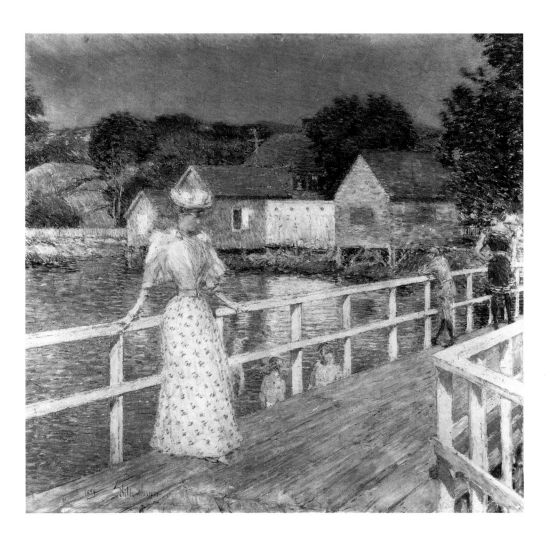

he had visited intermittently since his early student days. Unlike the Isles of Shoals, which was a seasonal resort, Gloucester was a large commercial port, whose year-round fishing trade brought fleets from around the world to its harbor, giving it the flavor, as Baedecker said, of a "quaint and foreign-looking city." Like other visiting artists, Hassam usually stayed at East Gloucester, a populous commercial and residential district a few miles away from the town center and connected by electric tram to the main railway. It was from this vantage point that his most characteristic panoramas of the harbor and town were to be painted. In the early and mid-1890s, however, Hassam was less interested in landscape at Gloucester than in figure pictures that recorded scenes of townsfolk and summer residents (see figs. 97-100, 102).

Hassam arrived at Gloucester in early July 1894, when we learn that he held a private exhibition at his hotel cottage after arranging with the Macbeth Gallery to have some of his watercolors sent up from New York.[31] Among the works produced during that stay were *The Summer Girl* (fig. 98), a portrait of a young woman posing in her summer finery on a swimming dock, and *The White Dory, Gloucester* (fig. 99), for which Maude Hassam probably served as model. Hassam often sketched out the structure of his paintings on the canvas, and then returned

to the studio to finish them. Sometimes the date on a picture reflects this remove in time. This is the case with *The White Dory* and *A Fisherman's Cottage, Gloucester* (fig. 100): dated and exhibited in the spring of 1895 — that is, before Hassam went to Gloucester for that year's season — they must have been substantially painted the summer before.

Although the greater part of Hassam's output in the early and mid-1890s was derived from independent work in New York and Boston, on the Isles of Shoals and in Gloucester, the artist also took on a number of paid commissions. Hassam described how he was called to Chicago in 1892 in the midst of preparations for the World's Columbian Exposition to prepare views of the Exposition buildings for publication as lithographs. His task was to enliven a series of existing architectural drawings by painting in the skies and groups of figures. He regarded these pastiches with contempt, but said he was very well paid for them. While engaged in this, he was hired separately by Frank Millet, artist in charge of the Exposition's decorations, to record the Exposition buildings in a series of original drawings.[32] In addition to this commissioned work, Hassam painted several oils and watercolors in Chicago, some of them on the Exposition grounds, others in the city and its surroundings (see figs. 101, 103, 104, 111). He left Chicago before the Ex-

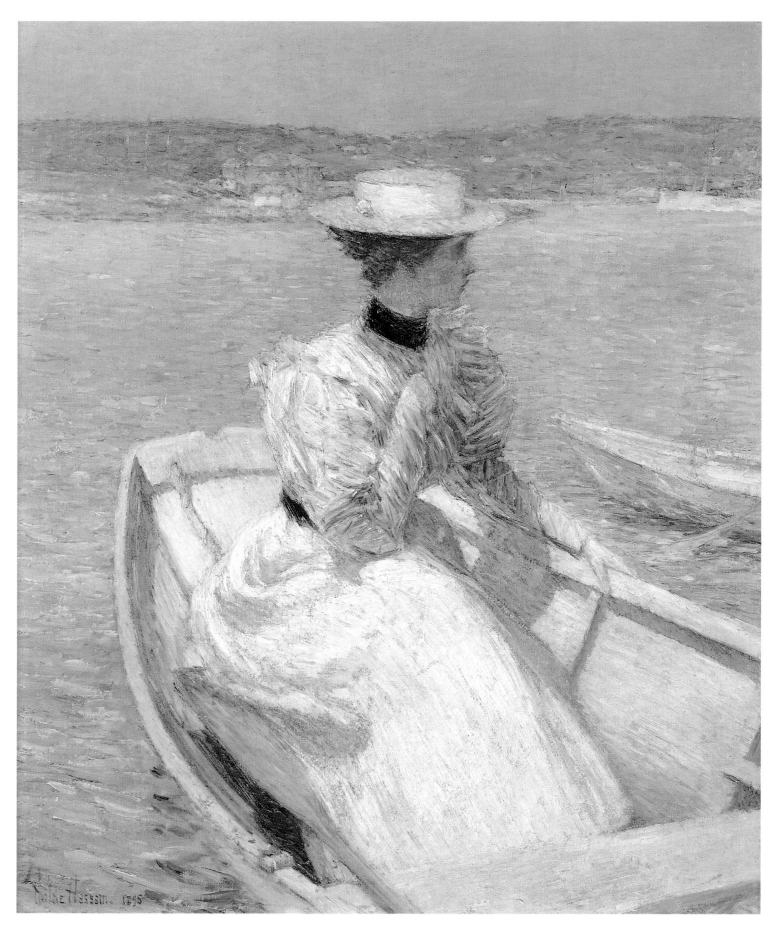

Fig. 99 *The White Dory, Gloucester,* 1895.
26 x 21 in. (66.4 x 53.7 cm). Private collection

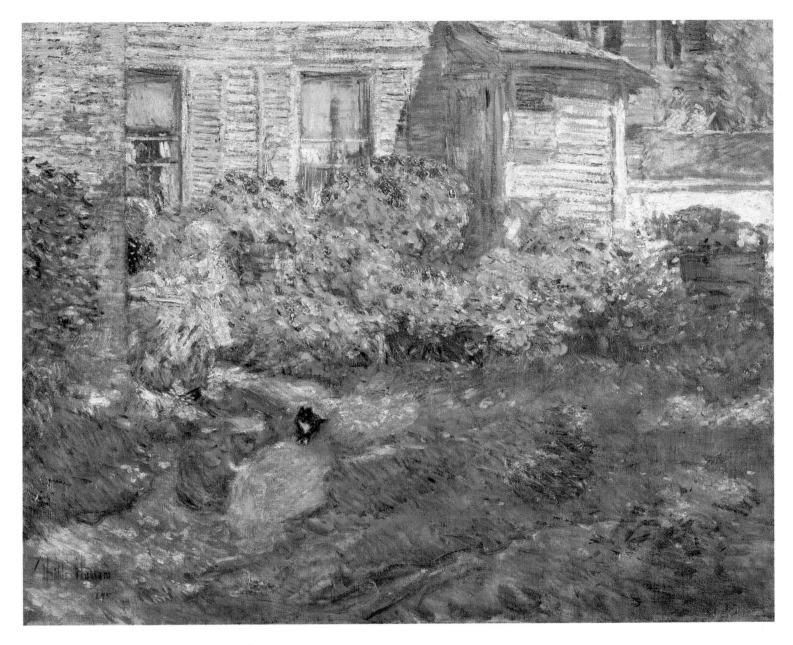

Fig. 100 *A Fisherman's Cottage, Gloucester*, 1895.
20 x 24 in. (50.8 x 61 cm). Richard Rubin Collection

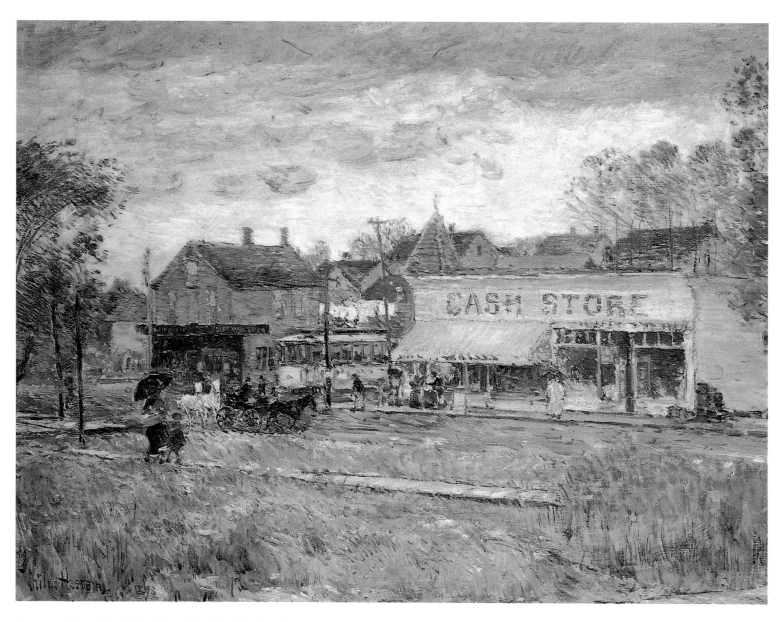

Fig. 101 *End of the Trolley Line, Oak Park, Illinois*, 1893.
17½ x 21¾ in. (44.5 x 55.3 cm). Private collection

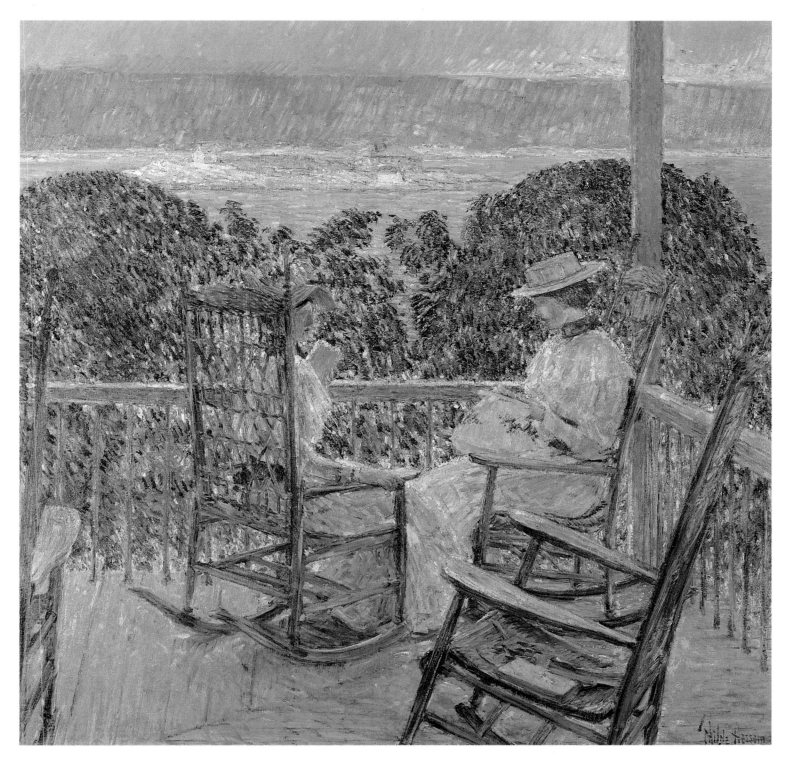

Fig. 102 *Ten Pound Island*, 1896.
32 x 32 in. (81.3 x 81.3 cm). The David Warner Foundation, Tuscaloosa, Alabama

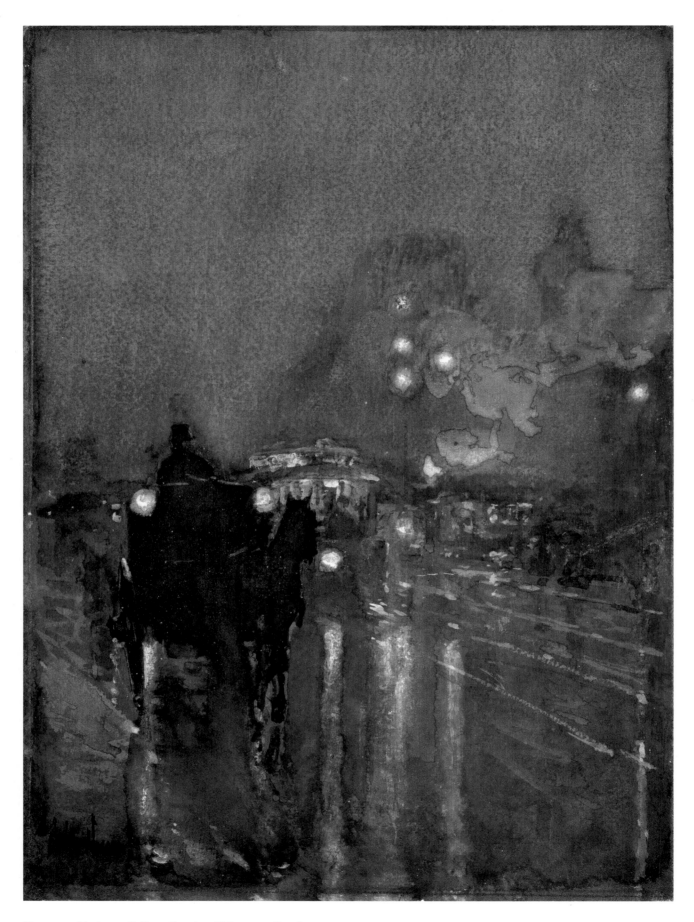

Fig. 103 *Nocturne, Railway Crossing, Chicago*, c. 1892/93.
Watercolor on paper, 15½ x 11 in. (39.4 x 27.9 cm).
Museum of Fine Arts, Boston; Charles Henry Hayden Fund

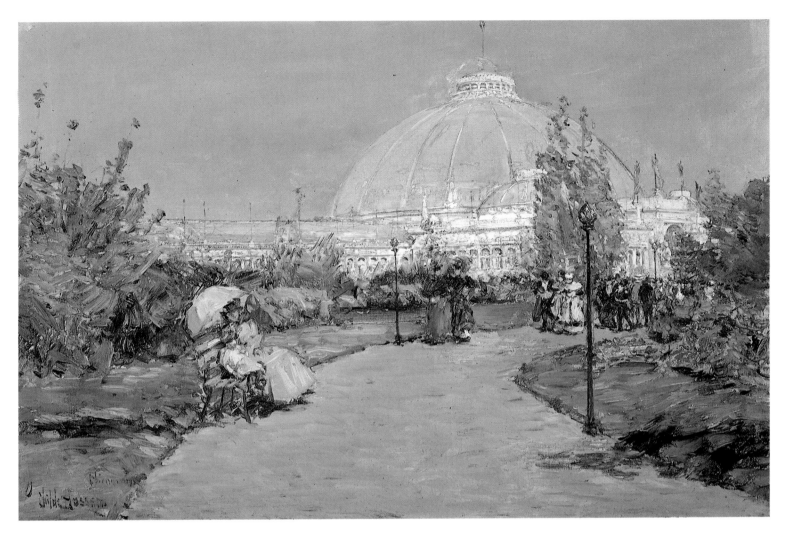

Fig. 104 *Horticultural Building, World's Columbian Exposition, Chicago*, 1893.
18½ x 26¼ in. (47 x 66.7 cm). Daniel J. Terra Collection.
Photo courtesy Terra Museum of American Art, Chicago

position opened in May 1893, but he did exhibit six major paintings and a group of watercolors there that earned him medals in each of those categories.[33]

Hassam's willingness to take on purely commercial assignments at this time was undoubtedly a sign that his income from the sale of pictures needed to be augmented. There were other paid commissions. In April and May of 1893 he prepared drawings for an article on Fifth Avenue that appeared in the November issue of *Century Magazine*,[34] and he had earlier contributed watercolor illustrations to an edition of William Dean Howells's *Venetian Life*.[35] For these two projects he used both existing works (see fig. 5) and specially created ones (see fig. 105). Another commission he received was for illustrations to *An Island Garden*, a small autobiographical volume by Celia Thaxter describing her life on Appledore Island.[36]

Hassam remained in his first studio on lower Fifth Avenue until 1892, when he moved to an apartment in the Chelsea Hotel, staying there for about a year.[37] The Chelsea's location, on West Twenty-third Street, kept Hassam in his familiar orbit around Madison and Union squares. In 1893, however, he

moved considerably further uptown, to the Rembrandt Studio Building at 152 West Fifty-seventh Street. Hassam said that he had actually considered this address on first coming to New York, but had thought it to be "away out in the country."[38] Subjects drawn from his new neighborhood began to appear immediately in his work. Several such paintings, including the 1893 *Posters* (unlocated), which showed a desolate stretch of Broadway looking south from Fifty-seventh Street, were reproduced in *Three Cities*, a book of his city views published several years later.[39] Another uptown view made that year is the watercolor *Rainy Day on Fifth Avenue* (fig. 106), whose original title, *Fifth Avenue at Central Park*, reflected the beginning of Hassam's interest in this park, which was now in his neighborhood. Over the next five or six years, he completed a number of canvases of mothers and nurses with children strolling or playing in Central Park (see figs. 107, 122, 123).

In January 1895 Hassam traveled to Havana, Cuba, as a guest on the yacht of Frank Robinson, a businessman friend. Hassam spent more than a month there, living in a hotel on the main square, where he produced several major canvases of

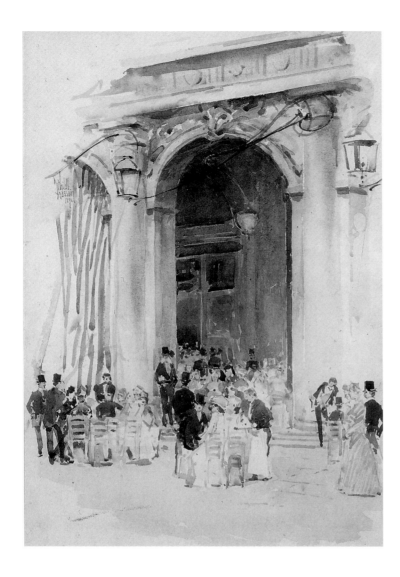

Fig. 105 *Florian's Cafe*, 1890. Watercolor on paper,
15 x 10 in. (38.1 x 25.4 cm).
Anotonette and Isaac Arnold.
Photo courtesy Meredith Long & Co., Houston

Fig. 106 *Rainy Day on Fifth Avenue*
(originally *Fifth Avenue at Central Park*), 1893.
Watercolor on paper, 14⅛ x 20¼ in. (35.9 x 51.4 cm).
The John and Mable Ringling Museum of Art, Sarasota, Florida

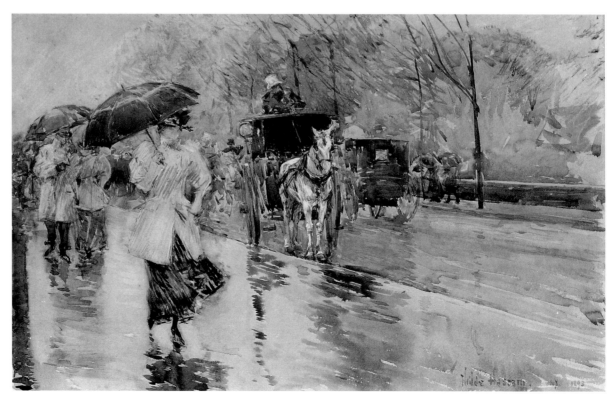

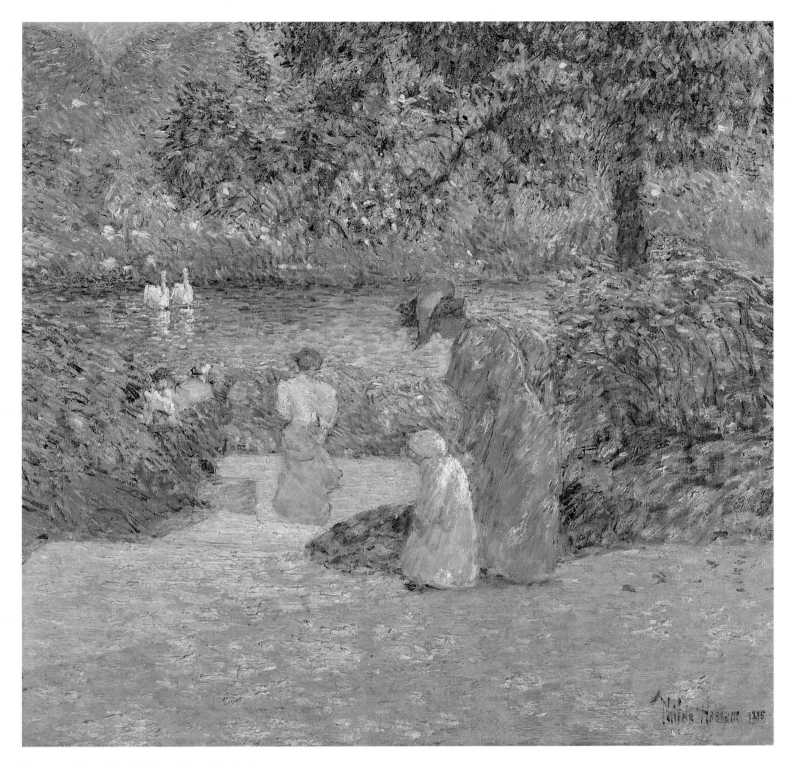

Fig. 107 *Descending the Steps, Central Park*, 1895.
22½ x 22½ in. (57.2 x 57.2 cm). Virginia Museum of Fine Arts

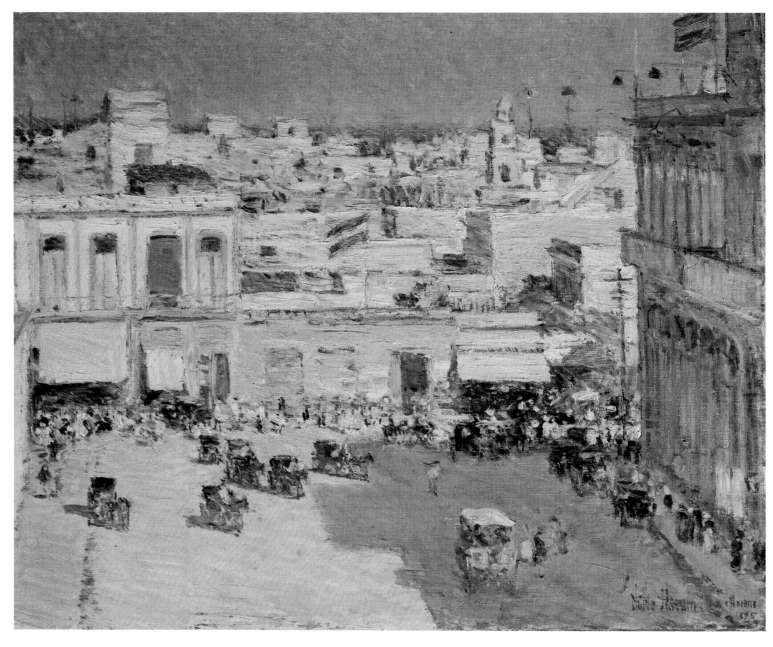

Fig. 108 *Havana*, 1895.
18¼ x 21 in. (46.4 x 53.3 cm). Jordan-Volpe Gallery, New York

this and the surrounding neighborhoods (see figs. 108, 110).[40] One of these, *Place Centrale and Fort Cabanas, Havana*, won the prestigious Webb Prize for landscape at the Society of American Artists that spring. This was a sign of the important role Hassam and the other Impressionists had assumed within the Society; indeed, the following year Hassam's friend Willard Metcalf received the same prize for *Gloucester Harbor* (Mead Art Museum, Amherst College), painted while the two artists were working together in Gloucester in the summer of 1895—for Metcalf, a recovery from a period of inactivity.[41]

Early in 1896 Hassam won another major prize, taking a second place at the annual exhibition of the Boston Art Club with *Summer Sunlight*. In fact, what was called the Impressionist

"cult" made a sweep of the Club's awards that year, with Weir winning first, and Benson third prize. As Hassam was soon to be reminded, however, success with juries consisting of his professional peers was one thing, with the buying public quite another.

Although Hassam held regular one-man exhibitions in several of Boston's private galleries throughout the 1890s, in New York he was known mainly through his steady presence at exhibitions of the many professional organizations to which he belonged. His first major one-man show in New York, held at the American Art Galleries on Madison Square in February 1896, was actually the preliminary to another clearance auction of the kind he had undertaken in Boston to finance his

Fig. 109 *The Prado, Havana, Cuba*, 1895.
Whereabouts unknown

Fig. 110 *Place Centrale and Fort Cabanas,
Havana*, 1895.
21¼ x 26¼ in. (54 x 67 cm).
© The Detroit Institute of Arts;
City of Detroit Purchase

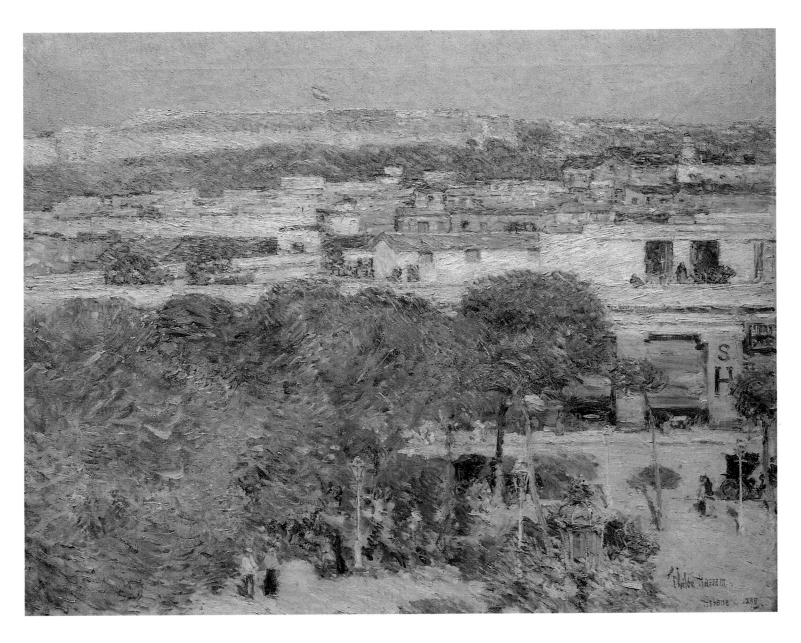

stay in Paris. This time, it was a two-night sale comprising two hundred and five pictures in oil, watercolor, and pastel from every phase of his career.[42] The exhibition contained many of Hassam's finest large canvases, among them Salon entries and even medal winners from the expositions in Paris and Chicago, including *Geraniums* (fig. 48), *Twilight* (fig. 31), *Cab Station, Rue Bonaparte* (fig. 24), *Autumn* (fig. 55), *The Rose Girl* (fig. 53), and *The Manhattan Club* (fig. 74). That Hassam had not managed to sell these pictures is itself a telling fact.

Like the first, this sale exhibition was a summarizing event for Hassam, in which the totality of his achievement was measured and judged. Critics did not hesitate to point out that he had enemies as well as friends, and expected that the sale results would constitute a vote on Hassam's style and methods, even a test of Impressionism itself. It was at least an exhibition to provoke discussion, said the *Times* critic, "for of the steadily increasing band of impressionists, Mr. Hassam is a priest high in the councils."[43]

With virtually the entire history of Hassam's development in front of them for the first time, most critics, while admiring Hassam's virtuosity, were convinced that, in his recent paintings, he had carried things to extremes. The *Sun* reviewer wrote: "Every painter will acknowledge the amazing skill and facility, the versatility and fancy, the artistic feeling and dashing manner of Mr. Hassam, but in the light of some of the earlier works here displayed it would seem that he had passed the point of his best achievement, and Icarus-like had been carried by his impetuous wings too near the sun. . . . His key of color has been rising higher and higher until it simply screeches. His impressionism has been growing more and more blear-eyed, until he has reached a point beyond which it is hardly possible he can go, and we may hope for a reaction that may restore his vision."[44] In similar vein, the critic for *Art Interchange* declared:

Mr. Hassam is essentially a painter's painter. He loves to experiment with the exceptional aspect of things, to indulge in paint for paint's sake, to show his dashing skill and reckless facility. He ignores the public that dearly loves a picture, and he fights shy of anything approaching sentiment as most people comprehend it. . . . To those who only know him by a few recent prize-winning pictures the exhibition was a revelation for its variety and billiancy. . . . There were pictures covering his career for a dozen years past, and as one compared recent with past achievements the feeling that degeneracy of vision had befallen him almost became a conviction; that he had forced his key of color beyond a rational point unto the realm of screeching unrest for most of us, and we longed for his return to less extreme methods. But however irrational and extreme Mr. Hassam in his experimental moods may be, he is always interesting, and never dull or stupid, and no one man's exhibition of the season has approached his in brilliancy or attractiveness.[45]

It is questionable whether less equivocal support from these or other journalists would have helped the sale. William Merritt Chase, after all, had been through the same experience a month before. In the end, despite considerable advance pub-

licity, the sale turned out to be a financial disaster. Bidding on the first night—on which it rained—was sluggish, with most pictures selling for what was described as "ridiculously low figures."[46] Excellent paintings could be had for $30 or $50— barely the price of the frames—while only a few fetched more than $100. *The Manhattan Club* went for $107.50, *The Rose Girl* for $110, and *Geraniums—In the Garden in June*, which purportedly helped win Hassam a medal at the Exposition Universelle in 1889, for $115. The next night's results were somewhat better, but the sale in all realized only $9,600 before commissions, an average of about $47 per picture.

In the months following the sale, Hassam showed signs of restlessness. That summer he moved about to an unusual degree, visiting in succession Gloucester, the Isles of Shoals, and Winter Harbor, Maine, where he painted views of Ironbound Island and Cadillac Mountain on Mt. Desert. In the fall he visited Twachtman at his Greenwich home for a while and went to Putnam, New York, with him. At this time Hassam also paid his first visit to Cos Cob, Connecticut, a small waterfront town that Twachtman and Weir had discovered. In October he wrote to John Beatty, director of the Carnegie Institute in Pittsburgh, that he would be sending to the First Carnegie International some paintings "of [a] different *kind*—let us say for the want of a word."[47]

In *Union Square in Spring* (fig. 113) Hassam adopted a higher vantage point than any he had previously used, reducing the vehicular and pedestrian traffic to little more than specks of color and movement. Not a single individual is recognizable; instead, there are only small blurs, blotches, and dashes of paint. Removed from the human activity of the street, Hassam concentrates on the abstract composition of the panorama and on the expression of his response to it. The picture represents a major break in Hassam's treatment of the city theme and, in dispensing with the requirements of descriptive image-making, held out for him the possibility of an abstract visual art.

With the country in the midst of an economic slump, there were indications everywhere that 1896 was proving to be an especially low point in the fortunes of American artists. A week after Hassam's sale, the painter J. Carroll Beckwith noted in his diary that the only pictures selling in New York were modern French or eighteenth-century English. Referring to the numerous auctions held that year, he said: "American fellows can positively get nothing for their work."[48] Late in the year, a writer for *Scribner's* described struggling and isolated artists in New York as a community of "discouraged limners and carvers"[49] who suffered from the lack of any real stimulation, either financial or moral. Given such poor prospects, Hassam decided to break with his present life and to see once more what Europe might offer him. Using the proceeds from his sale, together with his $1,500 Boston Art Club prize, to finance the trip, in the fall of 1896 Hassam sublet his apartment for a year and, with Maude, prepared again to head across the sea.

Fig. 111 *Figures in Sunlight*, 1893.
24¼ x 18¼ in. (61.6 x 46.4 cm).
Gift of Mr. Herbert Fitzpatrick,
Huntington Museum of Art, 52.455

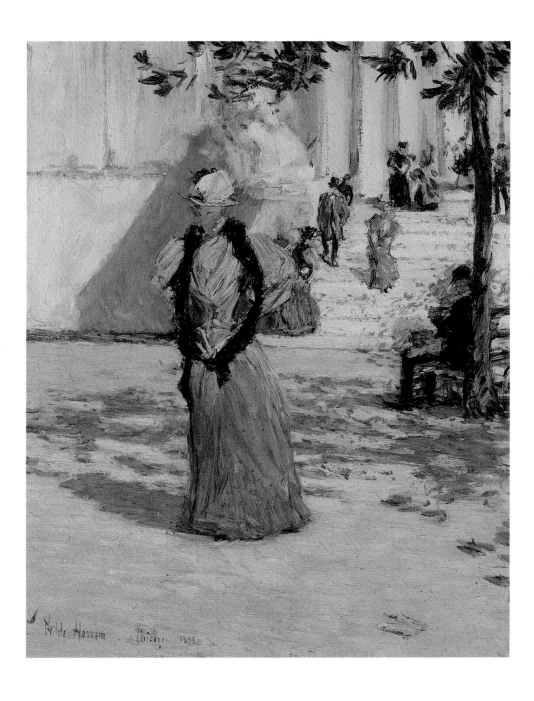

NOTES

All uncredited quotations are from documents published on pp. 177-82 of the present volume.

1 "Greta's Boston Letter," *Art Amateur* 4 (Mar. 1881), p. 71ff.

2 Quoted in Hamlin Garland, *Roadside Meetings*, New York, 1930, p. 27.

3 Lockman Interview, Feb. 3, 1927, pp. 5-6. The New York Water Color Club was incorporated on May 22, 1890 (see *New York Times*, May 23, 1890). The fact that its exhibition preceded that of the American Society of Water Color Painters displeased some of that older association's members. Within a short time, however, many of them also joined the New York Water Color Club, so that the rosters of the organizations became virtually identical. Although denied by Frank Gervasi ("A History of the American Watercolor Society, 1866-1950"; Archives of American Art, Roll N68-8), the foundation of the Club seems to have been accompanied by some dissension between the two organizations. See *Art Amateur* 22 (Mar. 1890), p. 73.

4 Lockman Interview, Jan. 31, 1927, p. 21ff. For a review of the opening night, see *New York Times*, Feb. 1, 1890, p. 5.

5 Hassam, "Reminiscences of Weir," in *Julian Alden Weir: An Appreciation of his Life and Works*, The Phillips Publications, No. 1, New York, 1922, pp. 67-68.

6 Hassam was elected to the American Watercolor Society at its annual meeting on March 19, 1890 (Minutes: Archives of American Art, Roll N68-8). He is next mentioned in the Minutes of the March 15, 1893, meeting, at which he supported Willard Metcalf's election.

7 Lockman Interview, Feb. 3, 1927, p. 6.

8 This is most likely the canvas Hassam exhibited at the Art Institute of Chicago from June 9 to July 30, 1890, under the title *Fifth Avenue and the Snow*. The painting was illustrated in Mariana G. Van Rensselaer, "Fifth Avenue with Pictures by Childe Hassam," *Century* 47 (Nov. 1893), p. 8, with the title *A Winter Morning*. In 1892, while still living at the

Fifth Avenue address, Hassam painted from the same window the small panel *Christmas Morning* (Smith College Museum of Art, Northampton, Mass.). For later variants, see p. 128.

9 Hassam Papers, clipping from *Le Figaro*, June 10, 1891: "Mais je cherche dans l'exposition américaine quelques passages vraiment américains: ils sont rares, il faut avouer; cependant M. Child Hassam, un des artistes les plus aimés des Etats-Unis, me donne une impression vraiment interessante avec un coin de New-York sous la neige, qu'il appelle Cinquième Avenue en hiver; bonne couleur: solidement peinte, cette toile est une des plus appréciées de l'Exposition Durand-Ruel." The *Exposition de Peintures et Sculptures par un groupe d'Artistes Américains* was held from June 4 to July 13, 1891. For other reviews, see *Le Temps*, June 13, 1891; [Charles De Kay], *New York Times*, July 13, 1891, p. 3; *Art Amateur* 25 (Aug. 1891), p. 49, and 25 (Sept. 1891), p. 72.

10 Van Rensselaer, *op. cit.*, p. 12.

11 *Ibid.*, p. 15.

12 A. E. Ives, "Talks with Artists: Mr. Childe Hassam on Painting Street Scenes," *Art Amateur* 27 (Oct. 1892), p. 116.

13 Illustrated in Royal Cortissoz, "Landmarks of Manhattan," *Scribner's Magazine* 18 (Nov. 1895), p. 539. Hassam contributed to this article the view *The Plaza at Fifty-ninth Street and Fifth Avenue*.

Hassam and Robinson were not on especially close terms, and usually met only in the company of a larger circle of acquaintances. After viewing Hassam's auction exhibition in 1896, Robinson wrote: "After a certain astonishment at the cleverness of his paintings of detail, one is struck by its superficiality, the glitter and nothing beside, 'tinsel' sort of art. A lack of something, not of endeavor of a certain kind [sic]. Is it Flaubert's 'l'honnête, la première condition de l'esthétique?'" Frick Art Reference Library, New York, Theodore Robinson diaries, Feb. 6, 1896.

14 *Art Amateur* 32 (May 1895), p. 158.

15 Frick Art Reference Library, Theodore Robinson diaries, Nov. 30, 1893, and Oct. 31, 1893.

16 *Ibid.*, Dec. 15, 1892.

17 Ives, *op. cit.*, pp. 116-17.

18 For instance, Hubert Beck, "Urban Iconography in Nineteenth-Century American Painting," in *American Icons: Transatlantic Perspectives on Eighteenth- and Nineteenth-Century American Art*, ed. Thomas W. Gaehtgens and Heinz Ickstadt, Santa Monica, CA, p. 324. The premises behind such a view are the narrowest definition of what constitutes a city, a confusion of New York with Paris, and ignorance of the difference between late nineteenth- and early twentieth-century New York.

19 William Henry Howe and George Torrey, "Childe Hassam," *Art Interchange* 34 (May 1895), p. 133.

20 Selected for its picturesqueness, it is hardly a subject recording "the anonymity of the new urban life," as first claimed by Carol Troyen (*The Boston Tradition: American Paintings from the Museum of Fine Arts, Boston*, exhibition catalogue, 1980, p. 166) and repeated in *Childe Hassam: An Island Garden Revisited*, exhibition catalogue, Denver Art Museum, 1990, p. 134. A Boston reviewer in 1893 termed it "A fine Boston subject...looking toward the State House along the squalid alley (though picturesque, like many other disagreeable things) that now disgraces the rear of Beacon Street." Hassam Papers, unidentified clipping.

21 *Boston Evening Transcript*, Jan. 28, 1893, p. 4.

22 Hassam Papers, letter to Miss Farmer, Feb. 22, 1933, in autobiography.

23 Marie Walther, letter of Aug. 8, 1893; William Page Papers, correspondence 1885-93, Archives of American Art, Roll 23.

24 Reproduced in *Childe Hassam: An Island Garden Revisited*, p. 46, fig. 1.31.

25 The painting, inscribed "To Celia Thaxter from Aladdin / Shoals, July 1890" (Sotheby's, New York, auction catalogue, May 23, 1981, no. 44), is one of those shown in the photograph cited in note 24 above. Thaxter referred to Hassam's picture, without identifying it, in her *An Island Garden, with Pictures and Illuminations by Childe Hassam*, Boston and New York, pp. 96-97.

26 Hassam Papers, undated clipping marked "Transcript" (a review of Hassam's exhibition at the Doll & Richards Gallery, c. 1891).

27 Hassam Papers, autograph note: "Paint & pigment may be used perfectly clear out of the tube and applied to surfaces of canvas — most carefully prepared linen or wood most carefully prepared." Hassam also described his materials in Lockman Interview, Jan. 31, 1927, p. 37: "I prefer a semi-absorbent canvas. Any good French, English or American canvas, which is semi-absorbent, and then using the colors as they are with very little medium, and if you do use medium use the simplest medium that there is — we'll say turpentine and very, very little varnish. If you use oil, I would say use it very sparingly because it is the oil that changes the color."

On the widespread concern about the stability of colors, particularly the bright new synthetic pigments used by such artists as Monet, Renoir, Pissarro, and Seurat, see John Gage, *Colour and Culture: Practice and Meaning from Antiquity to Abstraction*, London, 1993, p. 221ff.

28 See Elizabeth Luther Cary, "Childe Hassam, Sterling Artist: An Appreciation," *New York Times*, Sunday, Sept. 1, 1935, section 9, p. 9.

29 Hassam to John W. Beatty, Sept. 31, 1895; Carnegie Papers, File 00 H 81. Although the letter is dated September 31, this is undoubtedly an error for August 31, as proven by the notation "Ans[wered] Sep 5" inscribed on the letter by the Carnegie office. Gail Stavitsky, "Childe Hassam and the Carnegie Institute: A Correspondence," *Archives of American Art Journal* 22, no. 3 (1982), p. 3, transcribes the phrase "unique setting" as "original(?) thing." While many writers, including myself, have thought that Hassam avoided the Isles of Shoals immediately after Thaxter's death, this letter proves that he was there in 1895.

30 Thaxter, *op. cit.*, p. 94.

31 See Hassam to William Macbeth from The Delphine, East Gloucester, July 8, 1894; Archives of American Art, Roll NMc7.

32 See Lockman Interview, Jan. 31, 1927, pp. 39-40, where Hassam scoffs at the idea of people buying the embellished architectural drawings as his own work, but describes the work done for Millet as "actual paintings." Hassam also mentioned these in *Catalogue of Etchings, Lithographs, Drawings, Watercolors and Pastels by Childe Hassam*, exhibition catalogue, Arthur Harlow & Co., New York, Jan. 22 — Feb. 11, 1927.

A group of seven drawings, apparently from the original architectural/lithographic commission, is owned by the Chicago Historical Society. Other views in watercolor and gouache, apparently from the Millet project, are in the Terra Museum of American Art, Chicago, and the Fogg Art Museum, Harvard University. Still others were on the art market in 1985.

While in Chicago, Hassam also colored in a drawing for Steele McKaye's building called the Spectatorum. See Lockman Interview, Jan. 31, 1927, p. 40.

33 He exhibited *A Snowy Day on Fifth Avenue* (*Fifth Avenue in Winter*); *Autumn Landscape*; *Cab Station, Rue Bonaparte, Paris*; *Indian Summer, Madison Square, Midsummer Morning*; *On the Way to the Grand Prix*; and the watercolors *Montmartre*; *Springtime in the City*; *Fifth Avenue*; and *The Rain*. For the awards, see *Art Amateur* 29 (Nov. 1893), p. 163.

34 Van Rensselaer, *op. cit.*, p. 5ff.

35 *Venetian Life*, by William Dean Howells with Illustrations from Original Water Colors, London, 1891. Another apparently commercial project was the gouache and watercolor *A Winter Day on Brooklyn Bridge* (New York art market), dated December 18, 1892.

36 See note 25.

37 Lockman Interview, Jan. 31, 1927, p. 22. In a letter of January 13, 1893, to George Woodbury (Houghton Library, Harvard University, Cambridge, Mass.) Hassam seemed to say that he had moved to the Chelsea only recently.

38 Lockman Interview, Jan. 31, 1927, p. 22ff.

39 Childe Hassam, *Three Cities*, New York, 1899, plate 6. Another example was *Winter Night*, a view on Fifth Avenue in front of the New University Club at Fifty-fourth Street (dated 1898), plate 14. In late January 1892 Hassam exhibited the pastel *In Central Park* at the Pennsylvania Academy of the Fine Arts (Jan. 21 — Mar. 5, 1892, no. 349).

40 See Lockman Interview Jan. 31, 1927, pp. 38-39, and Feb. 2, p. 13. Hassam said he left the day before the Cuban insurrection started, which was February 24, 1895. Two of his Havana views were later illustrated in *Harper's Pictorial History of the War with Spain, with an Introduction by Major General Nelson A. Miles, Commanding United States Army*, 2 vols., New York and London, 1899 (see fig. 109). Other Cuban works include: *Royal Palms* (Nathaniel Pousette-Dart, Childe Hassam, New York, 1922); *In a Central American Forest* (gouache and ink; *Childe Hassam, 1859-1935*, exhibition catalogue, University of Arizona Museum of Art, Tucson, 1972, no. 44, ill.); *Scene in Havana* (*A Century of American Landscape Painting [1800-1900]*, exhibition catalogue, Whitney Museum of American Art, New York, 1938, no. 72).

41 See Lockman Interview, Feb. 2, 1927, p. 14.

42 *Catalogue of Oil Paintings, Water Colors and Pastels by Childe Hassam*, American Art Galleries, New York, Feb. 6-7, 1896.

43 *New York Times*, Feb. 2, 1896, p. 12.

44 *Sun*, Feb. 4, 1896, p. 7. For other reviews, see *Evening Post*, Feb. 1, 1896, p. 19; *New York Times*, Feb. 2, pp. 12 and 21; and *Art Interchange* 36, no. 3 (Mar. 1896), p. 68. For reports of the sale, see *New York Times*, Feb. 7, p. 3, and *New York Daily Tribune*, Feb. 7, 1896, p. 5.

45 "Paintings by Mr. Hassam," *Art Interchange* 36, no. 3 (Mar. 1896), p. 68.

46 *New York Daily Tribune*, Feb. 7, 1896, p. 5.

47 Hassam to John W. Beatty, Oct. 8, 1896; Carnegie Papers, File 180 H 2.

48 National Academy of Design, New York, diaries of J. Carroll Beckwith, Feb. 13, 1896: "there is a fine collection of pictures owned by one David King now on show here, to be sold by auction next week. They are all modern French or 18th century English. The only two styles that go at all here now. American fellows can positively get nothing for their work. This winter has abounded [?] in auction sales by the painters who have been obliged to raise some money and the prices have sometimes not paid for the frames."

49 "The Field of Art: Social Art Gatherings in New York," *Scribner's Magazine* 20 (Dec. 1896), p. 783.

Fig. 112 Union Square, New York.
Photograph by Adolph Wittemann, 1888

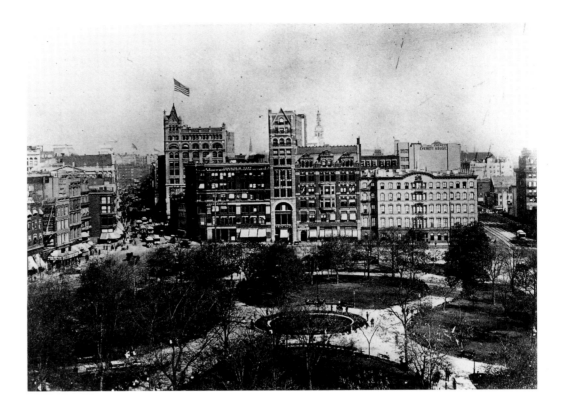

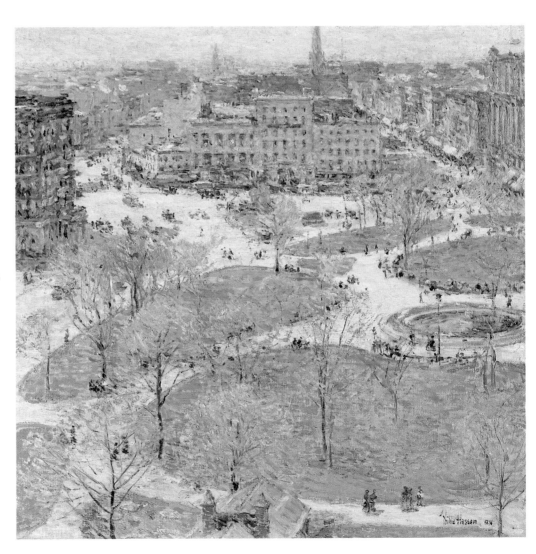

Fig. 113 *Union Square in Spring*, 1896.
21½ x 21 in. (54.6 x 53.3 cm).
Smith College Museum of Art, North-
ampton, Massachusetts; purchased 1905

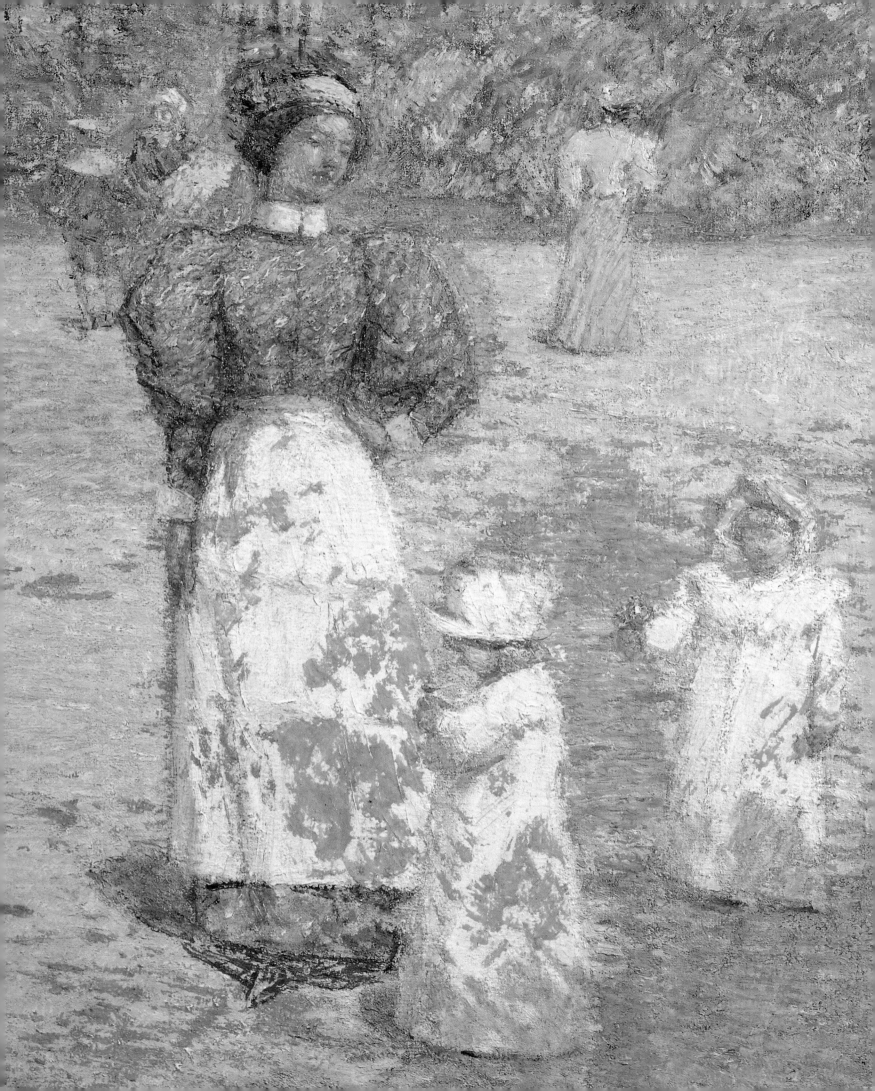

IV A PERIOD OF TRANSITION 1897-1908

It was seven years since Hassam had last seen Europe, and as many as fourteen since he had traveled beyond Paris or London. This time he had neither the need nor the desire to remain in one place. His itinerary suggests a prolonged and well-planned campaign of work that was both a journey of exploration and a sentimental revisiting of favorite places.

Italy seems to have been foremost in Hassam's mind from the outset. He sailed to Naples in December 1896, staying there to paint during January. From Naples he went to Rome and afterward Florence, where he spent much time in galleries and churches studying the Old Masters. In his own work Hassam continued to explore high vantage points, painting broad panoramic landscapes of Posilipo, Capri, and the Bay of Naples with Vesuvius in the distance. The best known composition from his Florence sojourn is a sweeping view of that city from a suburban villa. In other paintings he recorded the city's picturesque bridges — the Ponte S. Trinità and the Ponte Vecchio — seen against the rippling surface of the Arno River. In Rome he focused almost exclusively on the Spanish Stairs that rise to the Trinità dei Monti, painting them several times from different viewpoints (see fig. 114). Each image is enlivened by groups of colorfully dressed figures — usually painters' models who congregated on the steps — but the center of Hassam's interest was the abstract patterning of the monument's layered, white marble surfaces. While in his earlier work details of surface, color, and texture were expressed in naturalistic terms, in the later 1890s they acquired an ever greater autonomy as a result of the artist's pursuit of abstract pictorial values. In fact, Hassam came to prefer motifs in nature that inherently favored such patterns of surface, as he consciously strove to narrow the gap between representation and decoration.

After wintering in Italy, Hassam proceeded to Paris, where he arrived in time to exhibit four pictures at the new Salon of the Société Nationale des Beaux-Arts in April 1897.[1] Several paintings with American subjects, including *The Room of Flowers* (fig. 96) and *Summer Sunlight* (fig. 92), must have been brought from America in anticipation of just such an opportunity. In recognition of his work, Hassam was named an associate member of the Société in May.[2] Eight other pictures from his European tour were subsequently left in France to be framed for exhibition, and were shown at the Salon the following year. Further paintings, at least some of them deriving from his recent travels, were sent to the international exhibition in Munich that summer.[3]

From his hotel on the Quai Voltaire, Hassam painted several views overlooking the Seine, including *Pont Royal, Paris* (fig. 115), which won the Pennsylvania Academy's Temple Gold Medal in 1899, and the wonderfully animated *Le Louvre et le Pont Royal* (fig. 116). As he had done in the old days, he wandered through the streets in search of motifs, finding them along the nearby river bank in, for example, *Les Bouquinistes du Quai Voltaire, Avril* (New Jersey State Museum) and *Quais Malaquais* (private collection). Other subjects were painted on the Right Bank near the Louvre. These included the Tuileries Garden (High Museum of Art, Atlanta) and the church of St Germain l'Auxerrois (fig. 117), the latter a motif that he had also painted in the 1880s.

Apparently intent on finishing as much work as possible, Hassam adjusted his method to a hurried schedule, laying down the pigment in extremely rapid, summary strokes. Hence, the painted surfaces are often quite thin, but, at their best, possess an engaging sense of impulsiveness and a striking immediacy of effect. Also remarkable is the increased lightness of Hassam's palette, which had already become noticeable in certain pictures painted the previous year (see fig. 113). The artist once referred to these light-toned canvases as simply the result of personal preference, but other comments he made suggest that he was challenged by the particularly difficult problem of achieving successful harmonies in light tones. James McNeill Whistler and John Twachtman, Hassam believed, were the two painters who had excelled at this.[4]

During the spring or early summer, the Hassams returned to Villiers-le-Bel, undoubtedly to visit the home of their old friends the Blumenthals. *In a French Garden* (fig. 119) was painted there, as, most likely, was the undated *Lady in the Park* (*In the Garden*) (fig. 118).[5] Though their themes recall Has-

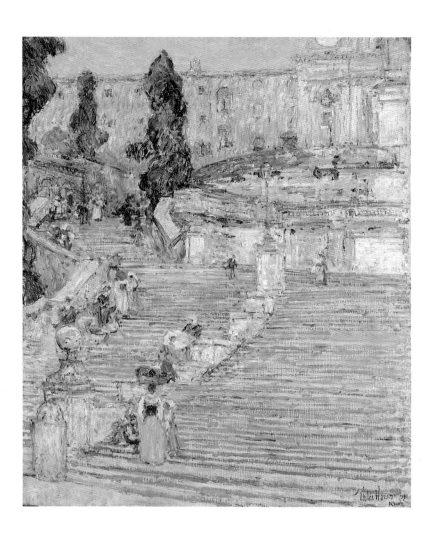

Fig. 114 *The Spanish Stairs*, 1897.
29 x 23 in. (73.6 x 58.4 cm).
William Randolph Hearst Collection,
Los Angeles County Museum of Art

Fig. 115 *Pont Royal, Paris*, 1897.
24½ x 28½ in. (62.2 x 72.4 cm). Cincinnati Art Museum;
Israel and Caroline Wilson Fund, 1899.69

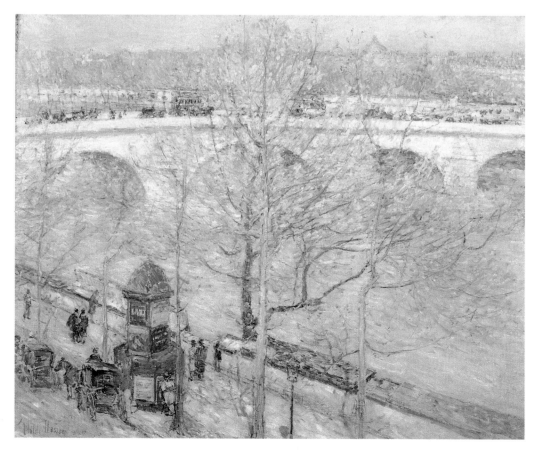

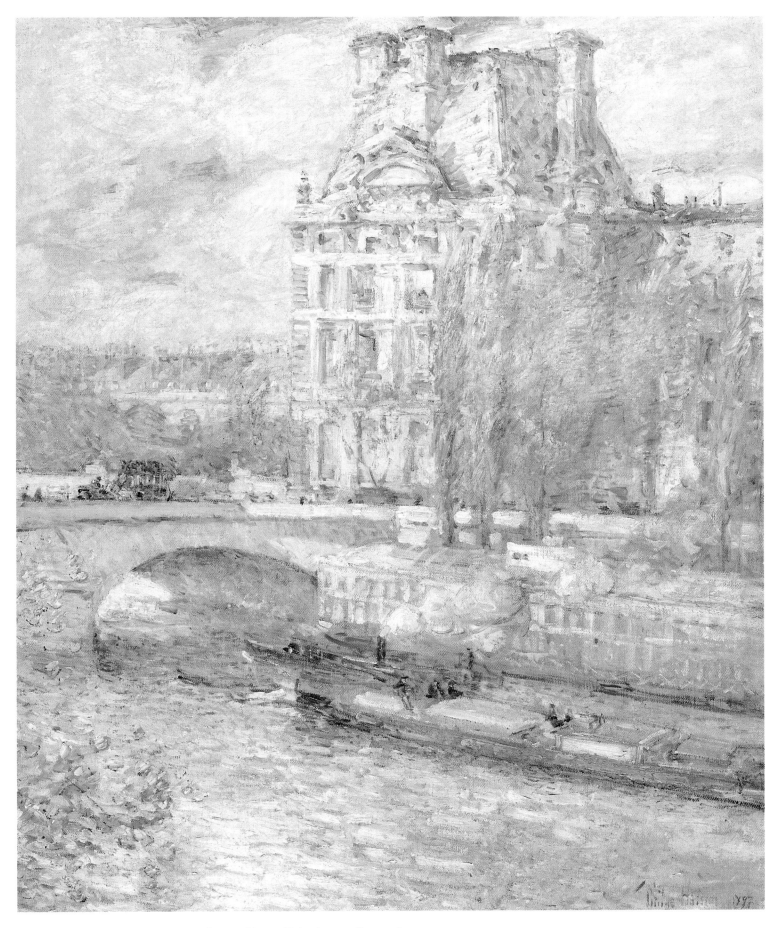

Fig. 116 *Le Louvre et le Pont Royal*, 1897. 30⅜ x 24⅜ in. (77.2 x 61.9 cm).
The Bill and Irma Runyon Art Collections, Texas A & M University

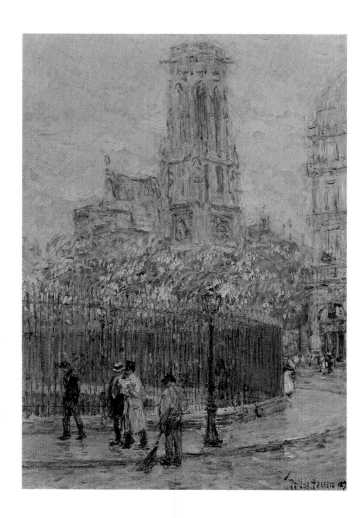

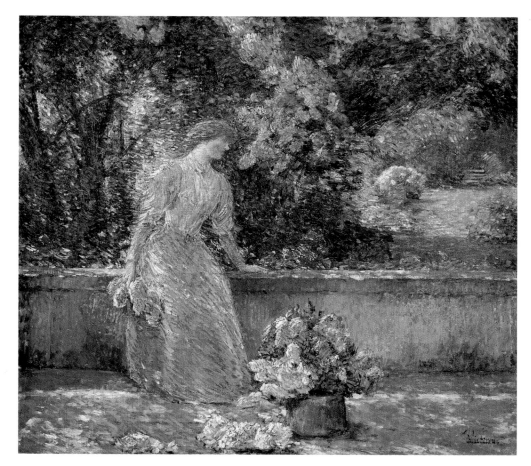

Fig. 118 *Lady in the Park* (*In the Garden*),
1897. 25½ x 28 in. (64.8 x 71.1 cm).
Private collection

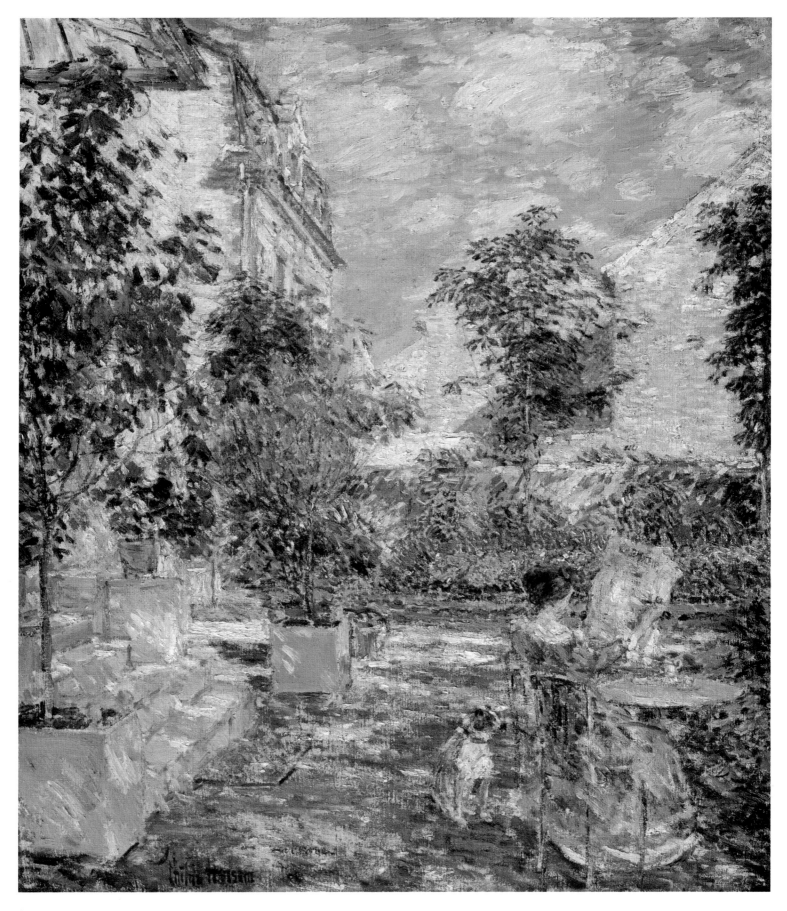

Fig. 119 *In a French Garden*, 1897.
25¾ x 21½ in. (72.4 x 65.4 cm). Private collection

Fig. 120 *Harvest Time, Brittany*, 1897.
21¾ x 15¼ in. (55.3 x 38.7 cm).
Colby College Museum of Art, Waterville, Maine;
Gift of Miss Adeline and Miss Caroline Wing

Fig. 121 *Rooftops: Pont-Aven*, 1897.
35¾ x 31⅝ in. (90.8 x 80.8 cm). Private collection

sam's paintings of the 1880s, their method of modeling, with short, nervous dashes of pigment, is vastly different and, while intended, perhaps, to reflect the shimmer of light upon surfaces, creates instead a shifting, dappled surface that becomes the picture's primary object of attention. In *In a French Garden* the artist's mosaic-like patterning produces not the atmospheric quality of a soft, continuous dissolve, but a fracturing of space through the alternation of light and shade. In subsequent works, Hassam oscillated between these alternatives of illusion and decoration, occasionally abandoning space for strong, tapestry-like surface effects.

Hassam's itinerary led him next to England, where he visited London and made an excursion along the River Stour to paint in the countryside made famous by John Constable. Afterward, he went to Pont-Aven in Brittany, where, judging by the number of canvases completed — over a dozen major works are known — he must have spent a good deal of time through the late summer and autumn. The company of other American artists in this popular locale might account for the length of his stay, yet there can also be little doubt that Hassam was fascinated by the romantic, old-fashioned aspect of life as it still existed in this provincial Breton town. Most of his work there centered on the life of the quaintly costumed peasants, and the sentimental, folkloric character of these figure paintings stands in glaring contrast both to his earlier explorations of modern city life and to the few Breton landscapes he produced, whose abstract, formal qualities reflected his latest ideas (see figs. 120, 121).

Because the European paintings provide a record of his travels, Hassam's work can be studied almost on a month-to-month basis during 1896 and 1897. They reveal no obvious pattern, only the artist's openness to stimuli from all directions and his willingness to explore alternative treatments of the picture surface. It is difficult, therefore, to define exactly what impact this year in Europe made upon him. It did affect his choice of subjects. Hassam reinforced his interest in panoramic landscape and came to renew his appreciation of historical architecture. The portrayal of old buildings for their own sake was something Hassam had not undertaken since his student days, yet, following his year abroad, his antiquarian interest in American historical landmarks increased, possibly reawakened by his experience of the venerable monuments of Europe's past. One of the first pictures he created after returning to the United States was *Putnam Cottage, Greenwich, Connecticut* (private collection), an image of that famous colonial building which offers a striking parallel to some of the architecture he had been painting at Pont-Aven. On the other hand, he also strengthened his appreciation of the modern city. "I think," said Hassam on returning, "that New York is a very beautiful city. It is far more interesting to me than Paris, with its monotony, its finish, its trivial sort of surface decoration, like that of the Louvre. The large, comparatively pure buildings of London and New York, are much more capable of a really distinguished effect."[6]

The artist came back to New York and to his apartment on Fifty-seventh Street in the fall of 1897; he did not, as one persistent notion has it, prolong his European tour through the following year.[7] In December 1897 Hassam became embroiled in one of the most sensational episodes of his career when he and nine other Impressionist painters seceded from the Society of American Artists to form a new exhibition society known as the Ten American Painters. Their action resulted from conflict that had been mounting over several years between the Society's conservative artists and the Impressionist camp, which included Hassam, Twachtman, J. Alden Weir, Willard Metcalf, Edmund Tarbell, Frank Benson, Robert Reid, and Joseph De Camp, along with Thomas Wilmer Dewing and Edward Simmons. Their defection and the bitter controversy it caused have been described extensively elsewhere.[8] One detail, however, has been overlooked, namely that it was Hassam himself who finally broke the gentlemanly silence that, for many weeks, had kept news of the quarrel and secession from reaching the public. One evening, over drinks in his studio, Hassam apparently decided to relate the incident in full to his friend Hutchins Hapgood, who was then working as a reporter for the *Commercial Advertiser*.[9] Hapgood broke the story on the front page of his newspaper the next day, setting in motion a violent controversy that pitted the Impressionists against many of their reactionary colleagues. Most of Hapgood's story was in the form of a long quote from what he described as an anonymous source:

We resigned from the Society because we felt that as it is constituted now the Society of American Artists no longer represents what was intended in the beginning. Many of the members have done little or no real work in art, many of them have not shown work in the national exhibition for years and consequently we feel that the Society of American Artists does not represent exclusively enough what is generally artistic. The supreme disadvantage for art that this condition brings about is that it lowers the standard of the exhibitions. Genuine artists would not seek to exhibit primarily what they thought would sell, but what they thought was really good. But as the Society is now organized, with its large leaven of business and society painters, art in the best sense is getting to be more and more a vanishing quantity, and the shop element is coming more and more into the foreground. As the organization has been managed for the last two years it might (as was said by one of the men who stayed) be called the Society of Mediocrity.[10]

Hassam then told of the Impressionists' plans for a new exhibition society and drew a parallel to successful secessionist movements in France and Germany — the Société Nationale des Beaux-Arts and the Munich Secession, respectively. He alone of the rebel group belonged to these organizations, and this may help place in perspective his later claim that "'The Ten' was my idea entirely."[11] According to Hassam, the notion of leaving the Society occurred to him one evening in the winter of 1897/98 while walking from his studio to Weir's house. He immediately proposed the idea to Weir, then to Twachtman and the others. Although we know that there had been earlier talk of leaving the Society, Hassam's account and his reference

Fig. 122 *Spring in Central Park* (originally *Springtime*), 1898.
29½ x 37½ in. (74.9 x 95.3 cm). Robert Rubin Collection

to the European secessions suggest that, perhaps energized by his experiences abroad, he may have brought home with him the crucial spark that finally ignited the movement.

The Ten American Painters opened their first exhibition at the Durand-Ruel Gallery in New York on March 30, 1898. Of the forty-five works in the show, seven were by Hassam, making him the largest contributor after Weir. Most of the paintings derived from his recent European travels and included a *Spanish Stairs* and *St. Germain l'Auxerrois* (fig. 117), the subjects of which reinforced the sense of foreignness that, to his critics, characterized Hassam's style.

Hassam was clearly counted among the most radical of the varied artistic personalities who made up the Ten. "Hassam is as impressionistic as the most extreme could wish," stated the *Herald* critic in reviewing their first exhibition.[12] The like-minded reviewer for the *World* claimed that, to be consistent, Hassam

and Weir should at once secede from Simmons and Metcalf, because Hassam's works "seem to have been painted with a desire to indulge in some assertion of radicalism."[13] His work obviously too advanced and little understood, Hassam was dismissed by most reviewers with relatively short comment. One said outright that his paintings were often "quite incomprehensible" and "queer."[14] Others, more thoughtful perhaps, declared that Hassam's work was too experimental to be taken seriously.[15]

Presumably, the remarkable *Spring in Central Park* (originally *Springtime*) (fig. 122) was not ready in time for the Ten exhibition, since Hassam showed it for the first time that April at the National Academy of Design.[16] A culmination of his best work of the 1890s, the picture evinces a near perfect equilibrium of formal discipline and painterly freedom. Its strong sense of place is accompanied by an ideal charm, realized

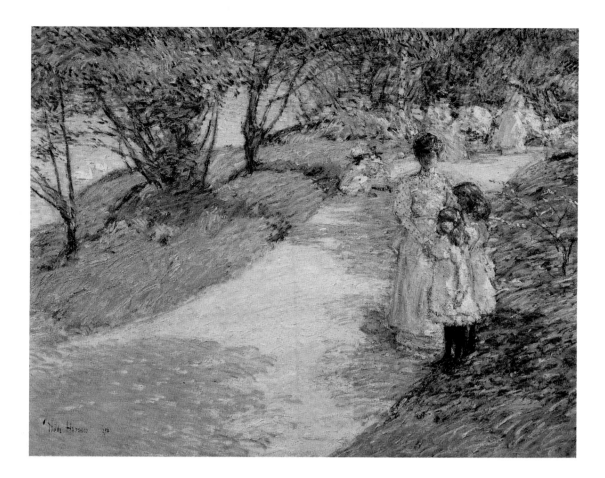

Fig. 123 *In Central Park*, 1898.
27¼ x 35¼ in. (69.2 x 89.5 cm).
Private collection

through the quality of color-filled light that permeates and har-monizes every element. A comparable achievement in the field of landscape was to be reached in his Gloucester series the following year.

In the summer of 1898 Hassam finished a large figure painting, begun two years earlier, titled *The Sea* (private collec-tion), which later that year won the silver medal and $1,000 prize at the Carnegie International. The artist called it "the most important canvas I have done"[17] and took great care to have a frame designed for it by Stanford White. The picture was subsequently reproduced by Harper and Brothers without Has-sam's permission and without using the "autochromatic [or-thochromatic] plate" necessary to capture its colors accurately. Said the outraged painter: "I gave no right to anybody to re-produce my painting much less to any bungler that expects [?] to take a negative on an ordinary plate Harpers and Bros. [also] took the unwarranted liberty of cutting the plate to fit their page. These reproductions are a libel on my beautiful painting and I want to stop any more being made except with my authorization."[18]

The outbreak of the Spanish-American War in April 1898, and fear that the Isles of Shoals might be vulnerable to attack, kept Hassam from returning there during the summer after his return from Europe. Instead, he went to East Hampton, Long Island, at the invitation of the painter G. Ruger Donoho, who owned a house there, and of Alexander Harrison, who was stay-ing as Donoho's guest. This was the first of many subsequent visits to East Hampton and resulted in a number of paintings, including two of the picturesque windmills nearby and the well-known composition *July Night* (private collection), which de-picts Maude Hassam in the Donohos' garden lit by Japanese lanterns.[19]

Hassam returned to the Isles of Shoals in 1899, and repeat-ed his yearly visits for the next decade and a half. He loved to swim there[20] and, even without Celia Thaxter's salon, enjoyed the company of the other summer guests. He prized, above all, the islands' cool climate, which allowed him to paint during the summers on what were essentially working vacations. While he had ignored the resort's public areas during Thaxter's life-time, in *August Afternoon, Appledore* (fig. 129) of 1900 he cre-ated a festive scene of the bathing pool at Appledore, with its colorful changing houses and a glimpse of the local steamer landing behind. A few years later he painted an abbreviated version of the scene.[21]

Hassam had always painted landscapes at Appledore, but toward the turn of the century he discovered in the island's cliffs and rocky coastline an aspect of nature in its most ele-mental state that seemed to offer opportunity for endless variation. From the summer of 1901, when he produced more than half a dozen canvases on this rugged coastal theme, Has-sam returned to the subject time and again, exploiting the qualities of vitality, authenticity, and strength that the spare,

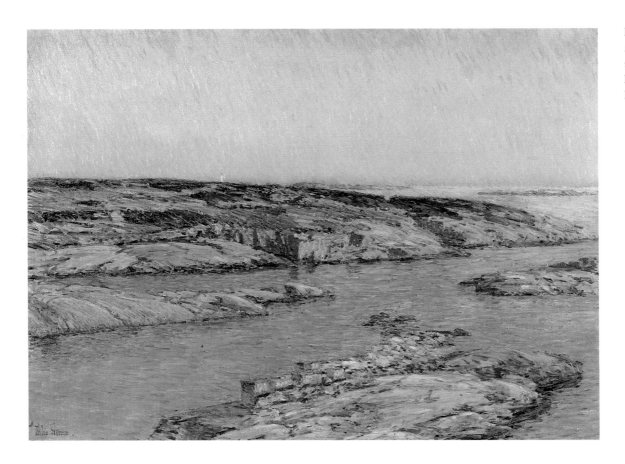

Fig. 124 *Summer Afternoon,
Isles of Shoals,* c. 1901.
26 x 34⅛ in. (66 x 86.7 cm).
Erie County Library,
Pennsylvania

Fig. 125 *Duck Island,* 1906. 20½ x 31½ in. (52.1 x 80 cm).
Dallas Museum of Art; Bequest of Joel T. Howard, 1951.41

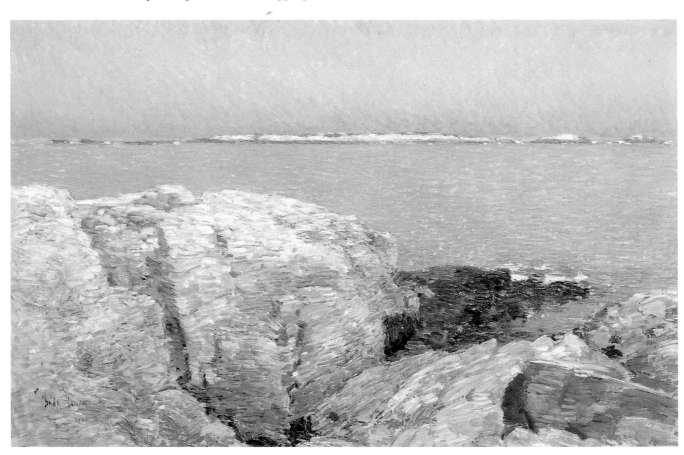

Fig. 126 "Painting Alice": the artist on the Isles of Shoals, 1899

Fig. 127 "Mr. Hassam at Work," 1899

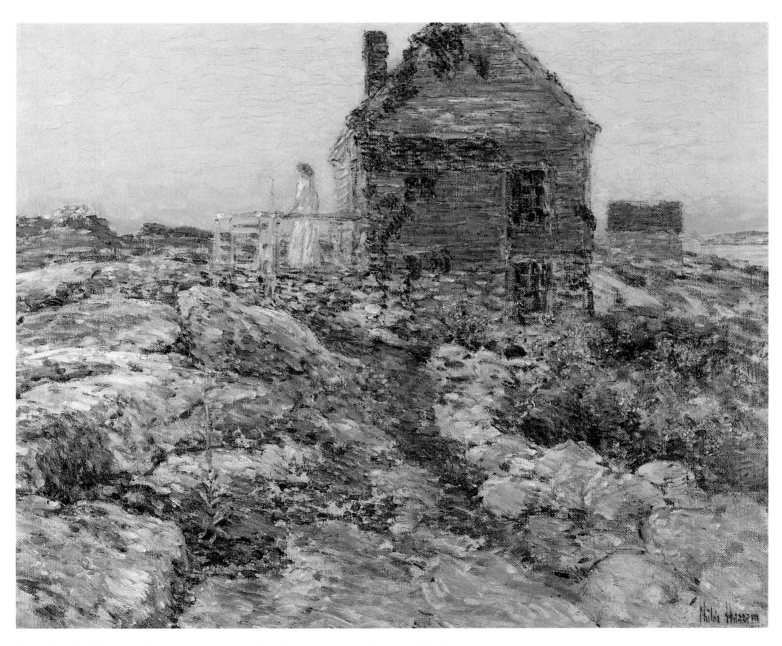

Fig. 128 *The Norwegian Cottage,* 1909. 25 x 30 in. (63.5 x 76.2 cm). Private collection

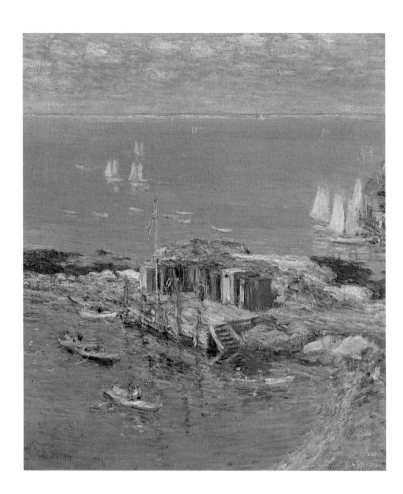

Fig. 129 *August Afternoon, Appledore*, 1900.
22¼ x 18 in. (56.6 x 45.7 cm). Mr. and Mrs. Hugh Halff, Jr.

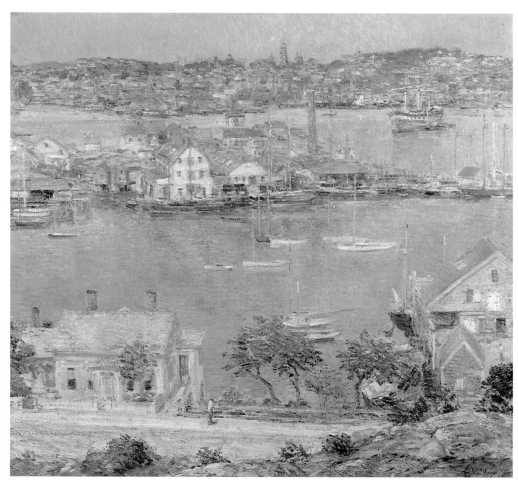

Fig. 130 *Gloucester Harbor*, 1899/1909.
26 x 25 in. (66 x 63.5 cm).
The Norton Gallery of Art,
West Palm Beach, Florida

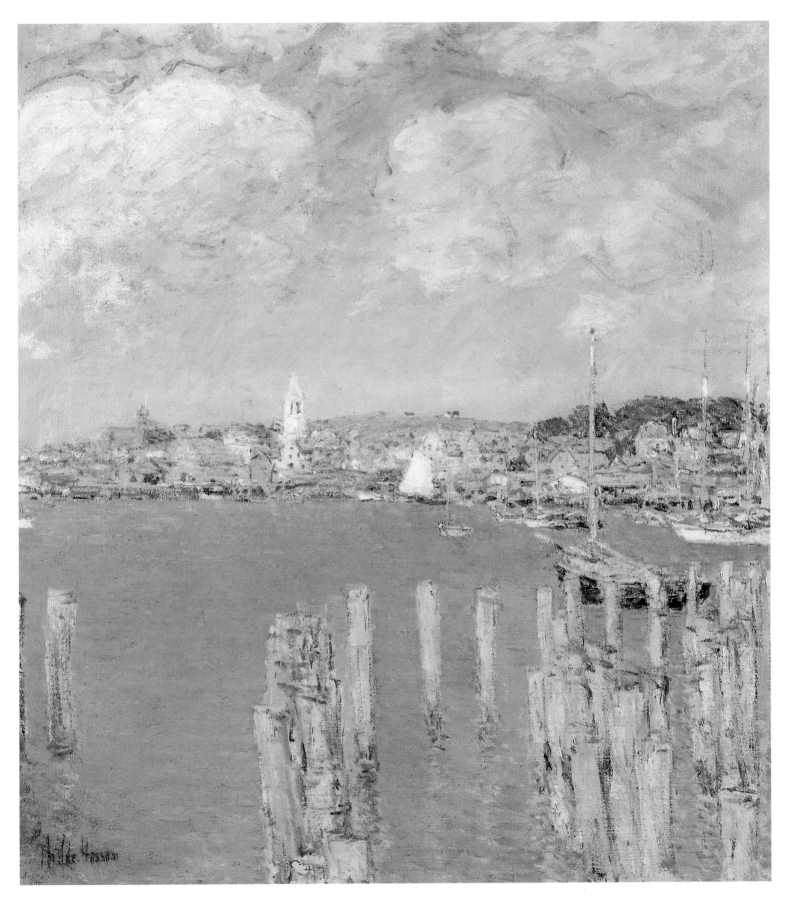

Fig. 131 *Gloucester Inner Harbor*, c. 1899.
24 x 20 in. (61 x 50.8 cm). Dumbarton Oaks Research Library and Collections, Washington, D.C.

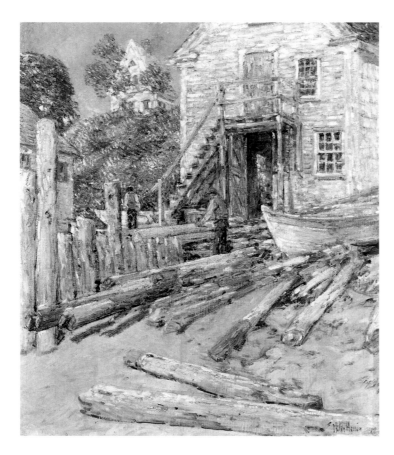

Fig. 132 *Rigger's Shop, Provincetown, Mass.*, 1900.
22 x 19 in. (55.9 x 48.3 cm). New Britain Museum of American Art,
Connecticut; Gift of Mr. and Mrs. J. Lawrence Pond

irreducible elements of sea, sky, and rock provided. His sense of awe at the vastness of nature is recorded in a remark he made years later to his friend C. E. S. Wood: "I read Thoreau quite often," said Hassam. "I can always read Thoreau. There is a lot of the desert in Thoreau and a great deal of the ocean! Big places."[22]

In resuming his usual summer schedule, Hassam also found new inspiration in other familiar New England coastal towns. In 1899 he painted once more at Gloucester, where Frank Duveneck, De Camp, and Metcalf were staying. (Twachtman, too, was later to spend the last few productive summers of his life at Gloucester.) It was during this visit that Hassam began to envision the Gloucester landscape in a fundamentally new way, replacing fragmentary incidents and scenery with enduring realities expressed in sweeping panoramas of the harbor and town (see figs. 130, 131).[23] These have come to be regarded as his quintessential Gloucester views, unrivalled for their breadth, complexity, and delicate atmospheric effect.

In 1900 Hassam went to Provincetown, Massachusetts, where, in addition to painting several spacious landscapes, he did a series of pictures recording scenes of daily life in the boatyards and in the streets and shops of the town (see figs. 132, 133). Unlike his earlier urban scenes, these images of small-town life seem curiously similar to the idealized views he

had painted at Pont-Aven, which, indeed, may have inspired him to investigate the possibilities of this American counterpart.

After spending August 1901 on the Isles of Shoals, Hassam informed his friend John Beatty that he would be in New York during September and October.[24] Instead, however, he went first to Cos Cob and then to Newport, Rhode Island, for an extended stay. With the exception of one street scene, the seven canvases he completed at Newport were views of the old town seen from the harbor, with the ancient, white, steepled Trinity Church prominently featured (see fig. 134). Hassam's work at both Provincetown and Newport displays his interest in such older New England buildings, not only as conspicuous elements in broad harbor views and townscapes, but also as subjects in their own right.

Hassam's last-minute decision to visit Newport was undoubtedly due to a studio move, for, when next documented in New York, at the end of October 1901, he had left his apartment in the Rembrandt Building and taken up residence in the Holbein Studio Building at 139 West 55th Street.[25] He remained there for a year. At the same time, he joined a group of fellow artists in planning to erect a cooperative studio building at 27 West 67th Street.[26] After spending a few months in the Sherwood Studio Building waiting for construction to be completed, Hassam moved into the Sixty-seventh Street cooperative in 1903. Located further uptown than he had previously lived or worked, it provided him with a studio that he considered larger and better for showing his work than any he had hitherto occupied. The move seems to have pressed him hard financially. In late March 1903 he told A. H. Griffith, director of the Detroit Institute of Arts, that he was especially eager to strike a bargain in the sale of a painting to a local collector, and asked for help in arranging an exhibition in Detroit, by which he hoped to raise money. "I am 'just in' this new studio building," he wrote, "and I need every spare dollar as you know perhaps. You must come and see me here and send anyone who would be interested." An emphatic postscript declared: "We *must make the sale.*"[27]

Unlike many of his colleagues, who depended on teaching or commissioned portrait work, Hassam always supported himself entirely from the sale of his works. The painter Jerome Myers marveled at his success in this, describing him as an artist "with a keen knowledge of distribution, the tactical ability to place his work."[28] Hassam's correspondence through the years shows him constantly preoccupied with the business of exhibiting and selling his pictures. Quite often, he proposed the idea of small shows of his work in museums and, at a time when it was proper to do so, enlisted the help of the museum directors in finding local patrons. He was also concerned to place before his audiences canvases and watercolors small enough to be affordable. Thus, he once wrote to the director of the Carnegie Museum in Pittsburgh asking his help in guiding collectors to his exhibition at Gillespie's Gallery, observing:

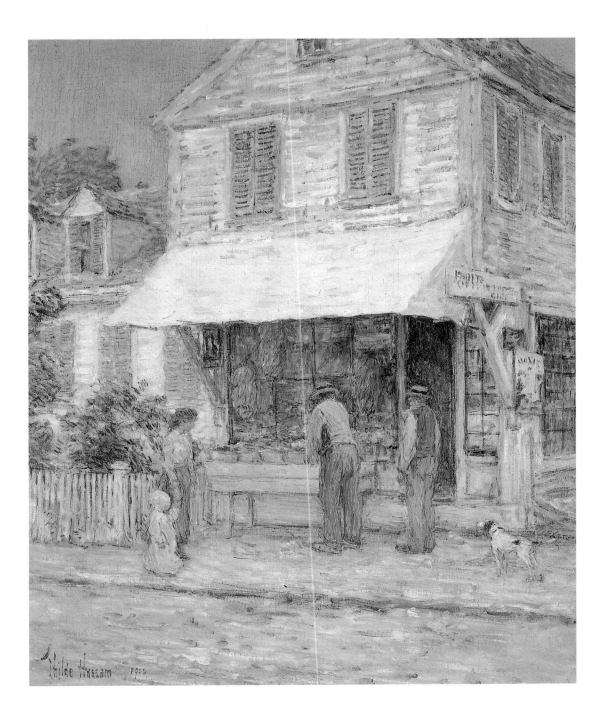

Fig. 133
Provincetown Grocery Store, 1900.
21¾ x 17¾ in. (55.3 x 45.1 cm).
Santa Barbara Museum of Art;
Bequest of Katherine Dexter

"Most of the pictures are small in size and within the means of the average buyer."[29] Although he exhibited constantly at the large annuals, and would sell directly from the exhibitions or his studio when he could, he also decided, long before it became general custom, to allow picture dealers to represent him, even if this meant paying commission. In time, he was represented simultaneously by most of the important New York galleries, including Macbeth, Montross, Milch, Knoedler, and Durand-Ruel, as well as by dealers in other cities.

Although Hassam does not seem to have sold much work abroad, he continued to send pictures to foreign exhibitions. *Fifth Avenue in Winter* was exhibited in Paris at the 1900 Exposition Universelle and won a silver medal; the next year he sent *The Sea* to the 4th Venice Biennale, and later showed there on at least three occasions. He also exhibited in Paris at the Salon and at Durand-Ruel's in the mid-1900s.[30] In September 1901 Hassam was accorded the rather special privilege of a small solo exhibition in Paris at the Durand-Ruel gallery. Ten pictures were shown, most of them painted in Europe during 1897, with at least two more recent works from Gloucester and Provincetown.[31] A critic for *L'Art Décoratif* found his canvases "clear, airy, and gently flowered," and wrote admiringly of their delicate vision and charming color harmonies.[32] Earlier that year, Hassam had sold three paintings to the French actor Constant Coquelin, who was playing opposite Sarah Bernhardt in a New York theater. To judge from a comment made by Coquelin, one of the pictures he took back with him to Paris may have been Hassam's *In Central Park* (fig. 123).[33]

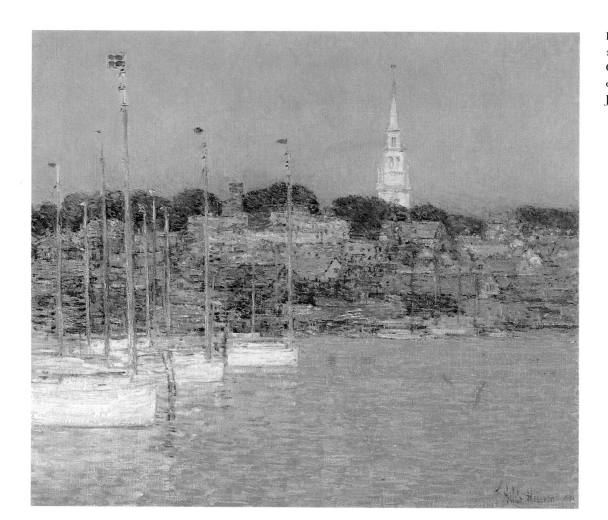

Fig. 134 *Cat Boats, Newport*, 1901. 24⅛ x 26⅛ in. (61.3 x 66.4 cm). Courtesy of the Pennsylvania Academy of the Fine Arts, Philadelphia; Joseph E. Temple Fund, 1902.2

By the turn of the century, opposition to Impressionism had become more moderate, so that even Hassam's fiercest critics now seemed to make disparaging comments more in resignation than in anger. Typical, perhaps, was the perfunctory comment of the *Commercial Advertiser* critic who wrote that one of his Gloucester views was "so sketchy... and incomplete" as to be unworthy of a "seriously considered exhibition."[34] The artist's peers on the award juries increasingly thought otherwise. In 1899 he was awarded the prestigious Temple Gold Medal at the Pennsylvania Academy of the Fine Arts and, over the next few years, this was followed by a string of prizes at major exhibitions, including a silver medal at the Exposition Universelle, Paris, in 1900, gold medals at the Pan-American Exposition in Buffalo in 1901 and the Louisiana Purchase Exposition, St. Louis, in 1904, as well as awards at the National Academy of Design, New York, and the Carnegie Institute, Pittsburgh, in 1905, and at the Society of American Artists in 1906. Hassam also sold in quick succession, in 1899 and 1900, his first pictures to museums: *Pont Royal* (fig. 115) to the Cincinnati Art Museum and *Fifth Avenue in Winter* (fig. 62) to the Carnegie Institute in Pittsburgh. Other sales to museums ensued and, by 1910, most major public collections owned one of his works. Ironically, a notable exception was the Boston Museum of Fine Arts, which did not acquire a Hassam until 1931.

In the summer of 1903 Hassam first painted at Old Lyme, a small Connecticut town of colonial origin situated near the northern shore of Long Island Sound. He was probably introduced to Old Lyme by other artists involved in the Sixty-seventh Street cooperative building. Although mildly antagonistic to Henry Ward Ranger, the nominal leader of Old Lyme's artistic colony, Hassam was on cordial terms with other members, including Frank DuMond and Allen Talcott.

Hassam's first mention of Old Lyme came in a letter he wrote that summer to Weir at his home in Branchville, Connecticut. "We are up here in another old corner of Connecticut," he wrote, "and it is very much like your country. There are some very large oaks and chestnuts and many fine hedges. Lyme, or Old Lyme as it is usually called, is at the mouth of the Connecticut River and it really is a pretty fine old town."[35] The following October, Hassam returned to Old Lyme for a week or ten days, while Maude Hassam stayed in New York to add the finishing touches to their new apartment.[36]

Over the next several years Hassam was an enthusiastic visitor to Old Lyme, drawn there in equal measure by the congenial company of artists and students and by the friendship he developed with Miss Florence Griswold, proprietress of the venerable old boarding house where the artists stayed. A special room and a studio in Miss Griswold's garden were reserved for

Fig. 135 Boating party of Old Lyme artists, c. 1903. From left to right: Hassam, Ekhart Wilcox, Will Howe Foote, Harry Hoffman (wearing white hat), Clark Voorhees, Arthur Heming, Gifford Beal, Florence Griswold, Adele Williams, Mrs. Manners, Allen Talcott, Carleton Wiggins, Henry Poore

him when he came. In a real sense, Old Lyme provided Hassam with the kind of stimulating community experience he had so valued on the Isles of Shoals while Celia Thaxter was alive. He brought some of his own friends to paint there, including Metcalf and, for at least one season, Simmons. Hassam spent his days outdoors painting the countryside with its rolling hills and lush vegetation, and continued in earnest his study of historic American buildings, which he came to view as symbols of the national heritage. Inspired on his first visit to paint the First Congregational Church (see fig. 139), which stood down the

street from the Griswold House, he would return to this theme several times during the next three years.[37] There is no question that his involvement with these landmarks was stimulated by an interest he was developing in classical styles of architecture. At one point, he made the correlation openly, saying that "New England churches have the same kind of beauty as Greek temples."[38] Yet an element of personal nostalgia may also have moved Hassam in this direction, since, as he later reported, he associated the old architecture with his own youth in Dorchester:

Fig. 136 Florence Griswold House, Old Lyme, Connecticut. The figure in the foreground is possibly Miss Griswold

Fig. 137 Members of the Old Lyme artists' colony. From left to right: (standing) Hassam, Frank DuMond, William Henry Howe, Henry Ward Ranger, Henry Poore; (seated) Clark Voorhees, Will Howe Foote, Harry Hoffman, Arthur Heming

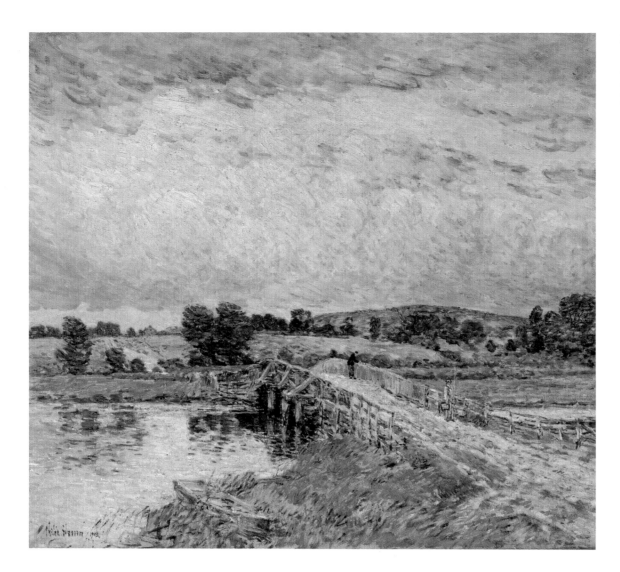

Fig. 138 *Old Lyme Bridge*, 1903.
24¼ x 26 in. (61.6 x 66 cm).
Ball State University Museum
of Art, Muncie, Indiana;
Edmund Burke Ball heirs,
80.010.6

Dorchester was a most beautiful and pleasant place for a boy to grow up and go to school — from Meeting House Hill and Milton Hill looking out on Dorchester Bay and Boston Harbor with the white sails and the blue water of our clear and radiant North American weather... if you like as fair as the isles of Greece . . . and white houses often of very simple and good architecture juxtaposed to it all. Some of the white churches were actual masterpieces of architecture, and the white church on Meeting House Hill as I look back on it was no exception.... I can look back and very truly say that probably and all unconsciously I as a very young boy looked at this New England church and without knowing it appreciated partly its great beauty as it stood there then against one of our radiant North American clear blue skies.[39]

The return in 1903 to the formal principles represented by classical art, and the qualities of reflection and permanence that these subjects lent Hassam's paintings, may be related to the death, probably induced by alcoholism, of his friend Twachtman the previous year and to the loss of another friend, the painter Alfred Q. Collins, from Bright's disease. Also in 1903, his friend Metcalf was experiencing a physical and mental breakdown. Now in his forties, Hassam perhaps began to sense the mutability of life, and suggested as much in a few unusually candid lines written to Weir from the Isles of Shoals in August 1903, just after Collins's death: "I felt pretty blue here for the first few days. The place is filled with ghosts (the first time I met Collins was right here) and a good many of the people I know can just hobble about. I was very young when I came here first."[40] The artist was still under financial pressure arising from the expense of his new apartment, and closed the letter by remarking on how much it would mean to him if a pending sale went through. Hassam's shaken equilibrium was noted six months later, in February 1904, when Weir made a rare comment on his friend's excessive drinking. "Old Hassam," he told their mutual friend C. E. S. Wood, "has been off on a bat for three weeks but is all right again."[41] Later that year, when Hassam was visiting in Oregon, it was Wood's turn to report a similar binge. "Mr. Hassam," he said, "has taken advantage of the trip to have an attack, and I hope to bring him back in a clear and sane condition. Poor fellow. My heart aches for one with such cravings but perhaps as was said of Villon 'Had we had a better *man* we would have had a worse *poet*.'"[42]

It may have been the effects of his drinking, as well as the specter of middle age, that led Hassam to adopt a health regime at his time. Certainly, it is from this period that we begin to hear of his serious pursuit of swimming, especially in the ice-cold water at the Isles of Shoals. Always a robust, athletic man,

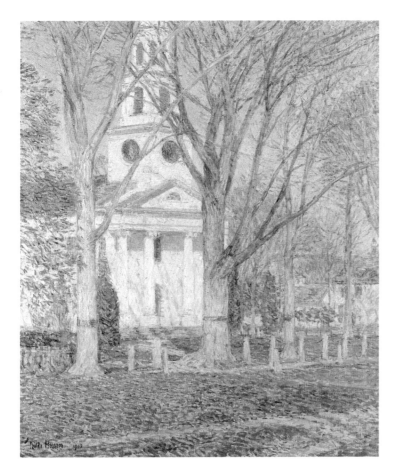

Fig. 139 *Church at Old Lyme*, 1903.
36½ x 28½ in. (92.7 x 72.4 cm). Estate of Wright S. Ludington

and thereafter painted them on a regular basis.[45] Many of his paintings with nudes were titled "idylls," while others, in an attempt to reinforce their ideal nature and universal character, bore titles derived from classical mythology, such as *Lorelei, Leda,* and *Aphrodite.* The inspiration for such subjects seems to have come from several sources at once: from the popularity of the nude among colleagues in the Ten, Reid and De Camp especially; from Hassam's admiration of Puvis de Chavannes;[46] and, perhaps, from his knowledge of Auguste Renoir, whose work he regarded as "academically complete."[47]

In painting these arcadian landscapes, Hassam undoubtedly set out to modernize the classical nude by placing it in Impressionist outdoor settings and by applying to the figures themselves his modern, painterly techniques. In the end, however, such pictures are neither classical nor credibly modern. In idealizing the human figure, Hassam was not only tackling a subject in which he had always been at his weakest, but, by substituting "ideas" for his keen reactive sense—proceeding, that is, from concepts rather than instinct—he was also denying the very essence of his strength as an artist. Yet conservative critics applauded. In 1905, reviewing the artist's solo exhibition at the Montross Gallery in New York, his critic friend Royal Cortissoz referred to the nudes that appeared in Hassam's arcadian landscape *Through the Trees, June* as representing "beauty added to truth,"[48] which, in the opinion of another writer, brought Hassam and the public to a "common ground...that both would have regarded as impossible fifteen years ago."[49] Kenyon Cox, reviewing the 1907 National Academy of Design show, noted that the "excesses of Impressionism" were a thing of the past, and remarked that Hassam's *Little June Idylle* was a work "as

he was lampooned at Old Lyme for his habit of painting barechested in the fields. The story was told of how the painter Henry Rankin Poore, out bicycling at Old Lyme, heard a whirring noise in the distance. Being a hunter, he identified the sound as that of a partridge in the underbrush but, instead, discovered Hassam standing in front of his easel, stripped to the waist and beating on his chest "for warmth and health."[43]

In addition to painting landscapes at Old Lyme, Hassam reported in 1903 that he had completed most of the work on two figure studies, a nude and a figure at an open window, that he would finish in the studio.[44] Nudes and interiors were additions to his widening repertory of subjects, which would come to embrace still lifes and portraits as well. The nudes represent Hassam's most conspicuous turn to classical precedent in his search for constants, placing him in terms of subject, if not of technique, in the role of a traditionalist and counterpart of those artists in France then seeking to redress what they viewed as the disorder of Impressionism with the traditions and discipline of classicism. Sometimes, Hassam developed nudes as full-length figure studies (see fig. 141), but more often he introduced them into his landscapes in either woodland or marine settings (see fig. 142). He had included a nude in the first exhibition of the Ten in 1898, two more the following year,

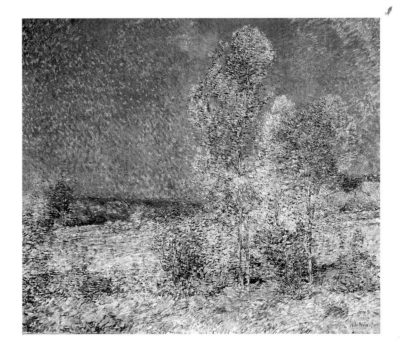

Fig. 140 *Indian Summer*, 1905.
32½ x 36½ in. (82.6 x 92.7 cm). Private collection

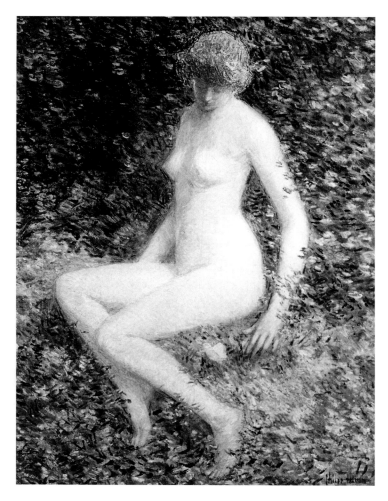

Fig. 141 *The Butterfly*, 1902. 27³/₁₆ x 20³/₁₆ in. (69 x 51.3 cm).
Gift of Mr. Herbert Fitzpatrick, Huntington Museum of Art, 52.374

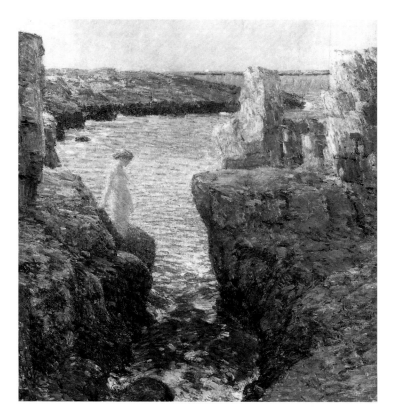

Fig. 142 *The Nymph at Siren's Grotto*, 1909. 26¼ x 24 in. (66 x 61 cm).
The Colvocoresses Family Collection.
Photo courtesy The Currier Gallery of Art

modern as Monet, yet as poetic, as classic as Corot."[50] Most critics, however, and even friends of the artist, were disturbed by the clumsiness of his figures and the note of artificiality they introduced into his work. One critic suggested that the pleasure in these pictures increased in inverse proportion to the size of the figures, commenting that, in *In the Sunlight*, the "figure floats between realism and the unreal."[51] Another, observing the thin angularity of one of Hassam's earliest nudes remarked: "One tries to find the painter's point of view, but it is difficult."[52] In 1908 the writer James W. Pattison called Hassam's Lorelei a "carved ivory figure," adding: "It looks very much as if Hassam were seeking to hand his name down to posterity as a great academical man, rather than a painter of light and air."[53]

Hassam's classicism brought him rewards from establishment organizations. In 1902 he was elected Associate, and in 1906 Academician, of the National Academy of Design. In 1905 he won that institution's Clarke Prize for *Lorelei* (Walters Art Gallery, Baltimore), which shows a nude posed on a rocky shore, probably at Appledore. Later that year, he received a medal at the Carnegie International for his depiction of three frolicking nudes in a monumental, 7 by 7-foot canvas titled *June*

(American Academy of Arts and Letters, New York) which, the following year, when the Ten were invited to show in the Society of American Artists' final exhibition, was awarded the Carnegie prize of $500.

Hassam's interest in urban genre, at least as he had previously practiced it, diminished noticeably during these years. The sale of *Fifth Avenue in Winter* (fig. 62) to the Carnegie Museum in 1900, or perhaps simple nostalgia for his favorite old neighborhood, prompted him to paint several small variants of that composition in the years that followed. These were essentially excerpts focusing on the motif of the messenger boy in the lower left foreground; he replaced this figure on one occasion with a female pedestrian, while retaining the same background. *Messenger Boy* (fig. 143) of 1903 developed this theme in an independent, friezelike composition in which, as in other snow scenes painted over the next few years, the former sense of dash and vitality is replaced by a slow, even mournful tempo. Hassam's willingness to mine his own work for motifs stands in sharp contrast to his earlier exertions in tracking down subjects in the streets under all conditions and at all times of night or day. Although he did not cease painting from street level, he tended to prefer the remove of more distant, higher vantage points for his city scenes, and to seek out subjects in quieter, outlying neighborhoods, where the city's movement was hardly felt at all (see figs. 144, 148).

Hassam painted a series of city scenes from the windows of his Sixty-seventh Street apartment. *The Hovel and the Skyscraper*

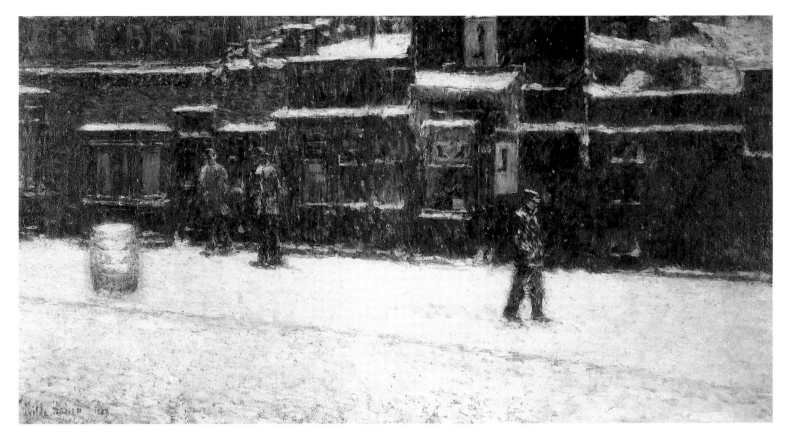

Fig. 143 *Messenger Boy*, 1902. 18 x 32 in. (45.7 x 81.3 cm).
Museum of Art, Rhode Island School of Design, Providence;
Jesse Metcalf Fund

Fig. 144 *Ice on the Hudson*, 1908. 20 x 30 in. (50.8 x 76.2 cm).
Collection Jean and Alvin Snowiss.
Photo courtesy Kennedy Galleries, New York

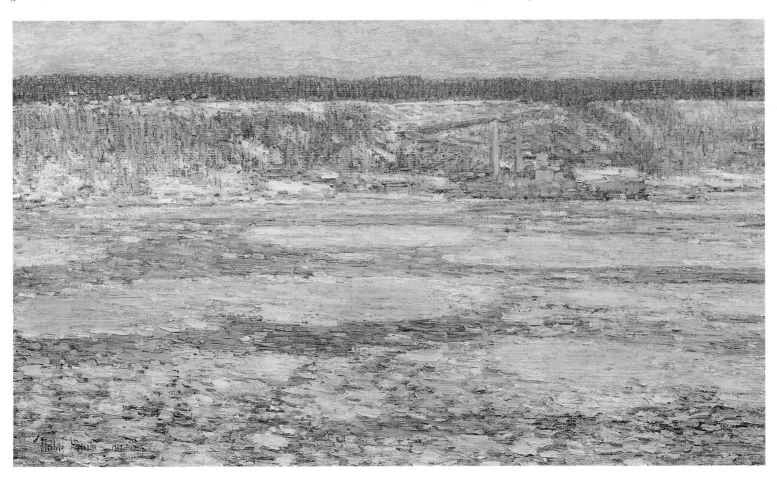

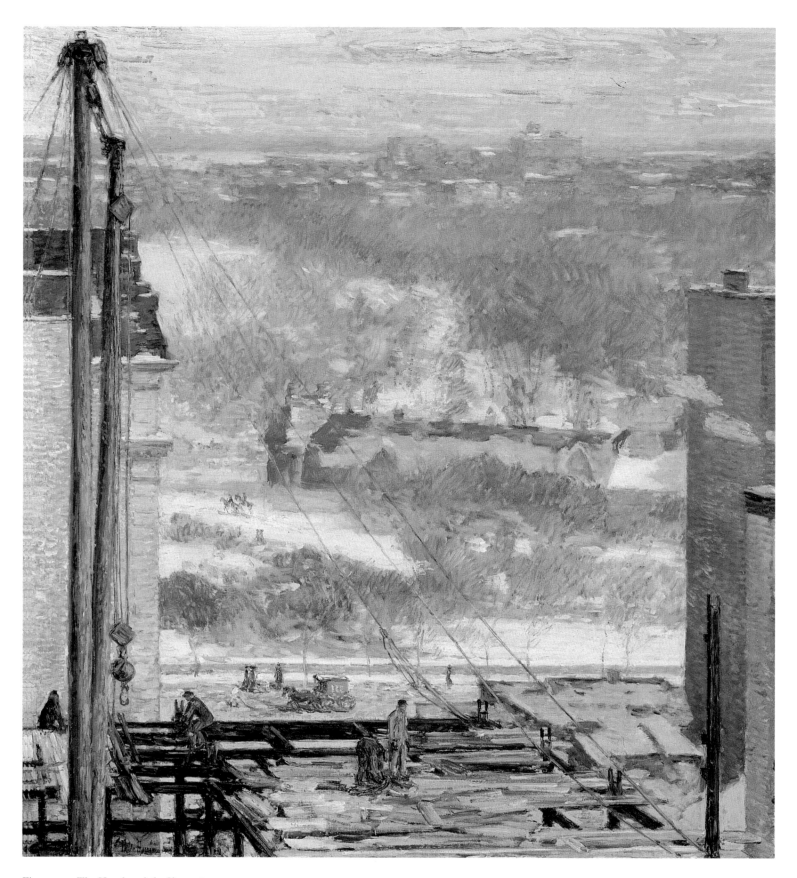

Fig. 145 *The Hovel and the Skyscraper*, 1904.
35 x 31 in. (88.9 x 78.7 cm). Mr. & Mrs. Meyer P. Potamkin

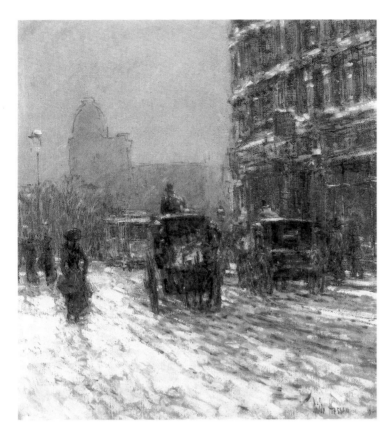

Fig. 146 *Winter Morning on Broadway*, 1901/4.
21 x 18¼ in. (53.3 x 46.4 cm). Private collection

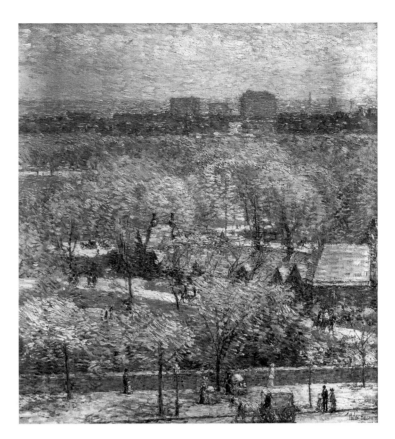

Fig. 147 *Across the Park*, 1904.
23¾ x 24½ in. (60.3 x 62.3 cm). Private collection.
Photo courtesy American Academy of Arts and Letters, New York

of 1904 (fig. 145), a view looking eastward across Central Park, is the best known of these, recording the artist's response to the phenomenon of urban growth in its contrast of a humble old park structure—actually, a riding stable—with the modern, steel-frame building rising in the foreground. Painted earlier in the year, with the trees in full bloom, *Across the Park* (fig. 147) depicts the same view with the surrounding buildings edited out. Hassam manipulates the same material to very different ends, producing here an idyllic, almost pastoral image of the city. Reality, Hassam maintained, was always subordinate to the artist's judgment: "The definition so often given of the work of modern painters in landscape—which is, that they take a motif anywhere, as if looking out of an open window, and paint it just as they see it—is partly erroneous, only a half truth. These painters do try to give you frankly the aspect of the thing seen in its fundamental and essential truths; but that they do not place things as they feel they should be placed to get the balance and beauty of the whole, well seen within the frame, is a mistaken idea."[54]

Hassam's increasing absences from New York suggest a growing antipathy toward city life in general, and he said as much to Florence Griswold in December 1906: "I don't know that I wish a very large dose of New York for any of my friends."[55] One was certain to find Hassam in the city only in winter. At other times, his apartment became a pied-à-terre, serving for a stop-over of a day or two while the artist was en route to other desti-

nations. "I am the Marco Polo of the painters," he happily told Miss Griswold," [going] from Paris to Portland, Oregon and why not say Pekin."[56] While he mostly traveled a well-beaten path, at times it seems that he positively disliked staying in one place. In 1906, for instance, we know that he made separate trips to Old Lyme in May, June, and July; visited Weir in Branchville, Connecticut, in June or early July; spent August on the Isles of Shoals; stopped at New London, Connecticut; was at Wainscott, Long Island, in September; and finally returned to Old Lyme in mid-October and early November.

The city that Hassam had come back to after his European tour and that he now increasingly sought to escape from was in the process of radical transformation. In 1897 a Greater New York was created by charter out of five boroughs, nearly doubling the city's population. Within a decade New York had assumed a new aspect. The gracious, boisterous city that Hassam first encountered was all but gone. Motor buses had replaced horsedrawn trolleys on Fifth Avenue, subways had been opened, and the elevated railroads, now electrified, had dispensed with their picturesque steam engines. While private hackney cabs and hansom carriages were still in evidence, their numbers grew fewer each year.

Many of Hassam's favorite landmarks disappeared. The Stewart Mansion on Thirty-fourth Street (see fig. 74) was torn down in 1901 to make way for a bank; the place where "The Little Flower Shop" (fig. 70) once stood became, in 1902, the

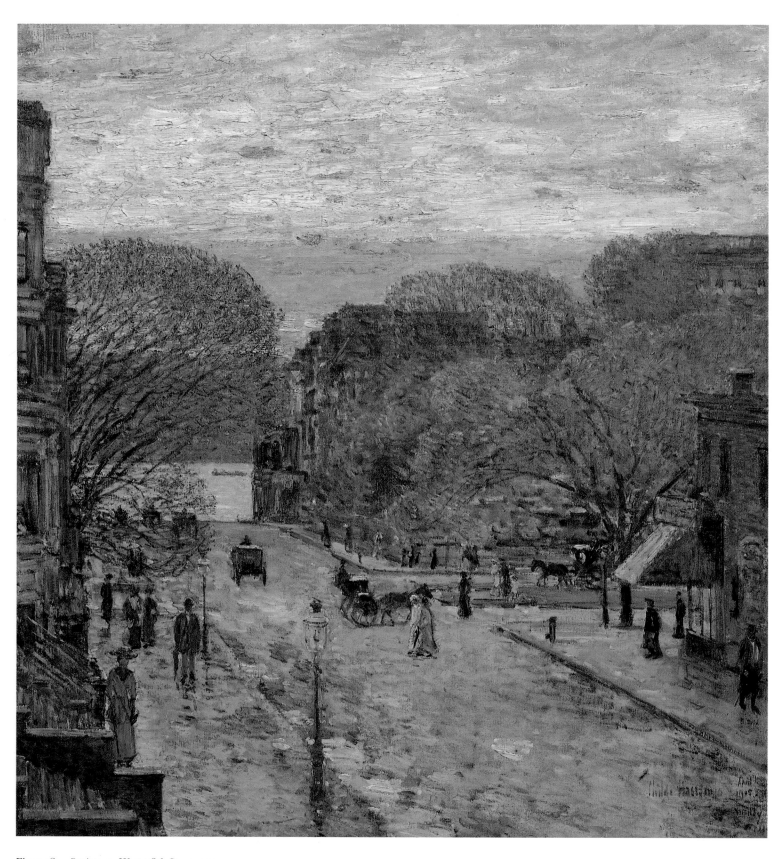

Fig. 148 *Spring on West 78th Street,* 1905.
34 x 30 in. (86.4 x 76.2 cm). Private collection

Fig. 149 *Brooklyn Bridge in Winter*, 1904.
30 x 34¹⁄₁₆ in. (76.2 x 86.5 cm).
Telfair Academy of Arts and Sciences,
Savannah, Georgia; Museum Purchase

Fig. 150 *Shoveling Snow, New England*, c. 1905.
18 x 22 in. (45.7 x 55.9 cm). Gift of
Mr. Hubert Peck in memory of his wife
Romaine Pritchard Peck,
Huntington Museum of Art, 89.34

Fig. 151 New York Stock Exchange.
Photograph by Adolph Wittemann, c. 1907

Fig. 152 The artist in Philadelphia, April 1908.
Photograph by Haeseler Photography Studios

site of the city's first skyscraper, Daniel Burnham's Flatiron Building; the venerable Fifth Avenue Hotel was demolished in 1908; and over Madison Square there loomed the fifty-story Metropolitan Life Insurance Company Building, New York's tallest building. Whereas tall buildings had previously pierced the city skyline like isolated cathedral spires, by the end of the 1900s structures of twenty stories or more were commonplace in New York. Its financial district was so densely packed that the lower reaches of Broadway were described at the time as "canyon-like."[57]

Hassam rather admired the density of the skyscraper city for its beauty under certain picturesque conditions and as an American phenomenon. By the mid-1900s he had begun painting distant views of Manhattan's skyline, the individual forms shrouded in a golden atmosphere.[58] "One must grant of course that if taken individually a skyscraper is not so much a marvel of art as a wildly formed architectural freak," he declared. "It is when taken in groups with their zig zag outlines towering against the sky and melting tenderly into the distance that the skyscrapers are truly beautiful. Naturally any skyscraper taken alone and examined in all its hideous detail is a very ugly structure indeed, but when silhouetted with a dozen or more other buildings against the sky it is more beautiful than many of the old castles in Europe, especially if viewed in the

early evening when just a few flickering lights are seen here and there and the city is a magical evocation of blended strength and mystery."[59]

Hassam memorialized the new buildings in *Lower Manhattan* (formerly *Broad and Wall Streets*) (fig. 153), a view toward the intersection of Broad and Wall streets with the porticoed facade of the New York Stock Exchange, built in 1903, visible at left and a corner of the United States Sub-Treasury Building (where George Washington had taken the Oath of Office in 1789) in the distance. The juxtaposition of architectural styles in the painting, from Federal to neo-classical, from neo-Renaissance to skyscraper modern, constitutes a paradigm of the transient and eclectic nature of the city. Adopting a characteristically high viewpoint, and employing an extremely tall canvas, Hassam overawes the spectator with a wall of buildings that reaches upward beyond the frame. The human element is much diminished, as the pedestrian crowds merge into indistinguishable clumps, broken only here and there by silhouettes recognizable as human figures or hansom cabs. While only a corner of the sky is visible, the architecture is bathed in light, with white, light blues, and grays striking a buoyant, optimistic note in spite of the overbearing mass. Hassam included the picture among the works he selected for the tenth anniversary exhibition of the Ten in 1908.

Fig. 153 *Lower Manhattan*
(originally *Broad and Wall Streets*),
1907. 30¼ x 16 in. (76.8 x 40.6 cm).
Herbert F. Johnson Museum of Art,
Cornell University;
Willard Straight Hall Collection,
Gift of Leonard K. Elmhirst, 94.70

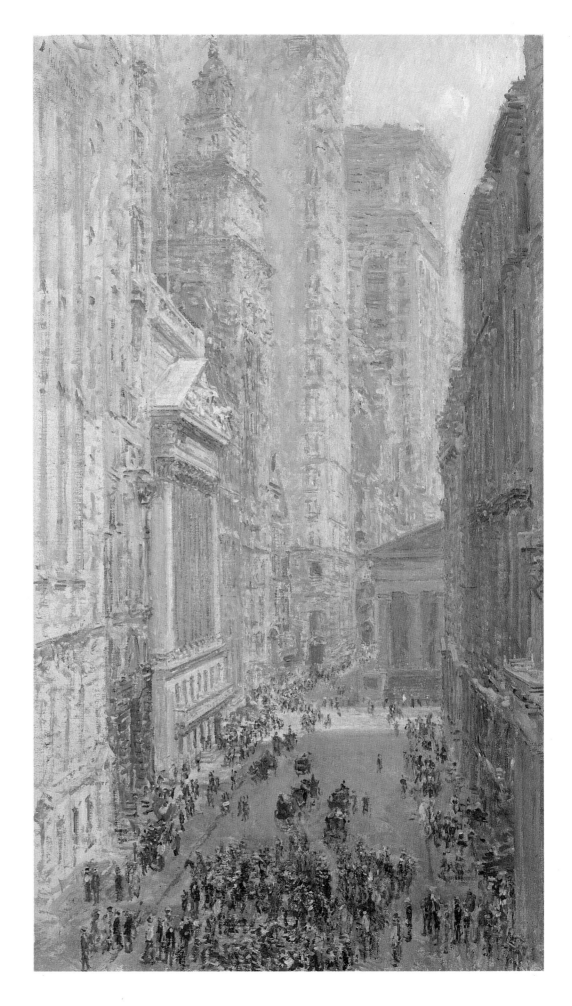

Fig. 154 *Afternoon Sky,
Harney Desert*, 1908.
20⅛ x 30⅛ in. (51.1 x 76.5 cm).
Portland Art Museum; Gift of
August Berg, Henrietta E. Failing,
Winslow B. Ayer, William
D. Wheelright, I. N. Fleischner,
estate of D. P. Thompson

In the fall of 1908 Hassam prepared to move yet again, this time to a new cooperative building then under construction at 130 West 57th Street. He had already vacated his Sixty-seventh Street address and was left without an apartment until December, when the new structure was scheduled for completion.[60] He took the opportunity to make another trip west to visit C. E. S. Wood in Oregon, evidently intending to resume the painting campaign in the Harney desert which, four years earlier, he had cut short in order to serve on the jury of that year's Carnegie International.[61] He had gone to Oregon in 1904 to install a mural he had painted for Wood's study, which Wood hoped would transform the space from Victorian clutter to "Greek Simplicity." Wood's unrealized hope was to have three murals done by each of his best artist friends: Hassam for the study, Weir for the dining room, and Albert Pinkham Ryder for the hall.[62] Hassam's was the only room completed.

On his return to Oregon in 1908, Hassam spent about two months during September and October camping and painting near Burns, in eastern Oregon at the junction of the Malheur and Harney deserts. In a few lines written to Weir from the desert, he eschewed talk of art in favor of their mutual interest in hunting, fishing, and good food: "200 miles in the desert — with wood trout a thousand yards long. Mallard ducks so thick they knock your hat off when you put your head out of cover. Venison, hoe cake, and alfalfa honey. Here is some on the card. [signed] Marco Polo Muley Hassam."[63] He was evidently in high spirits, for Wood remarked that, even in the midst of terrible weather, Hassam "takes everything as a joke." In fact, distracted by his pleasure in the outdoors, he seemed to need some urging to work. Said Wood: "if I hadn't nagged Hassam, he would not have brought half that he did out of the Desert.

That *Golden Afternoon* in the Metropolitan Museum, the most poetical thing of his — would never have existed if . . . I hadn't gone to the carpenter shop, made the stretcher, stretched the canvas and galvanized old Muley."[64] In the end, Hassam managed to produce a great number of canvases and watercolors, many of which were shown in a special exhibition at the Montross Gallery the following April in New York,[65] and later in Portland, Oregon (see fig. 154).

Hassam took great pride in having explored and painted this uncharted territory, whose beauty he found irresistible: "I was at a point," he declared, "the furthest removed from railroad and telegraph in the United States . . . the Harney desert is probably the least accessible place on this continent. The nearest town — Ontario, Ore — is 187 miles distant. The desert is on a plateau forty five hundred feet above the sea level. The air is limpid and liquid, the skies are stupendous and the distances amethystine."[66] Later, he remarked: "It is an aspect of North America that has not been done (I think) except by me."[67] By early November, Hassam was back in Portland, where he painted a number of portraits of Wood's family and friends, before returning home for good sometime in December.

Maude Hassam, meanwhile, had remained in New York through the fall, attending to her husband's correspondence from temporary quarters in the Hotel Gregorian on West Thirty-fifth Street. The Hassams expected to move into their new apartment on Fifty-seventh Street on December 1,[68] but were apparently delayed. It was not until early January 1909 that the artist could report with relief: "We are really not well settled yet, but we are in!"[69] Hassam was to occupy this apartment and studio for the remainder of his life. The change of address marked the beginning of a new chapter in his career.

All uncredited quotations are from documents published on pp. 177-82 of the present volume.

1 *Exposition Nationale des Beaux-arts: Catalogue Illustré des ouvrages de Peinture, Sculpture et Gravure, Exposés au Champ-De-Mars, Le 24 Avril 1897*, Paris, 1897: *Vieillard* (no. 288), *Chambre avec Fleurs* (no. 289), *Jeune Fille dans les rochers* (no. 290), and *Le Soir, Piazza di Spagna* (no. 622). This same group was sent the following fall to the Art Institute of Chicago annual: *The Room of Flowers, Old Age, Summer Sunlight*, and *Spanish Stairs, Rome* (nos. 167-70).

A second group of paintings was left behind after Hassam's departure for the United States and exhibited at the Salon of 1898: *Le Village de Pont-Aven* (no. 595), *Le Soir en Bretagne* (no. 596, illustrated in the catalogue), *Le Clocher de Pont-Aven* (no. 597), *Une Rue à Pont-Aven* (no. 598), *Une Rue à Pont-Aven* (no. 599), *Bretonnes du Pouldu* (no. 600), *Rome* (no. 601), and *Pont Royal (Paris)* (no. 602).

2 See Hassam Papers for the letter of May 18, 1897, confirming his election.

3 See *Offizieller Katalog der VII. Internationalen Kunstausstellung im Kgl. Glaspalaste zu München, 1897, 1. Juni-Ende Oktober, Veranstaltet von der Münchener Künstlergenossenschaft im Vereine mit der "Münchener Secession,"* Munich, 1897: *Sommer; Unter den Weiden; Morgen, Neapel;* and *Vesuv, Abend* (nos. 654-57).

4 See Hassam to John W. Beatty, Dec. 15, 1917; Carnegie Papers, File 673.

5 Madame Blumenthal was alive at this time, and corresponded with the Hassams at least until the late 1920s (see Lockman Interview, Jan. 31, p. 18). For the place of execution of *In a French Garden*, see Adeline Adams, *Childe Hassam*, New York, 1938, p. 100.

6 Hassam in "New York Beautiful," *Commercial Advertiser*, Jan. 15, 1898, p. 1 (Appendix B, 3).

7 We know that he was in New York by December 17, 1897, when he signed the documents relating to the founding of the Ten American Painters. His own account of the group's creation (see note 8 below), indicates that he was there for some time beforehand. Hassam said that he sublet his apartment for a year before sailing to Naples in December 1896 (Lockman Interview, Jan. 31, 1927, p. 33), which suggests that he planned to return the following December.

The belief that Hassam continued his trip through 1898 is presumably based on the existence of about a dozen pictures with European subjects dated to that year. All the works in question, however, are drawings or watercolors that could easily have been produced in his studio from existing studies. One of these, the drawing for *Porte St. Martin* (Museum of Fine Arts, Boston), is even executed on tracing paper. The single oil painting in the group, *Evening Champs Elysées* (private collection), clearly has had its date altered from 1897 to 1898. All were used as illustrations in Hassam's book *Three Cities*, a compendium of New York, London, and Paris scenes published in New York in 1899. As he had done earlier for his illustrations in William Dean Howell's *Venetian Life*, Hassam seems to have produced these 1898 European subjects from works in his portfolio.

The possibility that Hassam returned to Europe at some time during 1898 cannot be ruled out entirely. However, no independent documentation exists for such a trip, while correspondence places him in America in January, March, June, August, September, and December 1898.

8 See Ulrich W. Hiesinger, *Impressionism in America: The Ten American Painters*, Munich, 1991, *passim*.

9 Hutchins Hapgood, *A Victorian in the Modern World*, New York, 1939, p. 139.

10 *Commercial Advertiser*, Jan. 8, 1898, p. 1; reprinted in Hiesinger, *op. cit.*, p. 229, II, a.

11 Hassam, "Reminiscences of Weir," in *Julian Alden Weir: An Appreciation of His Life and Works*, The Phillips Publications, No. 1, New York, 1922, p. 68.

12 "'Seceders' Open Their Exhibit," *New York Herald*, Mar. 31, 1898, p. 14.

13 "Ten American Painters," *World*, Apr. 3, 1898, p. 14.

14 "The Art World," *Commercial Advertiser*, Mar. 30, 1898, p. 6.

15 See "Ten American Painters," *New York Daily Tribune*, Mar. 30, 1898, p. 6.

16 See "The National Academy of Design," *Art Amateur* 38 (May 1898), p. 131.

17 Hassam to John W. Beatty, Dec. 12, 1898; Carnegie Papers.

18 Hassam to John W. Beatty, Dec. 26(?), 1898; Carnegie Papers.

19 See Lockman Interview, Feb. 2, 1927, p. 10. The windmill pictures were later exhibited at the Macbeth Gallery, New York, as *Old Hook Mill, East Hampton* and *Windmill at Sundown, East Hampton;* see *Exhibition of Paintings by Childe Hassam, N. A., Covering the Period from 1888 to 1919*, April 1929, nos. 10 and 25. The site of *July Night* is identified by Adams, *op. cit.*, pp. 91-92.

For Donoho, see Ronald G. Pisano, *G. Ruger Donoho (1857-1916): A Retrospective Exhibition*, Parrish Art Museum, Southampton, N.Y., Apr. 8-May 15, 1977.

20 See J. Alden Weir to C. E. S. Wood, n. d. (probably June 1913); quoted in Dorothy Weir Young, *The Life and Letters of J. Alden Weir*, New Haven, 1960, p. 242: "He [Hassam] goes now to the Isles of Shoals where it seems to fascinate him and where there is no well to fall into. He is a great lover of swimming and although the weather is as cold as the Arctic he revels in it." See also Hassam to J. Alden Weir from Old Lyme, July 3, 1905: "I shall stop there [Stratham, N. H.] on my way to the Shoals. I feel the call of the real ocean, and I am dying for a swim. The Sound does not seem like the real thing" (Weir Papers).

21 *Bathing Pool, Appledore*, 1907; Museum of Fine Arts, Boston.

22 Hassam to C. E. S. Wood, Dec. 15, 1927; Wood Papers.

23 The painting illustrated here as fig. 131, although undated, is virtually identical to one in the Newark Museum bearing the date 1899.

24 Hassam to John W. Beatty, Aug. 1901; Carnegie Papers, File 26.

25 See his letters to Mrs. G. A. Ball, Oct. 28, 1901 (George and Frances Ball Foundation, Muncie, Indiana; quoted in *Childe Hassam in Indiana*, exhibition catalogue, Ball State University Art Gallery, 1985, p. 66), and John W. Beatty, Nov. 4, 1901 (Carnegie Papers, File 30).

26 Among them were Allen Butler Talcott, Robert Sewell, Frank Vincent DuMond, and, acting as president, Henry Ward Ranger. For accounts of the cooperative venture, see Harold Spencer, in *Connecticut and American Impressionism*, exhibition catalogue, William Benton Museum of Art, University of Connecticut, Storrs, 1980, pp. 46 and 55, n. 2, in which two contemporary articles are cited: "Co-operative Studio Building for New York Artists," *Commercial Advertiser*, Mar. 28, 1903, p. 5, and "Artists Who Pay No Rent," *Brooklyn Daily Eagle*, July 7, 1907. For Hassam's account, see Lockman Interview, Jan. 31, 1927, pp. 32-33, and Feb. 2, pp. 6-7.

27 Hassam to A. H. Griffith, Mar. 29, 1903; Detroit Institute of Arts archives. Judging from a comment made by Weir the following summer, Hassam's financial condition did not soon improve. Hassam Papers, J. Alden Weir to Hassam, Aug. 2, 1903.

28 Jerome Myers, *Artist in Manhattan*, New York, 1940, p. 101.

29 Hassam to John W. Beatty, Jan. 11, 1901; Carnegie Papers, File 21.

30 At the Salon of 1905 Hassam exhibited *Printemps (le Central-park, New York), La Neige à New York, Juin*, and *La Petite Maison blanche (Nouvelle-Angleterre);* at the 1906 Salon he showed *L'Opale, Juin, le matin*, and *La Mer au grand matin*. He afterward transported the latter group to the Durand-Ruel gallery in Paris, and thence to the Venice Bien-nale. See Hassam to Durand-Ruel gallery, Paris, May 23 and June 26, 1906, and Feb. 2, 1907; Durand-Ruel archives, Paris.

31 See *Messieurs Durand-Ruel... quelques œuvres récents de Childe Hassam exposées du lundi 9 au jeudi 19 Septembre,* 16 Rue Laffitte, Paris, September 1901. The works included *Naples, le matin; Le Quai Voltaire, Paris; La Promenade, après-midi; L'Escalier des Espagnols, Rome; Jardin à Ermont; Pommiers et pruniers en fleurs; Pont-Aven; Le Soir: Gloucester; Le Calfatage;* and *Fleurs: Nasturtium et nymphea* (information courtesy Durand-Ruel archives).

32 A. T., "Chronique," *L'Art Décoratif* 37 (Oct. 1901), p. 41: "M. Childe Hassam nous montre une dizaine de toiles claires, aérées et doucement fleuries. C'est la vision d'un œil délicat, la touche d'une main légère, l'œuvre d'un artiste sensible à la beauté des choses, mais plus curieux d'éprouver des émotions nouvelles que d'approfondir l'émotion présente. Aucun effort pour dessiner les silhouettes, établir les plans, donner le relief et la solidité. M. Childe Hassam harmonise nonchalamment des taches délicieuses.... Autant de sites, autant d'images aimables et flottantes. Peinture à fleur de toile et sensations à fleur d'âme!"

33 This picture was christened *Promenade in the Bois de Boulogne* when it was discovered in France not many years ago. Its relationship to other Central Park scenes (see figs. 107, 122), however, leaves little doubt as to its American subject. In a letter to Hassam of April 24, 1901, Constant Coquelin referred to a painting "qui represente un coin de votre park avec les enfants" (Hassam Papers). Hassam's account of their meeting is found in Lockman Interview, Feb. 2, 1927, p. 1ff. See also *Herald*, Apr. 29, 1901, p. 3.

34 *Commercial Advertiser*, Mar. 19, 1901, p. 6.

35 Hassam Papers, Hassam to J. Alden Weir, July 17, 1903.

36 See *ibid.*, Hassam to J. Alden Weir, Oct. 20, 1903.

37 Other versions in oil are in the Albright-Knox Art Gallery, Buffalo (1905), the Parrish Art Museum, Southampton (1906), and a private collection (*Old Lyme Church, Moonlight* or *The Church Nocturne—Old Lyme*, 1905). The Old Lyme Church, since rebuilt, was destroyed by fire on July 2, 1907, prompting an indignant response from Hassam in a letter to Florence Griswold (Griswold Papers).

38 Quoted in Young, *op. cit.*, p. 192.

39 Hassam Papers, autobiography, p. 5.

40 Hassam to J. Alden Weir, Aug. 12, 1903, Weir Papers; quoted in Young, *op. cit.*, p. 218.

41 J. Alden Weir to C. E. S. Wood, Feb. 1904; quoted in Young, *op. cit.*, pp. 221-22.

42 C. E. S. Wood to his daughter Nancy, Sept. 19, 1904, from Seattle; Wood Papers. Wood illustrated his point by naming other artists and writers who had suffered drinking problems.

43 See Harrison Morris, *Confessions in Art*, New York, 1930, p. 189.

44 Hassam to J. Alden Weir, Aug. 12, 1903; Weir Papers: "I did two landscapes at Lyme and started and nearly finished two figure things to be finished in the studio. One a figure at an open window and the other a nude. I did work steadily there and I like the place."

45 In 1898 he exhibited *The Bather*, in 1899 *The Brook* and *Morning Mist*.

46 Hassam said that, even in Paris in the 1880s, he knew of Puvis de Chavannes, who occupied a studio near his own (Lockman Interview, Jan. 31, 1927, p. 18). Puvis' paintings in the Boston Library he called "one of the most beautiful mural decorations in the world" ("Reminiscences of Weir," pp. 71-72).

47 Lockman Interview, Jan. 31, 1927, p. 19.

48 Royal Cortissoz, *New York Daily Tribune*, Jan. 14, 1905, p. 9.

49 Hassam Papers, clipping from *Brooklyn Eagle*, Jan. 15, 1905.

50 Kenyon Cox, "The Winter Academy," 1907, unidentified clipping in Hassam Papers.

51 "A Painter of Sunlight," *New York Times*, Jan. 14, 1905, p. 9.

52 "Ten American Painters," *Artist* 25/26 (May—June 1899), p. vii. Even Hassam's friends were apparently troubled, as John Kimberly Mumford testified: "He has made exhaustive study of the nude. His friends feared at one time that flowery fields and shadow flecked stream sides, traversed by nude figures, were going to become a habit with him. That, too, he outgrew" ("Who's Who in New York—No. 75," *New York Herald Tribune*, Aug. 30, 1925, p. 11). Carl Zigrosser (*A World of Art and Museums*, Philadelphia and London, 1975, p. 20)

remarked: "I liked his etchings of city scenes and interiors with figures. He was adept at suggesting atmosphere and the play of light. I did not like his nudes en plein air; I considered them stiff and wooden. He, however, set great store by them, and was always asking me if I did not believe that they were better and solider than Zorn's photographic nudes. He could not see why Zorn should be so popular."

53 James W. Pattison, "The Art of Childe Hassam," *House Beautiful* 23 (Jan. 1908), p. 19.

54 In "John Twachtman: An Estimation, II," *North American Review* 176 (Apr. 1903), p. 556.

55 Hassam to Florence Griswold, Dec. 11, 1906; Griswold Papers.

56 Hassam to Florence Griswold, postmarked Mar. 20, 1906; Griswold Papers.

57 See Karl Baedeker, *The United States . . . Handbook for Travellers*, 4th ed., Leipzig, New York, and London, 1909, p. 34. The best known contemporary view of New York's transformation is John C. Van Dyke, *The New New York*, New York, 1909. For bibliography on the growth of New York during this period, see Wanda M. Corn, "The New New York," *Art in America* 61 (July—Aug. 1973), pp. 58-65, and, more recently, Erica E. Hirshler, "The 'New New York' and the Park Row Building: American Artists View an Icon of the Modern Age," *American Art Journal* 21, no. 4 (1989), pp. 26-45.

58 Among the earliest of these was the painting titled *New York* (unlocated), a view of the city skyline seen from the Battery. It was begun in 1904 and completed three years later, in which time, said a reviewer for the *New York American* (Hassam Papers), the skyline had changed considerably. The reviewer for the *Evening Mail* (Dec. 18, 1907) described its line of skyscrapers as seen "through a thick golden afternoon mist . . . deprived of its rawness and afflictive realism — the whole thing poetized." At the Montross Gallery in 1905 Hassam

showed a view of lower Manhattan titled *A Sunset in the October Haze* (unlocated). Other skyscraper pictures include *October Haze* (1910; private collection) and *Manhattan's Misty Sunset* (1911; Butler Institute of American Art, Youngstown, Ohio).

59 Quoted in "New York, the Beauty City," *Sun*, Feb. 23, 1913, p. 16 (Appendix B, 4).

60 C. E. S. Wood wrote to his daughter Nancy from the desert: "Mr. Hassam is a jovial Marco Polo and takes everything as a joke. I gave him your message about burglars *also* told him you had a spare room for him [?]. He said that was charming and he would be glad to come as he would be homeless till December — when his flat & studio will be completed . . . he has done some stunning desert scenes — big and powerful — but they will not be generally popular I think" (Wood Papers).

61 Hassam had gone to Oregon at about the beginning of August and, on September 19, wrote from Portland to say that he would be in Pittsburgh by October 14 to serve as a Carnegie juror. Hassam to John W. Beatty, Sept. 19, 1904; Carnegie Papers, File 49. For Hassam's trip, see a letter from C. E. S. Wood to J. Alden Weir, quoted in Young, *op. cit.*, p. 223.

62 This project was first mentioned in a letter of November 28, 1903, from Wood to J. Alden Weir (Wood Papers): "Hassam is *going* to do a wall for my den." Wood returned to it on January 2, 1904: "I had a nice letter from old Hassam. He is going to paint a panorama for my room. Poor old chap. I do hope he's not too serious about it. These resolves are good. . . . But I should hate to have him in the present state of my finances do the usual self immolation of impulsive and generous artistic souls" (Wood Papers).

On May 23, 1904, Wood wrote to Weir from Portland: "Did you ever see such a cuss whirled in and painted me a whole wall for my studio, and they tell me it is beautiful. I am anxious to see it. It grew out of a remark of mine that I was tired

of my *bric a brac* house like a dealer's shop, and wanted to get back to Greek Simplicity. The whole room done as an intentional whole by one man—and I suggested him for my study you for my Dining Room and Pinky for the hall as the largest of all." C. E. S. Wood to J. Alden Weir, May 23, 1904; Wood Papers (also quoted in Young, *op. cit.*, p. 222).

In addition to installing the mural, Hassam painted Pacific coastal scenes, desert views, and portraits, including one, titled *Amaryllis*, that he described as "an effort at exact portraiture in the open air, rather than the mere use of a figure in an open air setting." Hassam to John W. Beatty, Sept. 19, 1904; Carnegie Papers, File 49.

63 Hassam to J. Alden Weir, Sept. 17, 1908; Weir Papers.

64 C. E. S. Wood to J. Alden Weir, Dec. 29, 1916, Wood Papers; quoted in Young, *op. cit.*, p. 254.

65 *Paintings of Eastern Oregon by Childe Hassam*, Montross Gallery, New York, April 1909.

66 Quoted in "Desert Pictured by Mr. Hassam," unidentified clipping in Hassam Papers (Dec. 1908). Hassam reportedly said that he spent four months in the desert. However, in a letter of November 5 to John W. Beatty from Portland (Carnegie Papers, File 673) he stated: "I have been out here in the Harney desert for two months."

67 Hassam to C. E. S. Wood, Feb. 7, 1929; Wood Papers.

68 See Maude Hassam to John W. Beatty, Nov. 11, 1908, from the Hotel Gregorian, 42 West 35th Street; Carnegie Papers, File 673: "I am answering for Mr. Hassam as he is away in the extreme west. . . . All Mr. Hassam's mail as well as my own is forwarded here to the above address so that I can attend to all matters that require immediate attention. Our address after December 1st will be 130 West 57th Street—Until that time I will be here at the Gregorian and Mr. Hassam in Portland Oregon."

69 Hassam to John W. Beatty, Jan. 10, 1909; Carnegie Papers, File 673.

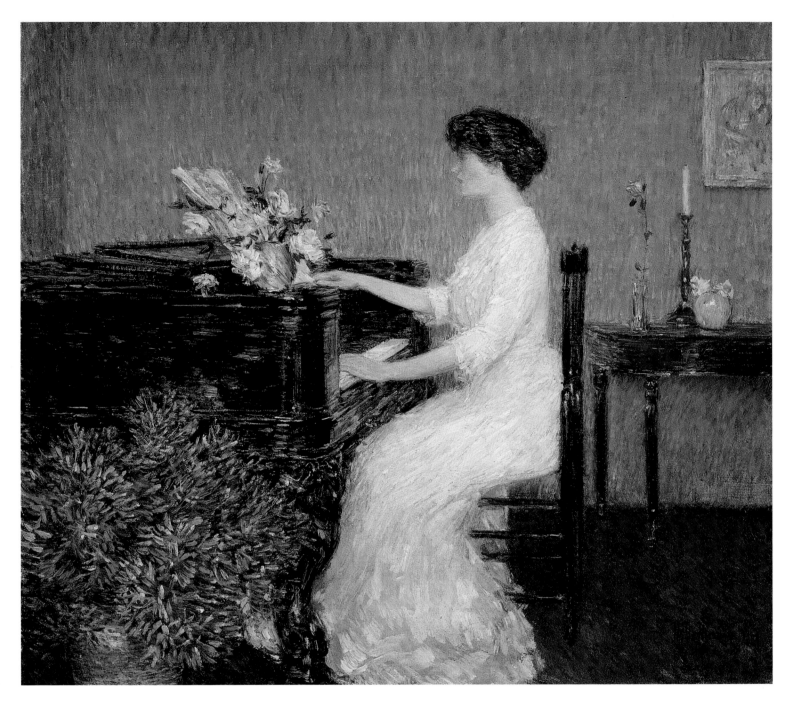

Fig. 155 *At the Piano*, 1908.
24⅛ x 26⅛ in. (61.3 x 66.4 cm).
Cincinnati Art Museum; Gift of Mrs. A. B. Closson, 1971.143

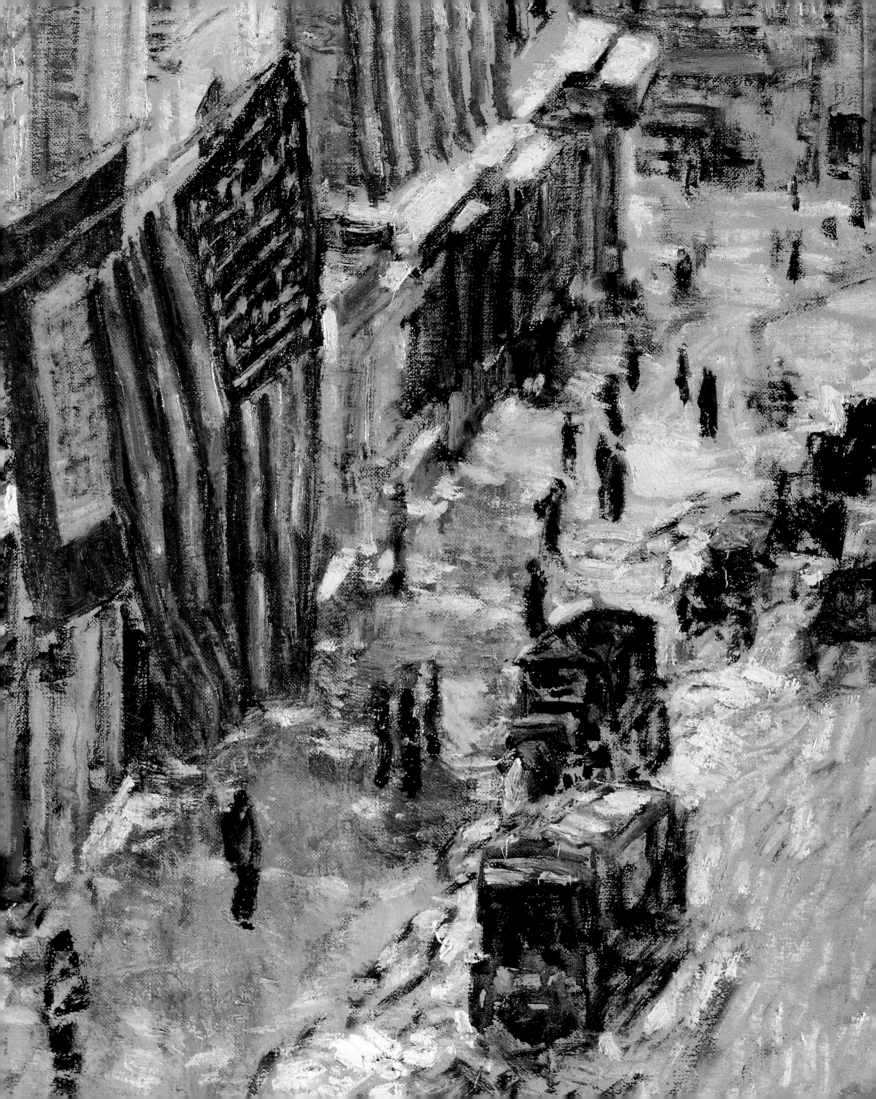

V LATE YEARS 1909-1935

It was evidently a rule of Hassam's — whether in Boston, Paris, or New York — to maintain as high a standard in living and working arrangements as he could afford. His move to 130 West 57th Street at the beginning of 1909 was obviously sustained by the growing prosperity he had enjoyed through the first decade of the century. Observing this remarkable turn of fortune, J. Alden Weir had commented to C. E. S. Wood not long before: "Our mutual friend Hassam has been in the greatest of luck and merited success. He sold his apartment studio and has sold more pictures this winter, I think, than ever before and is really on the crest of the wave. So he goes around with a crisp, cheerful air."[1]

The cooperative building on Fifty-Seventh Street survives, and Hassam's apartment and studio, though subdivided, can be seen with many of its original features intact.[2] The apartment was a large duplex on the top floor running the entire width of the building. Inside, a large two-story studio with a skylight and floor-to-ceiling windows faced north onto Fifty-seventh Street and offered what was then an open view of Central Park. A narrow iron balcony looked out onto the street below. Hassam's impressive new quarters provided the artist with a distinctive new environment and were thus a stimulus to his work. This fact only became evident with the passing years, however; in the short term, his life resumed its normal course.

In 1909 the artist followed again a busy, meandering schedule. In the spring he was reported "hard at work" in the open country near Portland, Maine.[3] He then spent a month during July and August on the Isles of Shoals and a week in September admiring the fine old houses in Portsmouth, New Hampshire. Immediately afterward, he went to Gloucester, which he had not visited since 1900, and was pleased to find it unchanged. "After ten years," he told Weir, "I'm in this port again and it is really as beautiful as ever. They have put up a few more 'Crabcroft's' and 'Lobster Lodges' but it is not spoiled yet."[4] After returning briefly to New York, Hassam proceeded to Ridgefield, Connecticut, to pay a working visit to his friend Frederick Remington, who had recently bought a house there. The two amused themselves driving around the country in a buckboard,

but adverse weather prevented Hassam from doing much work. "Bad October," he reported, "rain and wind. I have done nothing but 'cuss.'"[5]

Earlier that year, Hassam had sold his painting *Spring Morning* to the Carnegie Museum, Pittsburgh, for the substantial sum of $6,000. Since then, the museum's director, John W. Beatty, had conceived the idea of honoring the artist with a special exhibition of his paintings to coincide with the next year's Carnegie International. While at Ridgefield, Hassam began to work out the arrangements with Beatty, assembling an impressive list of lenders that included major public collections in New York, Washington, Cincinnati, Buffalo, Pittsburgh, Indianapolis, Savannah, Providence, Worcester, and Portland, Oregon. The majority of these works had been painted since the turn of the century, reflecting the role that museum officials had played in the artist's recent success. There were significant private holdings as well. One collector, Alexander Morten, owned twelve Hassams; among the other lenders were the familiar names of Mrs. William H. Bliss, William T. Evans, Desmond Fitzgerald, Henry Clay Frick, A. C. Humphreys, and Dorothy Whitney.

Hassam felt flattered and, to a certain extent, vindicated by Beatty's proposal of an exhibition: "It proves that there is interest enough in the work of a living American painter for them to go to the great expense and trouble of collecting his most important works and showing them properly in an adequate space — a large gallery. If the Metropolitan Museum would do this, it would at least be original and most interesting to the people who enjoy good painting. And some of the Americans are certainly painting well. They would do it at once for a second rate European painter of course!"[6] Although he felt strongly that Americans were prejudiced in favor of European art, he was himself still attracted to European subjects and pictures. The sale of four paintings in May 1910 to his friend C. E. S. Wood, who had just come into some long-awaited money, allowed the Hassams to realize a hoped-for return to Europe that summer. Wood recalled many years later how happy the Hassams had been in the studio, saying "now we can go abroad."[7]

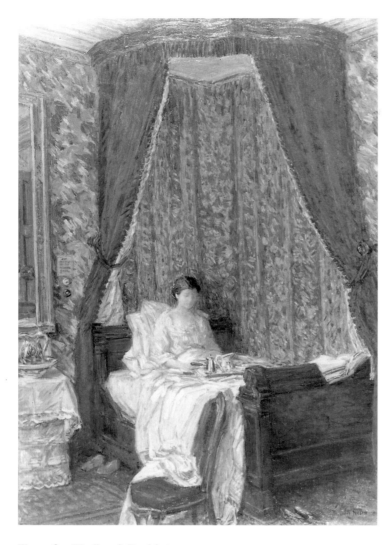

Fig. 156 *The French Breakfast*, 1910.
28⅞ x 19⅝ in. (73.3 x 49.8 cm). Private collection

In June, Hassam and his wife sailed once more for Europe after an absence of thirteen years. First stopping in England, they proceeded to the Netherlands and Belgium, where Hassam painted and visited museums in Haarlem, Amsterdam, The Hague, and Antwerp. He wrote a card to Weir noting the pictures he had seen by Frans Hals and Huigh de Groot.[8]

The Hassams reached Paris in the first week of July, intending to remain for two or three weeks, after which they planned to go to the Côte du Nord to escape the summer heat. Hassam spent a pleasant afternoon in Paris with the painter Henri Le Sidaner, whom he had befriended the previous spring in New York, but in general, the city of his youth had become a disappointment to the aging artist. He complained to Weir that Paris had become "a huge Coney Island—noisy, dirty. The streets are ankle deep in advertising cards and bills and when it rains the whole thing becomes a pulp. The town is all torn up like New York. Much building going on. They out American the Americans!...the town is full of American shops—shoe shops, Tiffany's, Insurance Companys [sic] Automobile and machinery—Everything."[9]

Despite his disenchantment, Hassam did find inspiration in the Bastille Day celebrations that took place during his visit, and reported to Weir that he had finished a canvas on the subject from the balcony of his hotel in the Rue Daunou (fig. 158).[10] Although this was Hassam's first large-scale treatment of the theme, he had portrayed Bastille Day celebrations long before in a series of watercolors and a least one small oil painting done while he was in Paris in the 1880s. These were the forerunners of his famous series of Flag paintings executed not many years later, during World War I.

The small, dated picture *At the Writing Desk* (fig. 157), which shows a woman seated at a desk in a high-ceilinged interior, was probably also painted in Hassam's Paris hotel, as indicated both by the character of the room and the blurred outline of a

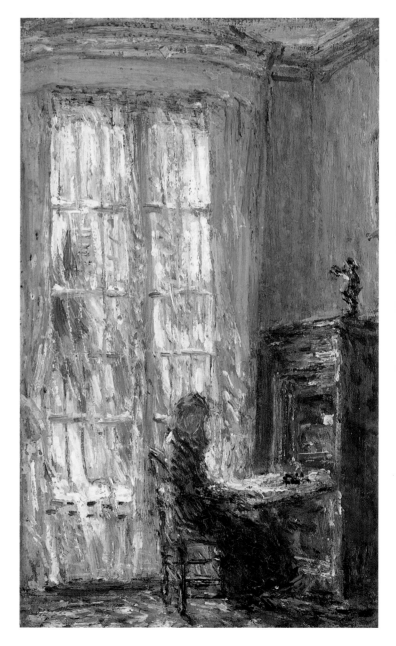

Fig. 157 *At the Writing Desk*, 1910.
Oil on panel, 8½ x 4⅞ in. (21.6 x 12.4 cm). Private collection

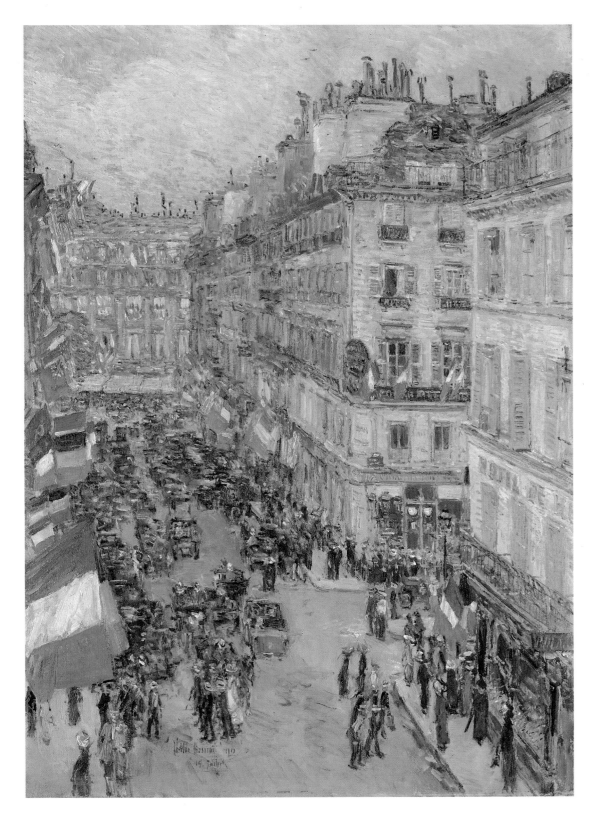

Fig. 158 *July Fourteenth, Rue Daunou*, 1910.
29⅛ x 19⅞ in. (74 x 50.5 cm).
The Metropolitan Museum of Art, New York; George A. Hearn Fund, 1929 (29.86)

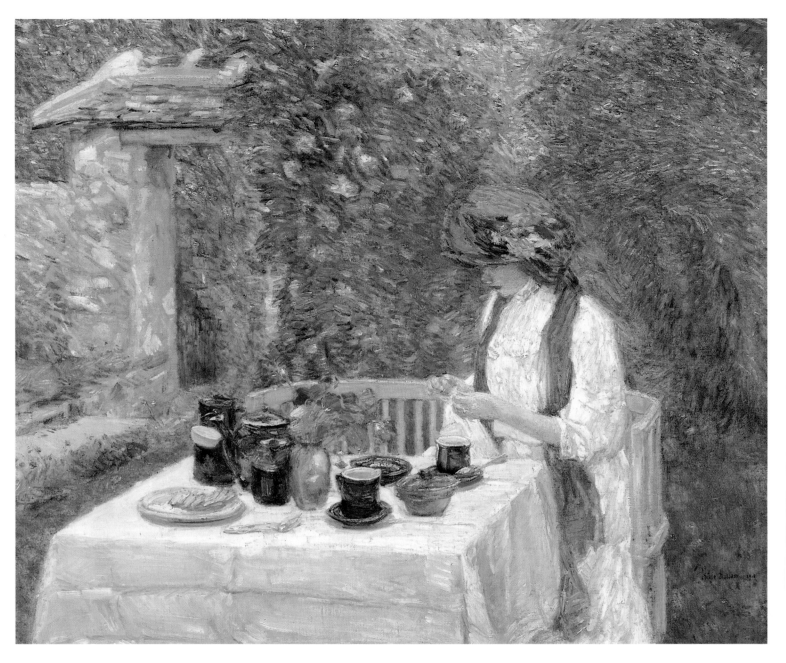

Fig. 159 *The Terre-Cuite Tea Set (French Tea Garden)*, 1910.
35 x 40¼ in. (88.9 x 102.2 cm). Hunter Museum of Art,
Chattanooga, Tennessee; Gift of the Benwood Foundation

tricolor visible through the French doors, with a balcony just beyond. This painting, too, relates to a series, the larger Window pictures then being developed by the artist. Like many of Hassam's small panels of around 1910, it shows his interest in a vibrant new range of warm colors that probably derives from his contact with contemporary French painting. In *The French Breakfast* (fig. 156) bright, decorative surface patterns suggest the influence of the Neo-Impressionist paintings of Pierre Bonnard or Edouard Vuillard, while the still life in *The Terre-Cuite Tea Set* (fig. 159) reflects a study of Auguste Renoir. A critic who evidently knew Hassam actually said that the purpose of the trip was for the artist to "look upon the [old] masterpieces of paint-

ing and form a definitive opinion of these and of the progress of painting through all its periods."[11]

After leaving Paris, Hassam traveled to the Côte du Nord, where he painted several works in the small town of Lannion and at nearby Brélévenez. He also painted for a considerable time at Grez in the Loing Valley. In the fall, after stopping at Nemours, the Hassams went southward through France to Spain. This, according to the artist, had been his main destination from the outset. Probably for a month or more, he painted views in Seville, Madrid, Toledo, Cordova, and La Ronda.[12]

The Hassams returned to New York via Gibraltar in early November 1910.[13] The impact of the European trip was con-

siderable, reinforcing Hassam's classicism and preoccupation with traditional formal problems. One indication of this was his increased interest in pure still life (see fig. 188), but its most striking manifestation occurred in a number of paintings structured around a large window with a female model posed in front of it, which has come to be known as his "Window series" (see figs. 161-63). As so often happened when Hassam developed a seemingly new formula, the central motif of the Window series can be traced back many years—ultimately, to *Summer Evening* of 1886 (private collection), which depicted a woman at an open window. Anticipating the series' features in a more direct way, in 1897 Hassam had painted *The Children* (fig. 160)—probably a portrayal of Twachtman's children in their house in Greenwich—in which he used a large floor-to-ceiling window to backlight the interior and provide the dominant theme.

Besides the light-filled window, what distinguishes the Window series is the frank artificiality of its makeup, each painting typically composed of a single contemplative female model, often dressed in a flowered kimono or posed beside a Japanese screen, in a setting adorned with such artfully arranged props as a bowl of flowers or fruit, or a tea set. Simple variations on this theme were worked out in the early and mid-1900s, although the disappearance of many of these paintings makes it difficult to follow Hassam's progress.

The influences on the series, too, are difficult to disentangle. He might have been encouraged by related experiments among his colleagues in the Ten, particularly Edmund Tarbell and Joseph De Camp, who, after the turn of the century, had begun to paint luminous interiors based on seventeenth-century Dutch models. Historical works encountered on his 1910 European tour may also have inspired Hassam. The sense of *gravitas*, the solemn, ritual bearing of some of the figures in these pictures, recalls nothing so much as a combination of qualities found in Antique statuary and in Italian Renaissance Madonnas placed before distant landscapes. That Hassam was susceptible to such historical influence is demonstrated by admiring remarks he later made about the colors and draftsmanship of the Italian "primitives."[14] The fine, large windows in his Sixty-seventh Street studio, where he painted *Spring Morning* (Carnegie Museum of Art, Pittsburgh), the first picture in the series, and those in his new Fifty-seventh Street apartment gave him the necessary means. In 1910 he settled on the theme in earnest, producing a handful of Window pictures that included the study of a seated, half-length figure called *Contre-Jour* (Art Institute of Chicago), whose title, "Against the Light," clearly describes its thesis.

Rather surprisingly, it was not the main studio on Fifty-seventh Street that Hassam used for his New York window pictures, but rather a small dining room facing south in the living quarters at the opposite end of the apartment. The titles of several pictures, including *The Breakfast Room* and *The Morning Room*, clearly suggest the everyday use of the room, as do the

table settings, fruit bowls, and other details. The room's intimate scale apparently suited the artist's purpose, while the southern exposure provided the dramatic backlight he needed. The window, centerpiece of many paintings, is still *in situ* with its double posts and triple mullions, somewhat age-worn, but otherwise exactly as it appeared when Hassam set up his easel and posed his models eighty years ago.

The Table Garden (fig. 162), one of the earliest and finest of the Window series, was set in this room, where the presence of sprouting plants was meant, as the artist put it on another occasion, to "typify and symbolize growth."[15] With *The Breakfast Room, Winter Morning* (fig. 161), painted the following year, Hassam reduced the size of the figure and opened up a great part of the canvas to the treatment of light. His composition is a remarkable, and undoubtedly conscious, marriage of many different elements, combining within the bounds of a single picture the depiction of interior space and landscape, and the study of figure and still life.

In 1912 the large-scale *The New York Window* won the gold medal at the Corcoran Gallery of Art's fourth biannual exhibition and was purchased for its collection. Hassam's Window pictures were an instant success with museums and, initially, he sold them nearly as fast as he could paint them. *Early Spring* was

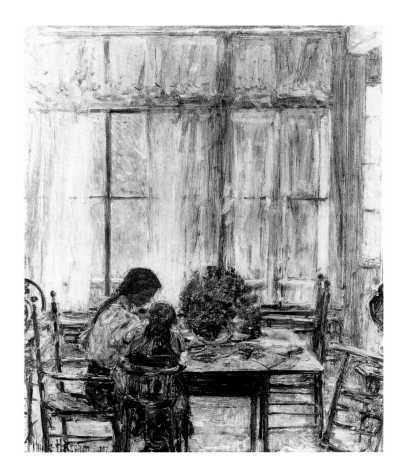

Fig. 160 *The Children*, 1897. 18¼ x 14½ in. (46.4 x 36.8 cm). Cincinnati Art Museum; Bequest of Ruth Harrison, 1940.693

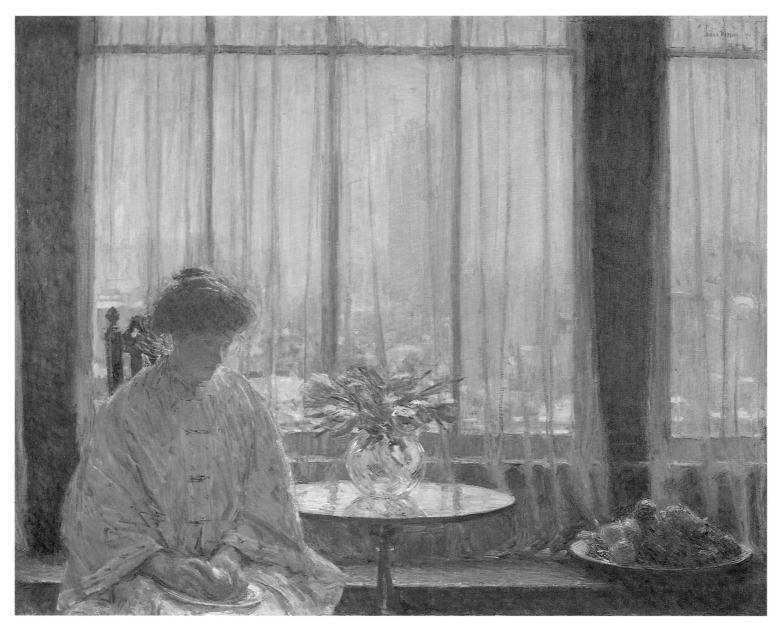

Fig. 161 *The Breakfast Room, Winter Morning*, 1911.
25⅛ x 30⅛ in. (63.8 x 76.5 cm). Worcester Art Museum, Worcester, Massachusetts

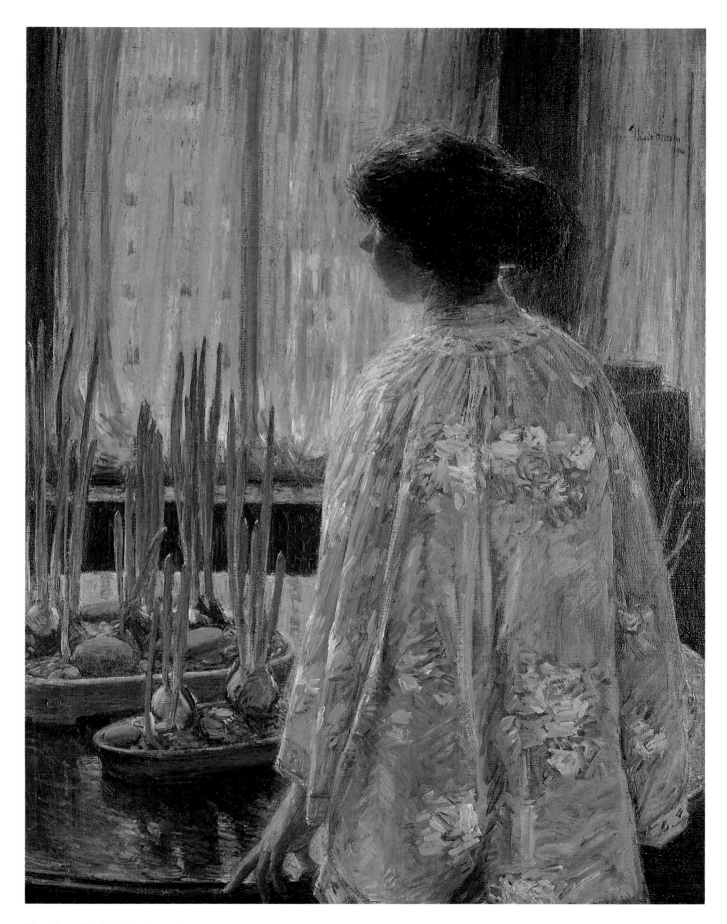

Fig. 162 *The Table Garden*, 1910.
39½ x 30 in. (100.3 x 76.2 cm).
Mitchell Museum at Cedarhurst; Gift of John R. & Eleanor R. Mitchell

bought by the Carnegie Institute, Pittsburgh, in 1909, *Contre-Jour* by the Art Institute of Chicago in 1910, and *The Breakfast Room* by the Worcester Art Museum in 1911.

Notwithstanding their technical excellence, these studio-oriented canvases embody to a certain extent a withdrawal from, if not an outright denial of, Hassam's former purposes. For the artist, however, they represented the surmounting of new challenges. In 1911, when trying to sell *Bowl of Nasturtiums* (unlocated) to the Detroit Institute of Arts, he referred to it as one of his best and most "advanced" canvases. With characteristic immodesty, he told the director that, if he could convince the powers at the museum to buy it, "they will all thank you later for what you did."[16] In this case, the museum shrank from paying the price of $4,500 and instead induced Hassam to sell them *Place Centrale and Fort Cabanas, Havana* (fig. 110), his prize-winning landscape of 1895, for about one-third of that sum.

Although the majority of the Window pictures were painted in New York, Hassam also translated the theme to other locations. *The Gold Fish Window* (fig. 163) was created at the Holley House, Cos Cob, where a model in a flowered kimono posed

before a window overlooking a sunlit garden. The picture is a modified version of a composition first painted in 1912 and must have been completed in the studio. Hassam continued to paint one or two Window pictures each year into the early 1920s; most of these later paintings are in private collections and little known.

The Holley House at Cos Cob, the headquarters of an artists' colony much like that at Old Lyme, provided the setting for a number of other interiors and figure pieces, in which Hassam used local friends as models (see figs. 164-66). Recalling this period, his friend Carolyn C. Mase wrote: "In the good old days of the Holley House, at Cos Cob just before the great war — where he [Hassam] painted some of his most beautiful canvases — he was always a genial, central figure. His wit, his love of literature, his utter lack of ego in his art talks — his universal kindness — made him always a favorite."[17]

Hassam's outlook in these years was especially good, as he continued to enjoy both material success and nearly unanimous critical acclaim. The one misgiving even friendly critics began to have was that he was overproducing, to the detriment

Fig. 163 *The Goldfish Window*, 1916. 33½ x 49½ in. (85.1 x 125.7 cm). The Currier Gallery of Art, Manchester, New Hampshire; Currier Funds, 1937.2

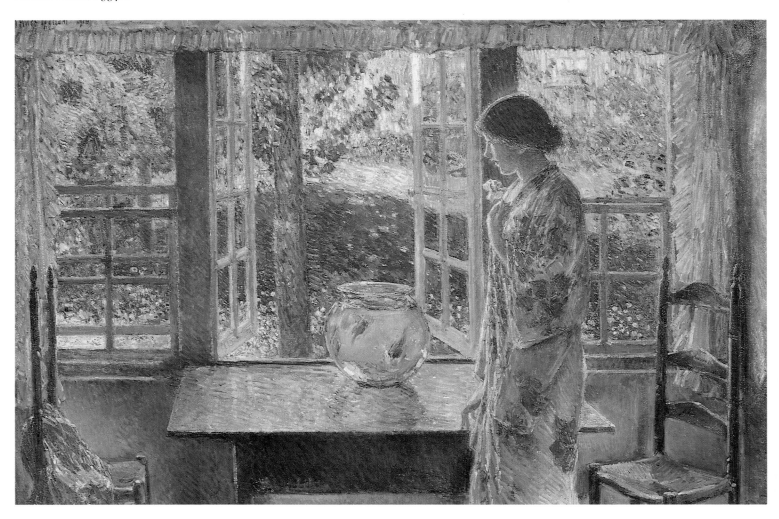

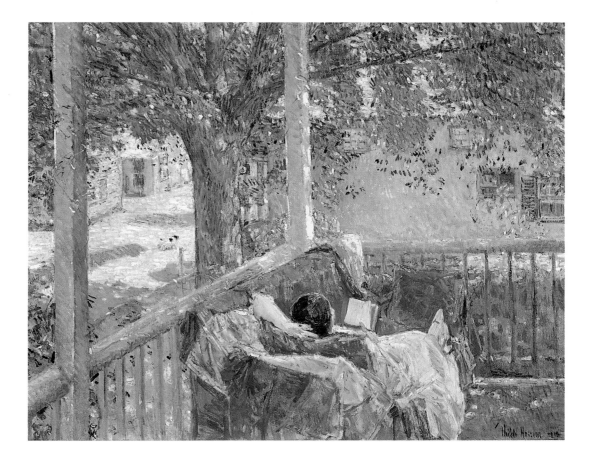

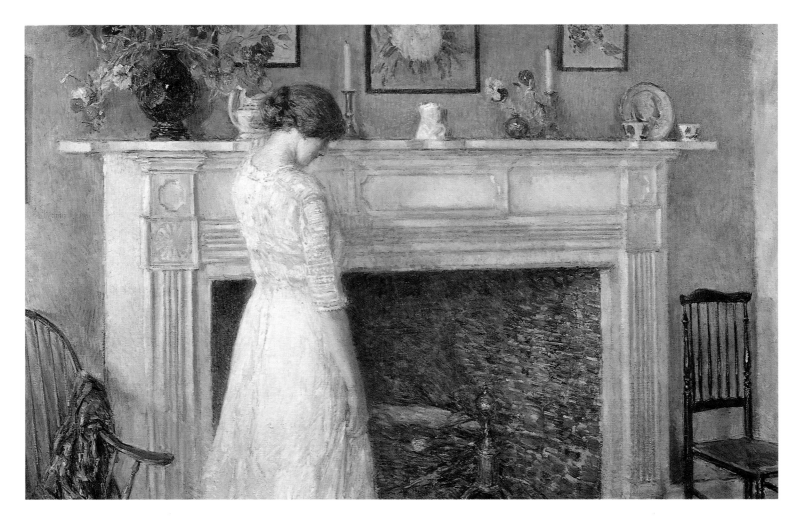

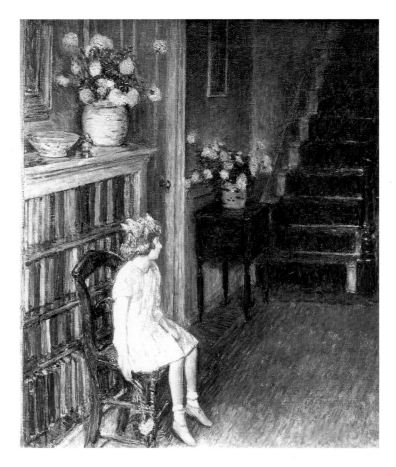

Fig. 166 *Clarissa*, 1912. 24½ x 22 in. (62.2 x 55.9 cm). Private collection. Photo courtesy American Academy of Arts and Letters, New York

of his work. "Think of the appalling number of Hassam pictures there will be in the world by the time the man is seventy years old!" exclaimed a critic after seeing some eighty examples of Hassam's recent work in 1911 at his annual exhibition at the Montross Gallery.[18] Another reviewer of the show suggested that some paintings came perilously close to being "pot-boilers," but were produced, instead, "as though [Hassam] sturdily went on painting regardless of whether or not he found himself in the mood or had tackled a thankless subject." Saying that he would rather own the one watercolor he admired than all six of the canvases recently painted in Spain, this writer (most probably Hassam's friend Royal Cortissoz) explained: "In the one case you have very creditable but not quite successful effort. In the other you have a kind of happy mastery, individuality easily and authoritatively expressing itself. The ups and downs, so to say, of Mr. Hassam's art are obvious. . . . Yet one does not think of him as doubtfully oscillating between success and failure, making one kind of picture at his best and a different kind at his worst. His singleness of aim is manifest. In his work the good and the bad frequently overlap. He is one of those painters of whom it is said that they have the defects of their qualities. Energy like his (and he brims over with it) is perhaps unnecessarily wayward: it has its lucky and its unlucky moments."[19]

In the spring of 1911 Hassam returned to Europe, this time traveling without Maude.[20] Arriving in Paris by late May, he intended to go to Venice, but was forced to cancel his plans owing to reports of cholera there. Frustrated, and disliking the heat of Paris, Hassam abruptly decided to return home and booked passage on the quickest ship. This European trip was to prove his last voyage abroad. He reached America in late June or early July, and apparently made a brief visit to East Hampton, Long Island. He then left for the Isles of Shoals, where we find him in high spirits on July 20: "Here I am catching up on my swimming," he told Weir. "I am very much behind-hand (none last year) and am attending strictly to it. The rocks and the sea are the few things that do not change and they are wonderfully beautiful—more so than ever!"[21]

For some reason, Hassam painted very little at Appledore that year, but produced there the following summer an especially large number of canvases and a series of watercolors notable for their deep, brilliant colors of sapphire and emerald (see fig. 168). His reawakened interest in watercolor during the mid-1910s led him to create several series on particular themes, which he referred to as "sets." He once identified four of these as The Isles of Shoals set, 1912-16; The Hudson River set, 1918 (see fig. 167); The Rockport Quarry set, 1919 (fig. 168); and The Portsmouth, New Hampshire, set, 1920 (fig. 171),[22] with a further Cos Cob set named separately at the artist's Montross Gallery exhibition in 1917.[23] The dates only approximate Hassam's involvement with these themes, since both the Hudson River and the Portsmouth set had been started a number of years earlier. As usual with him, the sets were loosely grouped together by subject and did not originate from a premeditated campaign of work.

Late in 1912 Hassam was offered, but declined, membership in the Association of American Painters and Sculptors,

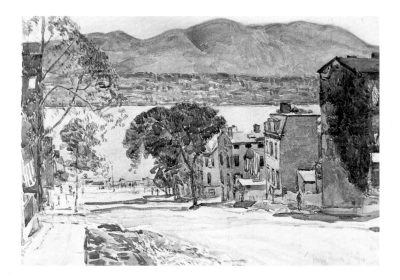

Fig. 167 *Broadway, Newburgh, New York*, 1916.
Watercolor on paper, 16 x 22 in. (40.6 x 55.9 cm).
Colby College Museum of Art, Waterville, Maine

Fig. 168 *Looking into the Beryl Pool*, 1912.
Watercolor on paper,
10¹⁵⁄₁₆ x 15¼ in. (27.8 x 38.8 cm).
Worcester Art Museum, Worcester,
Massachusetts; Bequest of
Mrs. Charlotte E. W. Buffington

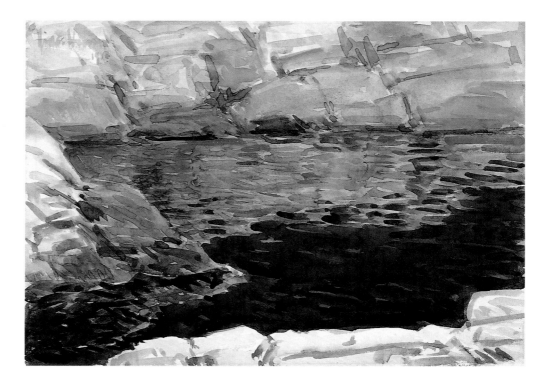

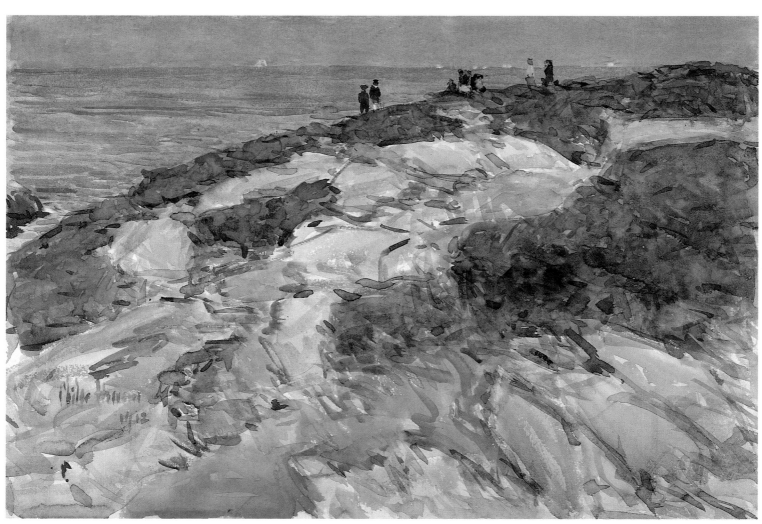

Fig. 169 *Sunday Morning, Appledore*, 1912.
13⁹⁄₁₆ x 19⁹⁄₁₆ in. (34.5 x 49.7 cm). The Brooklyn Museum; Museum Collection Fund, 24.104

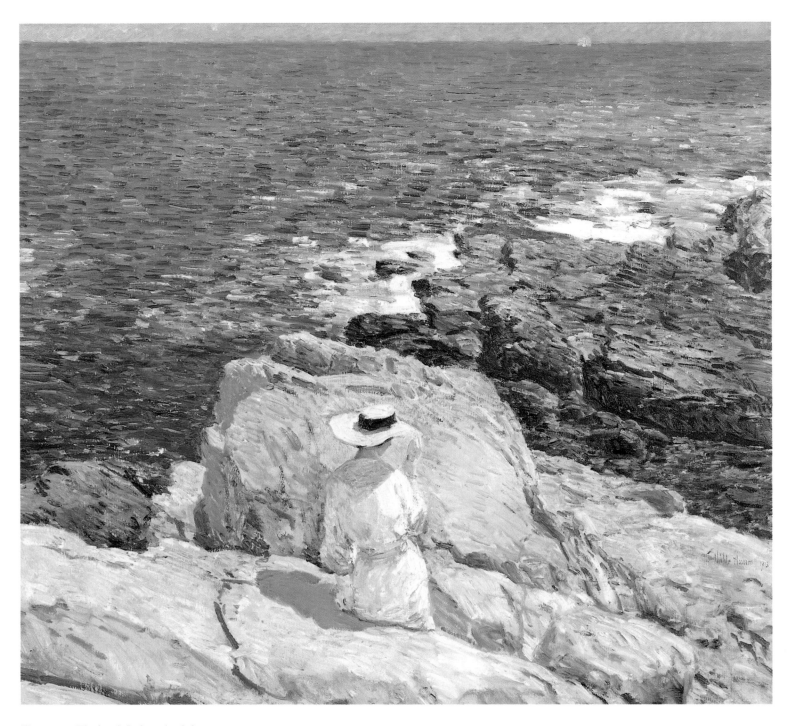

Fig. 170 *The South Ledges, Appledore*, 1913.
34¼ x 36⅛ in. (87 x 91.6 cm).
National Museum of American Art, Smithsonian Institution, Washington, D.C.; Gift of John Gellatly

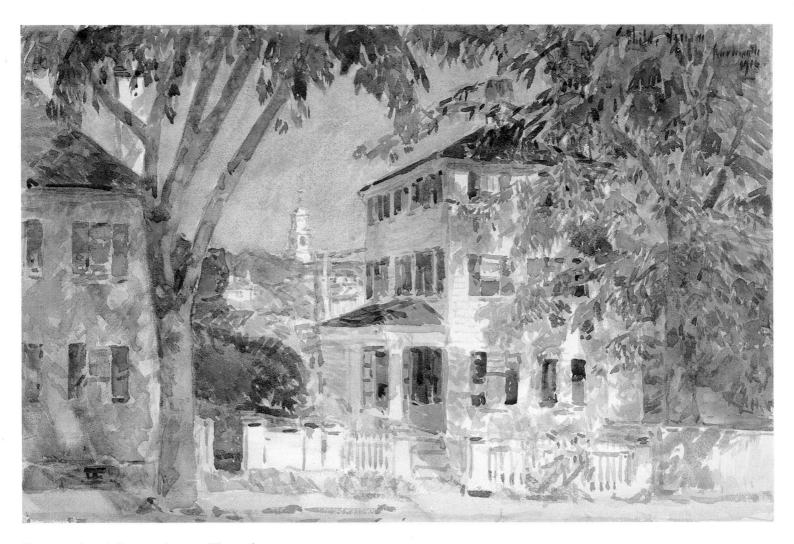

Fig. 171 *Street in Portsmouth*, 1917. Watercolor on paper,
15⅛ x 22 in. (38.4 x 55.9 cm). The Metropolitan Museum of Art,
New York; Rogers Fund, 1917 (17.31.2)

after Weir had abruptly resigned as president when the Association was reported to be "openly at war" with the Academy of Design. The Association was responsible for the famous International Exhibition of Modern Art at the Sixty-ninth Regiment Armory in 1913, which introduced Americans to Cubist, Futurist, and other modernist paintings. Hassam did eventually participate in the Armory Show (as it was universally known) — he and Weir were, in fact, the oldest living painters included — showing six oil paintings, most of them created during his 1897 European tour, as well as five pastels and one drawing.[24] As Hassam's exhibition of fifteen-year-old paintings suggests, Impressionism was by now an established, even a historical style. With the Armory Show's sensational revelation of the latest abstract European and American styles, Impressionism and the artists and critics loyal to its cause were finally and unequivocally stripped of any claim to radicalism.

Hassam's friend Royal Cortissoz said that the artist showed "a momentary pious tolerance" for the modernists after the Armory Show.[25] If that was true in public, his immediate private reaction to the exhibition was unambiguous. When asked in May 1913 to consider how art criticism might best serve artists, Hassam, taking unmistakable aim at the Armory Show, replied: "By attacking all shams, and showing humbugs to the people in a clear light. And this is the age of quacks, and quackery, and New York City is their objective point."[26]

In the following years, Hassam and Weir both lent their support to various modern organizations, but they did so as survivors, and their participation was more a matter of moral support rather than a vital contribution. Their legendary status was acknowledged by the painter Frank Crowninshield when he introduced them at a press dinner in 1916 for the American Society of Independents. Calling the two artists "the mammoth and the mastodon of American art," he said: "You probably did not know that these two prehistoric monsters were still alive, yet here they are, Mr. J. Alden Weir and Mr. Childe Hassam."[27]

Hassam's anger at the attention given the modernists may have been partly founded on his disappointment in the 1913 exhibition of the Ten, which opened while the Armory Show

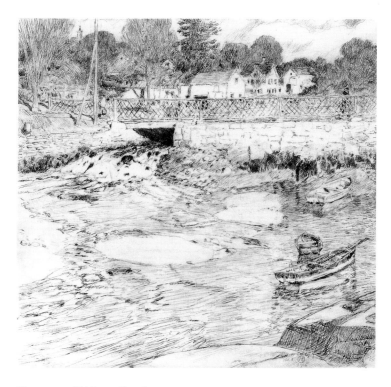

Fig. 172 *Old Lace*, October 1915.
Etching, plate size: 6⅞ x 7 in. (17.5 x 17.8 cm).
Philadelphia Museum of Art, 40-21-46; Gift of Mrs. Childe Hassam

was in progress. He summed up the disheartening situation in a few lines sent to Weir, who was in the Bahamas trying to recover his health: "The International closed with a record attendance and miles of rubbish written about it," he wrote. "There is no news here. Nothing selling in the Ten."[28] A few years later, things looked even worse to him. He called the Ten exhibition of 1915 "a rotten show on the whole" and, though it drew good crowds, he thought it would be criticized by anyone who knew anything.[29] He mentioned that year that, except for Weir, he now hardly ever saw any of the Ten.[30] Among his new artist friends were Gifford and Reynolds Beal, Walter Griffin, the architect Cass Gilbert, Elmer Schofield, Edward Redfield, Ruger Donoho, and a variety of lesser known figures. After Weir died in December 1919, Hassam kept in touch with his family, as he had over the years with John Twachtman's widow and children.

In 1913 Hassam was commissioned to paint a mural for the Panama-Pacific Exhibition in San Francisco. He went to California in the winter of 1914 to execute it, but also spent some time there painting outdoors. Along with a number of other artists, Hassam was honored at the Panama-Pacific Exhibition with a separate gallery of his paintings. Thirty-eight pictures were shown, about a dozen dating from his 1910 European trip, the others a general sampling of work he had done at Gloucester, Cos Cob, Appledore, and his other summer sites.

In the spring of 1915 Hassam visited the painters Gifford and Reynolds Beal at their home in Newburgh, New York, beginning a series of watercolors there and in the surrounding

towns that came to be known as his Hudson River set (see fig. 167). By June he was in Cos Cob, where he was now a regular visitor in spring and fall. Looking toward the summer was sadly different that year, for Hassam could no longer count on his annual visit to the Isles of Shoals. In the previous September, Appledore had been swept by a fire that destroyed Appledore House, the main inn, and many of the island's cottages, ending for the artist a period of thirty years association with the island.[31] Instead, in August he visited friends in Portsmouth, New Hampshire, and in nearby Exeter and Stratham.

After paying a brief visit to Boston, by mid-September of 1915 he was back at Cos Cob for his second visit that year. He announced to his old friend Beatty that he had a new occupation: "You will be interested to know that I am doing some etchings. There is a press out here and I am doing my own printing."[32] Hassam used the press that the artist Kerr Eby kept at Cos Cob, although it was his own idea to take up etching. As a young apprentice in Boston, he had acquired some experience of the medium, which he had renewed in the early 1910s, possibly at Old Lyme, where a press was on hand. His first at-

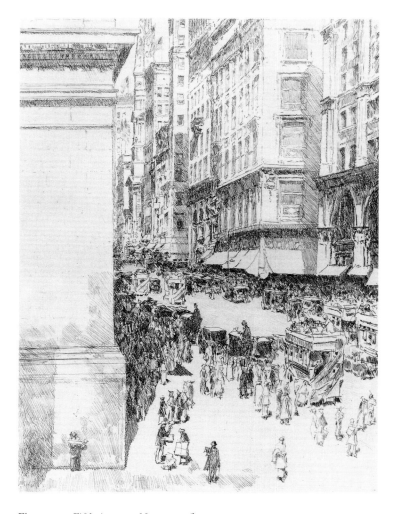

Fig. 173 *Fifth Avenue, Noon*, 1916.
Etching, 12½ x 9½ in. (31.7 x 24.1 cm). In the Collection of the Corcoran Gallery of Art; Gift of Mrs. Childe Hassam

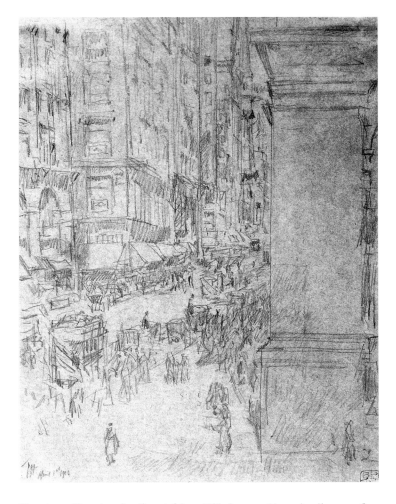

Fig. 174 Drawing for the etching *Fifth Avenue, Noon*, April 1, 1916. Pencil on brown paper, 10⁵⁄₁₆ x 7³⁄₄ in. (26.2 x 19.7 cm). Courtesy Boston Public Library, The Print Department, Gift of Albert H. Wiggin

tempts, he said, were "disastrous failures." In 1914 Hassam had written to Weir from Cos Cob asking about getting some plates, which he wanted to carry around with him in his pocket.[33] His finest prints from the autumn of 1915 were made along the waterfront of Cos Cob, including a view of the tidal dam titled *Old Lace* (fig. 172).

Work in etching continued to occupy Hassam throughout 1916, and he completed over sixty prints that year. These comprised a series of studio nudes, views from his apartment windows, and many other subjects based on drawings done during his past travels, including the 1910 European trip, the 1904 visit to San Francisco, and even the Paris stay of 1886-89. The new medium rekindled Hassam's interest in street scenes, and he produced etched views of Battery Park, Central Park, the Flatiron Building, and several historic churches. Among the finest of these early prints is *Fifth Avenue, Noon* (fig. 173). Looking north from Thirty-fourth Street, the scene contains a miniature self-portrait in the figure seen at street level against the corner of the B. Altman and Company Building. Twenty-five years earlier, the artist had stood at that very same intersection to paint *The Manhattan Club* (fig. 74), and on yet

Fig. 175 Fifth Avenue and Thirty-fourth Street, New York, c. 1920

another visit to the site, in 1917, he would begin work on one of his most successful Flag paintings (fig. 178). As the drawing for *Fifth Avenue, Noon* demonstrates (fig. 174), Hassam often worked up his plates from quick, spontaneous sketches made on the spot. At other times, he drew directly on the plate.

Etching became Hassam's preferred medium, and in the course of his career he produced more than three hundred and seventy-five copperplates. He also created a smaller body of lithographs, a medium he turned to in the fall of 1917, perhaps drawn to it by his friendship with the lithographer Joseph Pennell, a portrait of whom was among the first lithographs he executed. Hassam produced three lithographs that year and at least forty-two in 1918. They were never a commercial success, and he gave up lithographic work as suddenly as he had begun it. Despite his unwavering interest in printmaking, Hassam was forced to consider it an uncertain venture in both artistic and commercial terms. "I have made 163 etchings," he said in 1921. "Some of the plates are a success and of course many are not. It is a gamble as a medium of expression. Some sell and some of the best ones do not."[34] Ten years later, demand seems still not to have increased much. When a dealer damaged one of his proofs, Hassam referred to it as "one of my few successful plates," adding: "Not doing ducks and dogs my prints are rarely very successful."[35] Most prints of his that are now in public collections remained in his estate and were presented as gifts by Maude Hassam in the years following her husband's death.

Soon after he became involved in printmaking, Hassam told a friend that he was strongly tempted to execute a series of etchings from one and the same vantage point on Fifth Avenue at varying hours and seasons.[36] He never carried out the plan. Yet it is significant that he felt an impulse toward such a project—reviving a characteristic Impressionist tactic—for he subsequently embarked upon just such a graduated series of

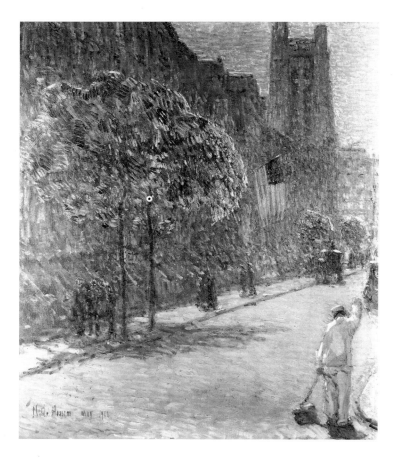

Fig. 176 *Just Off The Avenue, Fifty-Third Street, May 1916*, 1916.
31¼ x 26½ in. (79.4 x 67.3 cm). Private collection.
Photo courtesy American Academy of Arts and Letters, New York

Fifth Avenue pictures, in oil paints rather than etching, one that would preoccupy him for several years and would result in one of the greatest performances of his career. This was his famous "Flag series," representing Fifth Avenue — briefly renamed Avenue of the Allies after September 1918 — as it was transformed by the festive patriotic displays held during World War I (see figs. 177-81). Hassam later said that he painted the series in the aftermath of the Preparedness Day Parade, held in New York on May 13, 1916. This day-long event was intended to demonstrate American support of the Allied war cause and was marked by tens of thousands of marchers parading up a Fifth Avenue decorated with a profusion of flags and buntings. Among the artists who marched were Hassam's old friends Edward Simmons and J. Alden Weir. "I painted the flag series after we went into the war," he said. "There was that Preparedness Day, and I looked up the Avenue and saw these wonderful flags waving, and I painted the series of flag pictures after that."[37] Care needs to be taken in interpreting this seemingly plain statement, for it does not precisely say, nor do the facts indicate, that the May parade brought forth any immediate response in Hassam. Rather, several months seem to have gone by before his original emotion coalesced into a positive new vision.

The earliest picture that the artist always included in his exhibitions of Flag pictures, *Just Off the Avenue, Fifty-Third Street, May 1916* (fig. 176), does not relate to a parade. It shows not Fifth Avenue, but a quiet residential street, bereft of any sense of public celebration and decorated only by a single prominent flag, with a second largely hidden by a tree. Taken from within a few blocks of Hassam's house, it is above all else a street scene that evokes the artist's first days in New York and the genteel urban neighborhoods, such as Washington Square, that he had painted in the early 1890s (see fig. 63). The picture suggests that the Flag series was preceded by a revival of Hassam's interest in the urban scene on terms that he had not entertained for many years. What ultimately opened him to the possibilities of the series was the enthusiasm for etching that, in the winter of 1915/16, led him both to rummage in his portfolio for old motifs and to walk the streets once more in search of subjects. The first work to give prominence to the flag motif, in fact, was an etching of the Flatiron Building in Madison Square titled *Washington's Birthday*; this was created in February 1916, several months before he began his series in paint.

In both theory and practice Hassam connected the Flag series to his work in Paris twenty-five years earlier, when he first responded to the theme of flag-draped streets during the celebrations of Bastille Day. In February 1918 he exhibited two of the early Bastille Day pictures, *Montmartre: July 14, 1889* (private collection) and *Paris, July 14th, 1889* (unlocated), alongside a pair of his recent Flag paintings.[38] As with other episodes in Hassam's career, the Flag series can be seen as a creative reuse of ideas that lay stored and waiting.

Two months after the Preparedness Day parade the artist produced his first fully developed Flag painting, *The Fourth of July, 1916* (New York art market). Its subtitle, *The Greatest Display of the American Flag Ever Seen in New York, Climax of the Preparedness Day Parade in May*, suggests that the moment of Hassam's inspiration was this "climax" of the parade. It was most unusual for him to be in New York in July, and he must have made a deliberate effort to be on hand to observe the Independence Day celebrations. Hassam had actively participated in the war effort from the beginning of the war in Europe in 1915, volunteering his services to various committees, contributing pictures to sales for war relief, and agreeing in one case to accept payment for his pictures in Liberty Bonds. His emotional commitment to the war was intense, as is shown by several angry statements he made condemning the Germans.[39]

In light of his personal feelings, Hassam's artistic response to the war is especially remarkable, though wholly in keeping with his nature. Not only did he turn aside from crude propaganda — the images of marching troops, burning villages, and the like that marked the work of even some distinguished artists — he even ignored the very military parades and celebrations that purportedly inspired his paintings. For although the Flag paintings convey a festive impression, the activity at street level is always shown in its everyday aspect.[40] Hassam did not

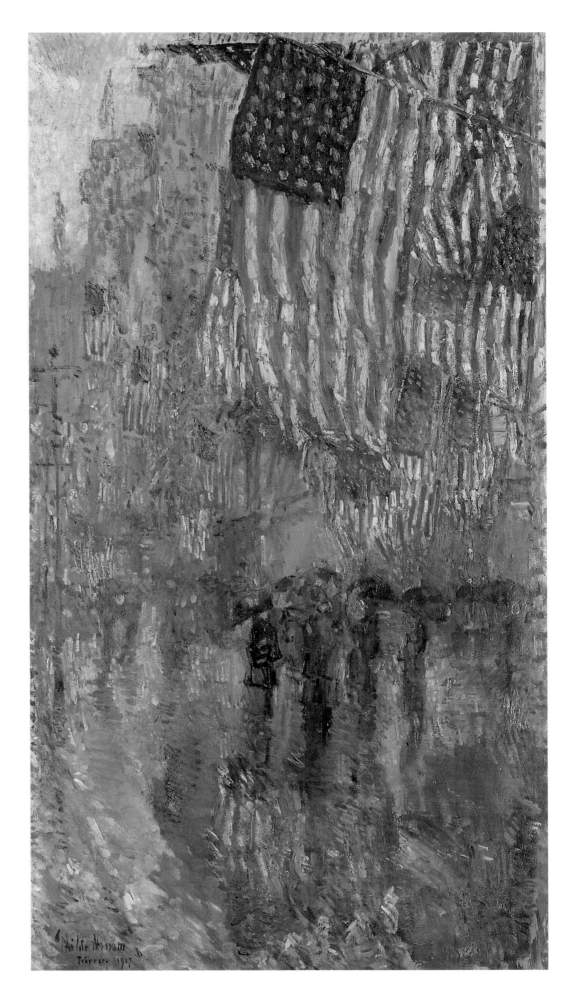

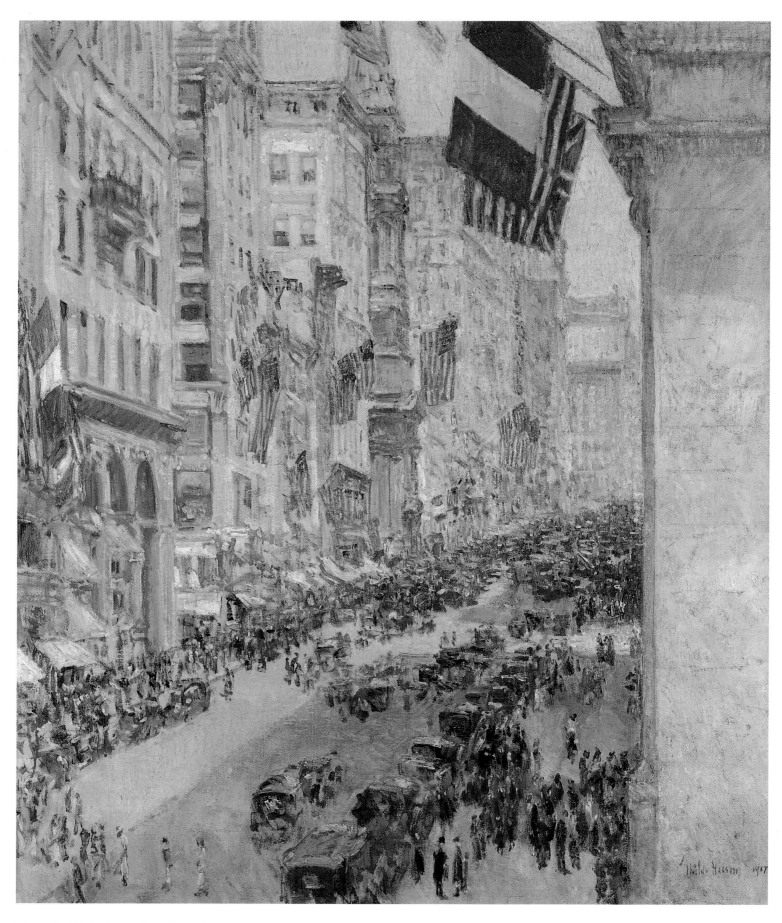

Fig. 178 *Up the Avenue from Thirty-Fourth Street, May 1917,* 1917.
36 x 29¹⁵⁄₁₆ in. (91.4 x 76.1 cm). Private collection

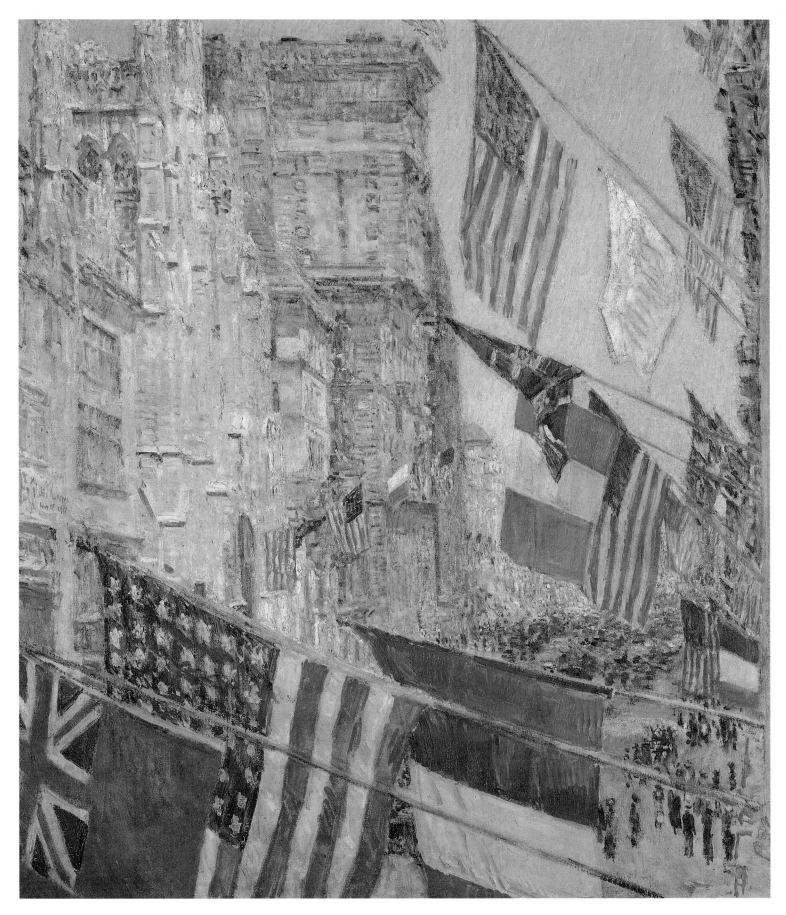

Fig. 179 *Allies Day, May 1917*, 1917.
36½ x 30¼ in. (92.7 x 76.8 cm). National Gallery of Art, Washington, D.C.;
Gift of Ethelyn McKinney in memory of her brother, Glenn Ford McKinney, 1943.9.1

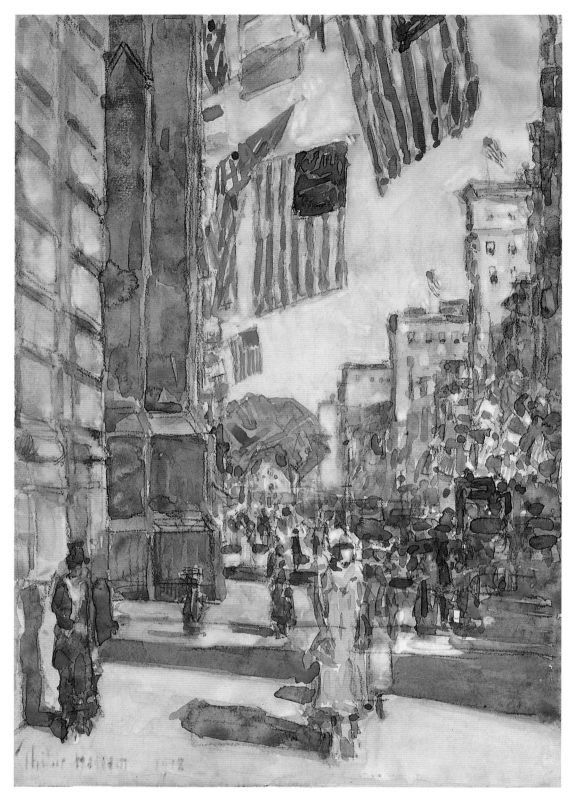

Fig. 180 *Flags, Fifth Avenue*, 1918.
Watercolor on paper, 13⅝ x 9⅜ in. (34.6 x 23.8 cm).
Dallas Museum of Art; Munger Fund, in Memory of Mrs. George Aldredge

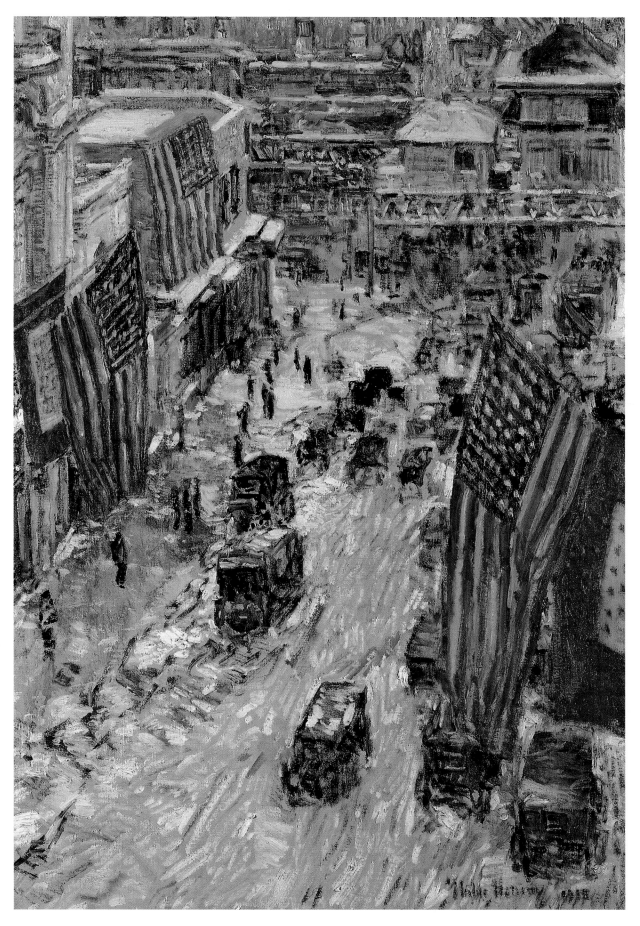

Fig. 181 *Flags on Fifty-Seventh Street, The Winter of 1918*, 1918.
36⅛ x 24 in. (91.7 x 60.9 cm). Collection of The New-York Historical Society

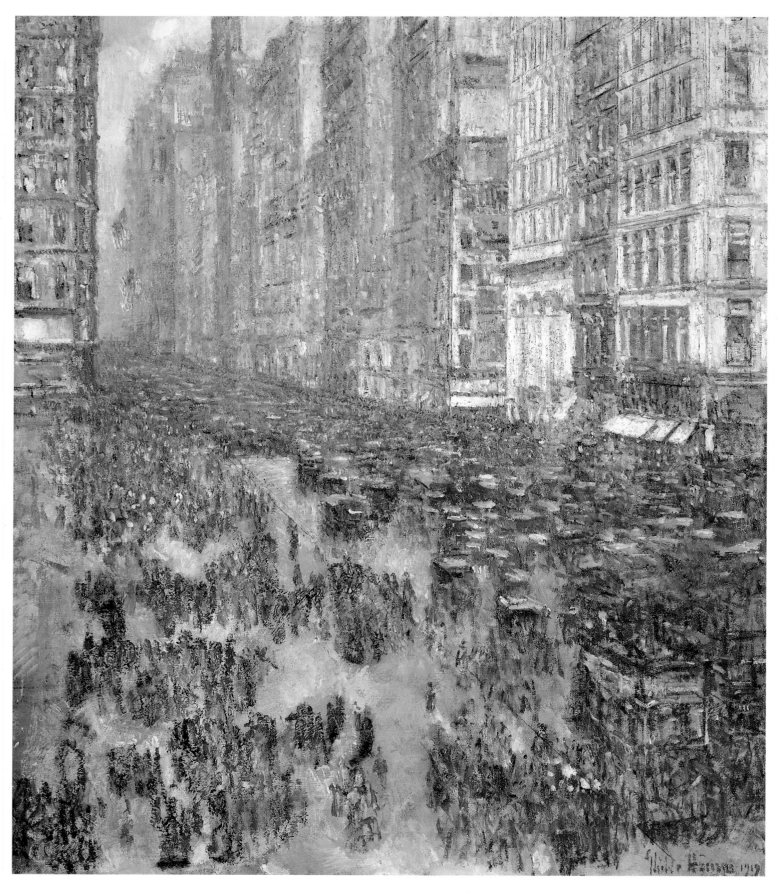

Fig. 182 *Fifth Avenue*, 1919.
23¼ x 20¼ in. (61.3 x 51.4 cm). The Cleveland Museum of Art; Anonymous Gift, 52.539

celebrate the patriotic events directly, but the general ambience, the physical spectacle, and its symbolic value.

The Avenue in the Rain (fig. 177), painted in the winter of 1917, is the most overtly Impressionist of the Flag series, a descendant both of Hassam's early Boston rainy day scenes and of his New York streets. Its format is unusually tall and narrow, and, although fairly large in scale, a wonderful unity of surface prevails as rain and atmosphere dissolve individual forms into a veil of glowing colors. Returning to his early roots in city subjects, the artist employed again the Impressionist technique of applying pure colors for luminous atmospheric effects. Here, among blue mists and rain-slicked pavements, the colored surfaces of the flags are made to radiate as if illuminated by some internal light. Clearly revitalized by his subject, Hassam reasserts all the energy, all the simplicity and boldness of color and mood that had informed his best work in the past. *The Avenue in the Rain* is at once a *tour de force* of technique and a great leap of spirit.

Allies Day, May 1917 (fig. 179) was painted a month after the United States entered World War I, and centered on the patriotic decorations that marked the visits of British and French war commissioners to New York that month. In reference to the new western alliance, American, British, and French flags appear grouped together in the lower part of the picture and on the buildings in the distance. Like many of the Flag paintings, it reads as both description and symbol. The view was taken near Fifty-second Street looking north along

Fifth Avenue and shows in recognizable form many of the buildings along the Avenue's west side, including, from left to right, the Vanderbilt Mansion, St. Thomas Cathedral (its facade still bright after rebuilding),[41] the University Club, the Gotham Hotel, and the forward edge of the Fifth Avenue Presbyterian Church. *Allies Day* became the single most famous of the Flag paintings owing to its constant exposure during and after the war. In 1918 it won the Altman Prize for landscape at the National Academy of Design. Colored reproductions, some autographed by the artist, were sold to benefit various war relief agencies.

The most personal of the series, *Flags on Fifty-Seventh Street, The Winter of 1918* (fig. 181), is a view from Hassam's apartment looking east along Fifty-seventh Street toward the intersection of Sixth Avenue, with the tracks and station buildings of the old elevated railroad in the distance. The two-story building at the corner, its street-level window glowing dimly, was the home of the Milch Galleries, one of the artist's principal dealers. Painted either from a window or, possibly, from one of the narrow balconies that fronted Hassam's building, the picture's true subject is the winter streetscape below: the flags, although prominent, remain subordinate. The painter records the specifics of time and season with Impressionist luminosity and accuracy (indeed, on some of the Flag pictures he inscribed the date and even time of day). The lights that glow dimly in the gallery window, and the headlights of the passing vehicles, suggest the approach of evening. Rapid, nervous layering of paint

Fig. 184 The artist in his studio, c. 1930

Fig. 185 *New York Spring, 1931*, 1931. Etching, 16½ x 11¾ in. (41.9 x 29.8 cm). In the Collection of the Corcoran Gallery of Art; Gift of Mrs. Childe Hassam. Depicted are Hassam and his wife on a small terrace at the rear of their apartment at 130 West 57th Street. The view, reversed in printing, faces downtown toward the southeast.

simulates the flicker of light on variously textured surfaces: the ruts of tires in the snowy street, the sheen on a shoveled portion of the far sidewalk, and traffic moving warily through the unplowed street. One of the few snow scenes of Hassam's later years, this is the only one among the Flag series.

The intense descriptiveness of *Flags on Fifty-Seventh Street* did not characterize all the Flag paintings. As the series progressed, Hassam tended to treat the flags in an increasingly abstract, iconic manner, using their flattened forms to fill larger areas of the picture and emphasizing their bold effects of color beyond all else in their physical surroundings.

Hassam considered the Flag pictures among his greatest achievements, and tried carefully to orchestrate their fate. In August 1918 he was planning an exhibition of the series,[42] and some pictures were, in fact, shown that autumn in a Fifth Avenue store window as part of the Liberty Fund Drive. The first major exhibition, comprising twenty-four paintings, opened at the Durand-Ruel Gallery in New York on November 15, 1918, four days after the signing of the armistice that ended World War I. When the show closed in December, Carnegie Institute director John Beatty asked to borrow the pictures for Pittsburgh, but the artist remained noncommittal. "I don't care to

make any engagement about the flag pictures at present," he said. "They are still up at Durand-Ruel and anything is liable to happen."[43] Whatever he anticipated, it did not come about, and a few weeks later Hassam agreed to a show at the Carnegie Institute, which took place from February 15 to April 1, 1919.[44]

During the Carnegie exhibition Hassam arranged with Durand-Ruel to have the Flag pictures shown at their Paris gallery, along with some of his prints. In April, Durand-Ruel sent a request to have the paintings shipped to Europe directly from Pittsburgh, but, after a flurry of letters attempting to surmount the difficulties of insurance and shipment to postwar France, the entire plan was abruptly called off.[45]

In lieu of a European venue, Hassam showed the Flag paintings in New York three times that year in different exhibitions,[46] partly in reaction to the efforts of a committee of citizens seeking funds through public subscription to keep the series together as a permanent war memorial. Hassam's asking price was one hundred thousand dollars, and, in an apparent effort to stimulate some response, a spurious report was circulated that twelve of the paintings had already been sold for an even higher sum, the sale conditional on the collection being acquired as a whole.[47] When informed that the outlook for the war mem-

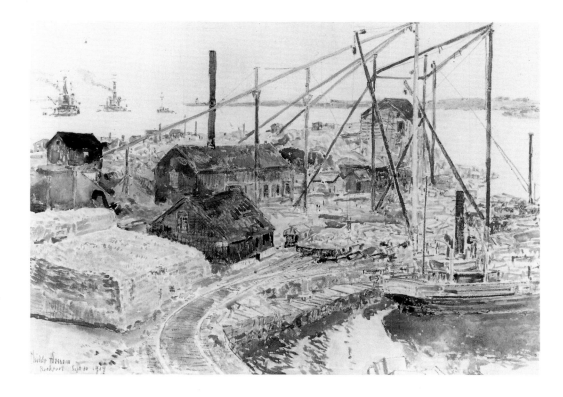

Fig. 186 *Rockport Quarry*, 1919.
Watercolor on paper,
15 3/8 x 22 1/4 in. (39.1 x 56.5 cm).
Museum Collection, Rockport Art
Association, Rockport, Massachusetts

orial scheme was not promising, Hassam exploded in exasperation. "I have heard it before!!" he told his dealer Albert Milch. "Nobody ever heard of New York subscribing anything for the fine arts.... They [the Flag paintings] will probably be sold in the West somewhere—and the enthusiastic New Yorkers will have to pay railroad fare to go and see them! I don't care a damn what you do about it."[48] Hassam must have been soothed, however, and his determination revived, for when, a few months later, Wood suggested selling one of the paintings, Hassam replied: "Sell a flag picture! I will sell the set! The dealer who had them this summer [Milch] probably said I would not break the set."[49] In the end this did not come about, and the pictures were sold individually. A last group show of the Flag series, reduced to nineteen pictures, was held in February 1922 at the Corcoran Gallery in Washington, D.C.[50]

With the war ended, Hassam thought again of going to Europe in the spring of 1919, this time in connection with an official project to record important war figures in outdoor portraits and to paint watercolors of famous buildings. He could get no government support for the undertaking, however, and, when friends advised him of the postwar disarray in France, he gave up the idea, thinking himself lucky that he had not gone through with his plan to send the Flag pictures to Paris.[51]

In 1919 Hassam painted *Fifth Avenue* (fig. 182), a view looking south from the intersection with Fifty-ninth Street. Though technically not part of the series, it proved in essence to be the last of his Flag pictures, as well as his final representation of the street that he had painted so often over the years. The wartime flags have now all but disappeared, reduced to a few tiny remnants of color at the end of the long vista. Without their

buoyant presence the streets are left an awesome, even terrifying spectacle of churning machines and anonymous crowds.

As his peripatetic schedule would indicate, Hassam remained ambivalent about New York. Sometimes optimistic, he extolled it as "the most wonderful and most beautiful city in the world" and said: "All life is in it; the mass of effects of its structures against the sky are incomparable. No street, no section of Paris or any other city I have seen is equal to New York."[52] At other times, he voiced pessimism. Disgusted that the once fascinating bustle of the city had turned garish and monstrously out of scale, he remarked that Times Square resembled "a perfect machine shop."[53] He ultimately abandoned the downtown areas, seeking, in the 1920s, subjects further and further uptown, toward the outskirts of the city.

In 1919 Hassam spent the entire summer painting at Gloucester.[54] He wrote to the Macbeth Gallery in August, asking to have a check sent for as large a sum as possible, since he needed money for the house he and Maude had just bought at East Hampton, on the eastern tip of Long Island.[55] The property, which stood in an old side street named Egypt Lane, belonged to the widow of Ruger Donoho, Hassam's friend and studio neighbor, who had died several years before. Hassam had first come to East Hampton as Donoho's guest in 1898. In later years, he seems to have visited Long Island more often than is usually supposed. Though the evidence of his work is scanty, letters trace him there from time to time, and he personally related that he went there every spring and autumn as guest of Henry Pomroy, a businessman and one-time president of the New York Stock Exchange.[56] The Pomroys were known to have a beautiful lily pond on their property, and it is possible

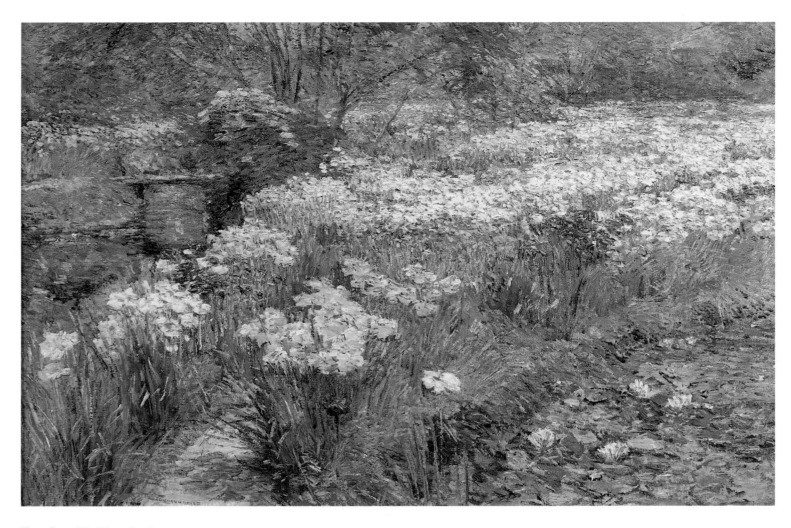

Fig. 187 *The Water Garden*, 1909.
24 x 36 in. (61 x 91.4 cm). Private collection

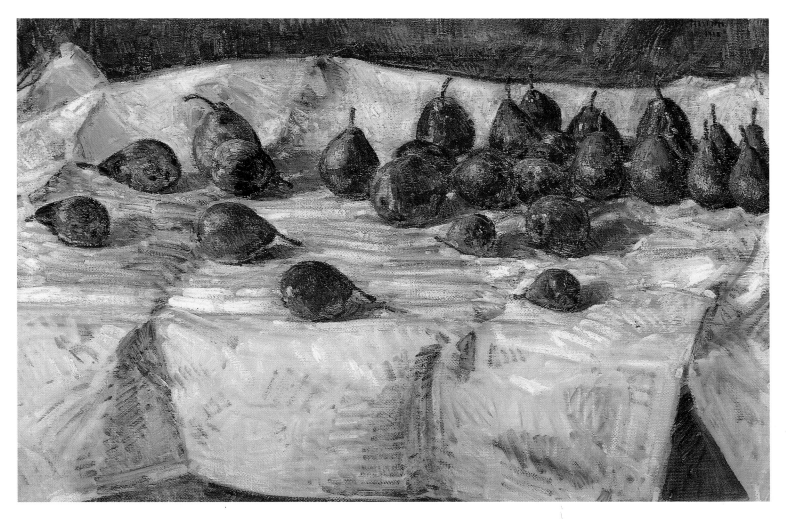

Fig. 188 *Winter Sickle Pears*, 1918.
20 x 30 in. (50.8 x 76.2 cm). Collection of Meredith and Cornelia Long

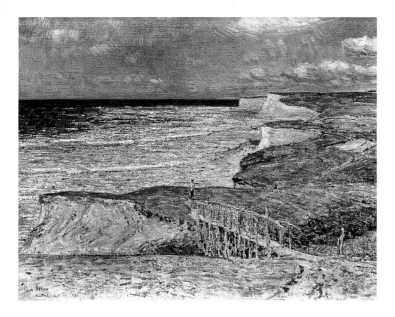

Fig. 189 *Montauk*, 1921.
20 x 24 in. (50.8 x 61 cm). Private collection.
Photo courtesy American Academy of Arts and Letters, New York

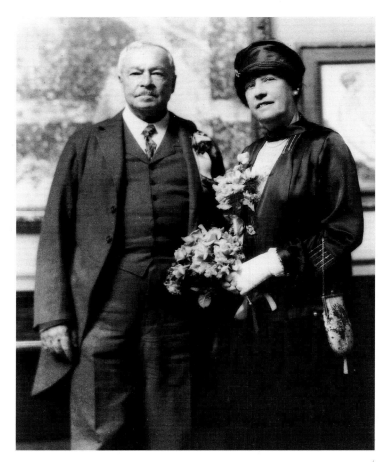

Fig. 190 Hassam and his wife at the opening of the artist's exhibition at the American Academy of Arts and Letters, New York, April 21, 1927

that several works with this subject may have been painted there, including *The Water Garden* (fig. 187).[57]

Hassam had painted at East Hampton for several years before he acquired Donoho's home, focusing particularly on its old houses, including the Hutchison, Mulford, and Lyon Gardiner residences. Hassam's own house in East Hampton, called "Willow Bend," was a colonial building and he took great delight in its raftered kitchen, hand-made hinges on doors and cupboards, fireplaces, and other old features. He moved into the house in May 1920 and remained there through October. Thus began a routine that he would maintain to the end of his life, spending half the year in the country and half in New York. He gave up all his old summer retreats, depending on East Hampton and its surroundings to supply him with subjects — shore views, the Maidstone Club, studio nudes, and increasing numbers of still lifes — for the paintings and prints he continued to produce in great numbers. During his first month in residence on Long Island, Hassam painted several fine views of the town's center, including *Main Street, East Hampton* (fig. 191).[58] Their expansiveness and poignant, small-town flavor recall the best of his Old Lyme canvases, and testify to the high quality of work he was still capable of when freshly inspired.

During the last fifteen years of his life there was an undeniable lessening of creativity and an increasing sameness about his canvases, although Hassam was too good a technician ever to be entirely commonplace. One critic in the mid-1920s wrote that the pictures the artist was sending to exhibitions lacked spontaneity and looked as if they were made for the occasion. In noting the repetitiousness of the Window pictures, he said: "this artist has appeared frankly bored."[59] Another reviewer, who greatly admired his early work, said on the occasion of a

large retrospective in 1929 that there were two Hassams: "Hassam the Younger who died about 1916 after a lingering illness, and Hassam the Elder who became active about the same time and is still producing.... Hassam the Younger was an artist, one of the foremost in America, keen, sensitive, possessed of a brilliant color sense and fine powers of organization. He was in the more accurate but less generally accepted sense a modern painter. He was a good technician but never permitted his technique to dominate his art. His follower, Hassam the Elder, inherited the master's technique, and made a brilliant thing of it, but he became literary, arrogant and, finally, dull."[60]

Certain of Hassam's late works introduce strange, even bizarre elements into his oeuvre. A case in point is his last series of classical subjects, produced over several seasons at Montauk, Long Island, in the early 1920s. Most of these paintings are spare, dreamlike landscapes with classical themes and mythological figures; they bear such titles as *The Dance of the Dryads, A Montauk Garden in the Age of Pericles* — and even *Adam and Eve walking out on Montauk in Early Spring*. The artist described these pictures as attempts at "treating the modern with the classic," though his use of unnaturally thin, elongated figures may also have represented an effort to recapture something of the simplicity and naïveté of American folk art.[61]

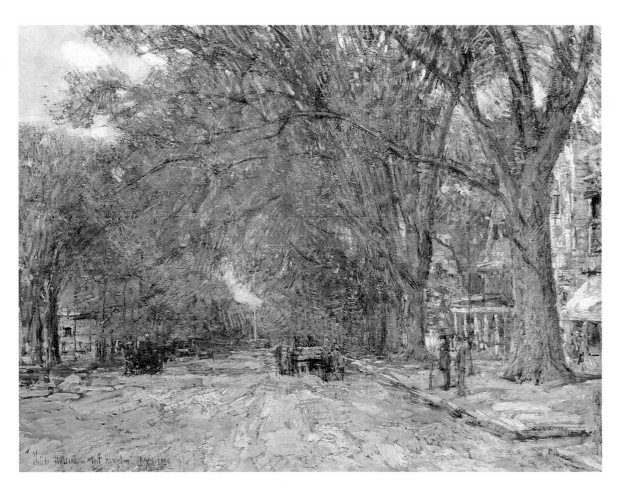

While artistically, with occasional exceptions, Hassam was in decline during his last years, his personal fortunes and celebrity continued to rise. A slump in the picture market during the war had forced him to reduce his prices somewhat, but even then, as he told Wood, he was in a position to give financial help to some of his poorer artist friends.[62] Hassam's popularity after the war is reflected in a voluminous correspondence with the Macbeth and Milch galleries, his principal dealers, concerning the steady sale of pictures. A constant theme throughout is the artist's unfailing confidence in the present and future value of his work. His prices were considerable for the times, with landscapes averaging $2,500 to $3,500 and larger figure pictures selling for $6,500 or more.[63] Although willing at times to grant a discount—as he did for a collector who wished to buy four of his paintings at once—he could afford to hold his ground on prices. To one buyer in 1919 he confirmed that the price of *Evening Mountain Laurel* (unlocated) was indeed $4,500, and "subject to change—up!"[64]

A newspaper reported Hassam's earnings in 1920 as $100,000, but his actual income was probably less. The previous year he had told C. E. S. Wood, apparently in response to a joke about his wealth: "As for my fortune it is vast. You would laugh. I have an assured income of about 12,000 a year if things always pay.... I think I could prove to you that I am poor enough to paint all the time anyway."[65] In later years, at his an-

nual return to New York from East Hampton, the demand from dealers seems to have been unrelenting. He said of them in 1926: "I'm away for six months and they get after me as soon as I get back to town and annoy the life out of me for small drawings, water colors, small and less expensive paintings. They might have done all this when I was younger. I'm showing some of the larger and more expensive paintings at Durand-Ruel on January 24th. It will be partly retrospective. I use the word 'expensive' advisedly for they all seem to want to make money. What has CH got that is less expensive? is their query. I suppose we owe all this to the phenomenal Sargent sale. Americans are now worth something!"[66]

The dealers' desire for less expensive material was the outcome of a remarkable, steady rise in the value of Hassam's paintings. *Allies Day, May 1917* had sold at the top of his price range in 1919 for $6,500, while during an exhibition at the Milch Galleries in 1928, *The Room of Flowers* (fig. 96) and a few other paintings had asking prices of $18,000.[67] In a letter written in the latter year to a museum friend whom he had just missed seeing in New York, Hassam described something of the brisk trade in his works and the methodical way in which he managed it: "I had very recently hung my best room with some of my more important water colors, where I could show them to the dealers—and unhang them (from the patent rods) as they wanted them. I hoped that you might interest someone in

Pittsburgh for your museum. John Gellatly has just bought some, and some of the pastels for his collection.... I had some new plates too.... But the water colors are going."[68]

As might be expected, Hassam also continued to garner official awards, winning the Gold Medal of Honor from the Pennsylvania Academy of the Fine Arts in 1920 for lifetime achievement, several prize medals at the National Academy of Design, and a Gold Medal at the Sesquicentennial International Exposition, Philadelphia, in 1926. His last major honor, the Saltus Medal of Merit from the National Academy of Design, was awarded posthumously in 1935 for his 1897 painting *Evening, Pont Aven* (private collection).

During these later years the artist traveled very little. In March 1925 he made a trip through the south, visiting Charleston, South Carolina, and Savannah, Georgia, while in the winter of 1926/27 he went to California, stopping on the way at New Orleans for about a week and at El Paso, Texas, and Yuma, Arizona. He arrived in Los Angeles toward the end of February and, after a few weeks, moved on to Coronado Beach. A day trip to Tijuana, Mexico, was spent drinking and gambling. During the trip Hassam was preoccupied with plans for a large exhibition of his works to be held in April at the American Academy of Arts and Letters in New York.[69]

This was one of several retrospective showings that had begun to replace exhibitions of "recent" work. The year before, the Durand-Ruel Gallery had mounted just such a retrospective. Other commercial retrospective exhibitions were held at the Milch Galleries in 1928 and the Macbeth Gallery in 1929.[70] At the time of the Macbeth showing it was noted, as justification for the undertaking, that few viewers were now familiar with the artist's pre-1900 paintings. The year 1929 also saw a major exhibition of Hassam's work at the Albright Art Gallery in Buffalo, New York, put on by his old friend Cornelia B. Sage, then director of that museum.[71]

Enjoying celebrity status in these later years, the artist used his position to denounce modernism and the abstract movement. He decried its "formless atrocities" and called it "fraudulent" and a "gigantic hoax."[72] Perhaps even more than the aesthetic issues involved, it was the continued domination of the modern advance (and of the commercial market) by foreigners, and the consequent neglect of American artists, that so enraged Hassam. This had long been a sore point with him, and the wave of xenophobia that swept America after World War I helped to deepen his resentment. He referred to Europe as a whole in terms that he had reserved for Germany during the war, finishing an appraisal of the politics of "those God damned rotten Europeans" by declaring: "To hell with Europe!"[73] His views on artistic matters were equally immoderate and encompassed virtually all American critics and collectors—whom he called "art boobys"[74]—as well as any institution that helped promote the new European aesthetic order.

The virulence of Hassam's denunciations increased in the later 1920s and the 1930s, perhaps aggravated by increasing bouts of ill health, which sometimes laid him up for weeks.[75] Excessive drinking seems to have remained a problem, and one suspects that some of his more outrageous comments, such as the threat to have the Carnegie Institute investigated for its support of modern art,[76] were made while intoxicated. His friend Wood recounted in the winter of 1932: "I had a letter from Sam Theobold—the artist—in New York who said he had met Childe Hassam on the street and Hassam's breath was the first drink of whiskey he had had this winter—The poor artists—I sent him a box—Brandy and Burgundy and the letter I received would have brought tears to your eyes—He and his wife both sick with flu and needing the stimulant."[77]

In 1934 Hassam's health took a definite turn for the worse. In August of that year he told Royal Cortissoz that he was "below the mark" and had been so since the previous winter. A medical examination revealed little except that he was suffering, in his own words, from "Anno Domini." Although he intended to undergo another examination at the Southampton hospital, he refused to accept the physician's advice to refrain from swimming in the breakers, pointing out that the doctor had since suffered a stroke and was himself barely alive. His mockery, however, was tinged with a sense of fatalism: "If the sun could cure me I would be well—or if salt water could do much—likewise. We are in the hands of mother nature—and mother nature takes her own course. So be it!"[78]

In October Hassam fell seriously ill, and the following December he drew up his last will and testament. Being childless, and having already shared with Maude the monetary portion of his estate, he bequeathed all the oil paintings, watercolors, and pastels that should remain in his estate to the American Academy of Arts and Letters. These were to be sold from time to time, following recommendations from his longtime dealers Albert Milch and Robert Macbeth. The proceeds were to be used to establish "The Hassam Fund," and income from the fund was, in turn, to be used to buy pictures from living American and Canadian artists. Thus, by bequest Hassam made good on his desire to provide stimulus for neglected American artists. Put into effect after the artist's death, The Hassam Fund is still administered by the Academy.[79]

In the spring of 1935 Hassam entered the last phase of his illness. At the end of March, Maude announced that they were leaving for East Hampton in a few days and "hope much from the sunshine and fresh air."[80] Hassam made the trip by ambulance, having reportedly told friends that be believed it to be his last illness and that he wanted to die in East Hampton. In May, too weak to write himself, he relied on Maude to help make arrangements for exhibiting his pictures.[81] Later that summer, with the end in sight, Maude described their situation to friends at the Academy of Arts and Letters: "It's a long slow pull and hard on both of us," she wrote. "Mr. Hassam is much more feeble than when we first came to East Hampton—slowly becoming more so but we are glad to be here where he can be comfortably cool and look out on the green fields and trees."[82]

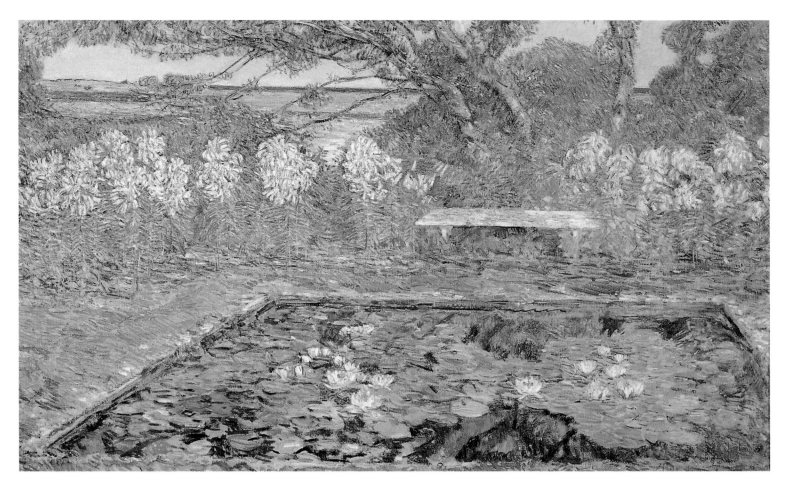

Fig. 192 *A Long Island Garden*, 1922.
30¾ x 49½ in. (78.1 x 125.7 cm). Collection Kansas City Art Institute; purchased through the H.W. Ranger Fund of the National Gallery of Art and the Smithsonian Institution, Washington, D.C.

Hassam died at his home on the morning of Tuesday, August 27, 1935, two months short of his seventy-sixth birthday. Following a ceremony held at the house two days later in the presence of a few friends and relatives, he was interred at Cedar Lawn Cemetery, East Hampton.[83]

In 1936 the American Academy of Arts and Letters mounted a large show of over two hundred of the works that the artist had bequeathed to it, but no memorial exhibition in the usual sense was ever held. There were long, fulsome obituaries in major newspapers and art journals, extolling Hassam's role as the country's foremost Impressionist. None, however, captured the simple pride he had expressed privately some months before his death to the owner of one of his early cityscapes, a view of Broadway at Fifty-seventh Street: "Though the painting is small," he said, "I always considered it one of my very good ones. Nobody else ever did anything at all like it and no other painter or etcher was doing anything of the kind. They are records if you will of America by an American. We all know what that finally means in the value of a picture, if it has any."[84]

All uncredited quotations are from documents published on pp. 177-82 of the present volume.

1 J. Alden Weir to C. E. S. Wood, May 1907 (?); quoted in Dorothy Weir Young, *The Life and Letters of J. Alden Weir*, New Haven, 1960, p. 225. Hassam himself confirmed this in a letter that described his busy schedule: "This is a fine year for artists!" Hassam to John W. Beatty, Feb. 11, 1908; Carnegie Papers, File 673.

2 The blueprints show the original layout and intended functions of the various rooms. An identical apartment next door, once occupied by the painter Irving Wiles, remains intact.

3 Walter Griffin to Florence Griswold, June 5, 1909; Griswold Papers.

4 Hassam to J. Alden Weir, Sept. 14, 1909, from "The Beachcroft," Eastern Point, Gloucester, Mass.; Weir Papers. Of his stay in Portsmouth Hassam reported: "I spent a week at Portsmouth in a Bullfinch mansion—a masterpiece. I think it the handsomest house in North America. Friends I've known for years, and I have always admired the outside of the house, but never till they asked me to stop a few days with them did I know it was theirs. Portsmouth is full of fine old houses however."

5 Hassam to John W. Beatty, Oct. 25, 1909, from The Bailey Inn, Ridgefield, Conn.; Carnegie Papers, File 673. It was perhaps on this trip that he stopped at New Haven and painted *New Haven Green* (Detroit Athletic Club).

6 Hassam to Miss Cornelia B. Sage, Oct. 18, 1909; archives of the Albright-Knox Art Gallery, Buffalo, N. Y.

7 Hassam Papers, C. E. S. Wood to Maude Hassam, Aug. 29, 1935. The pictures were sold for a total of $5,500, part of the proceeds from Wood's sale of a land grant. A statement among Wood's papers headed "Hassam's Account / May 23, 1910 Four Pictures" lists the paintings as *Willows in Spring, Moonlight — Isles of Shoals, Diamond Cove*, and *Oregon Valley*. Wood paid $2,500 on that date, another $2,000 in May 1913, and the remaining balance in small amounts in 1915, 1916, 1917, and 1919 (Wood Papers).

8 Hassam to J. Alden Weir, postcard dated Haarlem, July 2, 1910, and postmarked Amsterdam, July 4, 1910; Weir Papers.

9 Hassam Papers, Hassam to J. Alden Weir, July 21, 1910. Before departing for Europe, Hassam had written to John Beatty asking for the addresses of Alfred East in London (whom he did not visit) and of Le Sidaner in France. Beatty forwarded the addresses on June 7, 1910. Carnegie Papers, File 673.

10 This was the Hôtel l'Empire at 7, rue Daunou. In his letter to Weir (see previous note) Hassam stated: "I made a 14th July from a balcony here."

11 Hassam Papers, "A Modern Master: Childe Hassam," clipping from *Newark Evening News*, Feb. 4, 1911.

12 Lockman Interview, Feb. 2, 1927, p. 28ff.

13 Hassam to John W. Beatty, Nov. 10, 1910; Carnegie Papers, File 673: "I am just returned from Europe by way of Gibraltar." Hassam sent a postcard to J. Alden Weir postmarked Gibraltar, Oct. 16, 1910 (Weir Papers).

14 Lockman Interview, Feb. 3, 1927, p. 17.

15 Hassam to John W. Beatty, Mar. 8, 1920; Carnegie Papers, File 673. Hassam was describing his 1918 painting *Tanagra* (National Museum of American Art, Washington, D. C.)

16 Hassam to A. H. Griffith, Apr. 26, 1911; Detroit Institute of Arts archives.

17 *New York Herald Tribune*, Aug. 29, 1935, p. 16.

18 Hassam Papers, clipping from *Mail & Express*, n. d. (review of *Paintings in Oil, Water Color & Pastels by Childe Hassam*, Montross Gallery, New York, Feb. 1-15, 1911).

19 *New York Daily Tribune*, Feb. 4, 1911, p. 7.

20 See Maude Hassam to A. H. Griffith, June 16, 1911, where she says of a letter mailed earlier to her husband: "I mailed it at once to his Paris address—Credit Lyonnais Paris France—where he now is" (Detroit Institute of Arts archives). For Hassam's account of this return trip to Europe, which has been overlooked in the literature, see Lockman Interview, Feb. 2, 1927, p. 24.

21 Hassam Papers, Hassam to J. Alden Weir, July 20, 1911.

22 Hassam to Albert Gallatin, Apr. 5, 1922; Archives of American Art, Roll 507.

23 *Exhibition of Pictures by Childe Hassam*, Montross Gallery, New York, Jan. 4-20, 1917, nos. 64-72.

24 *Catalogue of International Exhibition of Modern Art, at the Armory of the Sixty-Ninth Infantry*, Association of American Painters and Sculptors, New York, Feb. 15-Mar. 15, 1913.

25 Royal Cortissoz, "The Life and Art of Childe Hassam," *New York Herald Tribune*, Jan. 1, 1939, section 6, p. 8.

26 Forbes Watson to Hassam, May 4, 1913; Archives of American Art, Roll D55. Hassam's reply of May 7 was written on Watson's letter and returned to him.

27 Quoted in Walter Pach, *Queer Thing Painting: Forty Years in the World of Art*, New York and London, 1938, p. 236.

28 Hassam to J. Alden Weir, Mar. 21, 1913; Weir Papers.

29 Hassam Papers, Hassam to J. Alden Weir, Mar. 17, 1915.

30 Hassam to John W. Beatty, n. d. [1915]; Carnegie Papers, File 673.

31 Hassam may have stayed on nearby Star Island, but there is no direct evidence of his presence on the islands after 1914. A few Isles of Shoals pictures that I have not seen are reported with dates later than this; they may have been finished in later years, or the dates may have been misread.

32 Hassam to John W. Beatty, Sept. 22, 1915; Carnegie Papers, File 673.

33 Hassam to J. Alden Weir, Aug. 7, 1914; Weir Papers. For Hassam's early etchings, see Lockman Interview, Jan. 31, 1927, p. 35, and Feb. 2, 1927, p. 20. Hassam said he did not take up etching until "about 1912," but it may have been earlier, since, in a letter of January 17 (?), 1910, he told John Beatty: "You shall have a proof of the first etching I make" (Carnegie Papers, File 673). See also Paula Eliasoph, *Handbook of the Complete Set of Etchings and Drypoints of Childe Hassam, N. A.*, New York, 1933, p. Vff. for a discussion of Hassam's early prints.

34 Hassam to C. E. S. Wood, Feb. 14, 1921; Wood Papers.

35 Hassam to F. W. Price at Ferargil Gallery, New York, Feb. 7, 1932; Archives of American Art, Roll N68-14.

36 See Carl Zigrosser, in *Childe Hassam*, Frederick Keppel & Co., New York, 1916, p. 22: "Hassam says he is strongly tempted to execute a series of etchings from this same vantage-point at varying hours and seasons. Let us hope that he will do so, for he excels in the suggestion of atmosphere, of sun, snow and rain."

37 Lockman Interview, Feb. 2, 1927, p. 26.

38 *Catalogue of the 113th Annual Exhibition of the Pennsylvania Academy of the Fine Arts*, Philadelphia, Feb. 3-Mar. 24, 1918, nos. 383-84 and 387-88. The small canvas *Montmartre: July 14, 1889*, which is illustrated in the catalogue, is demonstrably not the watercolor referred to by Ilene Susan Fort in *The Flag Paintings of Childe Hassam*, exhibition catalogue, Los Angeles County Museum, 1988, p. 30, fig. 33.

There was a long-standing tradition of decorating Fifth Avenue with flags on major occasions. Hassam may have witnessed one of the most spectacular flag displays prepared for the Columbus Day celebrations of 1892, when Fifth Avenue was reportedly covered with canopies of flags a mile long. Among the predecessors of his Flag paintings was also probably *Fifth Avenue on a Fourth of July* (unlocated). Exhibited at the Montross Gallery in February 1911, this picture must have been created in 1909 or earlier, since Hassam was abroad during the summer of 1910.

39 In one of these he described them in bold letters as "hell-breathing hyenas." Hassam to the editor of the *Boston Transcript*, July 31, 1916; William H. Downes Papers, Boston Atheneum, MSS L337.

40 To my knowledge, the only painting that may actually show a parade is the small panel titled *The Big Parade*; see *The Flag Paintings of Childe Hassam*, 1988, p. 92, fig. 45.

41 The church was destroyed by fire in 1905 and rebuilt soon after. This should explain the pristine appearance that Hassam reproduced, rather than the notion that its brightness "metaphorically suggest[s] that the new union of Allies has divine blessings" (Fort, in *The Flag Paintings of Childe Hassam*, 1988, p. 46).

42 Hassam to Albert Gallatin, Aug. 5, 1918, and Sept. 2, 1918; Archives of American Art, Roll 507.

43 Hassam to John W. Beatty, Jan. 4, 1919; Carnegie Papers, File 673.

44 *Childe Hassam: An Exhibition of Paintings, Flags of All Nations and Paintings of the Avenue of the Allies*, Department of Fine Arts, Carnegie Institute, Pittsburgh, 1919.

45 On March 29, 1919, Hassam wrote to Robert B. Harshe, Assistant Director of the Carnegie Institute, stating: "We are deliberating about sending them to their [Durand-Ruel's] Paris house for exhibition in May—with my etchings and lithographs—this will be at the time of the Luxembourg exhibit of 100 American works." Carnegie Papers, File 673. See *ibid.* for related correspondence of March 12 and April 5, 7, and 8, 1919.

46 Milch Galleries, New York, May 20-June 30, 1919; Church of the Ascension, New York, Oct. 27-Nov. 27, 1919; College of the City of New York, Dec. 1919-Jan. 28, 1920.

47 See *The Flag Paintings of Childe Hassam*, 1988, p. 112ff.

48 Hassam to Albert Milch, Aug. 19, 1919; Archives of American Art, Milch Gallery Papers.

49 Hassam to C. E. S. Wood, Oct. 21, 1919; Wood Papers.

50 *Exhibition of a Series of Flag Pictures by Childe Hassam*, Corcoran Gallery of Art, Washington, D. C., Feb. 7-28, 1922.

51 See Hassam to Albert Gallatin, July 5, 1919; Archives of American Art, Roll 507.

52 Quoted in John Kimberly Mumford, "Who's Who in New York—No. 75," *New York Herald Tribune*, Aug. 30, 1925, p. 11

53 Quoted in *Catalogue of Etchings, Lithographs, Drawings, Watercolors and Pastels, by Childe Hassam*, Arthur Harlow & Co., New York, Jan. 22-Feb. 11, 1927.

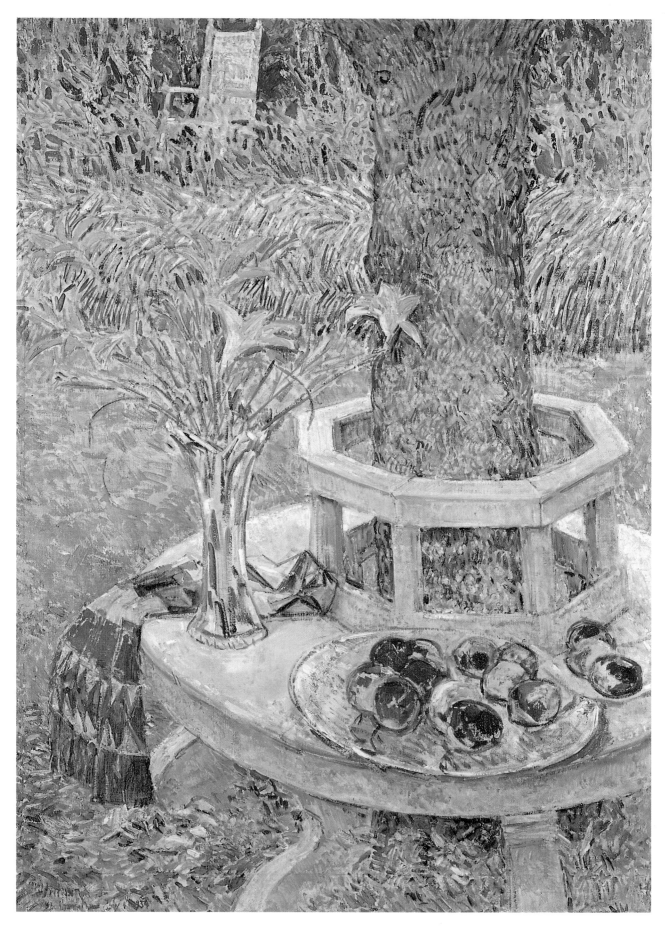

Fig. 193 *Mrs. Hassam's Garden at East Hampton, 1934.*
40¾ x 28½ in. (103.5 x 72.4 cm). Private collection. Photo courtesy Sotheby's, Inc.

54 See Hassam to C. E. S. Wood, Oct. 21, 1919; Wood Papers: "I painted all summer at Gloucester Mass. It is as fine as ever — they can't ruin Cape Ann."

55 Hassam to Robert McIntyre at Macbeth Gallery, Aug. 9, 1919, from The Moorland, East Gloucester; Archives of American Art, Roll NMc51.

56 See Lockman Interview, Feb. 2, 1927, pp. 24-25. Hassam did not indicate when these visits began.

57 For the Pomroy garden, see Judith Wolfe, in *Childe Hassam 1859-1935*, exhibition catalogue, Guild Hall Museum, East Hampton, N.Y., 1981, p. 13.

58 One variant of this picture (unlocated) shows only the right-hand portion of the scene, with a single figure. It is dated May 29, 1920.

59 "Hassam Shows Water Colors and Prints," *World*, Jan. 30, 1927, p. 9M.

60 *Art News* 27 (Apr. 20, 1929), p. 9.

61 Lockman Interview, Feb. 2, 1927, p. 27. A collection of twenty-seven of these works was shown at the Macbeth Gallery: *"Montauk," by Childe Hassam of the American Academy of Arts and Letters*, William Macbeth, Inc., New York, Dec. 30, 1924-Jan. 19, 1925.

Hassam visited Montauk frequently in 1920, and in 1921 camped there for the entire month of September with friends Jack Reudebush, Albert Smith, and Gifford and Reynolds Beal. In October 1921 Robert Macbeth proposed to Hassam a show of his Montauk pictures for the following January (Robert Macbeth to Hassam, Oct. 21, 1921; Archives of American Art, Roll NMc51). Macbeth took credit for introducing Hassam to Montauk: he had visited it in the summer of 1920 and had been reminded by

the landscape of Hassam's earlier Isles of Shoals paintings. Replying to Macbeth's letter, Hassam said he had about twenty Montauk pictures, but was anxious not to go to the expense of framing them all at once (Hassam to Robert Macbeth, Oct. 23, 1921; *ibid.*). On September 18, 1923, Macbeth again inquired if he could schedule the Montauk exhibition for the next January (*ibid.*).

62 Hassam to C. E. S. Wood, Dec. 15, 1917; Wood Papers: "I try not to think of the times — but even these times will pass — I have been in some luck to be quite free — and I have been able to help some of my poorer artist friends — for this thanks to the powers that run things!"

63 Before the war, Hassam had quoted the following prices: for a 20 by 24-inch canvas, $800-1,500; for a 25 by 30-inch, canvas, $2,500-3,500; and for "larger canvases of the figure or figures and landscapes," $6,500-7,500. Hassam to an unidentified art dealer, Jan. 12, 1911; Archives of American Art, Roll D10, frame 1273.

64 Hassam to Robert Macbeth, July 30, 1919; Archives of American Art, Roll NMc51.

65 Hassam to C. E. S. Wood, Oct. 21, 1919; Wood Papers.

66 Hassam to Royal Cortissoz, Dec. 18 (?), 1926; Cortissoz Papers.

67 *Works of Childe Hassam*, Milch Galleries, New York, Dec. 3-24, 1928; annotated gallery copy in Archives of American Art, Roll NM2. The financial crash of 1929 caused the prices of Hassam's paintings to plummet along with everyone else's. An example was *Listening to the Orchard Oriole* (U.S. State Department), which sold at auction in February 1928 for $2,300 (bought by

Milch) and again in March 1933 for $400.

68 Hassam to Edward Duff Balken, Mar. 22, 1928; Carnegie Papers, File 673.

69 *A Catalogue of an Exhibition of the Works of Childe Hassam at the American Academy of Arts and Letters*, Academy Publications, no. 58, New York [April 22-Oct. 22], 1927.

70 *Retrospective Exhibition of Works by Childe Hassam, 1890-1925*, introduction by Frank Jewett Mather, exhibition catalogue, Durand-Ruel Gallery, New York, 1926; *Works of Childe Hassam*, Milch Galleries, New York, Dec. 3-24, 1928; *Exhibition of Paintings by Childe Hassam, N. A., Covering the Period from 1888 to 1919*, Macbeth Gallery, New York, April 1929.

71 *Exhibition of a Retrospective Group of Paintings Representative of the Life Work of Childe Hassam, N. A.*, introduction by Ernest Haskell, exhibition catalogue, Buffalo Fine Arts Academy, Albright Art Gallery, Mar. 9-Apr. 8, 1929.

72 See Thomas Sugrue, "Childe Hassam Hits America's Gullibility," Hassam Papers, unidentified clipping [Oct. 16, 1933]; S. J. Woolf, "Hassam Speaks Out for American Art," *New York Times Magazine*, Oct. 14, 1934, section 6, p. 7.

73 Hassam to C. E. S. Wood, Oct. 22, 1922 (?); Wood Papers.

74 Hassam to C. E. S. Wood, June 19, 1929; Wood Papers.

75 See, for instance, Hassam to C. E. S. Wood, Jan. 15, 1928; Wood Papers.

76 Hassam Papers, Hassam to Frederick Keppel, Nov. 14, 1933.

77 C. E. S. Wood to his cousin Blanche Matthias, Dec. 30, 1932; Wood Papers.

78 Hassam to Royal Cortissoz, Aug. 11, 1934; Cortissoz Papers.

79 Copies of the will, dated December 20, 1934, are in the American Academy of Arts and Letters and among the Cortissoz Papers. The latter also contain a letter of October 14, 1935, from Grace D. Vanamee at the Academy, describing how Mrs. Hassam's estate would also eventually revert to the fund. According to a signed receipt dated January 7, 1936, Mrs. Hassam delivered 441 works from Hassam's studio to the Academy — 300 oil paintings, 19 decorative panels, 92 watercolors, and 30 pastels.

80 Hassam Papers, Maude Hassam to Grace D. Vanamee, American Academy of Arts and Letters, Mar. 31, 1935. Some obituaries reported in error that the artist had gone to East Hampton a full year before he died.

81 Maude Hassam to Homer St. Gaudens, May 8, 1935; Carnegie Papers, File 673.

82 Hassam Papers, Maude Hassam to the American Academy of Arts and Letters, undated (probably July 1935).

83 Among the numerous obituaries, not all reliable, see *New York Times* Aug. 28, 1935; *New York American*, Aug. 28, 1935; *New York Herald Tribune*, Aug. 28, 1935; *New York World Telegram*, Aug. 27, 1935; *East Hampton Star*, Sept. 5, 1935; *New York Sun*, Aug. 27, 1935; *Boston Globe*, Aug. 28, 1935; *Boston Evening Transcript*, Aug. 27, 1935; *Newsweek*, Sept. 7, 1935; *Boston Herald*, Aug. 29, 1935; *The Art Digest* 9 (Sept. 1, 1935), p. 13.

84 Hassam to Mrs. Charles D. Hilles, Jan. 20, 1935; The Beinecke Rare Book and Manuscript Library, Yale University.

Appendices

Documents

A Letters from Paris 1886-1889

Note: Hassam's orthography and punctuation have been largely retained here. Owners of the letters as follows: Portsmouth Library, Portsmouth, New Hampshire, Lyman V. Rutledge Isles of Shoals Collection (nos. 1, 3-5, 7; typescripts); Boston Athenaeum, William H. Downes Papers, MSS L337 (nos. 2, 8, 9); private collection (no. 6).

[1] Childe Hassam, 11 Boulevard de Clichy, Paris, Nov. 20, 1886
To Miss Rose Lamb, 83 Mt. Vernon Street, Boston

My Dear Miss Lamb,

We have arrived safely and have at last found a nice little apartment—with a tremendously fine large studio connected. It is fifty feet square, and as high, I should think. I wish you could see it. I am sure you would like it very much. Mrs. Maude likes Paris only pretty well as yet. She will be sure to like it better.

We are slowly furnishing our apartment with artistic bits of furniture that we pick up here and there. Some is old—and it is all alleged to be of course. "C'est inférieur" as long as it is artistic and well seasoned oak.

Mrs. Maude gave me a fine scolding because I came home one day with two fine old "prayer rugs" and a little Moorish table inlaid with Mother of Pearl. At this time we had a bed and two chairs and the trunk for a lounge.

She says if I keep on I will not have enough money to buy actual necessities in the way of furniture, and as she is my business manager, legal adviser and wife all in one, I find I have to stop.

We are on high ground and look down on Paris,—i.e. the Grand Opera and finest Boulevards are at the foot of the hill (Montmartre). We shall be first rate and snug when we are fixed up a little more. I started my first picture 3 days ago (a small one).

I went down to rue Bonaparte and found the Courbet you wished and will send it with one or two others that I thought you would enjoy; *General Prim*—Regnault; *Head*—Raphael. His best head in the Louvre, I think; Titian's *Entombment* also his best I should say, in this gallery.

Certainly the portrait of *Marshal Prim* is a great work, and the greatest of Regnault's. I tried to get you a photograph of *L'homme blesse* by Courbet which is finer to me than the other. Evidently the French do not think so, for it is hung high. It is finer in color—a most beautiful sentiment pervades it.

Give my regards to everybody. I am sure you see Mrs. Thaxter often. Do go down to Blakeslee's and see my large Common picture if you have time. It is there ere this I suppose.

I read your package of art notes with much pleasure. I wish Mr. Han [?], myself and all the pleasant people could be at the Shoals again next summer.

Yours most sincerely, Childe Hassam

[2] Childe Hassam, 11 Boulevard de Clichy, Paris, Jan. 11, 1887
To William Howe Downes, Boston

Friend Downs,

Was sorry I did not see you before I left Boston. I wanted to leave you some little thing of mine to add to your already charming little collection and ask you to do what you could towards the success of my auction in February.

I knew you would do it up as kindly as you always do but what I mean is if you and Robinson [?] and Weeks can't lead the attention of the public by a few short notices "au premier."

I wouldn't bother you if it was an exhibition simply but you know an auction in Boston is a beastly venture ie. a matter of life and death.

Weeks got a little oil of mine just before I left so he will I am sure feel kindly disposed to drive his quill a few blocks for Hassam.

And you shall have one—and our good friend F. T. R. also! In fact some little Paris thing of the streets will undoubtedly please you better as I have unquestionably arrived at my selection of subjects. It will probably be worth more to you at any rate as they are in some good American collections in N.Y., in Clarks and others as you know.

I depend a good deal on the success of that sale. I am settled well here but it has taken about all of my spare cash. I have a very large studio and a nice little apartment attached (by the way where Van Marcke made his reputation) but it has taken some time and money to fit it up I can assure you. These Frenchmen are not so rapid as you Americans!

I send some pictures to London shortly to see what luck I will have and shall paint London part of next year. I am drawing like a slave at Julians and shall until Spring. I don't believe all that there is in the academy is good. It teaches whoever comes within to draw mechanically exact—That's about all but it is of importance of course as far as it goes.

How is M[arcus]. Waterman and [I. H.] Caliga and [J. P.] Rinn and the rest of the pleasant fellows. Tell W. to write to a fellow.

By the way I have a lurking idea that I owe the P[aint]. and C[lay] $15. Am I right—I left their bill behind me without intending to. As you are still Sec[retary]. I suppose—won't you send me a bill and I will send it to B[oston] and see that it is paid.

One thing I can say, outside of a duty, I shall be delighted to pay it as I have had some fine old times there.

I suppose you continue to have some of those fine old racketts.

I started this for a short letter so I won't bore you longer but when a fellow writes to a Boston Man there is always a lot to say. Regards to *Everybody*,

Sincerely Childe Hassam

[3] Childe Hassam, Paris, Mar. 19, 1887
To Miss Rose Lamb

My Dear Miss Lamb,

Yours received today, and as the document accompanying it is so funny I hasten to defend myself against the "Prayer" idea! That is so funny! I haven't said a prayer or thought one since I was a bit of a boy. My make up is far from Saint-like, I am sure, and I often regret not having a little more of that decent and respectable

attitude. When I sent that letter (or just before) I had been buying a few rugs and wanted to buy still more but didn't. Amongst them were two or three "Prayer Rugs" that were fine in color and I have no doubt at the time that I pictured to myself some dark oriental double-up on one of them saying his prayers. This is the only thing I think of. I am intensely interested in Eastern rugs, "good ones." Enclose cutting from *Le Petit Journal*, 1ct a copy—largest circulation in the world.

Millet is to have a monument at last—it seems.

Just now I am having a rest after sending a couple of pictures to New York. I sent, or rather started three things to the Paint and Clay Ex. but they did not get there it seems. Noyes and Cobb want to know where they are! Their agent sent them to them! It is disgusting the way these dealers do business. I said anything but a prayer when I found they were not there. My swearing in English and French is something horrible, so Mrs. H. says. Mrs. Thaxter's Gossport fishermen whose oaths she admired so are nothing to some of the Frenchmen's.

When I have occasion for adjectives before Mrs. H. I use French—when by myself, English. Your friend is right—I do indeed detest intrusive people, and I had my powers of dislike taxed to their fullest extent on my voyage over here. A Boston person invited herself to come under our care (not Miss Bishop who is a charming lady) and for several things I can't forgive her. 1st—she is studying art without any talent and is beginning at 45. This is tiresome "d'abord." Secondly, she called me Fred—before people! a name that is only used by Mrs. H. and my mother and a few male friends. This was more than tiresome! Thirdly, she wrote to her husband saying I had not treated her very kindly on the journey. This, one cannot but believe! but it is amusing. Fourthly, she is probably telling everybody she knows what a horrid brute I am. Isn't it funny? It amuses me now but did not at the time.

You have painted some charming portraits this winter, I am sure. I had a letter from Mrs. Thaxter saying she had been very ill. I am sorry. You will be down at that beautiful place, the Shoals, again this summer. I wish I was to be there with Mrs. H. but I am afraid I will not see America again for some time to come.

My exhibition had a lot of bad stuff in it, I am sure, and they were principally old water colors that I should have burnt up. It also had the best water color I ever did, and some of the oils I was really sorry to part with. For they will go for nothing and will not be appreciated. I don't know as they will be able to give them away. Although at this date the sale is 10 days old I have heard nothing about it.

Expect to get a letter saying, Could not give your work away!!! Boston did not want it!!

But a lot of Modern French School, tinpan painting, will sell in Boston every winter. Nothing new here in art. No noted exhibitions this winter except the Rue Volney Ex. and Merlioton Club, two art and literary clubs here. There was the usual exhibit of Modern French—a fine Cazan though! Stunning!! Effect of "Close of Day." I wish you could see it. Why don't Mr. Ames know enough to buy a picture like this in place of a Jules Lefebvre? I think his pictures are stupid. I did study drawing with him for a while at Julian's though.

Mrs. Hassam sends her love to Miss Lamb. She often speaks of you. I think the poor child would be mighty glad to go back to America.

Yours always, Childe Hassam

[4] Childe Hassam, 11 Boulevard de Clichy, Paris, July 21, 1887
To Miss Rose Lamb, Thaxter Cottage, Isles of Shoals

My Dear Miss Lamb,

You are at the Shoals and you are enjoying it I am sure. Same sun, same moonlight, and the same flowers in Mrs. Thaxter's garden. And as all these things are charming always, and the best to be had in the world, of course you are enjoying the lovely place. I wouldn't dare to say how many times I have wished to be there this summer.

I am going down into Normandie next week to a little village where artists never go. I have been working pretty hard all winter. Mrs. Maude [is] very well and likes Paris better than ever. Hope we will see America again before long, but can't tell when.

This is villainous French paper. I would like very much to see your portrait of the Hindoo. I saw his photo at Mrs. Thaxter's and his head was fine and must be still more interesting in colour. The Salon disappointed me a little. There was a charge of "cuirassers" by Aimé Morot that was stunning. Awfully (just the word) true it was. All battle pictures, ancient and modern must succumb to it. There was a little Jimenez (12 x 16 only) of a peasant woman seated on the grass knitting, her baby playing near her. It was beautiful. Horses plowing by de Thoren — Grey day — Very like Corot in quality. It was a chef d'oeuvre, or as an American painter said, "a clincher." It certainly did take hold of one. A fine Dagnan-Bouveret, Breton peasants at some church ceremony. His picture in the Luxembourg to me is the finest small picture there. Perhaps you have never seen it. He is one of the last men. I was asked by letter by an enterprising American journalist for a description of my picture. I wrote it as you will see it on the next page. I thought, however, after I had written it that it was stupid to describe my own picture, so I never sent it. Theodore Child described it well in "*Harper's Weekly*" and that will do for America. So I send it to you. My picture was exposed at Goupil's for a week after the Salon closed. This is my luckiest stroke since I have been here. While it was in the "Salon" I had notices in four French journals — all favorable (this surprised me.) My picture in the Salon of 1887, *as per request*.

Mrs. Maude [sends] love to you and Mrs. Thaxter.

————————

It is a *light* Paris rainy day. The long dark line of "fiacres" with their tops shining with the wet are contrasted to the length of a flat wall covered with the warm tones of numberless bill-posters. Behind the wall lifts up a line of hedge which greys into the distance with the wall and fiacres. Near the first fiacre, and near a large oaken door in the wall three "cochers" are chatting. In the foreground is a labourer [sic] pulling along his hand cart aided by his little girl. They are both bare-headed according to their custom — rain or shine.

Along the sidewalk to the right come the better dressed and more fortunate wayfarers with umbrellas; and the buildings characteristic of the "Latin Quarter" fade down into the distance.

This is the Rue Bonaparte looking from the Place St. Sulpice toward the gardens of the Luxembourg. Size 6 ft. 8 in. by 3 ft. 4 in.

Yours very sincerely, Childe Hassam

N. B. My regards with Mrs. H's a tout le monde.

[5] Childe Hassam, 35 Boulevard Rochechouart, Paris, Nov. 29, 1887
To Miss Rose Lamb

Dear Miss Lamb,

I received your kind letter from the Shoals and was very glad to hear that you were having such a fine time, and that Art is flourishing so well amongst the "Summer Shoalers." As you see I have changed my quarters, but I am only a stone's throw from the other quarter. We like our new quarters much better — the studio is no better, but the living rooms are more connected and it is pleasanter in winter on that account. The studio is good in this way, that one side is all glass nearly to the floor, so that I can paint a figure here the same as on the street. That is to say grey day effect. Just now, by the way, I am painting sunlight (a picture 4 ½ ft. by 3 ft.) — a "four in hand" and the crowds of fiacres filled with the well dressed women who go to the "Grand Prix". The effect is on the "Avenue de la Grand Armée," quite near the "arc" with the long line of horse chestnut trees [on] one side of the street, the top of a palace and part of the arc.

I sold the smaller picture that I painted of the same subject to Mr. Williams when he was here, so I will not describe the motif as I hope you will see it there. Some of my friends, after I had the first picture under way told me I must paint it larger, it was such an interesting motif. I hope I shall do it as well as the smaller one which I thought was successful in some ways. I do hope you will get a chance to see it. There are two others I sold with it. I have not sent them yet, but shall this week. You will excuse my harangue on my own work, but I wish you would try and see them and write and tell me if you think I have made any progress in one year here. Now I must try and say some of the things I meant to say in my last letter. I was very sorry to hear of Mr. Gifford's loss! I found him such a nice man and he wished me success so kindly that morning I left Nonquit [?] that I have not forgotten him. And I wish now to thank you very much for going to my sale and caring enough for the two pictures to buy them and you were really too kind to take your time for that. I cannot express myself half gracefully enough I am sure! and can only give that as an excuse for not saying it in my last letter. Do thank Miss Furness kindly for liking my pictures in New York.

I hope you are well and am sure you are making charming portraits. I never saw but one you remember, but I liked it very much. Mrs. Maude sends her love to you and would like, I am sure, to see you walk in here to see us some day. I trust your old father is well and still has good eyes to see the "Shoals Moonlight."

With kindest regards, Yours sincerely, Childe Hassam

[P.S.] Who are the new lights in Boston Art? Are you going to have any more of Herkommer this winter — and Chase (W. M.)? R. T. is, I am sure *a little* strong on Mr. Chase as an artist.

[6] Childe Hassam, 35 Boulevard Rochechouart, Paris, June 13, 1888
To Celia Thaxter, Isles of Shoals

Dear Mrs. Thaxter,

It is mighty warm here in Paris now and that makes me think how fine it must be at the Shoals. You have been there for a long time already I am sure. You told me to write my next letter to you at the Shoals. I am very much behindhand. I have been working very hard however. The Salon this year is about as good as last year and the Americans make a good showing there. The time is long passed for apologizing for American Art. That little picture of Ruth was charming. I am very glad to have it. What a dear little thing she is! Mrs. Hassam takes great pains to show this little "americaine" to all her friends. I hope you are all well and I am certain that you are having a fine time as everybody does who has the good fortune to be down there with you. I would like so much to be down there and paint some of those moonrises and sunsets over the ocean. I was at [Le] Havre last week and the sunsets from the jetty reminded me so much of those effects at the Shoals. And the surroundings of pleasant people is equal always to that of nature. What I cannot find everywhere! Do you think you will come over here in 1889. All good Americans will travel that year. I may send some pictures over to Boston next winter. I am not sure though, it is such a doubtful market. I will not send my large ones certainly.

Mrs. Hassam and I have just lost a very dear friend. One never knows how dear until they go away forever. She was only 28, married, husband an artist and a nice fellow, enough money, etc. Everything bright ahead. Her death seems a cruelty and it started me to thinking and I am still thinking of the possibilities of there being a kind and good creator and if there is one, to what extent he occupies himself with the lives of such good people. And this young American lady was one of the few good people in the world. Give our love to little Ruth and remember us kindly to all our friends over there. We may come back to America some day. It is Mrs. Hassam's dream.

Yours always, Childe Hassam

[7] Childe Hassam, Paris, June 27, 1888
To Miss Rose Lamb, Isles of Shoals

My Dear Miss Lamb,

I received your letter of introduction but did not unfortunately, see the bearer. I shall call on Miss Rogers in a day or two and anything I am [able to] do for her you may be sure I shall do it. I suppose you are at the Shoals now. I shall address this letter there. Sargent has been painting a lot of portraits in Boston I suppose. There was one at the Salon — very ripe, matronly personage. Perhaps it is one from Boston. I liked it, I must say, very much. The Salon this year was the same as last year in a general way. Lots of good things but the preponderance bad, inartistic. That seems to me the great failing. The Americans showed up (as the Americans say) to good advantage. After the Frenchmen no country stands as well. I was very well hung and have no complaints to make so far over here. I wish we were at the Shoals for this summer, but we will really go to Villiers-le-Bel and I shall paint in a charming old French garden. That is where Couture lived and painted. Hunt must have been there. The proprietor of the property that my friend lives [in], married one of Couture's daughters, and has a houseful of his works. I wish very much to see them some day and will. It is lovely here and we like it very much. The Medaille d'honneur was given to Detaille, the military painter for an atrociously bad picture in my opinion, and I never heard anybody say that they really liked it. I hope you will have a lovely summer, as I am sure you will if you are at the Shoals.

Yours very truly, Childe Hassam

[8] Childe Hassam, Paris, Apr. 8, 1889
To William Howe Downes, Boston

Friend Downs,

Your letter came with notice, which I will thank you for right here. I am very much disgusted to think that it did come first and that mine did not arrive to you before it asking you to accept the little sketch or note, for

it is one of the notes that I made for my Salon picture—for the sky. I think that the results of the exhibition were not bad as Cobb will certainly sell a goodly number after the close of the exhibition. I have two pictures received at the Salon one a very large picture 11 ft. by 7 and at the American Section of the Universal I shall have five. Five was the limit—and the jury took them all. They were even more exigent than the Salon jury which you know has become a farce. They had the nerve to fire out several medalled pictures and probably the good taste I have no doubt. If you could live over here a couple of years to see how things are run here in art matters it would make you sick. Americans ought to know this. It ought to be shown up. The "French disinterestedness" does not exist for any *stranger*. The latest trick that Jules Lefebvre and the Julian Academy tried to play is worthy of an article. If you wish to write it I can give you the facts and will do it gladly for it will be doing good to American Art, which by the way is a thing that exists as our section will prove this year at the Universal.

With all kindest regards to yourself and wife, Yours
sincerely, Childe Hassam

[9] Childe Hassam, 35 Boulevard Rochechouart, Paris, May 28, 1889
 To William Howe Downes, Boston

My Dear Downs,

Thanks for the paper. I will try to explain to you the great Julian Academy combination. Note first this J[ules] L[efebvre] is *supposed* to teach two mornings in the week at Julians men's school one month and women's the month following but—note this he is never there half of the time. And I am sure it is the same story in the feminine section. At Cabanel's death there was a vacancy left at the Ecole des Beaux Arts, also a chair in l'Institut de France or the Academy as they call it. This J. L. thought he would scoop up at one blow and have the traditional influence of the "atelier" Cabanel at the Beaux Arts which was always a power, a great power even, and which had always been the opponent of the Julian power united once and for ever. Bear in mind that these cliques or syndicates, if you will, are all powerful because every *French* artist is a voter for the jury: and moreover a voter for the medal of honor which is given every year in the Salon to the artist (French of course) who can get the most votes from the artists (French) who have already had some recompense in the Salon—mention, medal, etc. So you see that it is even the interest of these leaders outside of the fame of their schools to push their pupils along to a mention at least. They vote for their leaders or masters of course no matter if the[y] be in sympathy with their art or not. Last year the Julian Academy syndicate tried to get the medal of honor for Boulanger who had never had it and who was one of the partners in the firm but (who I must say to his credit was universally respected and liked by everybody; apart from his art which was stiff, academique and paradoxical to the last degree). They failed but Detaille got it for the *worst* thing he ever painted and one of the acknowledged chromolithographs of the Salon of 1888. (You have seen the photo which will prove this to you if you have not already mistaken it for a Strobridge music cover for a war song.) Well this explains the motives as the detectives say. The Cabanel syndicate winning the day. You see that it was a Machiavelique stroke to unite these two powers. The French papers were full of it, the thing being perfectly well understood here and much abusive language was interchanged. (Remember time it would take J. L. to teach two more days a week at B[eaux]. A[rts]. It was ludicrous. He couldn't do it. He don't half teach at

J[ulian]'s.) J. L. was not only beaten at the Beaux Arts but at the Academy also—Henner taking the chair. Now Henner's work is not academic in the least and it was a tough blow for the other Prix de Romes and the "saines [sic] doctrines" of the academic school. As they had not yet replaced M. Boulanger, they had the brilliant idea of putting several new teachers in his place. They put in Benjamin Constant, Gabriel Ferrier, Francois Flameng, and [Lucien] Doucet—The deaths of Boulanger, Cabanel, Feyen-Perrin left three openings on the jury of the Salon. These places it is unnecessary to say were filled by Ferrier, Flameng, etc. so that the list of the Julian Professors on the Salon jury is a long list—Bouguereau, Tony-Robert Fleury, Lefebvre, Ferrier, Flameng, Benjamin Constant, Doucet and others whose places Julian controls.

Benjamin Constant wanted the medal of honor last year but you may be sure that he will have it this year without a doubt. While the intrigues failed signally Julian got a good deal more power on the jury but there is a strong fight against them on all sides as is easily seen by the annual voting for the jury. I received 42 different lists (by mistake, of course, no one but a Frenchman having any right to vote). There is already here a big fight against the Academy and the Prix de Rome system. It is nonsense. It crushes all originality out of the growing men. It tends to put them in a rut and it keeps them in it. An artist should paint his own time and treat nature as he feels it, not repeat the same stupidities of his predecessors, for mechanical exactitude becomes stupid in art and tiresome, like all things photographic to the real artist. The men who have made success today are the men who have got out of this rut. Henner, Dagnan-Bouveret and Cazin (and Cazin paints the figure too although some fools say he can't draw). These same people, and some of them unfortunately write on art matters, would find a thing charming that had been photographed onto a canvas and fairly well painted over it for the drawing). Even Claude Monet, Sisley, Pissaro [sic] and the school of extreme impressionists do some things that are charming and that will live, and even the major part of their work, although they are not always serious, and some time they try too much to "étonner le bourg[e]ois," are less tiresome than those, the "type" who goes out with a camera and a paint box and who has no more idea of what a "value" is or what air is than the "bourg[e]ois" himself. John Sargent, whose best things can vie with anything that has been done or is being done in art, did not learn what he knows in the academy. George Inness, who is admitted by men over here to be the greatest landscape painter living never studied here, and if he had would no doubt have had as original a style as he has all the same. The American Section in the Universal has convinced me for ever of the capability of Americans to claim a school. Inness, Whistler, Sargent and plenty of men just as well able to cope in their own chosen line with anything done over here. But as long as a crowd of apostates from America who have more money than brains continue to go to France to study for such a long time, sometimes so long that they finish by staying there altogether, there will be little growth of an American school. I don't mean men of real talent, of course; it don't make any difference where they live or where they paint as long as they see nature with their own eyes and do something a little different from other painters. All this tends to show you Downs that I believe too much of this foreign study for Americans is going to do what the Prix de Rome system has done and is doing for France. The Julian Academy is the personifiation of routine, and with the Beaux Arts has spoilt more than one artist who goes there *too long*. I don't think that the Americans will get anything in the

Salon this year. Weeks will get a third medal as he has been waiting a very long time and has deserved it before now. Vonnoh may get a mention as he is the oldest on the J[ulian]. A[cademy]. list and there may be one or two scattering mentions and that will end it. It is too gauzy [?] the whole business.

Excuse my scrawl, with regards to you and
Mrs. Downs,
Very truly yours, Childe Hassam

[P. S.] send you [an] article in *Gil Blas* by the best writer on art in Paris, Claude [?] Semannier [?]. Unless you believe in that horrible Jew Albert Wolf who is a frightful type.

B OTHER WRITINGS, INTERVIEWS

[1] A. E. Ives, "Talks with Artists: Mr. Childe Hassam on Painting Street Scenes," *Art Amateur* 27 (Oct. 1892), pp. 116-17

"I paint from cabs a good deal," said Mr. Childe Hassam, when asked how he got his spirited sketches of street life. "I select my point of view and set up my canvas, or wooden panel, on the little seat in front of me, which forms an admirable easel. I paint from a cab window when I want to be on a level with the people in the street and wish to get comparatively near views of them, as you would see them if walking in the street. When I want groups seen at a greater distance, I usually sketch from a more elevated position. This was painted from the second-story window in Dunlap's, about fifteen feet from the ground."

The sketch in question was a very snappy, life-like impression of the bit of New York one sees by looking north with Madison Square Park to the right. It was one of those spring days when the tender green of peeping leaves mingles with the dull reds and browns of the unopened buds. The grass had the freshness of young life. The tall buildings in the background composed admirably as foils in color to the brilliant tones brought against them, and seemed even to take on a tinge of romance in being brought into this Spring festival of life and color. In the foreground were groups of vehicles moving and standing still, and the ceaseless ebb and flow of humanity dotted the pavement with forms, giving interest and life to the whole. All this was apparent to the eye in a color sketch made at one sitting. At near view of the figures were the merest suggestion of men and women, more like odd, little hieroglyphs than anything else. Yet they were the short-hand characters which the artist knew how to render into a language that he who runs may read. When finished, they would be painted very simply, painted with merely a few strokes of the brush, because the strokes that were there already meant so much; they would not be much elaborated, but would only be brought out a little to make the effect more striking and the form more apparent even to the careless glance.

"I cannot imagine," said Mr. Hassam, "how a man who sees fifty feet into a picture can paint the eyes and noses of figures at that distance. I should call such a painting a good piece of work — yes, good scientific work; but I should not call it good art. Good art is, first of all, true. If you looked down a street and saw at one glance a moving throng of people, say fifty or one hundred feet away, it would not be true that you would see the details of their features or dress. Any one who paints a scene of that sort, and gives you such details, is not painting from the impression he gets on the spot, but from pre-conceived ideas he has formed from sketching studio models and figures near at hand. Such a man is an analyst, not an artist. Art, to me, is the interpretation of the impression which nature makes upon the eye and brain. The word 'impression' as applied to art has been abused, and in the general acceptance of the term has become perverted. It really means the only truth because it means going straight to nature for inspiration, and not allowing tradition to dictate to your brush, or to put brown, green or some other colored spectacles between you and nature as it really exists. The true impressionism is realism. So many people do not observe. They take the ready-made axioms laid down by others, and walk blindly in a rut without trying to see for themselves.

"I suppose a great many people think my pictures are too blue."

The writer frankly admitted that many persons did.

"Yes, no doubt. They have become so used to the molasses and bitumen school, that they think anything else is wrong. The fact is, the sort of atmosphere they like to see in a picture they couldn't breathe for two minutes. I like air that is breathable. They are fond of that rich brown tone in a painting. Well, I am not, because it is not true. To me, there is nothing so beautiful as truth. This blue that I see in the atmosphere is beautiful, because it is one of the conditions of this wonderful nature all about us. If you are looking toward any distant object, there will be between you and that object air, and the deeper or denser the volume of air, the bluer it will be. People would see and know this if the quality of observation was not dead in them. This is not confined to those outside of art; there are a good many painters afflicted with the same malady.

"So many of the older men are very far from being catholic in their views. They must walk in the old ruts, by the tradition of the elders, or not at all. I do not mean that there are no virtues in the old school. There are many, but there are also many mistakes, and we need not take the mistakes along with the virtues in our study of nature. The true artist should see things frankly, and suffer no trickery or artifice to anywhere distort his vision.

"I do not mean to convey the idea that you may at any minute find a subject ready at hand to paint. The artist must know how to compose a picture, and how to use the power of selection. I do not always find the streets interesting, so I wait until I see picturesque groups, and those that compose well in relation to the whole. I always see my picture as a whole. No matter how attractive a group might be, if it was going to drag my composition out of balance, either in line or color, I should resist the temptation of sketching it. I should wait, if it were a street scene, till the vehicles or people disposed themselves in a manner more conducive to a good effect for the whole."

"That group of cabs in the foreground of the Madison Square picture," said the writer, "is admirably managed to focus the attention there."

"That was my intention," the artist went on, "and you will notice how the lines in the composition radiate and gradually fade out from this center. Of course all those people and horses and vehicles didn't arrange themselves and stand still in those groupings for my especial benefit. I had to catch them, bit by bit, as they flitted past.

"Do I paint the buildings and background first? Well where, as in this picture, they are quite as important as the people, as a general thing, yes. But I have no rule for that. Sometimes I stop painting a tree or building to sketch a figure or group that interests me, and which must be caught on the instant or it is gone. Suppose that I am painting the top of the bank building here, and a vehicle drives down to the left-hand corner, just where it seems to me a good place to have something of this sort; perhaps the driver gets down and throws himself into some characteristic attitude; I immediately leave the roof of the building, and catch that group or single object as quickly as I can. You see, in pictures of this sort, where you are painting life in motion, you cannot lay down any rule as to where to begin or where to end. As to canvas, I prefer a clean one, just as it comes from the maker, or if it is a panel, the usual creamy white ground. I use an ordinary sketch book and pencil a great deal for making notes of characteristic attitudes and movements seen in the streets. If I want to observe night effects carefully, I stand out in the street with my little sketch-book, draw figures and shadows, and note down in colored crayons the tones seen in the sky, in the snow, in the reflections or in a gas lamp shining through the haze. I worked in that way for this bit of a street scene in winter under electric light."

"What a Dickens flavor there is to those cabbies, setting themselves down into their great-coats, trying to keep warm," put in the writer. "And how much character there is to this one's back."

"Yes," laughed Mr. Hassam, "there is no end of material in the cabbies. Their backs are quite as expressive as their faces. They live so much in their clothes, that they get to be like thin shells, and take on every angle and curve of their tempers as well as their forms. They interest one immensely.

"I believe the man who will go down to posterity is the man who paints his own time and the scenes of every-day life around him. Hitherto historical painting has been considered the highest branch of the art; but, after all, see what a misnomer it was. The painter was always depicting the manners, customs, dress and life of an epoch of which he knew nothing. A true historical painter, it seems to me, is one who paints the life he sees about him, and so makes a record of his own epoch. But that is not why I paint these scenes of the street. I sketch these things because I believe them to be aesthetic and fitting subjects for pictures. There is nothing so interesting to me as people. I am never tired of observing them in every-day life, as they hurry through the streets on business or saunter down the promenade on pleasure. Humanity in motion is a continual study to me. The scientific draughtsman who works long and patiently may learn to draw correctly from a model a figure in repose; but it takes an artist to catch the spirit, life, I might say poetry, of figures in motion. I have been asked if I did not think photographic views were a great help to the artist in this branch of study. Undoubtedly they might be, but they have not been so to me. I never owned a camera or pressed a button of a Kodak in my life. I don't know why I have not. It has just happened so, I suppose. But I think on the whole, I prefer to make my own studies right from the life, without any assistance from the camera.

"Understand, in my allusion to the study from models, I do not for one instant deprecate the importance of a careful training in this direction. You surely cannot draw a figure in motion till you have first learned to draw it in repose. A good scientific groundwork is needed in art. In saying this, I am not saying anything, and neither am I departing from the instructions of the old school when I urge the importance of studying figures in motion. So academic an artist as Gérôme used to say to his pupils, 'Go into the street and see how people walk.' Drawing from a figure in repose may be scientific, but good movement drawing is artistic."

Here the artist was asked how he came first to paint street life.

"I lived in Columbus Avenue in Boston. The street was all paved in asphalt, and I used to think it very pretty when it was wet and shining, and caught the reflections of passing people and vehicles. I was always interested in the movements of humanity in the street, and I painted my first picture from my window. Afterward I studied in Paris, but I believe the thoroughfares of the great French metropolis are not one whit more interesting than the streets of New York.... There are days here when the sky and atmosphere are exactly those of Paris, and when the squares and parks are every bit as beautiful in color and grouping."

[2] Childe Hassam, in "John Twachtman: An Estimation, II," *North American Review* 176 (April 1903), pp. 555-57

It is difficult to define, perhaps, what the charm is in a work of art, and in speaking here of Twachtman's work, which had so much charm and distinction. I shall probably parallel the thoughts of many of my fellow-painters, and possibly their words if they should speak of him.

The great beauty of design which is conspicuous in Twachtman's paintings is what impressed me always; and it is apparent to all who see and feel, that his works were sensitive and harmonious, strong, and at the same time delicate even to evasiveness, and always alluring in their evanescence.

His was surely the work of a painter too — a man's work. You felt the virile line. It was in his clouds and tree forms, in his stone walls and waterfalls, in his New England hillsides, and in the snow clinging to the roof of an old barn or edging the hemlock pool. His use of line was rhythmic, and the movements were always graceful. The many landscapes that these words will recall — with their simplicity and breadth of treatment, and their handling, often of great force and beauty, of brush-work and painter-like assurance — were amongst the very handsome modern open-air canvases. Their breadth, with the swing and sinuosity of line in his rocky pastures, and in brooks set with boulders, with the swirl of little waterfalls, had something that was very large and noble in expression. All this, with his arrangement of forms (for the pleinaerist does arrange forms when working from nature), made his work most valuable and interesting — designed, and with great beauty of design. By design I mean by no means conventional composition. The definition so often given of the work of modern painters in landscape — which is, that they take a motif anywhere, as if looking out of an open window, and paint it just as they see it — is partly erroneous, only a half truth. These painters do try to give you frankly the aspect of the thing seen in its fundamental and essential truths; but that they do not place things as they feel they should be placed to get the balance and beauty of the whole, well seen within the frame, is a mistaken idea. Twachtman might have painted, indeed he did paint, a tree in Nutley New Jersey, with a distance and middle distance of Gloucester Harbor, Massachusetts.

A noble and expressive line, with a joyous feeling for nature, a frank and manly directness in presenting

truths, by painting, however poetic and fleeting, must give value and distinction to any work in paint — or in any other medium in which we express ourselves in what is called Art.

Twachtman was a boy in the sunlight; and Thoreau, that other remarkable landscapist and pleinaerist in words, says somewhere that "the Greeks were boys in the sunlight," and to me that is a complete description of the Greek nature. His work as color had delicate refinement and truth. His color is the color of northern nature in the changing envelopes of subtle gradation. There is nothing swashbuckler about his subjects or his color, and in these days of spurious old masters, of artificiality, of rainbows and sunbursts that is refreshing. One gets tired of Alps and sunsets, at least in literature and painting; in music they can be better done. And in this province of the painter, Twachtman has, in his small, slight sketches, these qualities of charm of line and delicacy of vision. True to our northern nature, too! Truths well told, interestingly told, just as a few words well chosen will tell a truth that a thousand cannot!

Twachtman felt very keenly the unrelenting, constant war that mediocrity wages against the unusual and superior things. The public are anxious to take the word of an office-boy in any art-shop, in preference to that of an American painter of recognized ability. Art has no frontier, to be sure, but some of the dealers (not all) will assure you that there is a frontier and that it begins right here at the New York Custom House. It is curious how stupid the public can be about this! If the Celt and the Teuton cannot paint (and they have done the best painting) on this side of the ocean, then natural laws are changed.

In the last few years, American paintings have been purchased by art museums in the United States, especially by many of the minor ones. Some of the larger ones are in the hands of people too incompetent or interested to recognize the position of the American painter to-day. If it is a question of buying an American or a foreign painting — let us say, only of equal merit — by a museum, the foreign picture is bought.

The American people can at least go on record as having respected the art of their own country, which has been fully recognized abroad. Why should not the Metropolitan Museum have a gallery devoted to the work of American painters? The Metropolitan Museum should have an American room, and Twachtman should be well represented in it. We have an art! Let us respect it!

With such an estimation of the work of this American artist, a man who was an able painter and a joyous, energetic individuality, who worked for the love of it and worked well, one must feel that he has not yet been adequately appreciated.

[3] "New York Beautiful," *Commercial Advertiser*, Jan. 15, 1898, p. 1, col. 1
An architect (Thomas Hastings of Carrère & Hastings), a sculptor (Joe Evans), and three painters (Robert Reid, Thomas Wilmer Dewing, and Hassam) were asked to comment on the beauties of New York City. Hassam's contribution follows.

I think...that New York is a very beautiful city. It is far more interesting to me than Paris, with its monotony, its finish, its trivial sort of surface decoration, like that of the Louvre. The large, comparatively pure buildings of London and New York, are much more capable of a really distinguished effect. The very thing that makes New York irregular and topsy turvy...makes it capable of the most astounding effects. From the tops of the enormous buildings one can get magnificent sweeps along the rivers and over the tops of the buildings. And, then, the atmosphere! Why, toward the late afternoon the big masses of buildings in New York come out in that light with a significance and an effect which makes the Paris kind of thing quite trivial. Even the elevated railroad is at some times of day, in some lights, extremely effective. To see the thing shoot by, send off great spiral masses of smoke against the sky is inspiring in the extreme. Light! Atmosphere! Why Paris atmosphere is no good in comparison. We have as much atmosphere, if not more, than at Paris. Who ever heard of a corner in atmosphere? And yet people talk about Paris atmosphere. Some say that the sky here is not blue, but it is as blue as it is in Italy. One reason that people think it isn't is because the effect of our dark red or brown houses is to kill the light color of the sky; but now that we are getting more and more light buildings people will be able to see . . . that we have a very blue sky.

Many of our squares here are distinguished and fine — Madison and Union Squares, for instance — though they have lately put up some bad buildings, but the atmosphere effects and lights are wonderful there at some hours. And I have no sympathy for the outcry against posters. New York posters are more beautiful than those of Paris. I like to see a house like that stuck all over with signs. It is far better than the Marlborough Hotel, right next to it, or that horrible Casino. Of course, the artist has to select. If I were to do that building I would not take it all, but, nevertheless, it presents a lovely chance for a picturesque idea.

No, to me, the old part, the Bowery, etc., is not so interesting as the new. The old part is picturesque, but it is not picturesque in an original way. The new part is unlike any other place. It is distinguished, vital and picturesque in its own way. It has character and force, and that is why I like it.

[4] "New York, the Beauty City," *The Sun*, Feb. 23, 1913, section 4, p. 16
Excerpts from an interview that Hassam gave in his studio

"New York is the most beautiful city in the world. There is no boulevard in all Paris that compares to our own Fifth Avenue...and even London, which I consider infinitely more beautiful than Paris, has nothing to compare with our own Manhattan Island when seen in an October haze or an early twilight mist from Brooklyn Bridge. Now really, could anything be more thrillingly beautiful than the view of New York city as you sail toward it from the bay?

"But, you see we are all just a lot of victims of habit and slaves to tradition, and that is why the average American still fails to appreciate the beauty of his own country and goes on thinking that anything bearing a Paris label, whether a hat, a dress, a painting or a building, is the highest expression of Dame Art.

"Nothing could be more amusing to a student of art or a student of life, for that matter, than some of the customs and ideas resulting from these time worn traditions. Because a diamond has come to be associated with an engagement ring, and chiefly because a diamond is the most expensive of all precious stones, lovers will go on purchasing diamonds until the end of the world. Now as a matter of fact the diamond is not at all pretty. Even to the vulgar and inartistic eye it cannot appear as beautiful as the marvelous moonstone.

"But where is there a woman who would have the courage to wear a moonstone ring or necklace to the opera unless all of a sudden some such style should be started in Paris and the price of moonstones shoot up to fabulous figures in consequence? Because it has been called fashionable to have 5 o'clock tea at the Plaza every woman who lives in a Harlem flat but has an automobile goes there with the purpose of aping the Fifth Avenue woman who lives in a mansion and has several automobiles. Now many of the Fifth Avenue residents do not take tea at the Plaza, but I repeat that all of the Harlem women who own a Cadillac or a Maxwell do.

"But you won't find women of either type using their cars for a little spin over to Brooklyn or the Jersey shore for the sake of getting a good view of the beauty of their wonderful city. They will feel your pulse or tap your forehead significantly if you even dare to suggest anything so ridiculous. Yet these same persons will make early reservations for the European trip each year and rush off madly to do the galleries and rave about the artistic grandeur of the other side. They may even purchase a few pictures with the Parisian label, whereas they would never think of buying anything typical of the beauty of their own country.

"I've just been reading a play of art life, 'The Dreamer,' that exemplifies exactly what I mean. The hero is an artist who paints very great pictures, but because his art is New York, nobody buys. A fashionable art patroness looking at one of his canvases puts up her lorgnette and exclaims 'Paris of course,' but upon being told otherwise she declares 'Fancy anyone painting New York,' and passes on, while the heart broken artist looks out from his window discouraged and says something to this effect: 'Alas, we are as yet too small to see the beauty of New York! Ideas of beauty grow and change as everything else does that lives. We talk so much of Greek art. Do you think it could entirely satisfy us today? Beauty is no longer a mere thing of the eyes. It must be character, energy, power, humanity.'"

Interviewer: "But don't you think that Americans really are beginning to wake up to the beauty of New York?"

"Yes, (he replied in a disgusted tone), but only when some one comes over from Europe to point it out to us. Herman Struck, the German etcher, is now visiting our country with the express purpose of devoting the greatest part of his stay to making little lyric impressionistic sketches of American landscapes and especially of New York sky lines, and Arnold Bennett is another foreigner who has the seeing eye and is big enough and broad enough to appreciate beauty whenever he finds it. Mr. Bennett has written many true things about our wonderful skyscrapers in his 'Your United States.'

"Now while speaking of skyscrapers one must grant of course that if taken individually a skyscraper is not so much a marvel of art as a wildly formed architectural freak. But to stand gazing up at a single building would be like sticking your nose in the canvas of an oil painting. One must stand off at a proper angle to get the right light on the subject.

"It is when taken in groups with their zig zag outlines towering against the sky and melting tenderly into the distance that the skyscrapers are truly beautiful. Naturally any skyscraper taken alone and examined in all its hideous detail is a very ugly structure indeed, but when silhouetted with a dozen or more other buildings against the sky it is more beautiful than many of the old castles in Europe, especially if viewed in the early evening when just a few flickering lights are seen here and there and the city is a magical evocation of blended strength and mystery. Later in the evening when millions of electric bulbs are blazoned forth it is too suggestive of a gigantic cut rate drug store to be a good subject for painting.

"The portrait of a city, you see, is in a way like the portrait of a person — the difficulty is to catch not only the superficial resemblance but the inner self. The spirit, that's what counts, and one should strive to portray the soul of a city with the same care as the soul of a sitter."

[5] Letter to the *Sun and Globe*, Nov. 23, 1923, concerning well-balanced juries
 Typescript in the American Academy of Arts and Letters, New York

Let us try and see if it be not possible to correct a statement that is so far from being so [sic] that the exact opposite is the truth. In the article "Satisfying Artistic Hunger" by Harry W. Watrous, Vice President of the National Academy of Design, after that President for one year, printed in the issue of November 21st, 1923, by the *Sun and Globe*. "The American Federation of Arts etc . . . exhibits have taken to the people the best of contemporary art by men of established reputation, *and also much work by artists who are adjudged by well balanced juries as coming geniuses whose fame in the future is assured.*" Now this would seem too absurd to refute, but if the people are so anxious to know, tell them the truth! not forgetting that it takes two to tell the truth, one to speak it and one to hear it. Foresight, forecasting the career of young painters and sculptors has never been counted one of the acts of a "well balanced jury," but we know from hindsight what has happened when a "well-balanced jury" judges pictures and sculpture. Let us use our hindsight and recall and record once more what "well balanced juries" have done in the past in the way of discovering and "adjudging coming geniuses whose fame in the future is assured." In the largest and worst exhibition of pictures in the world, the Paris Salon, the presumably "well-balanced jury" of 1883 refused Whistler's portrait of his mother, the now famous picture hanging in the Louvre after hanging for the requisite number of years in the Luxembourg. The Royal Academy of London, not nearly as large but just as bad an exhibition as the Paris Salon, would not have a Whistler inside its doors.

John H. Twachtman was most always refused by the National Academy of Design, and if hung was skied, and skying in those days meant higher than the second line. If Albert Ryder had sent his "Jonah and the Whale," or his "Flying Dutchman" (both now in the Gellatly Collection) to the National Academy of Design, we may surmise what a "well balanced jury" would have done to these masterpieces.

Twachtman, one of the modern masters, never was even able to be elected an associate of the N.A.D., which merely means after all that you are not an Academician. His friend J. Alden Weir proposed his name for twenty-eight years in succession. This is only one more comment on the body of men from whom is chosen a "well balanced jury."

There is a continual cry from all points (points of the compass I suppose) for knowledge in art matters. The people want to be told. *They frankly admit ignorance.* It would be a good thing if we would admit ignorance too in this matter — tell the truth, for nobody knows what any young artist will do by early middle age when he is if ever, only to begin to produce his best work.

The fact is, in conclusion, that there is no such thing as a "well balanced jury." You cannot find here or anywhere else in a body of artists thirty men who know. I mean *who know!* A jury of three would be as near as you could get to a "well balanced jury." Two for the jury and one for the balance, and forever changing the group and balance as in chemical grouping. The Carnegie (Pittsburgh) jury is too large, five or eight (which is it),

and often enough strangely chosen and constituted. I perhaps ought to say here that I have served on so many juries including, of course, the Academy Jury, and may I add for the last time! I was asked to serve on the present Carnegie Institute jury, and have been asked to serve on it for the past several years. I did serve on two or three of the earlier ones in Pittsburgh.

As for the "best contemporary art of the men of established reputations," such pictures and sculptures do not go on tour from town to town, for they cannot be had, and the artists know better than to send such works out on tour.

Tell the people if you will that the N.A.D., and the Fine Arts Federation are doing the best they know how, and the best that they can do with what they have to do with, which is perhaps the best work of its kind being done in this or any other country today, but do not let statements by the genial and able Vice President of the National Academy of Design who talks so engagingly about "hand-painted pictures" go out into a confiding and art-thirsty world. If I may be permitted the word, it is pure bunk.

[6] Excerpts from the artist's "Twenty-Five Years of American Painting," *Art News* 26 (Apr. 14, 1928), pp. 22-28

The Armory Exhibition, which was a very large, heterogeneous lot of things, took place in the Armory of the 69th Regiment, New York Volunteer Militia, on Fourth Avenue, in 1913. It contained many fine works too. It was successful, enormously so on account of the shockingly foolish things there. It was so idiotic in spots that it captured the public. Barnum would have been tickled to death with it. Pay as you enter, go again and again and talk about it for weeks! I should perhaps say that I had a group of my works there, six or eight oil paintings by the side of my friend Weir and on the same panel. Twachtman was not far away. It seems absurd to me to spend time writing about and decrying any efforts at expression in the Fine Arts however futile these efforts may seem at the time. If any of it is good, it will stay on the Golden Bough of Art. So much of it is obviously insincere and on the fool-fringe of the Fine Arts that it will rot and drop off the tree finally. In one respect you may be sure that the Armory Exhibition could not be surpassed. It was the limit because no limit was set. There was no terminus. The old Roman god, if not already shattered, would have been shaken to bits there. As samples of the mass of incompetent art writing done during this time . . . the brother-in-law of a portrait painter (this was his only connection with the Fine Arts) came to Weir and to me and said that he was going to take up art criticism and asking our advice. This is typical of any one or another nonentity who takes up writing on art and is comparable to the effort (they sent out a questionnaire from teacher's College, Columbia University "How to teach teachers to teach art") of telling one how to pull down a salary with art jargon. We gave the advice. Take the actual history of the modern movement. It is not French. It is English. The English watercolor painters cleared up the palettes of the painters in oil. Tom Girtin, Bonnington, Turner, Constable and the rest of them. They had as much influence on the then hide-bound conventional French painting as Voltaire had on the French static body politic with his report of

English liberalism and scientific achievement. In a word he gave France a dose of Sir Isaac Newton and John Locke. You will offend, we told him, the French Art Trust (we had that as we then had a "German Music Trust"), but go right on. You should know about Ver Meer and Rubens and the early Dutch landscape painters. . . . Look at the work of the modern Dutch painter, Jongkind: look at his watercolors, if you can see one or two you will find out who first tried for light, and large form out of doors. Study his oils, too, one of the first to get that quality of paint and rich color in a small space, almost as fine as an Albert Ryder. Look too at the work of the Englishman [sic], Sisley, surely one of the best of the landscape painters of the nineteenth century.

We did not expect the little Pierrepont to know French, nor to know anything and, as it turned out, we were right. Our little ox-eyed aspirant of years ago plastered the editorial page of a great New York daily last year in the death of the French painter, Monet, with the usual platitudes and cliches on light, pure color, the spectrum, broken color, short strokes of the brush, dots, dashes, all that rubbish, a budding docent at the Worcester Art Museum could not have been more absurd and true to a formula, a fool formula. He finally wound up with the amusing statement, perfect for a man-milliner: "Monet cleaned up the dark brown palettes of his day and cleared the way for 'Fumiste'" — (my word for the painter who he mentioned). Well, platitudes please the many and jar only the few. He handed out what the astute dealers who had invested in this "outdoor" school had handed to the fool writers all over the world for the last forty years.

Modern landscape painting, as any one can learn, was taken to England from Holland, cleared in tone by the English school of watercolor painters, highly developed by such masters as Turner and Constable. The fine French school of 1830 was founded on the work of the English landscape painters. Turner influenced them even so late as our own period. Monet never made any claim to having cleared up the palettes of the modern painters. He knew better. Palettes were clear enough at the birth of oil painting. Van Eyck and Memlinck are as clear as crystal and sometimes almost as hard but no one since then has painted any better in certain technical ways and never will for that matter. Oil painting, like some of the first printing done, was as near to a certain kind of perfection as it can ever hope to attain. Vermeer painted the light falling on rooftops of houses across a canal in Amsterdam (a city subject) three hundred years ago and it has never been done any better since then, or perhaps as well. As we Americans are, or were, North European, it is just as natural to see a painter happen in North America as in Europe and that one or the other is just as good or better, here or there, is wholly fortuitous.

The so-called modern movement, the painting of light and air, and at its best, robust and full form in the light of day (Whistler and Jongkind and Ryder painted the night as well and Millet notably with his sinking moon over the sheepfold in the Walters gallery), and on which some forgotten ass had bestowed the name of Impressionism, repeated by the stodgily stupid in all countries over and over again until it became a cliche.

CHRONOLOGY

Reliable information on Hassam's whereabouts at any given time is difficult to come by; unless otherwise indicated, only fully documented data is included here. Only some of the more important exhibitions are listed.

1859-c.1877
Born October 17, 1859, at Dorchester, Massachusetts.
Educated in Dorchester at the Mather School, where he receives instruction in drawing and watercolor painting.

c.1877-1881
Leaves school before graduation and, after brief employment in the accounting department of Little Brown & Co., works for wood-engraver George E. Johnson, 9 Milk Street, Boston, as a commercial draftsman.
In the summer of 1880 or 1881 paints for the first time at Gloucester, Massachusetts.

c.1881
Starts working as a free-lance illustrator, specializing in children's stories, with successive studios at 28 School Street, 149 A Tremont Street, and 12 West Street.
Begins studies in drawing, painting, and anatomy under various teachers and at the Lowell Institute.

1882
Paints at Medway, Sudbury, and nearby towns in Massachusetts; visits Nantucket Island (summer).
Holds first one-man exhibition, of watercolors, at the Williams & Everett Gallery, Boston.

1883
At Portsmouth, New Hampshire, and possibly the Isles of Shoals.
Tours Europe in summer with artist friend Edmund H. Garrett, visiting Scotland, England, France, the Netherlands, Switzerland, Italy, and Spain.
Stops using first name "Frederick" professionally.
Attends Boston Art Club life classes and is a member of The Paint and Clay Club, Boston.

1884
Marries Kathleen Maude Doan, February 1.
Moves to 282 Columbus Avenue in Boston's Back Bay district, where he begins painting urban street scenes.
Exhibits watercolors done on his European trip at the Williams & Everett Gallery, Boston.

1885
Exhibits first Boston street paintings.

1886
Visits Appledore, Isles of Shoals, and paints watercolor series of White Island lighthouse (August).
Probably visits Nantucket.
Leaves for Paris in the autumn, planning to study there for three years. Rents an apartment and studio at 11 Boulevard Clichy and begins studies at the Académie Julian.

1887
Exhibits *Cab Station, Rue Bonaparte* at the Paris Salon, where he will exhibit every year of his stay in Paris.
Begins series of *Grand Prix* pictures and takes a trip to Normandy (summer).
First visits Villiers-le-Bel, where he spends time during each summer of his European sojourn.

Moves in the autumn to an apartment and studio at 35 Boulevard Rochechouart.
Auction sale of pre-Paris pictures is held at Noyes, Cobb & Co., Boston, March 9-10.

1888
Stops attending Académie Julian, probably in the spring.
Exhibits *Le Jour du Grand Prix* at the Paris Salon.
Visits Le Havre, Auvers sur l'Oise, and possibly Ecouen.

1889
Exhibits recent paintings at Noyes, Cobb & Co., Boston, March 11-23.
Shows four paintings in the American section of the Exposition Universelle, Paris, and is awarded a bronze medal.
Exhibits *L'Automne* and *Soleil et fleurs* at the Paris Salon.
Spends about half the summer in England, visiting, among other places, London, Broadstairs, and Canterbury.
Works for a short period in a studio vacated by Renoir, also at 35 Boulevard Rochechouart.
Returns to America in late October, going first to Boston. Has moved to New York by November, renting a studio apartment at 95 Fifth Avenue.

1890
Sells work in New York for the first time, at the American Watercolor Society exhibition in January.
Makes acquaintance of John Twachtman and J. Alden Weir.
Elected to numerous art organizations, including the Society of American Artists, The Players, and the American Watercolor Society; serves as first president of the New York Water Color Club.
Shows work at the last exhibition of The Society of Painters in Pastel, in New York (May), and in numerous places throughout America. These exhibitions include his first at the Doll & Richards Gallery, Boston.
Visits the Isles of Shoals (June, July, and September), beginning his series of "poppy" landscapes on Appledore Island; Gloucester (summer); and Bedford, Massachusetts (autumn).
Pictures by him are purchased by the Detroit Club and the Boston Art Club (*Winter Nightfall in the City*).
Exhibits *At the Florist* and *Une Cremière* (watercolor) at the Paris Salon.

1891
At the Isles of Shoals (summer) and at Lexington, Concord, Bedford, and Belmont, Massachusetts (September and October).
Exhibits thirty-five pastels and watercolors at the Doll & Richards Gallery, Boston (November).

1892
Moves late in the year to the Chelsea Hotel, 222 West 23rd Street, where he remains for about a year.
At the Isles of Shoals (July and August) and at Lexington, Lenox, and Quincy, Massachusetts (autumn).
Works in Chicago elaborating drawings, made by others, of the World's Columbian Exposition buildings; he remains there into the next year, but leaves before the Exposition opens in May.
Awarded Second Class (silver) medal at the Munich Künstlergenossenschaft exhibition and the Gold Medal for Watercolor by the Philadelphia Art Club (for *La Bouquetière et la Laitière*).

1893
At the Isles of Shoals (July).
Moves to Rembrandt Studio Building, 152 West 57th Street.
Awarded medals for oil painting (for *Snowy Day on Fifth Avenue*) and for watercolor (*Fifth Avenue*) at the World's Columbian Exposition, Chicago.

1894
At Gloucester (July) and Appledore (August).
Publishes illustrations for Celia Thaxter's *An Island Garden*.
Exhibits at, and is named corresponding member of, the Munich Secession (Verein Bildender Künstler Münchens).

1895
Spends over a month (January and February) in Havana, Cuba, departing there on February 23.
Paints at Gloucester with Willard Metcalf (July); visits Appledore (August).
Awarded Webb Prize, Society of American Artists, New York (for *Place Centrale and Fort Cabanas, Havana*), and Prize Medal ($300), Cleveland Art Association (for the watercolor *Church Parade*).

1896
Holds one-man exhibition at the St. Botolph Club, Boston (January-February).
Exhibition and auction of 205 works on February 6 and 7 at the American Art Association Gallery, New York.
At Gloucester (June); Winter Harbor, Maine (September); Putnam, N.Y.; and Cos Cob, Connecticut.
In December leaves for Europe, landing at Naples.
Awarded Second Prize ($1500), Boston Art Club (for *Summer Sunlight*).

1897
Visits Naples, Capri, Rome, Florence, Paris, Villiers-le-Bel, Pont-Aven, and various places in England and Brittany.
Exhibits in Paris at the Salon of the Société Nationale des Beaux-Arts, of which he is elected an associate member.
Returns to New York, probably in November.
At Greenwich, Connecticut, in the autumn.
Signs resolution on December 17, with nine other painters, to resign from the Society of American Artists and to form the exhibition group later known as the Ten American Painters.

1898
First exhibition of the Ten American Painters opens on March 30 at the Durand-Ruel Gallery, New York.
First visits East Hampton, Long Island (August), to which he returns regularly in the following years.
Awarded Second Class (silver) medal ($1,000), Carnegie International, Pittsburgh (for *The Sea*).

1899
At the Isles of Shoals and Gloucester.
Publication of *Three Cities*, a book of his views of New York, Paris, and London.
Teaches at the Art Students League, New York, substituting for Frank Duveneck (April and May).
Awarded Temple Gold Medal, Pennsylvania Academy of the Fine Arts, Philadelphia (for *Pont Royal*).

1900
At the Isles of Shoals, Gloucester (September), and Provincetown, Massachusetts.
Solo exhibition at St. Botolph Club, Boston, October 29-November 17.
Awarded Silver medal, Exposition Universelle, Paris (for *Fifth Avenue in Winter*).

1901
At Chicago (winter), the Isles of Shoals (August), Cos Cob (September), and Newport, Rhode Island (September, October).
Has one-man exhibition in Paris at the Durand-Ruel gallery, September 9-19.
Exhibits *The Sea* at the Venice Biennale, his first of four showings there.
Moves to the Holbein Studio Building, 139 West 55th Street, in October.
Awarded Gold Medal, Pan-American Exposition, Buffalo, N.Y.

1902
John Twachtman dies at Gloucester on August 8.
Elected Associate Member, National Academy of Design, New York.
At New Canaan, Connecticut (summer), and Cos Cob (November).

1903
Has moved into a cooperative studio building at 27 West 67th Street by late March, after a short stay at the Sherwood Studio Building on Fifty-seventh Street.
Makes first trips to Old Lyme, Connecticut (July and October); also visits the Isles of Shoals (August), Pittsburgh (October), Cos Cob, and probably Branchville, Connecticut (autumn).

1904
At Old Lyme (June, July, and November).
Trip to Portland, Oregon (August and September), with painting excursions to the sea coast and to the Malheur desert; also visits Seattle and San Francisco.
Serves as juror for the Carnegie International, Pittsburgh (October); back in New York by October 18.
Awarded Gold Medal, Louisiana Purchase Exposition, St. Louis, Missouri.

1905
At Old Lyme (April, July, and October); Isles of Shoals (July); Stedham, New Hampshire; and Windham, Connecticut (August).
Holds one-man exhibition at the Montross Gallery, New York, the first of many annuals there.
Awarded Thomas B. Clarke Prize, National Academy of Design, New York (for *Lorelei*), and Third Class Medal, Carnegie Institute, Pittsburgh (for *June*).

1906
Plans trip to Bermuda in the spring, which is apparently canceled.
Society of American Artists merges with the National Academy of Design; the Ten are invited to contribute to the Society's last exhibition.
Named Academician, National Academy of Design, New York.
At Old Lyme (May, June, July, October, and November); Branchville (late June/early July); the Isles of Shoals (August); New London, Connecticut (August); Wainscott, Long Island (September).
Negotiates sale of thirty drawings to the Carnegie Institute, Pittsburgh.

Awarded Carnegie Prize, Society of American Artists, New York (for *June*); Walter Lippincott Prize, Pennsylvania Academy of the Fine Arts, Philadelphia (for *Cliffe Rock, Appledore*); and Third Prize, Worcester Art Museum, 9th Annual Exhibition.

1907
At Wainscott (June), Appledore (July), and Phoenicia, N.Y.

1908
At Bedford Hills, N.Y., and possibly Old Lyme (spring).
Visits Philadelphia for the opening of the tenth anniversary exhibition of the Ten American Painters, held at the Pennsylvania Academy of the Fine Arts, April 11-May 3.
Makes second trip to Portland, Oregon, and to the Harney Desert (September and October); returns to Portland in November and to New York in late November or early December.

1909
By early January has moved to new apartment and studio at 130 West 57th Street.
Exhibition of Oregon pictures at Montross Gallery (April).
At Yarmouth and Portland, Maine (May and June); the Isles of Shoals (July and August); Portsmouth (August and September); Gloucester (September); Old Lyme; New Haven, Connecticut (autumn); and Ridgefield, Connecticut (October), where he visits Frederick Remington.

1910
One-man exhibition at Carnegie International Exhibition, Pittsburgh, May 2-June 30.
Departs June 11 for Europe. Visits London, Haarlem, Amsterdam, Paris, the Côte du Nord, Grez, and, in Spain, Madrid, Toledo, and Seville. Returns to America via Gibraltar in late October or early November.
Awarded Jennie Sesnan Gold Medal, Pennsylvania Academy of the Fine Arts, Philadelphia (for *Summer Sea*), as well as Third William A. Clark Prize and Corcoran Bronze Medal, Corcoran Gallery of Art, Washington, D.C. (for *Springtime*).

1911
Traveling alone, Hassam makes his fifth and final European trip. He stays in Paris in May and June, after canceling a trip to Venice, and returns home in early July.
At East Hampton (July); the Isles of Shoals (July and August); Rockingham, New Hampshire (early September); and possibly Branchville (September).
Exhibitions in Detroit; Michigan; Portland, Oregon; and Newark, New Jersey.

1912
At the Isles of Shoals (July).
Exhibition in St. Louis, Missouri, opens on April 7.
Awarded First William A. Clark Prize and Corcoran Gold Medal, Corcoran Gallery of Art, Washington, D.C. (for *The New York Window*), and Evans Prize ($300), American Watercolor Society, New York.

1913
At Cos Cob (September).
Receives commission in January to paint mural for Panama-Pacific Exposition in San Francisco.
Exhibits at the Armory Show, New York, February-March.

1914
Winter trip to California to paint Panama-Pacific Exposition mural *Fruits and Flowers* (February and March).
At Cos Cob (June), the Isles of Shoals (August), Boston (August), and Belfast, Maine.

1915
Stays with Gifford and Reynolds Beals at Newburgh, N.Y., visiting West Point, Mount Kisco, Poughkeepsie, Fishkill, and other places in the vicinity; paints series of Hudson River watercolors (May and June).
Begins his career as an etcher.
At Cos Cob (June, September, October, and November); Long Ridge, Connecticut; Portsmouth, Exeter, and Stratham, New Hampshire (August); Old Lyme (September; Boston; and possibly Gloucester.
Honored with his own gallery at the Panama-Pacific Exposition, San Francisco.
Awarded Gold Medal, Philadelphia Art Club.

1916
Begins series of Flag paintings, remaining in New York in the early summer (June and July).
At Buffalo (April); Cos Cob; Newburgh; Gloucester (July); Portsmouth (August); East Hampton; Newport (August); Boston; Newfields, New Hampshire; Stratham (September); Chicago (October); and Washington, D.C. (December).
Exhibitions in New York, Boston, Buffalo, and Rochester, N.Y.

1917
At Exeter (June); Catskill Mountains (June); East Hampton (July); Newfields (August), Stratham and Portsmouth (August and September); and Poland Springs, Maine (September).
Begins producing lithographs.

1918
At Bethel, Connecticut (June); Boston (June); Gloucester (July, August, and September), where he poses for a sculpted portrait by Charles Grafly; and Cos Cob (October).
First showing of his Flag paintings, at the Durand-Ruel Gallery, New York, November 15-December 7.
Awarded Second Altman Prize ($500), National Academy of Design, New York (for *Allies Day, May 1917*).

1919
At Southampton, Long Island (July); East Hampton; Gloucester (July, August, and September); Rockport, Massachusetts (September); Boston (September); and Newburgh and vicinity (October).
Buys house in August at East Hampton, where he lives each subsequent year from approximately May through October.
J. Alden Weir dies December 8, 1919.
Awarded Hudnut Prize, American Watercolor Society, New York, and Philadelphia Water Color Prize, Philadelphia Water Color Club.

1920
Elected member of the American Academy of Arts and Letters, New York (November).
At Montauk, Long Island (October), and Bethel.
Awarded Gold Medal of Honor, Pennsylvania Academy of the Fine Arts, Philadelphia, for lifetime achievement.

1921
Spends a month camping with artist friends at Montauk Point, Long Island (September).

1922
Awarded Second Altman Prize ($500), National Academy of Design, New York (for *The Sun Room*).

1923
Possibly at Peacham, Vermont.

1924
"Montauk" series exhibited at the Macbeth Gallery, New York, December 1924-January 1925.
At Baltimore, Maryland (April).
Awarded First Altman Prize ($1,000), National Academy of Design, New York.

1925
Travels to Savannah, Georgia, stopping at Baltimore, Richmond, Virginia, and Charleston, South Carolina (late March-early April).

1926
At Washington, D.C. (March), and Harpers Ferry, West Virginia (April).
Retrospective Exhibition at the Durand-Ruel Gallery, New York, opens on January 25; exhibits at the Milch Galleries, March 22-April 10.
Awarded First Altman Prize ($1,000) by National Academy of Design, New York, and Gold Medal at Sesquicentennial International Exposition, Philadelphia.

1927
Travels to California, stopping en route in New Orelans; Corpus Christi and El Paso, Texas; and Yuma, Arizona (February). Visits Los Angeles, Coronado Beach, and, for a day, Tijuana, Mexico.
By early April back in New York, where he attends the opening of his exhibition at the American Academy of Arts and Letters, April 22-October 22.

1928
At Atlantic City, New Jersey (February), and Annapolis, Maryland.

1929
At Williamsburg, Virginia (April).
Exhibition of recent paintings at California Palace of Legion of Honor, San Francisco, January 1-31.
Retrospective exhibitions at the Albright-Knox Art Gallery, Buffalo, March 9-April 8, and at the Macbeth Gallery, New York, April 16-29.

1930
At Andover, Massachusetts (September), and Washington, D.C.

1931
Awarded Nathan I. Bijur Prize, Brooklyn Society of Etchers, and Joseph Pennell Memorial Medal, Philadelphia Water Color Club.

1932
Is the subject of a one-reel film made by the Metropolitan Museum of Art, New York.
Exhibition at Guild Hall, East Hampton, July 17-August 8.

1933
At Boston (November).

1934
Awarded Gold Medal for Distinguished Services to Fine Art, American Art Dealers Association, New York.

1935
With the artist gravely ill, the Hassams leave for East Hampton in the spring. Hassam dies there, August 27. His artistic estate is bequeathed to the American Academy of Arts and Letters, New York. In following years Maude Hassam distributes groups of the artist's prints among museum collections throughout the country. She dies in New York, 1946.
Awarded John Elliott Memorial Prize, Newport Art Club, and Saltus Medal for Merit, National Academy of Design, New York (for *Evening, Pont-Aven*).

Selected Bibliography

Books and Articles

Adams, Adeline. *Childe Hassam.* New York, 1938.

"An Almost Complete Exhibition of Childe Hassam." *Arts and Decoration* 6 (Jan. 1916), p. 136.

Beuf, Carlo. "The Etchings of Childe Hassam." *Scribner's Magazine* 84 (Oct. 1928), pp. 415-22.

Bienenstock, Jennifer A. Martin. "Childe Hassam's Early Boston Cityscapes." *Arts Magazine* 55 (Nov. 1980), pp. 168-71.

Bryant, Lorinda Munson. *American Pictures and Their Painters,* pp. 172-77. New York, 1920.

Buchanan, Charles L. "The Ambidextrous Childe Hassam." *International Studio* 67 (Jan. 1916), pp. lxxxiii-lxxxvi.

Caffin, Charles H. *American Masters of Painting.* New York, 1902.

———. *Story of American Painting,* pp. 277-78. New York, 1907.

Cary, Elizabeth Luther. "Childe Hassam, American Impressionist." *New York Times,* July 31, 1932, section 9, p. 9.

Catalogue of the Etchings and Dry-Points of Childe Hassam, N. A. New York, 1925. Introduction by Royal Cortissoz.

"Childe Hassam: Painter and Graver, 1859-1935." *Index of Twentieth Century Artists* 3 (Oct. 1935), pp. 169-83 (reprinted 1970, pp. 461-75, 477).

"Childe Hassam and His Prints." *Prints* 6 (Oct. 1935), pp. 2-14, 59.

"Childe Hassam's Work in Various Mediums." *New York Times Magazine,* Nov. 16, 1919, p. 12.

Clark, Eliot. "Childe Hassam." *Art In America* 8 (June 1920), pp. 172-80.

———. "Frederick Childe Hassam." In *Dictionary of American Biography,* suppl. 1, pp. 381-83. New York, 1944.

Colt, Priscilla C. "Childe Hassam in Oregon." *Portland Art Museum Bulletin* 14 (Mar. 1953), unpaginated.

Cortissoz, Royal. *American Artists.* New York and London, 1923, pp. 138-143.

———. "The Life and Art of Childe Hassam." *New York Herald Tribune,* Jan. 1, 1939, section 6, p. 8.

———. "The Traits of the Late Childe Hassam." *New York Herald Tribune,* Sunday, October 6, 1935, section 5, p. 10.

Czestochowski, Joseph S. "Childe Hassam: Paintings from 1880 to 1900." *American Art Review* 4 (Jan. 1978), pp. 40-51, 101.

———. *94 Prints by Childe Hassam.* New York, 1980.

Dewhurst, Wynford. *Impressionist Painting.* London, 1904, p. 94.

E. W. "Exhibitions." *International Studio* 92 (Jan. 1929), p. 80.

E. W. "Exhibitions." *International Studio* 93 (June 1929), p. 78.

Eliasoph, Paula. *Handbook of the Complete Set of Etchings and Drypoints of Childe Hassam, N. A.* New York, 1933.

Fort, Ilene Susan. "The Flag Paintings of Childe Hassam." *Antiques Magazine* 133 (Apr. 1988), pp. 876-87.

G[allatin]., A[lbert]. E. "Childe Hassam: A Note." *Collector and Art Critic* 5 (Jan. 1907), pp. 101-4.

———. *Certain Contemporaries.* New York, 1916, pp. 38-39.

———. *American Water Colourists.* New York, 1922, pp. 13-14.

———. "Childe Hassam: A Note." In *Whistler Notes and Footnotes and Other Memoranda,* pp. 89-95. New York, 1907.

Gerdts, William H. *American Impressionism.* New York, 1984.

Griffith, Fuller. *The Lithographs of Childe Hassam: A Catalogue.* United States National Museum Bulletin, No. 232. Washington, D.C., 1962.

H[artmann]., S[adakichi]. "Studio Talk." *International Studio* 29 (1906), pp. 267-70.

Hassam, Childe. *Three Cities.* New York, 1899.

———. "John Twachtman: An Estimation, II." *North American Review* 176 (Apr. 1903), pp. 555-57.

———. "Twenty-Five Years of American Painting." *Art News* 26 (Apr. 14, 1928), pp. 22-28.

Hiesinger, Ulrich W. *Impressionism in America: The Ten American Painters.* Munich, 1991.

Hoopes, Donelson. *Childe Hassam.* New York, 1979.

Howe, William Henry, and George Torrey. "Childe Hassam." *Art Interchange* 34 (May 1895), p. 133.

Ives, A. E. "Talks with Artists: Mr. Childe Hassam on Painting Street Scenes." *Art Amateur* 27 (Oct. 1892), pp. 116-17.

M. "The Etchings of Childe Hassam." *Nation* 101 (Dec. 9, 1915), pp. 698-99.

McGuire, James C. *Childe Hassam, N. A.* American Etchers, vol. 3. New York, 1929.

McSpadden, Joseph Walker. *Famous Painters of America.* New York, 1907; rev. ed. 1916; and 1923, pp. 397-410.

May, Stephen. "Island Garden." *Historic Preservation* 43 (Sept./Oct. 1991), pp. 38-45, 95.

Mayor, A Hyatt. "Child Hassam." *Bulletin of the Metropolitan Museum of Art* 35 (July 1940), pp. 138-39.

Mechlin, Leila. "The Philadelphia Water Color Exhibition." *International Studio* 28 (June 1906), p. cxi.

Meyer, Annie Nathan. "A City Picture." *Art and Progress* 2 (Mar. 1911), pp. 137-39.

Morton, Frederick W. "Childe Hassam, Impressionist." *Brush and Pencil* 8 (June 1901), pp. 141-50.

Muther, Richard. *The History of Modern Painting.* 4 vols. London, 1907; vol. 4, p. 319.

National Cyclopedia of American Biography. Vol. 10, p. 374. New York, 1900.

Neuhaus, Eugene. *The History and Ideals of American Art.* Stanford and London, 1931, pp. 264-67.

O'Connor, John Jr. "The Graphic Art of Childe Hassam." *Carnegie Magazine* 14 (Nov. 1940), pp. 182-83.

"Painting America: Childe Hassam's Way." *Touchstone* 5 (July 1919), pp. 272-80.

Pattison, James W. "The Art of Childe Hassam." *House Beautiful* 23 (Jan. 1908), pp. 19-20.

Pousette-Dart, Nathaniel. *Childe Hassam.* New York, 1922. Introduction by Ernest Haskell.

Price, Frederick Newlin. "Childe Hassam: Puritan." *International Studio* 77 (Apr. 1923), pp. 3-7.

Reynard, Grant. "The Prints of Childe Hassam, 1859-1935." *American Artist* 24 (Nov. 1960), pp. 42-47.

Robinson, Frank T. *Living New England Artists.* Boston, 1888, pp. 101-6.

Ruge, Klara. "Amerikanische Maler." *Kunst und Kunsthandwerk* 6 (1903), pp. 408-9.

Saint-Gaudens, Homer. *The American Artist and His Times,* pp. 267-70. New York, 1941.

Smith, Jacob G. "The Watercolors of Childe Hassam." *American Artist* 19 (Nov. 1955), pp. 50-53, 59-63.

Stavitsky, Gail. "Childe Hassam and the Carnegie Institute: A Correspondence." *Archives of American Art Journal* 22, no. 3 (1982), pp. 2-7.

———. "Childe Hassam in the Collection of the Museum of Art, Carnegie Institute," *Carnegie Magazine* 56 (July/Aug. 1982), pp. 27-39.

Van Rensselaer, Mariana G. "Fifth Avenue with Pictures by Childe Hassam." *Century* 47 (Nov. 1893), pp. 5-18.

Weitenkampf, Frank. "Childe Hassam and Etching." *American Magazine of Art* 10 (Dec. 1918), pp. 49-51.

White, Israel L. "Childe Hassam: A Puritan." *International Studio* 45 (Dec. 1911), pp. xxix-xxxvi.

"Who's Who in American Art." *Arts and Decoration* 5 (Oct. 1915), p. 473.

Woolf, S. J. "Hassam Speaks Out for American Art." *New York Times Magazine,* Oct. 14, 1934, section 6, p. 7.

Young, Dorothy Weir. *The Life and Letters of J. Alden Weir.* New Haven, 1960.

Young, Mahonri Sharp. "A Quiet American." *Apollo* 79 (May 1964), pp. 401-2.

———. "A Boston Painter." *Apollo* 108 (Nov. 1978), pp. 344-45.

Exhibition Catalogues

Catalogue of an Exhibition of Etchings and Dry Points by Childe Hassam. Frederick Keppel & Co., New York, 1915. By Carl Zigrosser, with an appreciation by J. Alden Weir.

Retrospective Exhibition of Works by Childe Hassam. 1890-1925. Durand-Ruel Gallery, New York, 1926. With an introduction by Frank Jewett Mather.

A Catalogue of an Exhibition of the Works of Childe Hassam. American Academy of Arts and Letters, New York, 1927.

Exhibition of a Retrospective Group of Paintings Representative of the Life Work of Childe Hassam, N. A. Albright Art Gallery, Buffalo, N.Y. 1929. With an introduction by Ernest Haskell.

Leaders of American Impressionism: Mary Cassatt, Childe Hassam, John H. Twachtman, J. Alden Weir. The Brooklyn Museum, 1937. By John I. H. Baur.

Childe Hassam: A Retrospective Exhibition. Corcoran Gallery of Art, Washington, D.C., 1965 (traveled to Museum of Fine Arts, Boston, The Currier Gallery of Art, Manchester, N.H., and The Gallery of Modern Art, New York). By Charles E. Buckley et al.

Childe Hassam: Etchings — Lithographs. Associated American Artists, New York, 1973.

Childe Hassam as Printmaker. The Metropolitan Museum of Art, New York, 1977. By David W. Kiehl and Doreen Bolger Burke.

Childe Hassam 1859-1935. Guild Hall Museum, East Hampton, N.Y., 1981. By Stuart Feld, with contributions by Kathleen M. Burnside and Judith Wolfe.

Childe Hassam. American Academy and Institute of Arts and Letters, New York, 1981.

Childe Hassam, 1859-1935. University of Arizona Museum of Art, Tucson, 1972. By William E. Steadman.

Connecticut and American Impressionism. William Benton Museum of Art, University of Connecticut, Storrs, 1980. With essays by Harold Spencer, Susan G. Larkin, and Jeffrey W. Anderson.

Childe Hassam in Indiana. Ball State University Art Gallery, Muncie, Indiana, 1985. With essays by Alain G. Joyaux, Brian A. Moore, and Ned H. Griner.

Childe Hassam in Connecticut. Florence Griswold Museum, Old Lyme, Connecticut, 1987-88. With an essay by Kathleen M. Burnside.

The Flag Paintings of Childe Hassam. Los Angeles County Museum of Art, 1988 (traveled to National Gallery of Art, Washington, D.C., Amon Carter Museum, Fort Worth, Texas, and New York Historical Society, New York). By Ilene Susan Fort.

Childe Hassam: An Island Garden Revisited. The Denver Art Museum, 1990 (traveled to Yale University Art Museum, New Haven, Connecticut, and The National Museum of American Art, Washington, D.C.). By David Park Curry.

MANUSCRIPTS

Childe Hassam Papers, American Academy of Arts and Letters, New York (microfilm copies in Archives of American Art, Rolls NAA1 and NAA2). Includes photographs, letters, scrapbooks, etc. and a manuscript autobiography written in 1934. Cited herein as Hassam Papers.

Dewitt Lockman Papers, Interviews with Childe Hassam, Jan. 25, 31 and Feb. 2, 3, 1927, New York Historical Society (microfilm copy in Archives of American Art, Roll 503). Cited herein as Lockman Interview.

Florence Griswold Papers, Lyme Historical Society, Old Lyme, Connecticut. Cited herein as Griswold Papers.

J. Alden Weir Papers, Brigham Young University, Provo, Utah. Cited herein as Weir Papers.

C. E. S. Wood Papers, Henry E. Huntington Library and Art Gallery, San Marino, California. Cited herein as Wood Papers.

Royal Cortissoz Papers, The Beinecke Rare Book and Manuscript Library, Yale University, New Haven, Connecticut. Cited herein as Cortissoz Papers.

Carnegie Institute Papers, Archives of American Art, Washington, D.C. Cited herein as Carnegie Papers.

Lyman V. Rutledge Isles of Shoals Collection, Portsmouth Library, Portsmouth, New Hampshire.

Directors' Correspondence: Detroit Institute of Arts; Albright-Knox Art Gallery, Buffalo, New York; Corcoran Gallery of Art, Washington, D.C.; Art Institute of Chicago.

LIST OF WORKS ILLUSTRATED

INDEX OF NAMES

PHOTOGRAPHY CREDITS